W9-AVN-671

Metropolitan Museum Studies in Art, Science, and Technology

◆

Metropolitan Museum Studies in Art, Science, and Technology

◆

Volume 2 / 2014

THE METROPOLITAN MUSEUM OF ART, NEW YORK

DISTRIBUTED BY YALE UNIVERSITY PRESS, NEW HAVEN AND LONDON

EDITORIAL BOARD

Silvia A. Centeno
Research Scientist, Department of Scientific Research

Nora W. Kennedy
*Sherman Fairchild Conservator of Photographs,
Department of Photographs*

Marijn Manuels
*Conservator, Sherman Fairchild Center for
Objects Conservation*

Deborah Schorsch
*Conservator, Sherman Fairchild Center for
Objects Conservation*

Richard E. Stone
*Conservator Emeritus, Sherman Fairchild Center for
Objects Conservation*

Zhixin Jason Sun
Curator, Department of Asian Art

Mark T. Wypyski
Research Scientist, Department of Scientific Research

This publication is made possible by gifts from
Ludmila Schwarzenberg Bidwell and her late husband
Carl B. Hess. Further support was provided by the
members of the Visiting Committees of the Sherman
Fairchild Center for Objects Conservation, the
Sherman Fairchild Center for Paintings Conservation,
the Sherman Fairchild Center for Works on Paper
and Photograph Conservation, and the Department
of Scientific Research.

◆

Published by The Metropolitan Museum of Art,
New York

Mark Polizzotti, Publisher and Editor in Chief
Gwen Roginsky, Associate Publisher and General
 Manager of Publications
Peter Antony, Chief Production Manager
Michael Sittenfeld, Managing Editor
Robert Weisberg, Senior Project Manager
Edited by Ann Hofstra Grogg
Designed by Nancy Sylbert based on original design
 by Tony Drobinski
Production by Paul Booth
Proofread by Sylvia Tidwell

Inquiries and other correspondence may be sent to:
metropolitan.museum.studies@metmuseum.org.

Photographs of works in the Metropolitan Museum's
collection are by The Photograph Studio, The Metro-
politan Museum of Art, unless otherwise noted.
Additional picture credits appear at the end of each
article.

Typeset in Warnock Pro
Printed on 150 gsm Galaxi Matte
Separations by Professional Graphics, Inc.,
 Rockford, Illinois
Printed and bound by Verona Libri, Verona, Italy

◆

Cover illustrations: *Saint Michael*, lower right panel of the
retable of *Saint Anne with the Virgin and Child* (1938.141d;
Figure 5, page 74): (left), detail, photograph by Andrew
Winslow; (right) infrared reflectogram (Figure 19, page 80)

Frontispiece: Detail of Suzanne de Court, Mirror: *Venus
Mourning the Dead Adonis* (1975.1.1236; Figure 3a, page 159)

The Metropolitan Museum of Art endeavors to
respect copyright in a manner consistent with its
nonprofit educational mission. If you believe any
material has been included in this publication
improperly, please contact the Editorial Department.

Copyright © 2014 by The Metropolitan Museum of
Art, New York
First printing
All rights reserved. No part of this publication may
be reproduced or transmitted in any form or by any
means, electronic or mechanical, including photo-
copying, recording, or any information storage and
retrieval system, without permission in writing from
the publishers.

The Metropolitan Museum of Art
1000 Fifth Avenue
New York, New York 10028
metmuseum.org

Distributed by
Yale University Press, New Haven and London
yalebooks.com/art
yalebooks.co.uk

Cataloguing-in-Publication Data is available from
the Library of Congress.
ISBN 978-1-58839-527-6 (The Metropolitan Museum
of Art)
ISBN 978-0-300-20439-1 (Yale University Press)

Contents

Director's Foreword

Technical research entails looking closely at the surfaces of works of art and, beyond that, into their very fabric. This is amply demonstrated in Volume 2 of *Metropolitan Museum Studies in Art, Science, and Technology*. In these pages, we learn about the latest research on the sandstones used by the Khmer masons of the pre-Angkor and Angkor periods; the authorship of a Spanish medieval altarpiece in The Cloisters; the origins of sculptures associated with Buddhist caves of the Northern Qi dynasty; and the authenticity of copper figures from the mountains of southern Lebanon dating to about 2000 B.C. The authors of these studies used technical means to characterize structure and agency with the goal of advancing art-historical knowledge. Following a theme established in Volume 1 with a history of early conservation practices in the Metropolitan Museum, the examination and treatment of medieval polychrome wood sculpture in American collections are considered with parallel developments in collecting and display.

A series of technical notes, many of which highlight the research of conservation and conservation science fellows who work with Museum staff in the material study of the collections, expands the range of media, manufacturing processes, and modes of analysis presented here. The works of art under investigation include Egyptian hard stone sculpture, silvered Limoges enamels, French furniture decorated with Japanese lacquer, a landscape by the American painter Thomas Moran, the Museum's Lion Helmet, and gum dichromate prints by French Pictorialist photographers.

This volume underscores the Museum's mission to investigate the material nature of works of art in addition to their aesthetic qualities and cultural contexts. We thank The Andrew W. Mellon Foundation and Annette de la Renta for their continued support of conservation and conservation science fellows at the Metropolitan. I join the Editorial Board in gratefully acknowledging Ludmila Schwarzenberg Bidwell and her late husband Carl B. Hess, and members of the Visiting Committees of the Sherman Fairchild Center for Objects Conservation, the Sherman Fairchild Center for Paintings Conservation, the Sherman Fairchild Center for Works on Paper and Photograph Conservation, and the Department of Scientific Research for their generous support.

THOMAS P. CAMPBELL
Director
The Metropolitan Museum of Art

Acknowledgments

The Editorial Board most thankfully acknowledges the late Carl B. Hess, who provided substantial financial support for Volume 2 as well as for the inaugural volume of *Metropolitan Museum Studies in Art, Science, and Technology.* Over the years, we benefited not only from Carl's generous funding but also from his enthusiasm and encouragement, fueled by a deep commitment to scholarship in the fields of art, science, and technology.

We are grateful to Ludmila Schwarzenberg Bidwell, who has continued her late husband Carl's legacy in her generous support of Volume 2. Further support was provided by the members of the Visiting Committees of the Sherman Fairchild Center for Objects Conservation, the Sherman Fairchild Center for Paintings Conservation, the Sherman Fairchild Center for Works on Paper and Photograph Conservation, and the Department of Scientific Research, all of whom we thank enthusiastically for their contributions to this new publication dedicated to the conservation and technical investigation of works of art.

The Editorial Board would like to express its special appreciation to Thomas P. Campbell, Director, for his ongoing support, and to Lawrence Becker, Sherman Fairchild Conservator in Charge, Sherman Fairchild Center for Objects Conservation, for allotting precious departmental resources to this important initiative.

A large debt of gratitude is also owed to our dedicated and meticulous volume editor, Ann Hofstra Grogg, whose sense of style and order significantly enhanced the quality of this publication, and to our indefatigable proofreader Sylvia Tidwell. We are also grateful to Nancy Sylbert, who applied her skill and creativity to the design of Volume 2. New object photography was undertaken by Teresa Christiansen, Paul Lachenauer, Oi-Cheong Lee, Eugenia B. Tinsley, Juan Trujillo, and Karin L. Willis. We thank them and Barbara Bridgers, General Manager for Imaging, The Photograph Studio, The Metropolitan Museum of Art, for their many contributions.

Finally, we thank our large group of anonymous peer reviewers, whose expertise and insights have helped ensure the consistently high quality of the manuscripts. The same is true for our colleagues in the Museum, especially Peter Barnet, Senior Curator, Department of Medieval Art and The Cloisters; Federico Carò, Associate Research Scientist, and Tony Frantz, former Research Scientist, Department of Scientific Research; Elizabeth Mankin Kornhauser, Alice Brown Pratt Curator of American Paintings and Sculpture, The American Wing; and Andrew Winslow, Senior Departmental Technician, The Cloisters. Samir Iskander, Hung-hsi Chao, and Pamela Hernandez and Marina Ruiz-Molina kindly reviewed abstracts that appear here in Arabic, Chinese, and Spanish, respectively, assuring that these newly published studies are more accessible to foreign scholars in countries or regions that have special affinity with the works of art discussed herein.

THE EDITORIAL BOARD
Metropolitan Museum Studies in Art, Science, and Technology

Metropolitan Museum Studies in Art, Science, and Technology

◆

Conservation in Context: The Examination and Treatment of Medieval Polychrome Wood Sculpture in the United States

◆

Lucretia Kargère and Michele D. Marincola

ABSTRACT

Whereas the history of collecting medieval European polychrome sculpture in the United States has been discussed in art-historical literature to some extent, scant attention has been paid to the historical development of examination and treatment techniques. This article suggests a parallel and interdependent relationship between these two histories. In the early twentieth century, American museums acquired increasing numbers of medieval painted and gilded sculptures that were initially displayed in settings evocative of the Middle Ages. These sculptures were usually treated by paintings conservators with methods adapted from easel paintings, with a major focus on halting the ongoing deterioration of polychromy in uncontrolled environments. It is only later, thanks in large part to curators such as James Rorimer and the European-trained restorers who worked with them, that a more scholarly and scientific approach to the acquisition, examination, restoration, and display of medieval sculpture was adopted. These developments and others are explored using archival and biographical research and visual examination of sculptures from a number of important American museum collections.

La restauration, avant de devenir un problème technique, est d'abord un problème culturel, et que le premier n'est que la conséquence du second.

—Paul Philippot

Displays are . . . the locus where the previous history of a work and its past critical reception interface with contemporary responses determined by the specific historical moment of its presentation.

—Françoise Forster-Hahn

One of the glories of European medieval art is polychrome wood sculpture, carved figures that were decorated with paint, metal leaf, and other colorful materials. The overwhelming majority of these sculptures depict biblical scenes or Christian saints and other holy figures. Their polychromy served an essential role in their original function as devotional images, in that color helped viewers in candlelit interiors differentiate compositional elements and served to highlight the more important figures within a larger ensemble. Medieval polychrome sculpture is often highly realistic, employing color and texture to help create the illusion that the sculptures are alive.

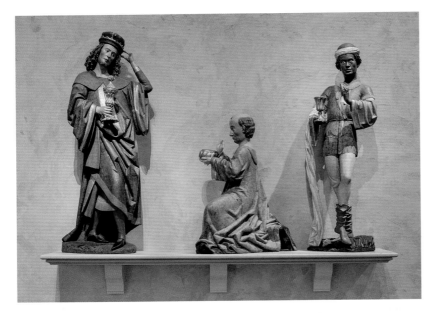

Figure 1 ◆ *Three Kings from an Adoration Group.* Swabia, Germany, before 1489. From left to right: *Balthasar* (52.83.3), poplar, paint, and gilding, H. 163.8 cm (64½ in.); *Melchior* (52.83.1), poplar, paint, and gilding, H. 101.6 cm (40 in.); *Caspar* (52.83.2), maple, paint, and gilding, H. 156.2 cm (61½ in.). The Metropolitan Museum of Art, The Cloisters Collection, 1952 (52.83.1–3)

The close imitation of skin, hair, garments, and attributes achieved through the painter's art amplifies the emotional connections of the faithful to the images, making these figures particularly effective aids in worship.[1]

Yet despite the importance of polychrome sculptures to religious practice and the large numbers that existed by the late Middle Ages, few survive in excellent condition. The wooden supports are prone to damage by insects, fire, and fluctuations in humidity. Paint layers fade, darken, or flake, and metal leaf tarnishes, altering the original relationships between colors and textures. Unlike other types of religious art such as panel paintings, polychrome sculptures were frequently overpainted, often when still in their original setting. New paint layers might be added in the context of religious devotion to refresh a sculpture's aspect and make it look "as good as new" or to reflect changes in style, such as a Baroque refurbishing of a Gothic church interior. Sculptures that survived the periodic European iconoclasms were sometimes removed from their ecclesiastical settings in altarpieces or shrines, placed in different locations within the church, or abandoned as no longer important for the rituals of worship.[2] In the nineteenth century, after medieval sculptures became of interest to collectors and other antiquarians and began to enter museum collections, their meaning and often their appearance changed again.

Medieval European polychrome wood sculptures displayed in museums today are in settings profoundly different from the original. For example, the figures in *Three Kings from an Adoration Group* in The Cloisters, The Metropolitan Museum of Art (52.83.1–3; Figure 1) have lost the focus of their adoration and seem lifeless when compared to sculptures in an extant altarpiece in its original location in Blaubeuren (Figure 2). Removed from their religious context and surrounding altarpiece or shrine, and often preserved in fragmentary condition, these sculptures serve a different purpose as works of art in new institutional environments.[3] This transition from religious image to museum object is accompanied by a change in the care and presentation of the sculpture. Once a polychrome sculpture enters a museum collection, stewardship evolves from renewal (in the form of repainting, for example) to preservation and restoration. The activities of conservation—technical study, preservation, and restoration—change over time, as they, too, are subject to shifts in taste and advances in knowledge and methodology. This article explores these changes for a subset of polychrome sculptures, those that have been collected and exhibited by American museums.

A key set of relationships emerges through study of biographical information and conservation records, collection-based research, and examination of the surviving primary documents—the artworks themselves. The development of conservation and restoration methodologies is closely intertwined with the evolution of art-historical and scientific analysis of objects, as well as with museum aesthetics and exhibition design. These relationships have been to some degree evaluated for other kinds of artwork, for example, Old Master paintings.[4] Excellent museum catalogues consider the restoration of polychrome wood sculpture in individual collections in Germany,[5] and there are important articles on the history of conservation in Europe for these works of art.[6] However,

very few publications in this field consider the history of museum-based collecting and exhibition design and its relationship to restoration practice.[7] In considering the history of conservation of polychrome sculpture in the United States, a set of questions central to the theme starts to arise: How did the collections of medieval polychrome sculpture develop in the United States, and who was responsible for the major acquisitions? How were conservation practices and the display of these sculptures informed by the goals, aesthetics, and interpretations of American museum professionals? How has the increasing role of science in conservation been reflected in museum practice in the United States? Studying the history of sculpture conservation in this way enhances understanding of the current condition of these artworks and provides guidance for their preservation in the future.

THE FORMATION OF MEDIEVAL POLYCHROME SCULPTURE COLLECTIONS AND THEIR EARLY DISPLAY IN THE UNITED STATES

Few medieval objects entered American museums during the nineteenth century. American directors and curators lacked the funds to compete in the European market,[8] and when they had the money, the concern remained that they might buy wrongly attributed or even spurious works.[9] Instead, art academies and museums at first acquired plaster casts of famous sculpture and monuments dating to all periods, including medieval art. The Metropolitan Museum of Art opened its extensive Main Hall of Casts in 1896. Inspired by European examples such as the vast collection of plaster reproductions of the Musée de Sculpture Comparée at the Palais du Trocadéro in Paris, American museums supported an explicitly didactic mission through the display of casts.[10] Reproductions of great works of art were intended to instruct a wide audience ranging from the general public to artists, to industrial designers.[11] For example, Raymond Pitcairn (1885–1966), a collector of medieval art, acquired casts as models for the artisans constructing the Church of the New Jerusalem in Bryn Athyn, Pennsylvania.[12]

In late nineteenth-century America, only a small number of private collectors were interested in acquiring original medieval sculptures. In the 1890s, Isabella Stewart Gardner (1840–1924) began purchasing examples of Romanesque and Gothic sculpture to incorporate into the fabric of her pseudo-Venetian palazzo in Boston.[13] In Baltimore, Henry Walters (1848–1931) opened his palatial residence on Mount Vernon Place to the public in 1909 after augmenting his father's collection to include significant medieval sculptures. The display was reminiscent of a European *Kunstkammer*, filled with antiquities from the Grand Tour and paintings hung densely up to the ceiling.[14]

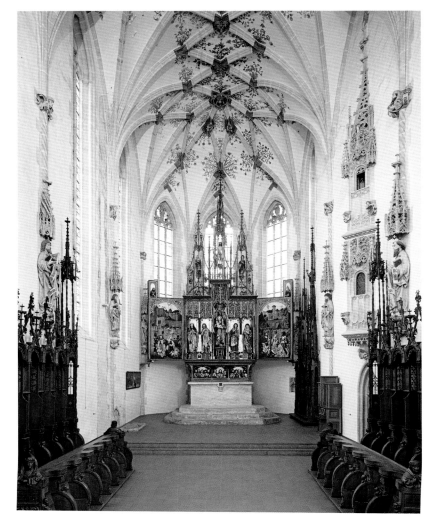

Figure 2 ◆ Interior of the Klosterkirche, Blaubeuren. Altarpiece attributed to Michel Erhart (Swabian, act. 1469–1518) or his son Gregor (1470?–1540). Swabia, Germany, ca. 1493–94. Lindenwood, paint, and gilding

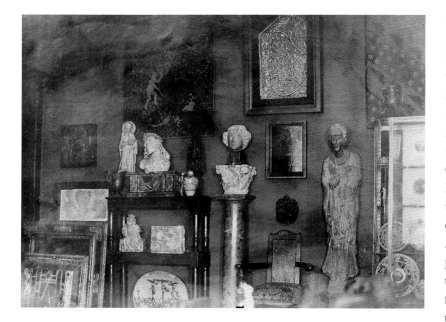

Figure 3 ◆ View of the Demotte Gallery, Paris, between 1910 and 1925. To the right of the armchair is the sculpture purchased in 1925 by Edward Waldo Forbes for the Fogg Museum, *Female Saint (Mary Magdalene?)*. Spain, Taüll, 12th century. Wood with traces of polychrome and gesso, H. 145.1 cm (57⅛ in.), W. 35.6 cm (14 in.), D. 30.2 cm (11⅞ in.). Harvard Art Museums/ Fogg Museum, Friends of the Fogg Art Museum Fund (1925.11)

By the beginning of the twentieth century, institutional holdings of original works were growing, and the rate of acquisition continued to increase in the next few decades. Whereas in 1895 The Metropolitan Museum of Art owned a mere four Gothic polychrome wood sculptures, all received as gifts, by 1920 more than one hundred such sculptures had been added to the collection. What had changed was the global economic and political climate. The United States had recovered quickly from the severe financial collapse of 1873, and American collectors and newly established museums were rapidly buying works made available by insolvency abroad. These institutions offered a safe haven for both people and artworks from an increasingly unstable Europe. American museums benefited from the sales of major French collections (Émile Gavet in 1889, Frédéric Spitzer in 1893, Georges Hoentschel in 1912, Octave Homberg in 1931)[15] and from rising political strife in Spain. In 1909, the Payne-Aldrich Tariff Act repealed the 20 percent tax for artworks brought into the United States from abroad, and the trickle of objects became a stream.[16]

In those early years, art dealers played a significant role in advising collectors and providing countless masterpieces to museums. Prominent dealers, such as Jacques Seligmann (1858–1923) and his son Germain Seligman

(1893–1978), Leopold and Ruth Blumka (1898–1973, 1920–1994), and Joseph and Ernest Brummer (1883–1947, 1890–1964), helped form the tastes and collections of noteworthy American collectors such as Benjamin Altman (1840–1913), Michael Friedsam (1858–1931), Isaac D. Fletcher (1844–1917), J. Pierpont Morgan (1837–1913), Michael Dreicer (1868–1921), and George Blumenthal (1858–1941).[17] Whereas European Old Master paintings, furniture, tapestries, bronze and ivory statuettes, and ceramics were avidly collected by wealthy Americans, each of these collectors also bought polychrome sculpture. In these transactions, they relied on the dealer's experience and eye for the selection of works. In time, many of their acquisitions were donated to American museums, forming the core of several important institutional collections.

Similarly, in the early decades of the twentieth century, a number of museum curators significantly improved their institutions' holdings. At the Cleveland Museum of Art, William Milliken (1889–1978), curator of medieval decorative arts from 1919 and its director from 1930 to 1958, had a keen eye for polychrome wood sculptures. In 1928, he purchased *Christ and Saint John the Evangelist* (1928.753), and a dozen other important polychrome wood sculptures entered the collection during his tenure.[18] Universities such as Harvard and Princeton also assembled their own collections, primarily as teaching aids for their art history departments. For example, Edward Waldo Forbes (1873–1969), director of the Fogg Art Museum (now the Harvard Art Museums/Fogg Museum), Cambridge, Massachusetts, from 1909 to 1944, purchased a rare *Female Saint (Mary Magdalene?)* (1925.11) in 1925, demonstrating an early interest in Spanish Romanesque artwork.[19] The sculpture can be identified in an old photograph of the gallery of the art dealer Georges-Joseph Demotte in Paris (Figure 3); in fact, Paul J. Sachs (1878–1965), Forbes's associate director, is known to have seen the sculpture in Paris before it came to the United States.[20]

Opportunities for employment in the United States also induced highly qualified German and Austrian museum professionals to emigrate to the United States, where they experimented with exhibition methodologies. William R. Valentiner (1880–1958), who had trained under Wilhelm von Bode at the Kaiser-Friedrich Museum in Berlin, served as curator of The Metropolitan Museum of Art's Department of Decorative Arts from 1908 to 1917. The banker-financier J. Pierpont Morgan, then president of the museum, hired Valentiner as someone capable of "arranging for display the Hoentschel Collection, which he had acquired in Paris."[21] Valentiner followed von Bode's innovative ideas about installation design, in which different types of artworks were not segregated in different galleries but integrated in didactic arrangements to suggest cultural as well as artistic connections. He installed Morgan's collection in chronological order in a series of three exhibitions (1908–10, 1912, 1914), creating coherent environments for the visitor with works of different types and materials from the same period, including tapestries, paintings, sculptures, and furniture, placed in the same room. The approach was clearly successful with the public; the final exhibition broke museum attendance records in 1914.[22] Valentiner was hired by the Detroit Institute of Arts in 1921, first as an adviser and then as director, and his museological methods greatly influenced the design of the new building being planned on Woodward Avenue at the time.[23] Until his retirement in 1944, Valentiner acquired superb examples of medieval polychrome sculpture, building one of the finest collections in the United States.

In New York, the collecting of medieval art was also shaped by the existence of a very different type of museum, the private collection of the American sculptor George Grey Barnard (1863–1938).[24] Opened to the public in 1914 at West 190th Street and Fort Washington Avenue in Upper Manhattan, the collection included a large number of medieval sculptures and architectural elements that had been gathered by Barnard during his travels in France and Spain between 1905 and 1913. Housed in a churchlike structure called The Cloisters, Barnard's museum largely rejected the installation of artworks under protective glazing in favor of displaying them in atmospheric settings subordinated to the overall aesthetic of the interior architecture. In a manner reminiscent of the Isabella Stewart Gardner Museum, which had opened in Boston in 1903,[25] Barnard created a highly personal, composite neomedieval setting in which Gothic polychrome wood sculptures were placed on Romanesque stone colonnettes against a modern brick background. The visitor's experience of the arts of the Middle Ages was heightened by candlelight, incense, medieval chants, and museum guides dressed in monk's robes (Figure 4).[26]

Barnard's romantic version of a "living museum," a variation of the European model of museums where one could "walk through time," would eventually greatly influence other institutions in the United States, including the Cleveland Museum of Art, the Detroit Institute of Arts, the Philadelphia Museum of Art, and the Worcester Art Museum, Worcester, Massachusetts.[27] All installed medieval art in spaces meant to evoke the original context of the works as it was then understood, ranging from literal interpretations of the Dark Ages featuring dimly lit interiors to ambitious recreations of monastic interiors.

EARLY INTERVENTIONS ON WORKS IN PRIVATE HANDS

The condition of medieval polychrome wood sculptures entering American collections was far from homogeneous. In addition to the changes, such as repainting, that occurred during the ritual life of sculptures, or damage from use or environmental conditions, the sculptures were often restored or otherwise altered when they entered the world of dealers and collectors. What took place is known largely through circumstantial evidence and must be inferred from traces of old treatment materials and methods visible on the sculptures

Figure 4 • Barnard's
Cloisters, Fort Washington
Avenue, New York,
interior courtyard with
candlelight illumination,
between 1915 and 1925

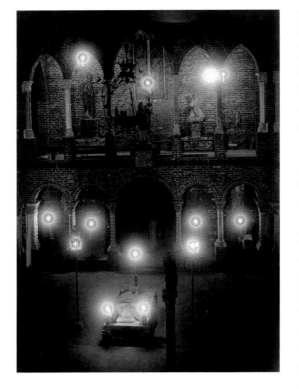

today. In a few cases, the dealer supplied information on the sculpture's condition, such as can be found in the files for the thirteenth-century Spanish head, originally thought to be Saint Christopher but now designated as *Head of Christ or a Saint*, today in the Rhode Island School of Design (RISD) Museum of Art (59.131), Providence, or the *Virgin and Child* from Soissons in the Museum of Fine Arts, Boston (59.701), both cleaned of overpaints prior to acquisition.[28] It is clear from examination that many polychrome sculptures were significantly altered by restorers, probably to increase their appeal to collectors. Restoration in this context meant the return of the object to its former splendor and iconographic function, although often these were presumed and misinterpreted. Missing elements and architectural details were replaced, and lost attributes essential to the correct identification of saints were added, sometimes arbitrarily, thereby obscuring the original meaning of the work.[29] The fourteenth-century *Figure of a King* (52.82; Figure 5a), for example, was most likely "improved" while in Demotte's shop in Paris before its acquisition by the Metropolitan

Museum for The Cloisters in 1952. Formerly it was styled as Saint Alexis, holding his attributes, a ladder and palm (Figure 5b), and then Saint Louis, with renewed polychromy, a bejeweled neckline and chest, and a new base designed by Demotte (Figure 5c).[30] The French dealer is known to have employed a talented sculptor named Émile Boutron, a man with the ability to "repair, amend, alter, and invent anew."[31] The Dumbarton Oaks' *Virgin and Child on the Crescent Moon* (HC.S. 1937.006. [W]), now understood to be the work of Tilman Riemenschneider,[32] and a *Saint Roch and the Angel* at The Cloisters (60.126) were also fully restored, probably by Georg Schuster (1869–1937), a sculptor-restorer-dealer in Munich who was criticized in his lifetime for completing fragmentary sculptures so skillfully that they appeared "untouched and old."[33] In preparation for sale on the Italian art market, the *Enthroned Virgin and Child* (16.154.10a, b) now in the Metropolitan Museum received a new tabernacle and fresh layers of paint, probably while owned by Elia Volpi (1858–1938), a renowned restorer-dealer in Florence who had staged his collection at the Palazzo Davanzati, partly to impress visiting American collectors.[34]

It was common for sculptures entering American institutions to have lost all traces of their original polychromy. The paint and gilding layers had been stripped at some previous time, for reasons ranging from antipathy toward color on sculpture to a mistaken belief that the carving conveyed the true essence of the work; paint layers might also have been in poor condition and removed as part of the renewal process during the sculpture's ritual life.[35] Early twentieth-century art-historical methods of research that relied on black-and-white photography made it easy to ignore color, or its absence.[36] Additionally, many American museums, conceived primarily as practical resources for artisans and designers, treated polychrome wood sculpture as decorative arts, like furniture. The Mr. and Mrs. Roland L. Taylor Collection, bequeathed to the Philadelphia Museum of Art in 1929, comprised

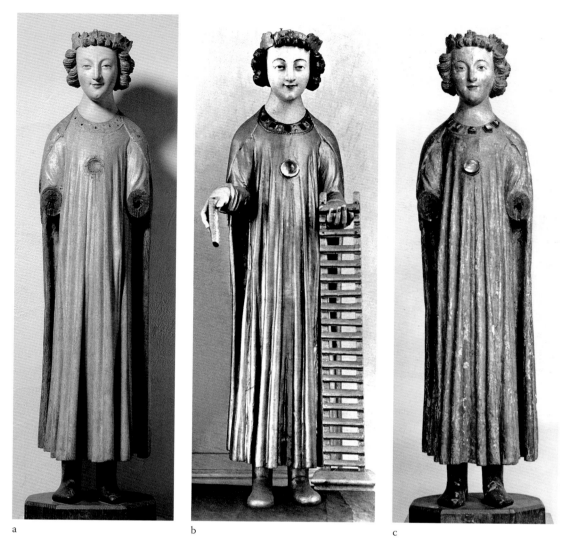

a b c

Figure 5 ◆ (a) *Figure of a King.* Flanders, South Netherlandish, 1300–1325. Oak with paint and gilding H. 116.8 cm (46 in.). The Metropolitan Museum of Art, The Cloisters Collection, 1952 (52.82); (b) same sculpture, interpreted as Saint Alexis, exhibited in the Grand Béguinage of Ghent, 1864; (c) same sculpture, interpreted as Saint Louis, in Georges-Joseph Demotte's shop, Paris, between 1910 and 1934, with face repainted, jewels at neckline replaced with new stones in gilded silver mounts, and a slightly smaller rock crystal cabochon mounted in a new frame on chest

numerous fragments of fifteenth-century wood paneling as well as a lesser number of medieval sculptures, all of which exhibit a similar shiny, dark brown surface.[37] The stained, varnished, or waxed wood could have appealed to collectors who already owned dark furniture and polished bronze statuettes. Almost two-thirds of the wooden sculptures from the J. Pierpont Morgan Collection that are now in the Metropolitan Museum have lost their paint and gilding, as can be concluded from extant traces of polychromy (e.g., 16.32.214; Figure 6).

The early restoration histories of private collections followed to a large extent the personal vision of their owners. For example, it does not appear that Barnard had any of the polychrome sculpture significantly restored for display in his museum.[38] In spite of its rather

poor condition, the *Enthroned Virgin and Child* now in the Philadelphia Museum of Art (1945-25-70; Figure 7a) apparently was not altered between the time it was in Demotte's shop in Paris (Figure 7b) and when it was exhibited in Barnard's Cloisters.[39] With the dim lighting and the sculptures displayed at varying heights, the condition of individual works of art became less of a priority, and their aged and uneven surfaces no doubt contributed to Barnard's aesthetic.

THE COLLECTING AND DISPLAY OF MEDIEVAL POLYCHROME WOOD SCULPTURES IN THE UNITED STATES, 1930–1950

The nascent field of art history was tremendously affected by the expulsion of academics

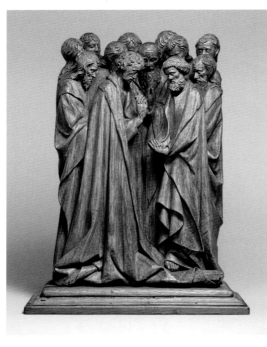

Figure 6 ◆ *Apostles in Prayer*. South Netherlandish, ca. 1400–1410. Oak, overall without base: H. 49.1 cm (19⁵⁄₁₆ in.), W. 32.7 cm (12⅞ in.), D. 11.1 cm (4⅜ in.); overall with base: H. 53.6 cm (21⅛ in.), W. 40.7 cm (16 in.), D. 13.0 cm (5⅛ in.). The Metropolitan Museum of Art, Gift of J. Pierpont Morgan, 1916 (16.32.214)

from Nazi Germany; in turn, their arrival in the United States had a large impact on American museology. Some of the finest art historians of the twentieth century, including the medieval and Renaissance scholars Erwin Panofsky (1892–1968) and Richard Offner (1889–1965), emigrated to the United States, bringing with them knowledge about and preference for medieval—often German— sculpture. The growth of medieval studies in academic circles continued to greatly influence the world of collecting. Georg Swarzenski (1876–1957), a German-born medievalist, had been director of the Liebieghaus in Frankfurt and assembled the core of its sculpture collection. While there, he had introduced several innovations in vogue at the time in Germany, including the installation of period rooms and musical concerts in the galleries.[40] Hired in 1939 by the Museum of Fine Arts, Boston, he rapidly built its medieval collection and in 1940 organized "Arts of the Middle Ages, 1000–1400," the first comprehensive loan exhibition of medieval art in America. More than three hundred works from American museums, private collections, and art dealers were displayed in a setting intended to emphasize the individual works rather than their

collective ability to evoke a medieval atmosphere.[41] Although the exhibition highlighted artworks in private hands, it also established Boston as a center for the scholarly study of medieval art. Among the dozen wood polychrome sculptures displayed was an *Enthroned Virgin and Child* from Autun owned by the Brummer Gallery, New York; it was later purchased by the Metropolitan Museum for display at The Cloisters (47.101.15).[42]

As American collections grew, it became increasingly difficult for museums to organize and present their holdings in a way that would make the aesthetic value and historical interest of the works of art clear to their visitors. In 1925, the American Association of Museums (AAM) initiated a series of pioneering studies on visitor behavior to enhance museums' ability to effectively educate the public.[43] The press, discussing the problems faced by museums, objected to the crowding of objects into gallery spaces that turned museums into "mausoleums of art" or "safe deposit vaults" and created a new ailment called "museum fatigue."[44] At the time, museums faced competition for the public's attention from art fairs and department stores, which were rapidly adopting successful merchandising techniques, including the installation of new lighting, cooling and heating systems, resting places for clients, and improved organization of space to accommodate crowds. By contrast, in 1930, The Metropolitan Museum of Art was still poorly heated and ventilated, and the galleries were inadequately lit and maintained.[45]

During the 1930s concurrent developments in installation design and in art-historical and materials research wrought a tremendous shift in the American museum world. At the first international conference on museology, held in Madrid in 1934, Fiske Kimball (1888–1955), director of the Pennsylvania Museum and School of Industrial Art (renamed the Philadelphia Museum of Art in the late 1930s), described how his institution approached the problem of museum display. He presented a two-tiered system for installation, with major

KARGÈRE AND MARINCOLA

a

b

Figure 7 ◆ (a) *Enthroned Virgin and Child*. France, Auvergne, 1175–1200. Wood with remains of painted decoration, H. 63.5 cm (25 in.), W. 27.9 cm (11 in.), D. 27.9 cm (11 in.). The Philadelphia Museum of Art, purchased with Museum funds from the George Grey Barnard Collection, 1945 (1945-25-70); (b) same sculpture, in Georges-Joseph Demotte's shop, Paris, between 1910 and 1934

art objects exhibited chronologically and geographically in period settings, and a more exhaustive display of the holdings located in study rooms "downstairs." On the upper floor, vitrines with many objects were replaced by single works of art installed on individual pedestals or exhibited in isolation behind glass, arrangements that, it was thought, permitted the objective assessment of works of art as well as their closer scrutiny.[46]

In New York, after Barnard's collection was acquired by The Metropolitan Museum of Art in 1925, a good deal of restoration was carried out in preparation for reinstallation in a new building being constructed in Fort Tryon Park. In 1932, the museum appointed Joseph Breck (1885–1933) to reorganize the rather picturesque arrangements of the Barnard material into a more orderly and chronological display for The Cloisters, which was to house much of the Metropolitan Museum's medieval collections.[47] With Breck's untimely death, the

project was turned over to his assistant, James J. Rorimer (1905–1966) (Figure 8), who completed the installation in 1938. The son of a prominent interior designer in Cleveland and a student of Paul J. Sachs and Edward Waldo Forbes at Harvard, Rorimer had been hired by Breck in 1927 as an assistant in the Department of Decorative Arts; he became curator of medieval art in 1934, curator of The Cloisters in 1938, its director in 1949, and the director of the Metropolitan Museum in 1955.[48] Rorimer carefully planned the installation of the collection at The Cloisters. He avoided a concentration of objects in individual galleries and strove instead to display each sculpture to its fullest effect through advantageous viewing angles and effective lighting (Figure 9). Having grown up with a father who had trained as an artist and craftsman, Rorimer was himself keenly interested in sculpture.[49] He built upon Barnard's collection, which included sixteen polychrome wood sculptures, as well as the

Figure 8 ◆ James J. Rorimer, 1964, with *Virgin and Child*. France, Burgundy, ca. 1400–1425. Limestone with traces of paint, H. 90.8 cm (35¾ in.), W. 36.2 cm (14¼ in.), D. 26.0 cm (10¼ in.). The Metropolitan Museum of Art, Gift of J. Pierpont Morgan, 1916 (16.32.163)

Figure 9 ◆ The Metropolitan Museum of Art, The Cloisters, Early Gothic Hall, 1939

Figure 10 ◆ Display in "Seven Joys of Our Lady: A Christmas Exhibition at The Cloisters," 1944, featuring *The Visitation*. Attributed to Master Heinrich of Constance (German, act. ca. 1300). Germany, Constance, 1310–20. Walnut, paint, gilding, rock crystal cabochons in gilded-silver mounts, H. 59.1 cm (23¼ in.), W. 30.2 cm (11⅞ in.), D. 18.4 cm (7¼ in). The Metropolitan Museum of Art, Gift of J. Pierpont Morgan, 1917 (17.190.724)

Metropolitan Museum's holdings, to amass significant examples of French, German, and Spanish polychrome wood sculpture; more than eighty were acquired under his guidance. Most were restored in preparation for installation, as discussed below. Upon its opening in 1938, The Cloisters was deemed a success; it was described by Germain Bazin, former chief curator of paintings at the Musée du Louvre in Paris, as "the crowning achievement of American museology."[50]

Rorimer adopted an installation model similar to Kimball's two-tiered system at the

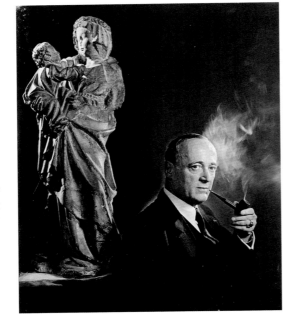

Philadelphia Museum of Art. To counterbalance the more art-historically rigorous displays of the permanent collection, which were found in most of The Cloisters galleries, Rorimer and his staff scheduled popular events and seasonal thematic exhibitions. In creating these elaborate mise-en-scènes, the staff took advantage of the mimetic and highly theatrical nature of polychrome sculpture. "Saints for Soldiers" (1943) was devoted to medieval sculptures of guardian saints whose charge was "to protect soldiers, sailors and men in hospitals" during armed conflicts, a particularly appropriate theme during World War II.[51] "Seven Joys of Our Lady" (1944) brought together paintings, manuscript illuminations, and sculptures of the Virgin, placing them in a setting of evergreens and flowers, backed with red and gold brocatelle reminiscent of the brocade canopies depicted in paintings (Figure 10). Beginning in the 1940s, an annual tradition of Christmas Nativity installations included sculptures from the Metropolitan Museum's collection displayed on green cloth, sheltered by an improvised shed, and set against a background of trees (Figure 11). Medieval music,

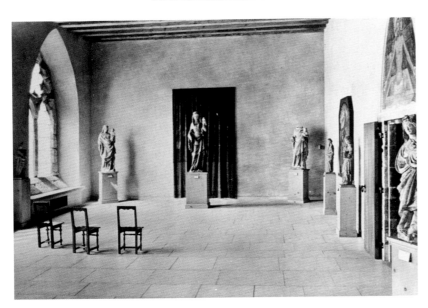

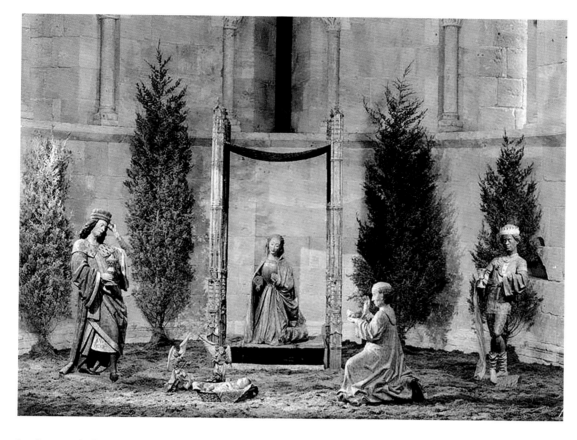

Figure 11 ◆ Nativity scene displayed at The Cloisters, 1960s, featuring *Three Kings from an Adoration Group* (52.83.1–3) (see Figure 1). *Kneeling Virgin.* Attributed to Paolo Aquilano (Italian, Abruzzo, act. ca. 1475–1503). Central Italy, Abruzzo, ca. 1474–1500. Willow and white fir, paint, and gilding, H. 117.2 cm (46⅛ in.), W. 80.0 cm (31½ in.), D. 50.2 cm (19¾ in). The Metropolitan Museum of Art, The Cloisters Collection, 1925 (25.120.217). *Christ Child* (from *Nativity*). Workshop of Antonio Rossellino (Italian, Settignano, 1427–ca. 1479). Italy, Florence, 15th century. Painted terracotta, L. 44.5 cm (17½ in.). The Metropolitan Museum of Art, Rogers Fund, 1911 (11.136.3). *Angel with Rebec* and *Angel with Lute.* Both South German, 20th century. Possibly limewood. Overall 50.8 cm (20 in.). The Metropolitan Museum of Art, Gift of Abby Aldridge Rockefeller, 1947 (47.89.2, 47.89.1)

both recorded and live, was introduced, and massive candelabra were lit each afternoon in selected galleries to enhance the visitor experience.[52]

Another approach to public outreach was tried with great success in Providence. Alexander Dorner (1893–1957), a German refugee hired as director of the RISD Museum of Art in 1938, created five galleries for arts of different eras, including one for the medieval period. His intent was to provide insight into that earlier culture through immersion: window openings were covered with back-lit, transparent re-creations of contemporaneous architecture; pedestals were eschewed in favor of built-in wall units; objects were clearly illuminated; and recorded music of the period was played in each gallery. Dorner had conceived of "atmosphere rooms" while in Hanover as director of the Niedersächsisches Landesmuseum.[53] His philosophy of restoration seems to have been in keeping with this re-creation of a "historical" ambience; he asked restorers to treat one work of art so that it conformed to his concept of its original appearance and meaning, a task requiring extensive intervention.[54]

MUSEUM CONSERVATION, 1930–1950

In preparation for new installations and in keeping with the increased art-historical and museological interest in polychrome wood sculpture, many artworks were restored between the wars, some for the first time since their acquisition. Major American museums had opened "repair shops" that were responsible for both restoration and installation of the collections—notably Boston's Museum of Fine Arts in 1902 and The Metropolitan Museum of Art as early as 1879.[55] From the 1920s to 1950s, Arthur Smith (foreman) and Michael Moffat (cabinetmaker) are among the recurring names in the brief treatment reports at the Metropolitan Museum.[56] Smith is known to have cleaned some of the "stained wood sculptures" in the Pierpont Morgan Wing.[57] Alongside full-time museum staff, men employed by the Works Progress

Administration (WPA) engaged in restoration work from 1934 to 1942.[58] Many were skilled artists. For example, Gerardus Driessen, who had studied fine arts in Amsterdam, could carve "marble, stone and wood" as well as cast and work metal.[59] In 1935, an unnamed WPA sculptor restored the missing ends of the cross of the monumental Spanish Romanesque *Crucifix* (35.36a, b) now hanging in the Fuentidueña Chapel at The Cloisters.[60]

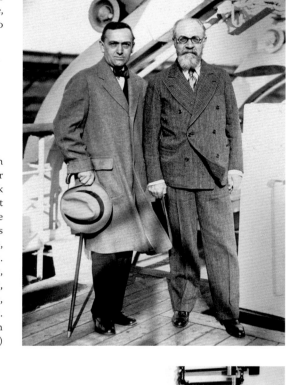

Figure 12 ◆ David Rosen (left) and Henri Matisse on board the *Île de France*, ca. 1930

Figure 13 ◆ Elisabeth Packard and Peter Michaels at the wax tank in the Walters Art Museum, 1967. The sculpture being treated is *Virgin and Child*. France, Le Mans, 1175–1225. Walnut with polychrome, H. 93.5 cm (36¹³⁄₁₆ in.), W. 27.0 cm (10⅝ in.), D. 29.0 cm (11⁷⁄₁₆ in.). The Walters Art Museum (27.255)

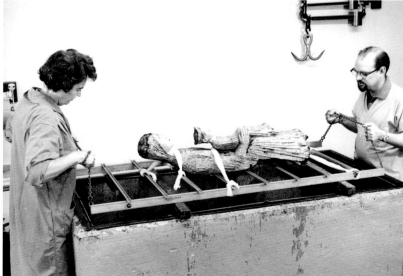

The tendency of wood supports to expand and contract with fluctuations of humidity, with resultant lifting and flaking of paint layers, affects both polychrome sculpture and panel paintings,[61] and during this period both were frequently treated, even in museum collections, by contractual paintings restorers. For example, solvent cleaning of painted surfaces and the application of protective varnishes are two techniques used on polychrome sculpture that were adapted from easel painting restoration.[62]

Perhaps the most important of these early restorers was David Rosen (1880–1960) (Figure 12). Although based in New York City, Rosen worked extensively on the holdings of at least seven major American institutions and became technical adviser to the Walters Art Gallery (now the Walters Art Museum), the Philadelphia Museum of Art, and the Worcester Art Museum. Born in Russia, Rosen had studied painting and sculpture in Paris before moving to the United States in 1913. Although primarily a paintings restorer, he was also retained to preserve and restore painted sculpture, and from the early 1930s he made the treatment of flaking polychromy a focus of his research.[63] At the Walters Art Museum, Rosen was hired not only to preserve the collection but also to carry out technical research that, it was hoped, would eventually benefit other institutions as well.[64]

It is difficult to overestimate the impact Rosen had on the treatment of polychrome sculpture in the United States. Almost every museum with significant holdings of this material was indebted to him for treatment or advice. The wax immersion treatment he developed in the early 1930s was applied to "several dozen Gothic statues and sections of retables" at the Walters Art Museum and remained in use until the 1970s.[65] The goal of this treatment was to fill pores and empty insect channels in the deteriorated wood with a combination of wax—a stable, hydrophobic material—and a resin, which added strength.[66] The mixture was heated well above its melting point in a wax

tank, and sculptures to be consolidated were immersed for several hours to absorb the molten material (Figures 13, 14). Hot wax immersion treatments were also carried out at the Fogg Museum and, under the guidance of Rosen, at the Philadelphia Museum of Art, the RISD Museum of Art, and the Worcester Art Museum.[67] His influence did not, however, extend to The Metropolitan Museum of Art. Although wax was certainly used there on medieval sculpture to consolidate flaking paint, fill individual insect holes, and refinish surfaces, as discussed below, apparently only one work in the Department of Medieval Art was treated by immersion.[68]

Another paintings restorer of great influence was William Suhr (1896–1984). Born in Prussia and trained in Berlin, Suhr came to the United States in 1928 at the invitation of Valentiner, then director of the Detroit Institute of Arts. He subsequently moved to New York to become conservator at the Frick Collection, where he worked from 1935 to 1977. Suhr, who was experienced in the treatment of blistering paint on panel paintings,[69] treated polychrome sculpture from the Detroit museum in 1947 and at least two important sculptures in the Cleveland Museum of Art, a *Vesterbild* (*Pietà*) (1938.294) and *Christ and Saint John the Evangelist* (1928.753).[70]

In 1936, Edmond de Beaumont (1911–1997), a Swiss emigrant trained at the Fogg Museum, was hired by the Worcester Art Museum, first as museum photographer and laboratory technician and later as the museum's first full-time paintings conservator. He treated many of the museum's medieval wood sculptures with techniques then used in paintings conservation, such as the application of molten wax to hold down flaking paint.[71] Theodor Siegl (1925?–1976), who had trained under the Austrian paintings conservator Joseph Schindler (d. 1951) at the Pennsylvania Academy of the Fine Arts in the early 1950s, was hired as paintings conservator in 1955 by the Philadelphia Museum of Art, and in this role he also treated polychrome sculpture for the collection.[72]

Polychrome wood sculptures were also treated by contractual conservators with experience in other types of three-dimensional works. Conservators at the Fogg Museum, most notably George Leslie Stout (1897–1978), worked as consultants to neighboring museums and examined or treated polychrome sculptures in Harvard's collections as well as at the RISD Museum of Art and the Wadsworth Atheneum, Hartford, Connecticut.[73] Joseph Ternbach (1897–1982), an Austrian conservator who had worked for the Kunsthistorisches Museum in Vienna, treated a *Madonna and Child Enthroned* (30.383) at the Detroit Institute

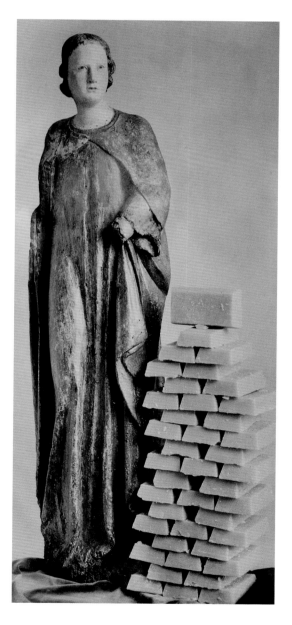

Figure 14 ◆ Preparation for wax immersion treatment at the Walters Art Museum, after 1937, showing type and number of wax-resin bricks that would be used for consolidation of *Angel of the Annunciation*. Italy, Siena, ca. 1350. Painted wood, H. 152.4 cm (60 in.). RISD Museum of Art, Museum Appropriation Fund (37.114)

of Arts in 1956.[74] Having fled Nazi Germany in 1939, Ternbach settled with his family in Forest Hills, New York. Once established and familiar to the New York circle of art dealers and collectors, he seems to have treated polychrome sculpture for the Art Institute of Chicago and the Saint Louis Art Museum as well, and he is mentioned in correspondence files at the Wadsworth Atheneum.[75]

Museums also began to hire staff conservators dedicated to the treatment of polychrome sculpture. Elisabeth Packard (1907–1994), originally in the cataloguing department, became an apprentice to David Rosen at the Walters Art Museum in 1937, and from then on until her retirement in 1977, she treated much of the polychrome sculpture in the collection. While consolidation of flaking paint and insect damage on sculptures was a major focus of her work, she also removed overpaints to reveal earlier polychrome layers, following protocols developed in Europe.[76]

The conservation history of medieval objects at The Metropolitan Museum of Art and The Cloisters stands apart from most other institutions, for it is there that specialization in the treatment of sculptures, and more specifically medieval polychrome wood sculptures, was possible. The tradition of employing such specialists was a function both of the large staff of the Metropolitan Museum, which permits this focus, and of the vision of The Cloisters' director James Rorimer. He had developed a rare combination of interests in art history, technical analysis, and treatment of medieval sculpture. Rorimer respected the work of restorers and closely followed developments in the field. Together with Charles Langlais (life dates unknown), a "restorer and repairer of sculpture" hired on contract by Breck in 1929, Rorimer undertook the examination, cleaning, and restoration of most of the medieval sculptures acquired for the museum.[77] Contacts with the Fogg Museum as well as with leading personalities in the field, such as the paintings conservator Sheldon Keck (1910–1993) at the Brooklyn Museum and the polychrome

sculpture experts Georg Schuster and Hubert Wilm (1887–1953) in Germany, helped Rorimer formulate his approach to the preservation of medieval polychrome sculpture.[78] Objecting both to the concealment of sculptural form by thick overpaints and to the indiscriminate scraping and chemical removal of paint then practiced in the trade, he called for a more "archaeological" approach to conservation:

> While unnecessary restorations were being removed from Greek and Roman sculptures by enthusiastic searchers for authentic documents, collectors of medieval antiquities were blindly acquiring and displaying objects which had been altered so as to conform to the tastes of the moment. Indeed, in collecting medieval sculpture most museums have had to depend almost entirely upon the tastes and impulses of non-archaeologically-minded people. Few museums have been able to protect their sculptures from the assiduous caretaker or the careless restorer.[79]

When Rorimer wrote this article in 1936, archaeology and the study of ancient sculpture were disciplines increasingly guided by scientific method and historical accuracy, approaches he admired.[80] Fragments without restored additions were perceived as authentic, conveying the "natural" condition of ancient sculptures. In comparison to this purist approach, the quest for authenticity in the treatment of medieval polychrome sculpture was far less developed at the time. A notable exception is the Imad Madonna, originally in the Cathedral treasury and now in the Diocese Museum in Paderborn, Germany, which was treated in 1917 to remove some nonoriginal paint layers and carved additions.[81] For Rorimer, the process of treating polychrome sculpture was also comparable to archaeology because a return to the original surface by removal of layers of repainting approximated the uncovering of strata in an excavation. Coincidently in 1931,

The Metropolitan Museum of Art mounted an exhibition of Russian icons that had been treated to reveal sequential layers of repainting in an attempt to educate the public on the complexity of their history.[82]

Despite his stated concern for scientific method, Rorimer did not always practice what he preached, as is clear from some of the treatments he and Langlais carried out. Keenly aware of the desirability of aged surfaces, Rorimer also removed overpaints with a sharp knife, leaving traces of each paint layer behind, and hiding disfiguring losses with loose strokes of inpainting. Although such treatments were intended to heighten the impression of the passage of time and create a pleasing surface, the relationship between the various paint layers remained ambiguous (e.g., 25.120.230; Figure 15).[83]

Looking at these treatments today, it seems Rorimer attempted a balance among original intent, aesthetics, and a respect for history, clearly reacting against arbitrary restorations of polychrome wood sculpture. While removing obvious modern additions and overpaints, he did not strictly abide by a purist approach. In addition to selective paint removal, he replaced missing elements deemed essential to the iconography of a work, with subtle differences in surface treatment alerting the viewer to the modern intervention.[84] This restoration philosophy finds a parallel in the interior design of The Cloisters. More than four hundred Romanesque and Gothic stone architectural elements were fit into the modern interior structure built in medieval style. The boundaries between historic elements and the surrounding 1930s matrix were obscured, and the difference between old and new masonry only subtly indicated by the uniformity of tool marks on the new blocks. Under Rorimer's guidance, a shift tremendously important to the appreciation and conservation of medieval wood sculpture at the Metropolitan Museum had occurred: the object's appearance, even diminished or altered over time, had become as significant as its iconographical function or historical value.[85] The sculptures no longer

Figure 15 ◆ *Angel*. France, late 13th century. Wood, paint, H. 67.0 cm (26⅜ in.). The Metropolitan Museum of Art, The Cloisters Collection, 1925 (25.120.230). Detail showing surface appearance after indiscriminate removal of overpaints and subsequent application of isolated strokes of inpainting

functioned solely as iconographic types or enhancements of a historical ambience but as works of art to be valued on their own. The evolution in museum display that placed sculptures on pedestals for closer scrutiny was thus met by the development of conservation methodology that emphasized the aesthetic value of the individual object.

DEFINING DECADES: THE HISTORIC ROLE OF SCIENCE IN CONSERVATION IN THE UNITED STATES, 1930–1950

The development of conservation protocols in the United States was paralleled by advances in scientific analysis of artists' methods and materials as well as by research into the mechanisms of deterioration and their arrest. As conservation evolved from a craft-oriented trade to a recognized academic profession, museum repair shops evolved into well-equipped laboratories with scientific research capabilities and staff proficient in treating the collections.[86] Following the Fogg Museum as the model of an analytical laboratory within an art museum, research laboratories were started at the Museum of Fine Arts, Boston, in the

early 1930s, The Metropolitan Museum of Art in 1932, the Philadelphia Museum of Art in 1933,[87] and the Walters Art Museum in 1934.

Scientific analysis applied to works of art was critical to three main concerns of American museums: the authentication of works of art, the study of materials and techniques as an aid to conservation and art-historical research, and the analysis of deterioration processes and formulation of conservation treatments. The first—authentication—clearly concerned American museums because of their rapid acquisition of works of art and the somewhat indiscriminate acquisition practices of their donors. New scientific techniques, especially radiography, became indispensable tools in the examination of artworks for purchase. Starting in 1925, Alan Burroughs (1897–1965) at the Fogg Museum used a portable unit for X-ray radiography, becoming one of the most important specialists in its application to authenticity studies.[88] While both at home and abroad Burroughs focused mainly on the examination of paintings, his analysis at the Cleveland Museum of Art revealed a polychrome wood *Standing Virgin and Child* attributed to Giovanni Pisano as a modern forgery by Alceo Dossena.[89] At the Metropolitan Museum, the figures *Mourning Virgin* (25.120.214) and *Saint John* (25.120.215) were also radiographed by Burroughs to help determine the nature and condition of the original paint layers before removal of overpaints by Rorimer and Langlais.[90] Museum curators were also concerned about their ability to detect heavily restored works of art offered to them for sale. Rorimer investigated the application of ultraviolet light examination to the detection of past restoration, and the Metropolitan Museum published the results of his research in *Ultraviolet Rays and Their Use in the Examination of Works of Art* in 1931.[91]

New scientific dating methods were applied to materials in works of art and other cultural artifacts. A. E. Douglass (1867–1962), an American astronomer, collaborated in the 1910s with the American Museum of National History in New York to develop a method of archaeological dating based on tree-ring growth patterns called dendrochronology, which was soon adapted for art-historical research. Dendrochronology has become an important tool for dating paintings on oak panels but seems not to have been used with the same regularity in the United States as in Europe to date the wood substrates of polychrome sculptures.[92] The American physical chemist Willard Libby (1908–1980) led the team at the University of Chicago that introduced radiocarbon dating in 1949, a method that revolutionized archaeology.[93] Although more useful for ancient material, radiocarbon analysis has been applied to medieval polychrome sculpture to settle questions of authenticity, as it can be used to distinguish wood harvested during the Middle Ages from modern wood. Radiocarbon dating was performed on The Cloisters' *Standing Virgin and Child* (1996.14) attributed to Niclaus Gerhaert von Leyden.[94]

Second, science provided information on the materials and methods of artists that was increasingly valuable to curators. Paul B. Coremans (1908–1965), the future director of Belgium's Institut Royal du Patrimoine Artistique (KIK-IRPA), toured the United States in 1938 and commented on the important place such investigations had assumed in America.[95] The report of his visit represents a snapshot of the figures involved in scientific analysis of works of art at the time.[96] Coremans was particularly interested in ultraviolet microscopy, developed by Francis F. Lucas at the Bell Telephone Laboratories, as well as in the research of Leopold Mannes on "colored films" for microscopy and ultraviolet light at the Eastman Kodak Research Laboratories. At the Fogg Museum, the chemist Rutherford J. Gettens (1900–1974) and the conservator and head of research George Stout developed expertise in microchemical and microscopic analysis, assembling a large reference collection of traditional painting materials, including pigments, ground preparations, binders, and coatings. Of

the tools available to technical researchers for the study of polychrome sculptures, microscopic examination of paint samples prepared in cross section was and still is indubitably one of the most useful.[97] Surely inspired by such advances, Rorimer and Langlais at the Metropolitan Museum regularly used a binocular microscope to examine layers of paint; identification of materials on polychrome sculptures was, however, sometimes inaccurate. For example, Langlais described the metal cladding on the figures from an Italian *Mourning Virgin* (25.120.214) and *Saint John* (25.120.215) as "tin . . . as bright as new metal";[98] it has been recently determined to be silver.[99] The Fogg Museum's staff also adapted instrumentation developed before and during World War II for surveying reflectance curves to characterize pigments, measure undesirable effects such as metamerism, and quantify the fading of pigments and dyes.[100] After the war, the identification of wood species was recognized as a valuable analytical tool for provenance studies, and American museums requested help from wood microscopists at public institutions such as the Forest Products Laboratory of the U.S. Department of Agriculture in Madison, Wisconsin, and the Smithsonian Institution in Washington, D.C.

Third, scientists and conservators were increasingly faced with the deterioration of painted wooden artworks and were asked to find ways to preserve them. Flaking paint was the primary concern. Sculpture coming from Europe had endured a long transatlantic crossing entailing extreme and sudden changes of humidity and temperature, and the museums they entered had difficulty maintaining proper environmental conditions. At the Fogg Museum, Gettens applied a more scientific approach to the wax immersion method developed by Rosen in the early 1930s, conducting empirical trials in 1936 using various mixtures of wax, several acrylic resins, and different pretreatments with solvents. These trials led to the recommendation and implementation of a specific wax-resin recipe.[101] The success of the

treatment was tied to the extent of penetration of the mixture, which was assessed by weighing the sculptures before and after immersion. Although the wax may alter the colors and finish of polychrome surfaces, and immersion at an elevated temperature destroys wax-based pressed-brocade decoration, the conservation records of the time do not mention these risks. Immersion also loosened the layers of overpaints on sculpture, which at the time was considered an advantage, because these later layers could then be easily removed.[102] Wax-resin mixtures were also applied to the surface of sculptures and heated with infrared lamps or conventional irons to consolidate flaking paint.[103]

The use of moisture barriers in conservation was also of active interest in the 1940s. While in charge of the wartime repository of the Fogg Museum in Petersham, Massachusetts, Richard Buck tested waxes on the back of panel paintings to minimize warping, with results suggesting that waxes were effective moisture barriers against short-term humidity fluctuations but only partially prophylactic against longer humidity and temperature cycles.[104] With no humidity control in its galleries and no other recourse for treatment, the Philadelphia Museum of Art attempted this method in 1958, applying a thick wax barrier to the back of a wooden relief, *Saint Anne Teaching Her Daughter the Virgin Mary to Read (The Education of the Virgin)* (1930-1-163a).[105]

The treatment of sculptures infested with wood-boring insects was equally experimental. At the Metropolitan Museum, several methods involving the use of formaldehyde, carbon disulphide, chloroform, X-rays, and vacuum tanks were attempted. Hydrocyanic-acid gas was eventually selected; it had been used by the U.S. Department of Agriculture as an insecticide for pests in stored grains since 1880.[106] The technology was exported to Germany in 1916, and its application to works of art as Zyklon B is recorded in Sweden in 1921, in Denmark in 1928, and in Austria in 1929.[107] Restorers also attempted fumigation with

paradichlorobenzene,[108] impregnation with carbon tetrachloride/ethylene dichloride, and dichlorodiphenyltrichloroethane (DDT).[109]

THE CONSERVATION OF MEDIEVAL POLYCHROME WOOD SCULPTURES IN THE UNITED STATES, 1950–1970

During the 1950s and 1960s, in both Europe and the United States, there was much discussion about ethics and standards of practice in conservation. The Italian art historian and conservation theorist Cesare Brandi (1906–1988) and Paul Philippot (b. 1925), a Belgian art historian with a background in law, formulated standards of practice for the conservation of painted surfaces that were discussed and disseminated through new international organizations such as the International Council of Museums (ICOM) Committee for the Care of Paintings (founded in 1948 as the Commission on the Care of Paintings, with a subgroup for polychrome sculpture formed in 1967), the International Institute for Conservation of Historic and Artistic Works (IIC, founded 1950), and the International Centre for the Study of the Preservation and Restoration of Cultural Property in Rome (now called ICCROM, founded 1956).[110] One aspect of an international conference at Princeton University in 1961 focused on the problem of damaged pictures and how best to approach their restoration.[111] Despite far-ranging discussions, no consensus was reached about the appropriateness of different treatments, nor was there agreement on how the authenticity of an object was to be defined and preserved, conditions that largely persist to this day.

Intellectual inquiry into polychrome sculpture took a different route in Europe, particularly in Germany and Switzerland, where the serious study of painted sculpture began in the late 1950s. The development of meticulous methodologies for the treatment of polychrome wood sculptures was initiated by Ernst Willemsen (1913–1971), the head of the restoration workshop at the Rheinisches Landesmuseum in Bonn; Johannes Taubert (1922–1975), the equally influential historian and restorer at the Bayerisches Landesamt für Denkmalpflege in Munich; and Thomas Brachert (b. 1928), head of the Schweizerisches Institut für Kunstwissenschaft in Zurich in the 1960s. Their work established the importance of technical examination to the formulation of treatment methodologies. In many cases, their careful observations led to startling discoveries of original decoration hidden under later layers that, when revealed through mechanical cleaning, helped rewrite the history of medieval art. In the United States, however, there was only a limited application of this sophisticated approach to understanding the complex layering of polychrome sculpture, largely by conservators trained in Germany or Belgium. At the Metropolitan Museum, Murray Pease (1903–1964) and Kate Lefferts (1911–2000), conservators in the Conservation Department, were very much involved with the emerging international conservation committees and frequently in touch with European colleagues, but there is no indication in the records that systematic investigations of polychromy took place.[112] Indeed, with the exception of a single work, little treatment of medieval sculpture was carried out in the Conservation Department.[113] This was left to James Rorimer, who maintained a separate conservation laboratory for the Department of Medieval Art, where Langlais worked at least through the early 1960s.[114]

The Cloisters secured its own specialist in 1955 when Rorimer hired Mojmir Frinta (b. 1922 in Prague) as restorer; Frinta treated polychrome sculpture until his departure for the art history faculty of the State University of New York at Albany in 1963 (Figure 16).[115] He combined to an unusual degree the manual skills needed for restoration work, an excellent education in the history of art—he received a PhD from the University of Michigan in 1960—and an intellectual capacity for research. As a young man, he had been trained in the renowned studio of Chauffrey-Muller in Paris, which specialized in the

restoration of pre-Baroque paintings and polychrome sculpture.[116] Learning how to use X-ray radiography during an internship at the Musée du Louvre with Madeleine Hours, Frinta had acquired experience with some scientific investigation methods as well.[117] Whereas his training by apprenticeship was traditional, his treatment methodologies reveal awareness of the contemporaneous debate regarding loss compensation, mentioned above, and the opinion that invisible, illusionistic inpainting was deceptive.[118] Frinta experimented with alternatives to imitative retouching and left areas of loss on The Cloisters' *Lamentation* (55.85) readily distinguishable from the original.[119] His examination skills and valuable contacts with European laboratories, notably the Scientific Department in the National Gallery, London, led to the discovery in 1963 of brocade relief ornaments composed of wax or wax-resin mixtures on medieval sculpture.[120]

At the Walters Art Museum, Elisabeth Packard and David Rosen continued to treat or oversee the treatment of sculpture. At the Cleveland Museum of Art, where a Conservation Department was established in 1958, Frederick Hollendonner (1927–1990), a painter, sculptor, and graduate of the Cleveland Institute of Art, was hired as restorer and eventually promoted to chief conservator. He examined and treated many of the polychrome wood sculptures in the collection, mostly consolidating flaking paint layers with gelatin and applying protective polyvinyl acetate coatings, as discussed below.[121]

Most other museums continued to hire contractual conservators for the treatment of polychrome wood sculpture. In 1953, Alice Muehsam of New York worked on a group of polychrome figures belonging to the Wadsworth Atheneum, *Saints Vincent, Urban, and Killian(?)* (1953.96, .97, .98).[122] In 1965, Anton Konrad, a German conservator trained under Taubert at the Bayerisches Landesamt für Denkmalpflege, advised the Philadelphia Museum of Art on the treatment of *Saint*

Barbara (1930-1-167) and *Saint Catherine* (1930-1-168), a pair of reliefs by Niklaus Weckmann the Elder and workshop.[123]

SCIENCE IN CONSERVATION, 1950–1970

In American museum laboratories, scientific investigation often focused on the problems of paintings conservation, with some benefit for polychrome wood sculpture. After World War II, scientific research within the art museum context broadened to include polymer science and the potential of new synthetic products for the conservation of museum objects.[124] The discoloration or insolubility over time of traditional inpainting media such as drying oils and egg tempera posed a problem for conservators, and scientists began investigating alternatives, such as polyvinyl acetates.[125] First synthesized in Germany by Fritz Klatte (1880–1934) around 1912, polyvinyl acetate resins (PVA) used by the plastic molding industry were tested for possible conservation application by Gettens and Stout at the Fogg Museum in 1935 and by Garry Thomson (1925–2007) at the National Gallery, London,

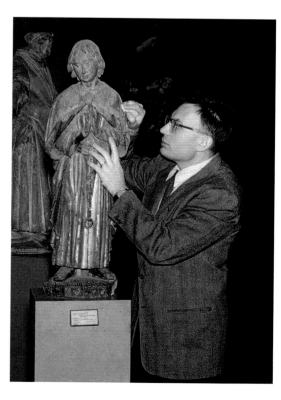

Figure 16 ◆ Mojmir Frinta, 1959 or 1960. The sculpture being cleaned is *Saint Frederick*. Northern France, second half of 15th century. Wood, paint, and gilding, H. 85.1 cm (33½ in.). The Metropolitan Museum of Art, The Cloisters Collection, 1934 (34.123)

in 1957.[126] One low-molecular-weight polyvinyl acetate, AYAB, first used by the paintings restorer Mario Modestini (1907–2006) for retouching paintings in the 1950s and 1960s, proved effective for imitating the surfaces of aged oil paint without changing color over time.[127] Its application to polychrome sculpture can be documented only from the late 1970s;[128] before then PVAs were mostly employed in the form of proprietary adhesives (Elmer's Glue or Alvar), consolidants, or coatings.[129]

The consolidation of deteriorated wood remained another subject of inquiry. In 1957, the Metropolitan Museum restorer Langlais treated the deteriorated support of a wooden *Saint Nicholas with the Three Boys in the Pickling Tub* (16.32.193) from the Morgan Collection with Vinylite, a copolymer of vinyl chloride and vinyl acetate introduced by Union Carbide in 1930.[130] In 1961, he impregnated the wooden base of The Cloisters' *Seated Virgin and Child* (25.120.290), said to be from Saint-Denis near Paris, with PVA.[131] Wood preservatives that combined a synthetic consolidant with a biocide were sold in Germany under the trade name Xylamon;[132] these were brought to the attention of American conservators in 1962 by Konrad, who had seen the resins employed in Europe since the early 1950s.[133]

In addition, surface coatings were applied to polychrome sculpture. In the 1960s and 1970s, a number of works at the Cleveland Museum of Art and the Philadelphia Museum of Art were coated with a dilute solution of polyvinyl acetate as a "preservative," sometimes followed by a solution of hard wax in petroleum benzine as a final moisture barrier; at the Walters Art Museum, Vinylite was applied to protect areas of retouching.[134] During this period Robert Feller researched natural and synthetic picture varnishes at the Mellon Institute in Pittsburgh as part of a fellowship established in 1950 by the National Gallery of Art in Washington, D.C. Included in his research was another class of thermoplastic resins, a group of acrylics based on methylmethacrylate and its copolymers produced by Rohm and Haas. These resins

were available in the United States from the 1930s, but it took several decades for conservation scientists to test their suitability for conservation.[135] Introduced in the 1950s for various conservation applications, the highly stable ethyl methacrylate–methyl acrylate copolymer Paraloid (formerly called Acryloid in the United States) B-72 seems to have been used to consolidate deteriorated polychrome sculpture starting in 1984, when it was applied to a Flemish or German sculpture at the Walters Art Museum.[136] Acrylics were used as retouching media starting in the 1960s, with Liquitex paints noted at the Fogg Museum and at the Walters Art Museum and Magna Colors at the Philadelphia Museum of Art.[137]

After World War II, tremendous progress also occurred in paint media analysis, thanks to the research of scientists Joyce Plesters and John Mills at the National Gallery, London, and the introduction of infrared spectrography and thin layer chromatography for the study of organic materials.[138] The United States was somewhat slow to adopt these methods for the analysis of organic paint media, in part because scientists focused their research more directly on developing conservation treatments. In addition, the scientific investigation of materials and artistic methods in American museums often concentrated more on archaeological objects than on other types of three-dimensional works.[139] There was also a lack of expertise. Until the 1970s, relatively few scientists were employed full-time by American museums. Conservators interested in organic paint media analysis of polychrome sculpture sometimes turned to European colleagues for assistance; for example, in the 1960s Frinta sent paint samples to Plesters and Mills in London.[140]

COLLECTING, DISPLAY, AND TREATMENT OF POLYCHROME SCULPTURE AT AMERICAN MUSEUMS, 1970S–1980S

Toward the end of the twentieth century most museum activities, including conservation, were deeply influenced by the broader concerns

of museum economics and politics.[141] As museums attracted larger crowds, many American institutions embarked on grand building campaigns as well as fund-raising efforts. The resulting expansion of commercial operations to include museum shops and restaurants and the rise of blockbuster exhibitions are trends that had an impact on conservation goals and aesthetics.

At the Metropolitan Museum, Thomas Hoving (1931–2009), a former curator of The Cloisters and the charismatic director of the Museum from 1967 to 1977, aggressively promoted the Museum and its collection through adept use of the media and marketing strategies, with the goal of increasing attendance and popular appeal. At The Cloisters, Florens Deuchler (b. 1931), hired as chairman of the Department of Medieval Art and The Cloisters in 1968, had the stucco walls covered in white paint, bringing the spaces more in line with modernist taste (Figure 17). Exhibition design in this period reflected the interest in dramatic displays, and objects were sometimes spotlit within darkened galleries (Figure 18).

A review of conservation reports in various American museums suggests that conservators treating polychrome sculpture during this period were concerned primarily with preservation activities such as the consolidation of flaking paint. Building improvements could, however, present opportunities for conservation treatment. For example, in 1976 the Philadelphia Museum of Art undertook the installation of air-conditioning in its building; the three-year project required objects in each gallery to be "dismantled, recorded, packed, and arranged in secure storage areas until the project's completion."[142] Museum conservators took advantage of this time to complete an extensive treatment on the large Southern Netherlandish *Crucified Christ with the Virgin Mary, Saint John the Evangelist, and Angels with Instruments of the Passion* (1945-25-86a–b), including removal of overpaint and stabilization of paint layers and deteriorated wood, in preparation for its reinstallation.[143]

Conservators also became increasingly involved in the process of museum acquisitions. At a number of museums, including the Museum of Fine Arts in Boston, the Philadelphia Museum of Art, and The Metropolitan Museum of Art, a thorough examination of any work offered for purchase, along with a written report by a conservator specialized in the field, became an essential part of the acquisition process.[144]

The 1970 IIC conference "Conservation of Stone and Wooden Objects," held in New York, was an important event that hosted a number of European specialists in polychrome wood sculpture.[145] Agnes Ballestrem (1935–2007) described the stratigraphic methodology for the investigation of paint layers.[146] Other key papers were presented by Taubert, who called for cooperation among countries as well as across the disciplines of art history, science, and conservation; by Philippot, who described the nature of polychrome sculptures and their treatment; and by Packard, who discussed wood consolidation.[147] The conference proceedings added an important English-language publication to the field, making many fundamental principles of examination and treatment more accessible to American conservators.[148]

At The Metropolitan Museum of Art and The Cloisters, the acquisition of polychrome wood sculpture increased significantly under the leadership of department chairman William D. Wixom (b. 1929, act. at the Metropolitan Museum until 1998), hired in 1979 after two decades of achievement at the Cleveland Museum of Art.[149] After a hiatus following Frinta's departure and the brief tenure of the artist-restorer Geoffrey Moss (b. 1938) in 1969, The Cloisters continued its concentration on the examination and treatment of polychrome sculpture, often focusing on Wixom's acquisitions.[150] In 1971, Florens Deuchler hired Rudolph Meyer (b. 1941). Until he left full-time employment at the Museum in 1987, Meyer treated most of the important polychrome sculptures at The Cloisters, and his approach is important to summarize for an accurate

Figure 17 ♦ The Metro-
politan Museum of Art,
The Cloisters, Late Gothic
Hall, view looking toward
the Main Hall in 1994,
showing the walls that
were painted white in
the 1970s

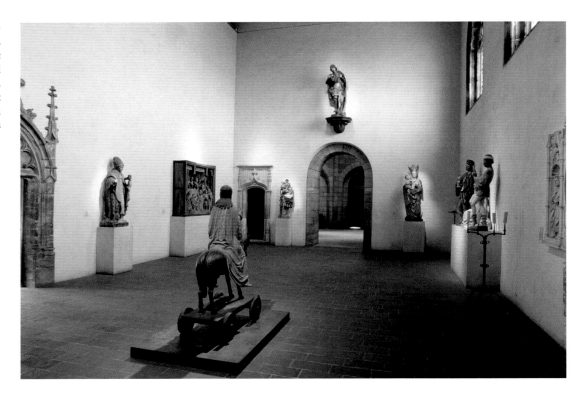

understanding of the current condition of the
collection.

Meyer was trained in Munich as an appren-
tice to Franz Josef Ostenrieder (life dates
unknown), a "master church painter" who ran
a workshop for the decoration of sculptures,
furniture, and frames.[151] Meyer had also served
as an assistant conservator at the Bayerisches
Nationalmuseum in Munich with the art his-
torian Alfred Schädler (1927–1999), who was
well acquainted with the work of Taubert. At
The Cloisters, Meyer proved to have a strong
sympathy for the original function of polychrome
sculpture, and his treatments reveal a desire to
recover some of the lost aspects that had ani-
mated the figures when they were in their orig-
inal ecclesiastical settings. He used retouching,
varnishes, and wax finishes (e.g., 52.83.3;
Figure 19) in an attempt to recapture what
Taubert had identified as so important to the
genre, namely, the original splendor of the
sculptures, with their three-dimensional sur-
faces interacting with light and enhancing the
differences among areas of matte azurite paint,
burnished gold leaf, and translucent glazes.[152]
A case in point is Meyer's selective application

of varnishes to restored surfaces. Human
visual perception is acutely sensitive to subtle
differences in gloss and texture. The distinctive
sheen of burnished water-gilding arising from
the interaction of light with a smooth, highly
reflective metal surface is perceptually differ-
ent from a coating applied to produce this
effect. The difference in optical characteristics
of synthetic and natural varnishes and their
impact on the appearance of painted surfaces
have been studied for Old Master paintings,
but these important questions remain largely
unexplored for medieval polychrome sculp-
ture.[153] Perhaps this level of intervention was
driven by Meyer's and the curators' vision of
sculpture as part of a larger scheme: the realiza-
tion of a *Gesamtkunstwerk*, where extraordinary
works of art were installed in an equally fine
architectural ensemble.

A potential problem in this approach,
however, lies in the ambiguous relationship
between the sculptures' former religious func-
tion and their present "reuse" as works of art
in a museum with a strong ecclesiastical aes-
thetic; perhaps this confusion was and is inevi-
table.[154] Indeed, the comparison between the

KARGÈRE AND MARINCOLA

meaning of objects in their original contexts and their value as objects in museums had been discussed in an influential essay by Walter Benjamin, who suggested that in response to the earlier rituals of the church the work of art has become the object of a "secularized ritual even in the most profane forms of the cult of beauty."[155]

To some extent, The Cloisters' philosophy of restoration at the time—making damaged religious statues from a remote past readily accessible to the lay visitor and their subtle surface characteristics easier to read—had the same ideological intent as a broader populist shift evidenced in museums. Interestingly, during this period the color reproductions of artworks by fine art books publishers were printed on highly glossy paper to capture the immediacy, brilliance, and intensity of colored art forms. It is conceivable that this aesthetic shaped contemporary expectations for treatment results, just as the earlier black-and-white reproductions of polychrome sculpture encouraged a preference for monochromy.[156]

This review of the reception and treatment of medieval polychrome wood sculpture in the United States sets out to demonstrate the important connections in the twentieth century between the cultural and social histories of these artworks—in particular their collection, exhibition, and publication—and their restoration and conservation. It is evident that conservation is inseparable from the milieu in which it is practiced. While it is difficult to offer a critique of the present or an interpretation of current practices, some trends emerge within this historical continuum.

Medieval art historians are increasingly reconsidering the original conditions for viewing the sculptures, and more attention is paid to the role of the surrounding space and lighting. Eva Frodl-Kraft's (1916–2011) 1962 study of the great retable displayed in the Pilgrimage and Parish Church of Saint Wolfgang in Kefermarkt, Austria, has influenced current curatorial thinking. She demonstrated that this

Figure 18 ◆ "Medieval Art from Private Collections," an exhibition at The Cloisters, 1968–69, view of the Late Gothic Hall

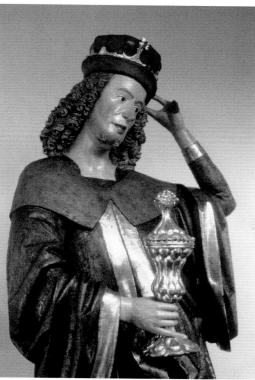

Figure 19 ◆ *Balthasar* (52.83.3) (see Figure 1), detail, 1982. A thick layer of varnish is especially evident on the face and gilded surfaces.

altarpiece was meant to be lit from the back, with an additional source of light from the side, and that the use of frontal "spots" would "destroy this original unity and transform the work into a simple sum of details."[157] Equally if not more influential was Michael Baxandall's proposal of an "arc of address" to describe the ideal range of viewing angles for medieval polychrome wood sculpture. Sculptures, he reminded us, have more than one angle of

Figure 20 ◆ Cloisters,
Late Gothic Hall, 2011

view; furthermore, form is defined through the play between light and shade, and modeling therefore is strongly affected by lighting.[158] Wixom was a strong proponent of the need to consider proper viewing angles,[159] and his successor as chairman of the Department of Medieval Art and The Cloisters, Peter Barnet (b. 1951), continued this emphasis. Recent reinstallations at The Cloisters, with sculptures placed high on walls at some distance from the viewer, suggest the original height at which they were installed in the church. In many cases, the correct proportion of the figures, as conceived by their creators, is now better perceived from this lower vantage point (Figure 20).

The stark white walls at The Cloisters, which Museum staff felt had a deadening effect on sculptures, were given warmer tones during recent renovations, approximating the Museum's original design. Stained-glass panels have been installed in the window frames of the Early Gothic Gallery, bringing light refracted through colored and irregular glass to the surfaces of sculptures.

In most American museums, conservation of polychrome sculpture involves less treatment and more preventive care, including monitoring of the museum environment, and the installation of effective climate control systems has greatly reduced the recurring problem of flaking paint. One of the most troublesome conditions of polychrome wood sculptures, the infestation of the support by insects, is now successfully treated by oxygen reduction. The technique, developed in the 1980s and 1990s by scientists at the Getty Conservation Institute and The Metropolitan Museum of Art, represents a significant advance in the field of conservation and is now adopted by numerous institutions around the world.[160] Minimal intervention has become the standard approach to conservation treatment, and both museum curators and conservators are concerned first with stabilization and preservation of the object. When treatment is necessary, it tends to concentrate on revealing what survives of the original or to suggest through restoration, but not replace, what has been lost.

Currently, objects conservators are responsible for treating polychrome sculpture in the

United States. The separate educational tracks in North America for paintings conservators, who concentrate on easel paintings, and objects conservators, who are trained as generalists to treat all types of three-dimensional artworks, are unlike some European models, where conservators are prepared to work on both easel paintings and polychrome sculptures. This difference in education and specialization may contribute to the often minimal interventions by contemporary American conservators, since few have amassed the years of experience needed for proper technical examination or overpaint removal. There are possibly also fewer exchanges in technical knowledge between American paintings conservators and sculpture conservators. For example, recent advances in the cleaning of painted surfaces as practiced in easel paintings conservation, such as the Modular Cleaning Program,[161] are just beginning to be incorporated into polychrome sculpture conservation practice.

Science continues to inform and support the field of conservation, and conservators more frequently collaborate with scientists in the study of polychrome sculpture. New analytical methods from medical or industrial domains have increasingly been applied to works of art. Nondestructive microanalysis, such as X-ray fluorescence (XRF) and Raman spectroscopy, is now frequently used for the characterization of art materials in the United States.[162] Organic materials analysis has also radically changed. Extremely sensitive techniques, such as protein analysis using matrix-assisted laser desorption/ionization–mass fingerprinting (MALDI-MFP), an established proteomics technique, was recently applied to the study of paint media on The Cloisters' monumental Spanish Romanesque *Crucifix* (35.36a, b).[163] Immunofluorescence microscopy (IFM) and enzyme-linked immunosorbent assay (ELISA) may also become routine analytical tools in museum laboratories; the latter technique was used on The Cloisters' mid-thirteenth-century Italian *Saint John* (25.120.215) to characterize an adhesive found under the silver leaf.[164]

Where once the dealer's and curator's eyes were the main tools for connoisseurship and appreciation, the wide range of analytical methods now available fosters increasingly sophisticated collaboration among conservators, conservation scientists, and art historians. In the United States, this interdisciplinary approach is perhaps less developed for medieval polychrome wood sculptures than for paintings. It has, however, led to a few truly collaborative museum publications, such as the recent catalogue of *Italian Medieval Sculpture in The Metropolitan Museum of Art and The Cloisters*, which includes significant technical analysis by conservators and scientists.[165] Other museum publications and exhibits have focused on earlier or later material. Important studies of Spanish Baroque polychrome sculpture have taken place at the National Gallery of Art, Washington, D.C., and at the J. Paul Getty Museum in Los Angeles, and a volume published in conjunction with the 2008 exhibition "The Color of Life" at the Getty Villa in Malibu, California, examined painted sculpture from antiquity to the present.[166]

Whereas original paint uncovered during an investigation is a marvelous discovery, the strong colors of the medieval palette may appear garish to modern viewers, and conservators' reconstructions of the original color schemes, whether in two- or three-dimensional formats, are often equally surprising.[167] Nonetheless, increased access to high-resolution color images on museum websites and the application of imaging technologies to virtually re-create original polychromy through 3-D modeling are likely to inform viewers who had been unaware that the sculptures were once brightly painted.

These digital images and virtual re-creations do carry a risk, however, as they tend to distance the viewer from the tangible aspects of the original works of art—from their three-dimensionality, scale, tactility, texture, and physical setting. Essentially, they divert the public from a direct encounter with the object. Thus what remains most difficult to capture of

polychrome sculpture—its immaterial nature, the mimetic quality of its highly illusionistic painting, the expressive features of its carving—is precisely the aspect of its nature most difficult to preserve.

LUCRETIA KARGÈRE
Conservator
Sherman Fairchild Center for
Objects Conservation
The Cloisters, The Metropolitan Museum of Art

MICHELE D. MARINCOLA
Sherman Fairchild Chairman and
Professor of Conservation
Conservation Center of the Institute of Fine Arts
New York University

ACKNOWLEDGMENTS

We gratefully acknowledge the generosity of colleagues at the many museums we visited during the research phase of this paper, including Terry Drayman-Weisser, Meg Loew Craft, and especially Elissa O'Loughlin, Walters Art Museum, Baltimore; Pamela Hatchfield, Museum of Fine Arts, Boston; Peter Schilling, Tony Sigel, and Francesca Bewer, Harvard Art Museums, Cambridge, Massachusetts; Bret Bostock, Glencairn Foundation, Bryn Athyn, Pennsylvania; Christina Nielsen and Frank Zuccari, Art Institute of Chicago; Alan Darr, Yao-Fen You, and John Steele, Detroit Institute of Arts; Shelley Paine and Samantha Springer, Cleveland Museum of Art; Eric Zafran, Wadsworth Atheneum, Hartford, Connecticut; Laurence Kanter and Karen Serres, Yale University Art Gallery, New Haven; Andrew Lins, Sally Malenka, Joseph Rishel, Jack Hinton, Carl Strehlke, and Joshua Waterman, Philadelphia Museum of Art; Ingrid Neuman and Maureen O'Brien, RISD Museum of Art, Providence; Paula Artal-Isbrand and Rita Albertson, Worcester Art Museum, Worcester, Massachusetts; and Joyce Hill Stoner, Winterthur Museum, Wilmington, Delaware. The Cloisters' librarian Michael Carter; C. Griffith Mann, Michel David-Weill Curator in Charge, formerly Cleveland Museum of Art; Christine E. Brennan and Christine McDermott, Department of Medieval Art and The Cloisters, and Barbara File, Archives, The Metropolitan Museum of Art, were consistently helpful in our research. Julien Chapuis, Skulpturensammlung und Museum für Byzantinische Kunst, Berlin, was very thorough in his reading of an early version of this text. Our anonymous readers were equally generous with advice, corrections, and additional sources. Lastly, we are most grateful to Geri Garbaccio and to New York University for their support during this research.

NOTES

The epigraphs are from Philippot 1985, p. 7, and Forster-Hahn 1995, p. 174.

1 Taubert 1978, pp. 11–27.
2 E.g., the *Virgin* (47.101.11) in The Cloisters, The Metropolitan Museum of Art, said to be from the jube formerly in Strasbourg Cathedral but moved in the seventeenth century after the destruction of the massive screen (Wixom 1988–89, p. 45 [ill.]). See also Dupeux, Delivré, and Kargère 2014.
3 Very few American museums own and exhibit complete altarpieces, the preeminent form of Gothic sculpture. Notable exceptions include the Harvard Art Museums/Busch-Reisinger Museum, *Carved Altarpiece with Madonna and Child in Glory, St. Erasmus, St. Catherine; the Twelve Apostles; St. Anthony, St. Anne with Madonna and Child, St. Vitus, St. Margaret, St. Sebastian* (BR49.306.A–G); the Philadelphia Museum of Art, *Altarpiece with Scenes of the Passion* (1945-25-117a–s); and the Walters Art Museum, *Altarpiece with the Passion of Christ* (61.57).
4 Such as Aronson 2003, pp. 30–53; Modestini 2003, pp. 208–24; Hoeniger 1999, pp. 144–61.
5 Eikelmann 2005; Preising 2007.
6 Taubert 1978; Philippot 1998.
7 Important sources for consideration of medieval sculpture in American collections are Cahn and Seidel 1979 and Gillerman 1989, both of which contain valuable catalogue information on the provenance, condition, and in some cases the restoration history of these works.
8 Perkins 1870, pp. 6–7.
9 The American collector James Jackson Jarves, who lived in Florence in the late nineteenth century, described a typical scene in the art market there: "A speculator arrives. . . . He buys several thousand daubs at an average of a few dimes each, spends as much more in varnishing, regilding, and a little retouching, and sends them to America, where they are duly offered for sale as . . . lights of the European schools" (quoted in "Forgery of Art" 1961, p. 117). Arthur Kingsley Porter, medievalist and research professor in the Fine Arts Department at Harvard University, doubted the authenticity of every medieval sculpture unless it was accompanied by impeccable documentation of provenance (Brush 2004, pp. 44, 51 n. 3).

10 McClintock 1996b, pp. 55–60; Noble 1959, p. 138. In 1906, the American Association of Museums (AAM) underscored the educational function of museums by calling for an alliance with the National Education Association (NEA) (Hirzy 1978, p. 45).

11 This practice of collecting casts rather than originals continued well into the twentieth century. The Busch-Reisinger Museum at Harvard University purchased painted plaster casts of the Blaubeuren (BR22.20) and Breisach altarpieces (BR30.5.A–C) in 1922 and 1930, respectively (Harris 1962, p. 552).

12 Lombardi 1996, p. 186.

13 Goldfarb 1995.

14 See the history of the Walters Art Museum (formerly the Walters Art Gallery), http://thewalters.org/about/history (accessed May 2, 2013); Walters Art Gallery 1934.

15 Brilliant 2009. On Gavet, see Molinier 1889; on Spitzer, see Spitzer 1890–93, vol. 2; on Hoentschel, see Pérraté and Birère 1908 and Kisluk-Grosheide, Krohn, and Leben 2013; on Homberg, see Homberg 1931.

16 Nielsen 2008, pp. 25–38. This was the first modification in tariff laws since the Dingley Act of 1897, a protectionist trade measure.

17 Seligman 1961; Tomkins 1970b.

18 Milliken 1929.

19 Brush 2004, esp. p. 46 n. 19. Edward Waldo Forbes was already familiar with Spanish Romanesque art, for in 1921 he had purchased a fresco from the church of Santa Maria de Mur for the Museum of Fine Arts, Boston (ibid., p. 45).

20 Demotte SP.4869, Georges-Joseph Demotte and Lucien Demotte Archives, Département des sculptures, Musée du Louvre, Paris. The sculpture is also known to have been in the hands of various Parisian art collectors, including Henri Daguerre (life dates unknown) and Alphonse Kann (1870–1948).

21 Quoted in Sterne 1980, p. 92. Most of the medieval works in the Hoentschel Collection came to the Metropolitan Museum in 1916 and 1917, after the death of J. Pierpont Morgan in 1913. See Valentiner 1908, pp. 129–33; "Pierpont Morgan Gift" 1918, pp. 1–20; Gennari-Santori 2010, pp. 81–98; Kisluk-Grosheide, Krohn, and Leben 2013. For von Bode's role in Morgan's hiring of Valentiner, see Chapuis 2006, pp. 160–62.

22 "Saw Art Treasures Sunday" 1914, p. 11.

23 Peck 1991, p. 65.

24 Schrader 1979.

25 Vermeule, Cahn, and Hadley 1977.

26 Schrader 1979, pp. 32–33, figs. 42–43; Emery and Morowitz 2004, pp. 288–89. This desire to make the past live again descends directly from European museums such as Alexandre Lenoir's Musée des Monuments Français in Paris, the very first public museum with a significant collection of medieval art, which opened in 1795, and the recipient of some of its collection, the Musée National du Moyen Âge—Thermes et Hôtel de Cluny, which opened in 1844. In the older museum, each room was "devoted to a separate century of French sculpture; as the viewer passed from the rooms holding early medieval objects to those of more recent origin, they became successively brighter, symbolizing the passage from the Dark Ages to the Enlightenment" (Emery and Morowitz 2004,

p. 288). Popular appropriation of the Middle Ages saw its apogee at the Paris World's Fairs of 1889 and 1900, which "featured costumed minstrels and artisans, recreated medieval towns, staged battles and jousts, and performances of medieval plays and concerts" (ibid., p. 289).

27 Landais 1992; Barnet 2008, pp. 44–50; Smith 1996, pp. 133–42, esp. p. 136; Emery and Morowitz 2004, p. 289.

28 Janke 1989, pp. 374–76; George Zarnecki, Courtauld Institute of Art, to David G. Carter, director (1959–65) of the Rhode Island School of Design (RISD) Museum of Art, November 13, 1959, museum file 59.131, RISD Museum of Art, Providence, R.I.; H. Swarzenski 1960, pp. 78–79.

29 Preising 2007, p. 21.

30 Randall 1995, pp. 294–97.

31 Secrest 2004, p. 216.

32 Chapuis 1999, pp. 335–38.

33 Wilm 1938. Georg Schuster not only restored sculptures in his own gallery; he also worked for prominent dealers in Germany, Austria, Hungary, France, and the United States. For Saint Roch and the Angel, see Chapuis and Marincola 2008, pp. 66–75, fig. 5.

34 Hoeniger 1999, p. 148; Castelnuovo-Tedesco and Soultanian 2010, p. xi, cat. no. 41, pp. 186–98.

35 Beginning with Johann J. Winckelmann (1717–1768), many scholars have seen color on sculpture as barbaric and unsophisticated. For discussion on this topic, see Boldrick, Park, and Williamson 2002, pp. 20–23. The Münnerstadt altar by Tilman Riemenschneider, which had its polychromy stripped in 1649 to facilitate repainting, is a documented case of such a renewal process (Krohm and Oellermann 1980).

36 Sauerländer 2002, p. 33; Panzanelli 2008, pp. 4–8.

37 Taylor 1929. The surface treatment is reminiscent of nineteenth-century practice in Munich, where works by Riemenschneider in the Bayerisches National-museum were so darkly stained that they were referred to as "chocolate bunnies" (Wixom 1988–89, p. 11).

38 A letter from James Rorimer to Herbert Winlock, director of the Metropolitan Museum, November 8, 1933, illustrates this point: "Mr. Langlais is going to start removing the comparatively modern polychromy if you have no objections. . . . I feel quite confident that the irascible Mr. Barnard will howl when he sees his favorite 'Virgin' cleaned" (The Cloisters Institutional and Administrative Records, box 32, The Cloisters Library and Archives, The Metropolitan Museum of Art, New York).

39 For the sculpture's condition while in the Barnard Collection, see Weinberger 1941, pl. 28, fig. 70.

40 Wendland 1999, vol. 2, pp. 677–83.

41 McClintock 1996a, pp. 203–8.

42 G. Swarzenski 1940, p. 53, cat. no. 168; Wixom 1988–89, illustrated on the front cover.

43 Hirzy 1978.

44 "Stop-Watches" 1927, p. 13; "Anatomist: Museum Fatigue" 1927, p. 24. See also Poncelet 2008.

45 Harris 1978, p. 152.

46 International Museum Office 1935. See also Kimball 1931; Taylor 1931; Poncelet 2008, pp. 7–8, 13–17. This conference identified for the first time and on an international level the importance of museology, a

field of research concerned with the organization and management of museums and museum collections.

47 Joseph Breck had first been hired by William R. Valentiner as his assistant in 1909 and went on to become curator of decorative arts, and finally director of The Cloisters (Forsyth 1992).

48 Rorimer 1938; Rorimer 1948; Houghton et al. 1966. See also the online *Dictionary of Art Historians*, http://www.dictionaryofarthistorians.org/rorimerj.htm (accessed February 17, 2014).

49 Piña 1990, pp. 5–6; Mayor 1966.

50 Quoted in Tomkins 1970a, p. 308. See also Landais 1992.

51 Press release for "Saints for Soldiers," 1943, The Cloisters Institutional and Administrative Records, box 15, The Cloisters Library and Archives.

52 Lighting of candles at The Cloisters took place until 1990, when concerns for public and collection safety led to its discontinuation.

53 Cauman 1958, pp. 88–89, 129–32.

54 Ibid., p. 133. A fragmentary Egyptian wood tomb figure was completed to re-create the lost severity of the pose. Unfortunately, no record exists regarding the conservation of medieval polychrome wood sculpture. See also Woodward 1985, p. 39.

55 Becker and Schorsch 2010, p. 12.

56 At The Metropolitan Museum of Art, the Sub-Department of Conservation and Technical Research was established in 1942 (Becker and Schorsch 2010, p. 30). Its title was changed to Technical Laboratory in 1949 and to Conservation Department in 1956. For a photograph of Michael Moffat at work, see "Museum's Work" 1953, p. 25. For references to treatments, see departmental files, Department of Medieval Art and The Cloisters, The Metropolitan Museum of Art. E.g., Moffat fastened and touched up a loose finger on the *Standing Virgin and Child* (53.49), and he carved a new section for the dog's paw for *Saint Roch* (25.120.239a, b).

57 James J. Rorimer to Mr. Harris, February 8, 1936, Rorimer Papers, folder 6, The Cloisters Library and Archives.

58 Taylor 1942.

59 The Cloisters Institutional and Administrative Records, box 29, The Cloisters Library and Archives.

60 Wixom 1988–89, p. 37, colorpl.; departmental catalogue cards, Department of Medieval Art and The Cloisters, The Metropolitan Museum of Art.

61 Mecklenburg, Tumosa, and Erhardt 1998. Sculptures are more prone to such issues than panel paintings, however, because in radially cut panels, the natural tendency of wood to distort as it dries out over time has been all but eliminated. In more voluminous sculptural works the characteristic concentric growth structure of the wood is retained, and as it shrinks, internal tensions build up, resulting in distortion and radial cracking.

62 Kargère and Marincola 2011. See also conservation files in the Cleveland Museum of Art, the Harvard Art Museums (Object Files, Straus Center for Conservation, Cambridge, Mass., for both the Fogg Museum and the Busch-Reisinger Museum; hereafter conservation files and name of museum), the Philadelphia Museum of Art, and the Walters Art Museum (Division of Conservation and Technical Research, Object Records 1937–2013, Walters Art Museum, Baltimore,

Md.; hereafter conservation files, Walters Art Museum).

63 Blewett 2006; Conservation and Technical Research Collection, Philadelphia Museum of Art Archives, http://www.philamuseum.org/pma_archives/ead. php?c=CTR&p=hn (accessed June 27, 2011).

64 RG19, Records of the Department of Technical Services, Series 1, Records of David Rosen, Archives of the Walters Art Mueum; Walters Art Gallery 1935, p. 4. A chemist, Harold Ellsworth, was also hired in 1934 to carry out infrared, radiographic, and ultraviolet light examinations.

65 Rosen 1934, pp. 114–15; Rosen 1950–51, pp. 45–71. See also Packard 1967; Packard 1971, pp. 13–23. The hot wax tank was in use at the Walters Art Museum until 1972. See, e.g., conservation files, *Angel Bearing a Candle* (27.581), Walters Art Museum.

66 This treatment option was once more an adaptation of a method employed in the restoration of paintings, where wax-resin mixtures were used to line paintings (Plenderleith and Cursiter 1934).

67 The first documented wax-resin immersions of damaged wood objects were carried out by C. Gurlitt in 1902 in Dresden (Aberle and Koller 1968, p. 7). Paraffin wax was used at the Institut Royal du Patrimoine Artistique (KIK-IRPA) in Brussels, and in Louvain and Lyons, until 1965 (Serck-Dewaide 1996–98, pp. 162– 70, esp. p. 162); at the British Museum in London under the guidance of Harold Plenderleith (Unger, Schniewind, and Unger 2001, p. 387); and in Norway at the University of Oslo (Unger, Schniewind, and Unger 2001, p. 387).

68 A "six-foot thermostatically controlled tank for wax-impregnation of wood sculpture" purchased by the Metropolitan Museum in 1955 is noted in "1955 Annual Report for the Technical Laboratory," Office of the Secretary Records, The Metropolitan Museum of Art Archives. The Museum had for decades owned a wax tank used by the Department of Egyptian Art (Becker and Schorsch 2010, pp. 20–21). Still, only one record refers to a wax immersion treatment, which was carried out on an early sixteenth-century German wooden relief, *Death of the Virgin* (16.32.210), by Murray Pease in December 1956 (conservation files, Department of Medieval Art and The Cloisters, The Metropolitan Museum of Art). A 1955 report for *Seated Virgin and Child* (25.120.290) mentions the intention to immerse the sculpture, but no apparent sequel is documented, and the sculpture's surface bears no evidence for such a treatment (conservation files, Department of Medieval Art and The Cloisters, The Metropolitan Museum of Art).

69 Suhr 1932.

70 Milliken 1929; Milliken 1939.

71 E.g., conservation files, *Virgin and Child* (1933.160), Worcester Art Museum, Worcester, Mass.

72 Schädler 1992, pp. 60, 68, figs. 22, 23; conservation files, Philadelphia Museum of Art. In 1966, Theodor Siegl sprayed varnish on the surfaces of the *Saint Barbara* (1930-1-167) and *Saint Catherine* (1930-1-168) reliefs by Niklaus Weckmann the Elder and workshop, a treatment familiar to paintings conservators (Siegl 1966, fig. 18; Cheryl Leibold, "'Service Rendered to the Great Cause of Art': A Guide to the Archives of the Pennsylvania Academy of the Fine Arts," 2008,

p. 37, http://www.pafa.org/SiteData/doc/GuideText-forWeb%20fnl/6981004983e95cf9ce358fe007049374/GuideTextforWeb%20fnl.pdf [accessed February 15, 2014]).

73 Conservation files at the Fogg Museum, RISD Museum of Art, and the Wadsworth Atheneum, Departmental Records, Wadsworth Museum, Hartford, Conn.

74 Inge Sonn, interview by Rebecca Rushfield regarding Joseph Ternbach, 2004, Foundation of the American Institute for Conservation (FAIC) Oral History File, Winterthur Museum, Library, and Archives, Winterthur, Del.

75 Departmental records, Wadsworth Atheneum. Joseph Ternbach cofounded the Godwin-Ternbach Museum, Queens College, City University of New York, which houses his collection, including several examples of medieval polychrome wood sculpture.

76 Fritz 1953; Willemsen 1960; Taubert 1961.

77 Becker and Schorsch 2010, p. 28. In 1932, Rorimer passionately argued with Breck that, given Charles Langlais's "admirable skill and attitude," he should be promoted to permanent staff and receive the benefits of full employment (Rorimer to Breck, November 4, 1932, The Cloisters Institutional and Administrative Records, box 29, The Cloisters Library and Archives). In an earlier letter to Breck, October 26, 1932, Rorimer comments that Langlais worked about three times as many days at The Cloisters as in the main building. Whereas documentation of treatments from this era is sparse, Langlais did note the type of treatment and the number of hours he spent on each sculpture, recorded beautifully in a book with Venetian marbled paper covers. On February 25, 1935, he "removed new paint and glued loose paint and gold, 80 hours," from the monumental Spanish Romanesque *Crucifix* (35.36a, b). On June 13, 1939, he recorded the removal of "new paint, 168 hours" from the Lavaudieu *Torso of Christ from a Deposition* (25.120.221). Rorimer joined Langlais in carrying out treatments; his name is regularly cited in departmental catalogue card records for having cleaned sculptures with a solution of "parafine [sic], acetone and benzol," apparently his own concoction.

78 Rorimer 1936, p. 172 n. 4. Rorimer graduated from Harvard in 1927. Although he studied under Edward Waldo Forbes and Paul J. Sachs, Rorimer completed his studies two years before the Fogg Museum's "laboratory for the arts" was fully realized. For the history of this formative research laboratory, see Bewer 2001; Bewer 2010, pp. 83, 175–77.

79 Rorimer 1936, p. 170.

80 Grossman, Podany, and True 2003, pp. 16–22.

81 All remaining modern additions on the Imad Madonna were removed in 1970 (Serck-Dewaide 1995, p. 215). Full-fledged quests for purism led to the removal of all modern additions from the Italian paintings in the Jarves Collection at Yale University in the 1970s (Aronson 2003) and from antique sculptures such as the Aegina pediment in the Munich Glyptothek in the 1960s (Diebold 1995).

82 The exhibition also traveled to the Worcester Art Museum and to the Memorial Art Gallery of the University of Rochester, Rochester, N.Y. The restorers who performed the stratigraphic analysis of the paint layers were from the Soviet Union (Grabar 1931, pp. 9–17; see also Bewer 2010, pp. 150–51).

83 Rorimer 1936, pp. 172–73, fig. 2a–c.

84 This type of treatment was carried out on the monumental Spanish Romanesque *Crucifix* (35.36a, b) that was extensively restored in preparation for exhibition shortly after acquisition (Rorimer 1935, p. 238 n. 4; Wixom 1988–89, p. 37; see also p. 22 in text).

85 For a discussion of changes in societal values that led conservators to establish a code of professional ethics, see Clavir 2008.

86 Essential writings on this topic include Becker and Schorsch 2010 and Bewer 2010. See also International Centre 1960.

87 Henri Marceau (1896–1969), curator and later director of the Philadelphia Museum of Art, believed strongly in the value of technical examination for art-historical research. He founded a laboratory for this purpose in 1939 but still worked largely with consulting conservators until Theodor Siegl was hired in 1955 ("Conservation and Technical Research Collection: Historical Note," Philadelphia Museum of Art Archives, http://www.philamuseum.org/pma_archives/ead.php?c=CTR&p=hn [accessed May 6, 2013]).

88 *Scientific Examination of Art* 2005, p. 41.

89 Sox 1987, p. 49; Whiting 1929.

90 Rorimer 1936, p. 179. Rorimer notes that the radiographs unfortunately showed little information on the condition of the underlying paint layers.

91 Rorimer was keen on pursuing technical advances for the examination of works of art. Writing to Sheldon Keck on December 24, 1942, he bemoans the lack of heat in the building and adds: "I have been having some interesting times in the laboratory lately and I am anxious to show you my new equipment. It will keep you jealous until after the war when priorities will make lamps possible" (The Cloisters Institutional and Administrative Records, box 33, The Cloisters Library and Archives).

92 E.g., dendrochronology has been used to date the wood substrate of the Gero Crucifix in the Cologne Cathedral, Germany (Schulze-Senger et al. 1987, pp. 39–45). KIK-IRPA regularly uses this method for dating sculptures in Belgian collections.

93 Arnold and Libby 1949, pp. 678–80.

94 See Theiss, Soultanian, and Kargère 2011; Wixom 2007, pp. 26–27.

95 Coremans 1961.

96 Rorimer Papers, box 1, The Cloisters Library and Archives. The list includes Colin G. Fink at Columbia University, Anton Alexander Benedetti-Pichler at New York University, Arthur H. Kopp and James Rorimer at The Metropolitan Museum of Art, William J. Young at the Museum of Fine Arts in Boston, Earle R. Caley at the Frick Museum in New York, Rutherford J. Gettens, George Stout, and Alan Burroughs at the Fogg Museum, and James L. Clark at the American Museum of Natural History in New York. Coremans also visited David Rosen at the Walters Art Museum and Sheldon Keck at the Brooklyn Museum, as well as the Pennsylvania Museum and School of Industrial Art (now the Philadelphia Museum of Art), Princeton University, and Johns Hopkins University.

97 For early developments in microscopy in the field of conservation in Europe, see Nadolny 2003, p. 43.

98 Charles Langlais, report addressed to William Forsyth, March 12, 1934, Department of Medieval Art and The Cloisters, The Metropolitan Museum of Art.

99 Castelnuovo-Tedesco and Soultanian 2010, pp. 128–35.

100 Barnes 1939, pp. 120–38.

101 Conservation report for the thirteenth-century Italian *Section of a Cassone Panel Depicting Beasts in Roundels* (1936.129), departmental files, Harvard Art Museums. See also Cahn and Seidel 1979, p. 191, cat. no. 42, fig. 200.

102 This process is referred to in the Walters Art Museum conservation files as the *decapé* (scraping) method. Sometimes paint fell off during the wax treatment. When the wax tank there was emptied many years later, a thick layer of paint flakes was found at the bottom. Terry Drayman-Weisser, conservator, Walters Art Museum, personal communication, October 18, 2010. The methodical examination of overpaint structures that was to develop in the 1950s was precluded by this treatment.

103 E.g., the Worcester Art Museum's Spanish, Catalonia (?), *Virgin and Child*, second half of the twelfth century (1933.160), and the late thirteenth-century Spanish *Crucifixion with the Virgin and Saint John* (1934.26a–c) were treated using a mixture of 40 parts beeswax, 30 paraffin wax, 20 resin, 10 gum elemi (by weight) (Plenderleith and Cursiter 1934). According to a notation on a departmental catalogue card, the paint on the Metropolitan Museum's fourteenth-century French *Seated Virgin and Child* (25.120.290) was consolidated in 1939 by Langlais with a mixture of 80% bleached beeswax and 20% gum elemi, applied with a warm tacking iron. For wax-resin mixtures, see Stout and Pease 1938–39, pp. 39–40.

104 Buck 1952; Buck 1961; Gettens, Pease, and Stout 1941, pp. 127–44.

105 Buck 1947; conservation file for *Saint Anne Teaching Her Daughter the Virgin Mary to Read (The Education of the Virgin)*, attributed to the Master of Saint Benedict, German, act. Hildesheim, 1510–30 (1930-1-163a), Philadelphia Museum of Art. See also Wixom 1999c, p. 151, ill. 5.

106 Rorimer 1936, p. 172.

107 Unger, Schniewind, and Unger 2001, p. 4. Gaseous hydrocyanic acid was used in 1929 on the retable in the Pilgrimage and Parish Church of Saint Wolfgang in Kefermarkt, Austria.

108 Conservation file on a late twelfth-century *Enthroned Madonna* from Northern Europe (70.56), Cleveland Museum of Art. See also Lee 1971, p. 28, fig. 29.

109 For carbon tetrachloride treatment, see conservation file on a twelfth-century French *Virgin and Child in Majesty* (1937.29), Fogg Museum; Shestack 1965 p. 21, fig. 1. For DDT treatment, see conservation file on "Stele" (no other information given), Fogg Museum.

110 Boothroyd Brooks 2000; Brommelle, Moncrieff, and Werner 1967; Brommelle and Moncrieff 1969.

111 Rubin 1963, vol. 4; see introduction by Craig Hugh Smyth (pp. 137–38), articles by Cesare Brandi (pp. 146–51), Richard Offner (pp. 152–62), and transcript of a discussion session (pp. 163–85) collected under the heading "The Aesthetic and Historical Aspects of the Presentation of Damaged Pictures." While Offner and Millard Meiss championed the removal of retouchings for an "aesthetic liberation of the original" (p. 166), Brandi defended the importance of the impact of history on works of art; Paul Coremans, Sheldon Keck, and George Stout all strove to reach a balance between the two opposing views.

112 Hired in 1941 and named associate curator in 1942, Murray Pease was promoted to curator in 1949 and conservator in 1956. See Becker and Schorsch 2010, p. 30. Pease was in frequent contact with Paul Coremans in Brussels, Harold Plenderleith at the British Museum, and Arthur van Schendel at the Rijksmuseum in Amsterdam. See interview with Kate C. Lefferts and Lawrence Majewski, November 26, 1975, pp. 1–16, esp. p. 5, FAIC Oral History File.

113 See note 68 above.

114 Charles Langlais is mentioned in the Metropolitan Museum's conservation records at least until 1961.

115 Mojmir Frinta, interview by authors, May 21, 2010.

116 Bergeon et al. 1998, pp. 265–66.

117 Madeleine Hours to George Stout, June 7, 1951, Frinta personal archives; Frinta, personal communication, May 21, 2010.

118 See note 111 above; see also Brandi 1963.

119 Wixom 1988–89, p. 16 (color ill.).

120 Frinta 1963. About the same time, Thomas Brachert made a similar discovery (Brachert 1963).

121 See, e.g., conservation files for a twelfth-century *Corpus from a Crucifix* (1980.1) and a fourteenth-century *Christ and Saint John the Evangelist* (1928.753), Cleveland Museum of Art.

122 See Holladay 1989, pp. 304–5.

123 See interview with Anton J. Konrad, 1977, FAIC Oral History File. Konrad had emigrated to the United States in the early 1950s and opened a private practice in Brooklyn. He also worked for the Art Institute of Chicago in the 1950s under Louis Pomerantz.

124 Konrad was very impressed by the new methods of treatment used in the United States when he first arrived in the 1950s (Konrad interview).

125 Herbert E. Ives, an American scientist who painted as a hobby, was appointed fellow in color science research at the Fogg Museum in 1935 and helped develop PVA as a new inpainting medium (Clarke and Ives 1935, pp. 36–41). Gettens (1935, p. 24) mentioned PVA as a potential picture varnish as well.

126 Powell and Madson 1972; Gettens 1935; Thomson 1957. Robert L. Feller at the National Gallery of Art, Washington, D.C., was also critical to the development of criteria for the testing of synthetic resins (Epley 1996).

127 Berger 1990. Mario Modestini, a widely acknowledged connoisseur and restorer, was the conservator and curator of the Kress Collection from 1949 to 1961.

128 See, e.g., conservation files for *Figure of a King* (52.82), Department of Medieval Art and The Cloisters, The Metropolitan Museum of Art.

129 PVA (Alvar) resin was selected in 1936 to adhere pieces of a wooden *cassone* at the Fogg Museum (*Section of a Cassone Panel Depicting Beasts in Roundels*, 1936.129; see note 101 above), and Elmer's Glue, a proprietary emulsion of polyvinyl acetate, was used in 1964 to set down flaking paint on an *Angel* (BR64.34) at the Busch-Reisinger Museum (conservation files, Busch-Reisinger Museum). Elmer's Glue was used for several years at the Museum of Fine Arts in Boston (conservation files, Museum of Fine Arts, Boston).

130 Pératé and Brière 1908, vol. 1, p. 12, pl. 24; conservation files, The Cloisters, Department of Medieval Art and The Cloisters.

131 Conservation files, The Cloisters, Department of Medieval Art and The Cloisters; Wixom 1988–89, p. 33, color ill.

132 Unger, Schniewind, and Unger 2001, p. 191.

133 Packard 1971, pp. 14–15, fig. 8. Experiments with Xylamon were conducted at the Walters Art Museum, and it was actually used on *Figures from a Deposition* (61.148) (conservation files, Walters Art Museum). Konrad recommended Xylamon to the Philadelphia Museum of Art in 1965 for the treatment of Niklaus Weckmann's *Saint Catherine* (1930-1-168) (conservation files, Philadelphia Museum of Art).

134 At the Cleveland Museum of Art, this "protective" coating was applied on two fifteenth-century *Female Busts* (1962.283, 1962.284), an Austrian fourteenth-century *Virgin and Child* (1962.207), the *Lute-Playing Angel* by Hans Schnatterpeck (1959.340), the early sixteenth-century *Mourning Virgin from a Crucifixion Group* by Veit Stoss (1939.64), and an early fourteenth-century German *Christ and Saint John the Evangelist* (1928.753) (conservation files, Cleveland Museum of Art). At the Philadelphia Museum of Art, it was applied to the *Saint Barbara* (1930-1-167) and *Saint Catherine* (1930-1-168) by Niklaus Weckmann the Elder and workshop (conservation files, Philadelphia Museum of Art). At the Walters Art Museum, Vinylite (PVC) was used on *Man Throwing a Stone* (61.137) (conservation files, Walters Art Museum). Ketone resins, first patented in the 1920s in Germany by I. G. Farbenindustrie and produced commercially in Germany by BASF in the 1930s, were used on a number of sculptures at The Cloisters in the 1970s and 1980s. Examples include *Blessing Bishop (Saint Nicholas of Bari)* (25.120.218) (Wixom 1988–89, p. 30, colorpl. ill.); the *Seated Virgin and Child* (25.120.290) (Wixom 1988–89, p. 33, colorpl. ill.); the Italian *Kneeling Virgin* (25.120.217) (Castelnuovo-Tedesco and Soultanian 2010, pp. 268–75, ill. p. 269); *Virgin and Child on a Crescent Moon* (1984.198) (Wixom 1988–89, p. 22, colorpl. ill.); *Saint Christopher Carrying Christ* (1973.135) (Wixom 1988–89, p. 54, colorpl. ill.); and *Three Kings from an Adoration Group* (52.83.1–3) (Wixom 1988–89, pp. 18–19, colorpl. ill.).

135 Epley 1996.

136 Conservation files on a Flemish or German *Devotional Statuette of Saint Sebastian* (61.116), Walters Art Museum. Acryloid B-72 was used by Konrad for the consolidation of "primitive art" at the Brooklyn Museum in the late 1960s (Packard 1971, p. 14; Konrad interview). The Philadelphia Museum of Art Conservation Department tested adhesives for wood consolidation in 1993 and determined that polyvinyl butyral stained the wood to a lesser extent than Paraloid B-72. In 1989, Valerie Dorge, then a fellow at the Detroit Institute of Arts, traveled to Europe to conduct research on conservation materials and practice for polychrome sculpture, reporting that polyvinyl butyral was used at the Victoria and Albert Museum in London with satisfactory results, and that at KIK-IRPA in Brussels, Paraloid B-72 in toluene had been found to cause darkening. For Dorge's research,

see conservation files on the late fifteenth-century German *Madonna and Child* (21.182), Detroit Institute of Arts.

137 Conservation files on a fifteenth-century *Kneeling Angel* (BR63.3), Busch-Reisinger Museum (see also Ehresmann 1989, pp. 212–13, no. 172); on a late twelfth-century or early thirteenth-century *Virgin and Child* (27.255), Walters Art Museum (see also Cahn and Seidel 1979, no. 1. p. 97 [ill.]); on the sixteenth-century German *Saint Anne Teaching Her Daughter the Virgin Mary to Read (The Education of the Virgin)* (1930-1-163a), Philadelphia Museum of Art (see also Wixom 1999b, p. 151, fig. 5).

138 Derrick, Stulik, and Landry 1999; Plesters and Brommelle 1974, pp. 767–70.

139 The seminars initiated by William J. Young at the Museum of Fine Arts, Boston, were devoted chiefly to investigations of archaeological materials (Young 1958; Young 1965; Young 1973).

140 Frinta 1963, p. 138.

141 Harris 1999.

142 Philadelphia Museum of Art, "History: 1970–1980," www. Philamuseum.org/information/45-602-502.html (accessed May 7, 2013).

143 Conservation files, Philadelphia Museum of Art. See also Kimball 1945, fig. 86; Walker 1995, p. 112.

144 Acquisition reports, Department of Medieval Art and The Cloisters, The Metropolitan Museum of Art, and oral survey conducted by the authors with conservators at cited museums, October 2011.

145 *Preprints* 1971.

146 Ballestrem 1971. The German-born Agnes Ballestrem started her career in the conservation of polychrome sculpture as a student of Johannes Taubert and Ernst Willemsen. At the time of the conference, she was the head of the polychrome sculpture workshop at the KIK-IRPA in Brussels.

147 Taubert 1971; Philippot 1971; Packard 1971.

148 *Preprints* 1971. In 1970, Ballestrem had published a valuable bibliography on the materials, techniques, and treatment of polychrome wood sculpture in *Studies in Conservation*. See Ballestrem 1970.

149 See Wixom 1999a; Wixom 1999b.

150 Timothy Husband, curator, The Cloisters, personal communication. There is little record of Geoffrey Moss in museum files or archives.

151 Rudolph Meyer, personal communication, January 3, 2011.

152 Wixom 1988–89, pp. 11, 18–19, fig. 18. E.g., Meyer used Rembrandt Picture Varnish, which is a polycyclohexanone or reduced ketone resin based varnish (conservation files, The Cloisters, Department of Medieval Art and The Cloisters). Unfortunately, some of the materials used by Meyer have had detrimental effects, such as the commercial casein he applied to azurite surfaces as a matting agent that has discolored over time and cannot be removed.

153 Carlyle 2012. For an observation concerning the removal of an old varnish from a polychrome wood sculpture, see Castelnuovo-Tedesco and Soultanian 2010, pp. 196, 206. See also Seidel and Caglioti 2010, for Italian polychrome wood sculptures with modern highly reflective varnishes, e.g., cats. A9 (ill. pp. 44–45), A13 (ill. p. 55), A26 (ill. p. 91), A29 (ill. p. 97), and A30 (ill. p. 99).

154 Phillips 1997. Phillips compares Thomas Hoving to an early eleventh-century abbot: "Each took over an institution with a reputation for a certain austerity, but left behind him a much rebuilt institution whose high profile had attracted great wealth in gifts" (pp. 17–18). For a discussion of art's atemporal condition, see Brandi (1963) 1996, pp. 232–33.

155 Benjamin (1936) 1968, pp. 224–25. Benjamin's essay was first published in 1936, reworked in 1955, and translated into English in 1968. It continues to play a significant role in the history of modern aesthetics and criticism.

156 Phillips 1997, p. 167.

157 Frodl-Kraft 1962, p. 83. This statement is discussed by Philippot (1990) 1996, p. 226. Similarly, the High Altar in Lautenbach's Pilgrimage Church of the Virgin and the Riemenschneider altarpieces in churches in Creglingen and Rothenburg were illuminated from behind with natural light (Kahsnitz 2006, p. 277).

158 Baxandall 1980, pp. 166–72.

159 Wixom 1988–89, pp. 5–6.

160 Gilberg 1989; Koestler 1993.

161 The Modular Cleaning Program is both a database system and an approach to the cleaning of artworks developed by the paintings conservator Chris Stavroudis to assist conservators in the rapid development of cleaning systems with solvents, solvent gels, or aqueous mixtures. See Stavroudis 2009.

162 Castelnuovo-Tedesco and Soultanian 2010, pp. 100–9, 199–207; Kargère and Rizzo 2010.

163 Marincola, forthcoming. Daniel P. Kirby of Harvard Art Museums performed the analysis.

164 Arslanoglu and Schultz 2009; Castelnuovo-Tedesco and Soultanian 2010, pp. 133–35, esp. n. 38.

165 Castelnuovo-Tedesco and Soultanian 2010.

166 Panzanelli 2008.

167 Ulmann 2010.

REFERENCES

Aberle and Koller 1968. Brigitte Aberle and Manfred Koller. *Konservierung von Holzskulpturen: Probleme und Methoden.* Vienna: Institut für Österreichische Kunstforschung des Bundesdenkmalamtes, 1968.

"Anatomist: Museum Fatigue" 1927. "Anatomist: Museum Fatigue." *New York Times*, October 14, 1927, p. 24.

Arnold and Libby 1949. J. R. Arnold and W. F. Libby. "Age Determination by Radiocarbon Content: Checks with Samples of Known Age." *Science* 110, no. 2869 (1949), pp. 678–80.

Aronson 2003. Mark Aronson. "The Conservation History of the Early Italian Collection at Yale." In *Early Italian Paintings—Approaches to Conservation: Proceedings of a Symposium at the Yale University Art Gallery, April 2002*, edited by Patricia Sherwin Garland, pp. 30–53. New Haven: Yale University Art Gallery, 2003.

Arslanoglu and Schultz 2009. Julie Arslanoglu and Julia Schultz. "Immunology and Art: Using Antibody-Based Techniques to Identify Proteins and Gums in Binding Media and Adhesives." *Metropolitan Museum of Art Bulletin* 67, no. 1 (2009), pp. 40–45.

Ballestrem 1970. Agnes Ballestrem. "Sculpture polychrome: Bibliographie." Special Issue on the Conservation, Technique and Examination of Polychrome Sculpture, *Studies in Conservation* 15, no. 4 (1970), pp. 253–71.

Ballestrem 1971. Agnes Ballestrem. "Cleaning of Polychrome Sculpture." In *Preprints of the Contributions to the New York Conference on Conservation of Stone and Wooden Objects, 7–13 June 1970*, vol. 2, pp. 69–73. London: International Institute for Conservation of Historic and Artistic Works, 1971.

Barnes 1939. N. F. Barnes. "A Spectrophotometric Study of Artists' Pigments." *Technical Studies in the Field of the Fine Arts* 7, no. 3 (1939), pp. 120–38.

Barnet 2008. Peter Barnet. "'The Greatest Epoch': Medieval Art in Detroit from Valentiner to 'The Big Idea'." In *To Inspire and Instruct: A History of Medieval Art in Midwestern Museums*, edited by Christina Nielsen, pp. 39–53. Newcastle: Cambridge Scholars, 2008.

Baxandall 1980. Michael Baxandall. *The Limewood Sculptors of Renaissance Germany.* New Haven: Yale University Press, 1980.

Becker and Schorsch 2010. Lawrence Becker and Deborah Schorsch. "The Practice of Objects Conservation in The Metropolitan Museum of Art (1870–1942)." *Metropolitan Museum Studies in Art, Science, and Technology* 1 (2010), pp. 11–37.

Benjamin (1936) 1968. Walter Benjamin. "The Work of Art in the Age of Mechanical Reproduction." In *Illuminations: Essays and Reflections*, edited by Hannah Arendt, translated by Harry Zohn, pp. 217–51. New York: Schocken Books, 1968.

Bergeon et al. 1998. Ségolène Bergeon, Gilberte Emile-Mâle, Claude Huot, and Odile Baÿ. "The Restoration of Wooden Painting Supports: Two Hundred Years of History in France." In *The Structural Conservation of Panel Paintings: Proceedings of a Symposium at the J. Paul Getty Museum, 24–28 April, 1995*, edited by Kathleen Dardes and Andrea Rothe, pp. 264–88. Los Angeles: Getty Conservation Institute, 1998.

Berger 1990. Gustav A. Berger. "Inpainting Using PVA Medium." In *Cleaning, Retouching and Coatings: Technology and Practice for Easel Paintings and Polychrome Sculpture: Preprints of the Contributions to the Brussels Congress, 3–7 September 1990*, edited by John S. Mills and Perry Smith, pp. 150–55. London: International Institute for Conservation of Historic and Artistic Works, 1990.

Bewer 2001. Francesca G. Bewer. "Technical Research and the Care of Works of Art at the Fogg Museum (1900–1950)." In *Past Practice, Future Prospects*, edited by Sandra Smith and W. Andrew Oddy, pp. 13–18. British Museum Occasional Paper 145. London: British Museum, 2001.

Bewer 2010. Francesca G. Bewer. *A Laboratory for Art: Harvard's Fogg Museum and the Emergence of*

Conservation in America, 1900–1950. New Haven: Yale University Press, 2010.

Blewett 2006. Morwenna Blewett. "The History of Conservation Documentation at Worcester Art Museum." In *AIC Paintings Specialty Group Postprints*, vol. 18, pp. 94–106. 34th Annual Meeting of the American Institute for Conservation of Historic and Artistic Works, Minneapolis, Minn., June 8–13, 2005. Washington, D.C.: American Institute for Conservation, 2006.

Boldrick, Park, and Williamson 2002. Stacy Boldrick, David Park, and Paul Williamson. *Wonder: Painted Sculpture from Medieval England.* Exh. cat. Leeds: Henry Moore Institute, 2002.

Boothroyd Brooks 2000. Hero Boothroyd Brooks. *A Short History of IIC: Foundation and Development.* London: International Institute for Conservation of Historic and Artistic Works, 2000.

Brachert 1963. Thomas Brachert. "Pressbrokat-Applikationen, ein Hilfsmittel für die Stilkritik." *Jahresbericht Schweizerisches Institut für Kunstwissenschaft* (1963), pp. 37–43.

Brandi 1963. Cesare Brandi. "Il trattamento delle lacune e la Gestalt psycologie." In *Studies in Western Art: Acts of the 20th International Congress of the History of Art,* edited by Ida E. Rubin, vol. 4, *Problems of the 19th and 20th Centuries,* pp. 146–51. New York, September 7–12, 1961. Princeton: Princeton University Press, 1963.

Brandi (1963) 1996. Cesare Brandi. *Teoria del restauro.* Rome, 1963. Translated by Gianni Ponti with Alessandra Melucco Vaccaro, in *Historical and Philosophical Issues in the Conservation of Cultural Heritage,* edited by Nicholas Stanley Price, M. Kirby Talley Jr., and Alessandra Melucco Vaccaro, pp. 230–35. Los Angeles: Getty Conservation Institute, 1996.

Brilliant 2009. Virginia Brilliant. *Gothic Art in the Gilded Age: Medieval and Renaissance Treasures in the Gavet-Vanderbilt-Ringling Collection.* Pittsburgh: John and Mable Ringling Museum of Art, 2009.

Brommelle, Moncrieff, and Werner 1967. Norman S. Brommelle, Anne J. Moncrieff, and A.E.A. Werner, eds. *Papers on the Conservation and Technology of Wood—Deterioration and Treatment of Wood: Joint Meeting of the ICOM Committee for Scientific Museum Laboratories and the ICOM Sub-committee for the Care of Paintings, Brussels, September 1967.* London: Victoria and Albert Museum, 1967.

Brommelle and Moncrieff 1969. Norman S. Brommelle and Anne J. Moncrieff, eds. *Papers on the Conservation and Technology of Wood—Deterioration and Treatment of Wood: Joint Meeting of the ICOM Committee for Scientific Museum Laboratories and the ICOM Sub-committee for the Care of Paintings, Amsterdam, September 1969.* London: Victoria and Albert Museum, 1969.

Brush 2004. Kathryn Brush. "Le Fogg Art Museum et la sculpture romane espagnole." In *Catalogne romane: Sculptures du Val de Boí,* pp. 42–53. Exh. cat. Paris: Réunion des Musées Nationaux; Barcelona: Museu Nacional d'Art de Catalunya, 2004.

Buck 1947. Richard D. Buck. "Treatment of Paintings on Wood in Museums Not Air-Conditioned." *Museum News* 25, no. 3 (1947), pp. 7–8.

Buck 1952. Richard D. Buck. "A Note on the Effect of Age on the Hygroscopic Behavior of Wood." *Studies in Conservation* 1, no. 1 (1952), pp. 39–44.

Buck 1961. Richard D. Buck. "The Use of Moisture Barriers on Panel Paintings." *Studies in Conservation* 6, no. 1 (1961), pp. 9–20.

Cahn and Seidel 1979. Walter Cahn and Linda Seidel. *Romanesque Sculpture in American Collections,* vol. 1, *New England.* New York: Burt Franklin, 1979.

Carlyle 2012. Leslie Carlyle, ed. *Picture Varnishes: Authenticity and Permanence.* London: Archetype, 2012.

Castelnuovo-Tedesco and Soultanian 2010. Lisbeth Castelnuovo-Tedesco and Jack Soultanian. *Italian Medieval Sculpture in The Metropolitan Museum of Art and The Cloisters.* New York: Metropolitan Museum of Art, 2010.

Cauman 1958. Samuel Cauman. *The Living Museum: Experiences of an Art Historian and Museum Director—Alexander Dorner.* New York: New York University Press, 1958.

Chapuis 1999. Julien Chapuis. *Tilman Riemenschneider: Master Sculptor of the Late Middle Ages.* Exh. cat. Washington, D.C.: National Gallery of Art; New Haven: Yale University Press, 1999.

Chapuis 2006. Julien Chapuis. "Bode und Amerika: Eine komplexe Beziehung." *Jahrbuch Preussischer Kulturbesitz* 43 (2006), pp. 143–76.

Chapuis and Marincola 2008. Julien Chapuis and Michele D. Marincola. "Bemerkungen zum Meister der Biberacher Sippe und zu einem hl. Rochus in The Cloisters." In *Nicht die Bibliothek, sondern das Auge: Westeuropäische Skulptur und Malerei an der Wende zur Neuzeit,* pp. 66–75. Petersberg: Michael Imhof Verlag; Berlin: Staatliche Museen zu Berlin—Stiftung Preussischer Kulturbesitz, 2008.

Clarke and Ives 1935. W. J. Clarke and H. E. Ives. "The Use of Polymerized Vinyl Acetate as an Artist's Medium." *Technical Studies in the Field of the Fine Arts* 4, no. 1 (1935), pp. 36–41.

Clavir 2008. Miriam Clavir. "The Social and Historic Construction of Professional Values in Conservation." *Studies in Conservation* 43, no. 1 (2008), pp. 1–8.

Coremans 1961. Paul Coremans. "La recherche scientifique et la restauration des tableaux." *Bulletin de l'Institut Royal du Patrimoine Artistique* 4 (1961), pp. 109–15.

Derrick, Stulik, and Landry 1999. Michele R. Derrick, Dusan Stulik, and James M. Landry.

Infrared Spectroscopy in Conservation Science: Scientific Tools for Conservation. Los Angeles: Getty Conservation Institute, 1999.

Diebold 1995. William J. Diebold. "The Politics of Derestoration: The Aegina Pediments and the German Confrontation with the Past." *Art Journal* 54, no. 2 (Summer 1995), pp. 60–66.

Dupeux, Delivré, and Kargère 2014. Cécile Dupeux, Jean Delivré, and Lucretia Kargère. "Les sculptures du jubé de la cathédrale de Strasbourg: Une étude technique comparative entre New York et Strasbourg." *Technè* 39 (2014), forthcoming.

Ehresmann 1989. Donald L. Ehresmann. "The Harvard Museums: Busch-Reisinger Museum." In *Gothic Sculpture in America*, vol. 1, *The New England Museums*, edited by Dorothy Gillerman, pp. 182–213. Publications of the International Center of Medieval Art 2. New York: Garland, 1989.

Eikelmann 2005. Renate Eikelmann. *Die Sammlung Bollert: Bildwerke aus Gotik und Renaissance Bayerisches Nationalmuseum*, edited by Matthias Weniger and Jens Ludwig Burk. Kataloge des Bayerischen Nationalmuseums München, NF, vol. 2. Munich: Hirmer Verlag, 2005.

Emery and Morowitz 2004. Elizabeth Emery and Laura Morowitz. "From the Living Room to the Museum and Back Again: The Collection and Display of Medieval Art in the Fin de Siècle." *Journal of the History of Collections* 16, no. 2 (2004), pp. 285–309.

Epley 1996. Bradford Epley. "The History of Synthetic Resin Varnishes." *Painting Conservation Catalog*, chap. 3, 1996, http://www.conservation-wiki.com/index.php?title=Chapter_III_-The_History_of_Synthetic_Resin_Varnishes (accessed May 10, 2013).

"Forgery of Art" 1961. "The Forgery of Art." *New Yorker*, September 16, 1961, pp. 112–45.

Forster-Hahn 1995. Françoise Forster-Hahn. "The Politics of Display or the Display of Politics?" The Problematics of Collecting and Display," pt. 2, *Art Bulletin* 77, no. 2 (June 1995), pp. 174–79.

Forsyth 1992. William H. Forsyth. "Five Crucial People in the Building of The Cloisters." In *The Cloisters: Studies in Honor of the Fiftieth Anniversary*, edited by Elizabeth C. Parker, with the assistance of Mary B. Shepard, pp. 51–58. New York: Metropolitan Museum of Art, International Center of Medieval Art, 1992.

Frinta 1963. Mojmir Frinta. "The Use of Wax for Appliqué Relief Brocade on Wooden Statuary." *Studies in Conservation* 8, no. 4 (1963), pp. 136–49.

Fritz 1953. Rolf von Fritz. "Der Crucifixus von Cappenberg: Ein Meisterwerk französischer Bildhauerkunst." *Westfalen* 31, no. 2–3 (1953), pp. 204–18.

Frodl-Kraft 1962. Eva Frodl-Kraft. "Die Beleuchtung spätgotischer Flügelaltäre." *Österreichische Zeitschrift für Kunst und Denkmalpflege* 15, no. 1 (1962), pp. 83–86.

Gennari-Santori 2010. Flaminia Gennari-Santori. "Medieval Art for America: The Arrival of the J. Pierpont Morgan Collection at The Metropolitan Museum of Art." *Journal of the History of Collections* 22, no. 1 (2010), pp. 81–98.

Gettens 1935. Rutherford J. Gettens. "Polymerized Vinyl Acetate and Related Compounds in the Restoration of Objects of Art." *Technical Studies in the Field of Fine Arts* 4, no. 1 (1935), pp. 15–27.

Gettens, Pease, and Stout 1941. Rutherford J. Gettens, Murray Pease, and George L. Stout. "The Problem of Mold Growth in Paintings." *Technical Studies in the Field of the Fine Arts* 9, no. 3 (1941), pp. 127–44.

Gilberg 1989. Mark Gilberg. "Inert Atmosphere Fumigation of Museum Objects." *Studies in Conservation* 34, no. 2 (1989), pp. 80–84.

Gillerman 1989. Dorothy Gillerman, ed. *Gothic Sculpture in America*, vol. 1, *The New England Museums*. Publications of the International Center of Medieval Art 2. New York: Garland, 1989.

Goldfarb 1995. Hilliard T. Goldfarb. *The Isabella Gardner Museum: A Companion Guide and History*. New Haven: Yale University Press, 1995.

Grabar 1931. Igor Grabar. *A Catalogue of Russian Icons Received from the American Russian Institute for Exhibition*. Exh. cat. New York: Metropolitan Museum of Art, 1931.

Grossman, Podany, and True 2003. Janet Burnett Grossman, Jerry Podany, and Marion True, eds. *History of the Restoration of Ancient Stone Sculptures: Papers Delivered at a Symposium Organized by the Departments of Antiquities and Antiquities Conservation of the J. Paul Getty Museum and Held at the Museum 25–27 October 2001*. Los Angeles: J. Paul Getty Museum, 2003.

Harris 1962. Neil Harris. "The Gilded Age Revisited: Boston and the Museum Movement." *American Quarterly* 14, no. 4 (1962), pp. 545–66.

Harris 1978. Neil Harris. "Museums, Merchandising, and Popular Taste: The Struggle for Influence." In *Material Culture and the Study of American Life*, edited by Ian M. Quimby, pp. 141–74. New York: W. W. Norton, 1978.

Harris 1999. Neil Harris. "The Divided House of the American Art Museum." *Daedalus* 128, no. 3 (1999), pp. 33–56.

Hirzy 1978. Ellen C. Hirzy. "The AAM after 72 Years." *Museum News* 56, no. 5 (May–June 1978), pp. 44–48.

Hoeniger 1999. Cathleen Hoeniger. "The Restoration of the Early Italian 'Primitives' during the 20th Century: Valuing Art and Its Consequences." *Journal of the American Institute for Conservation* 38, no. 2 (1999), pp. 144–61.

Holladay 1989. Joan A. Holladay. "The Wadsworth Atheneum." In *Gothic Sculpture in America*, vol. 1, *The New England Museums*, edited by Dorothy Gillerman, pp. 304–5. Publications of the

International Center of Medieval Art 2. New York: Garland, 1989.

Homberg 1931. Octave Homberg. *Catalogue des tableaux anciens, objets d'art et de haute curiosité, européens et orientaux; Objets d'Extrême-Orient; Meubles et sièges; Sculptures et bronzes du XVIIIe siècle; Composant la collection de M. Octave Homberg, dont la vente aux enchères publiques aura lieu à Paris.* Sale cat., Galerie Georges Petit, Paris, June 3–5, 1931.

Houghton et al. 1966. Arthur A. Houghton Jr., Theodore Rousseau, Edouard Morot-Sir, and Sherman E. Lee. "James J. Rorimer." *Metropolitan Museum of Art Bulletin* 25, no. 1, pt. 2 (1966), pp. 39–56.

International Centre 1960. International Centre for the Study of the Preservation and the Restoration of Cultural Property. *International Inventory of the Museum Laboratories and Restoration Workshops.* Rome: International Centre for the Study of the Preservation and the Restoration of Cultural Property, 1960.

International Museum Office 1935. International Museum Office. *Muséographie—Architecture et aménagement des musées d'art: Conférence internationale d'études, Madrid, 1934.* 2 vols. Paris: International Museum Office, 1935.

Janke 1989. R. Steven Janke. "Head of Saint Christopher." In *Gothic Sculpture in America*, vol. 1, *The New England Museums*, edited by Dorothy Gillerman, pp. 374–76. Publications of the International Center of Medieval Art 2. New York: Garland, 1989.

Kahsnitz 2006. Rainer Kahsnitz. *Carved Splendor: Late Gothic Altarpieces in Southern Germany, Austria, and South Tirol.* Los Angeles: Getty Publications, 2006.

Kargère and Rizzo 2010. Lucretia Kargère and Adriana Rizzo. "Twelfth-Century French Polychrome Sculpture in The Metropolitan Museum of Art: Materials and Techniques." *Metropolitan Museum Studies in Art, Science, and Technology* 1 (2010), pp. 39–72.

Kargère and Marincola 2011. Lucretia Kargère and Michele D. Marincola. "The Conservation of Polychrome Wood Sculpture in the United States: An Historical Overview, 1870–1970." Synopsis in *Preprints: ICOM-CC 16th Triennial Conference, Lisbon, 19–23 September 2011*, p. 264. Paris: ICOM, 2011; text in CD File 1703_31_Kargere_ICOM-CC_2011.pdf.

Kimball 1931. Fiske Kimball. "The Display Collection of the Art of the Middle Ages." *Bulletin of the Pennsylvania Museum* 26, no. 141 (1931), pp. 2–27.

Kimball 1945. Fiske Kimball. "The Barnard Collection." *Philadelphia Museum Bulletin* 40, no. 205 (1945), pp. 51–62.

Kisluk-Grosheide, Krohn, and Leben 2013. Danièlle Kisluk-Grosheide, Deborah L. Krohn, and Ulrich Leben. *Salvaging the Past: Georges Hoentschel and French Decorative Arts from The Metropolitan Museum of Art, 1907–2013.* New Haven: Yale University Press, 2013.

Koestler 1993. Robert J. Koestler. "Insect Eradication Using Controlled Atmospheres and FTIR Measurement for Insect Activity." In *Preprints of the ICOM Committee for Conservation Tenth Triennial Meeting, Washington D.C., 22–27 August 1993*, pp. 882–86. Paris: ICOM Committee for Conservation, 1993.

Krohm and Oellermann 1980. Hartmut Krohm and Eike Oellermann. "Der ehemalige Münnerstädter Magdalenenaltar von Tilman Riemenschneider und seine Geschichte: Forschungsergebnisse zur monochromen Oberflächengestalt." *Zeitschrift des Deutschen Vereins für Kunstwissenschaft* 34, no. 1–4 (1980), pp. 16–99.

Landais 1992. Hubert Landais. "The Cloisters or the Passion for the Middle Ages." In *The Cloisters: Studies in Honor of the Fiftieth Anniversary*, edited by Elizabeth C. Parker, with the assistance of Mary B. Shepard, pp. 41–48. New York: Metropolitan Museum of Art, International Center of Medieval Art, 1992.

Lee 1971. Sherman E. Lee. "The Year in Review for 1970." *Bulletin of the Cleveland Museum of Art* 58, no. 2 (1971), pp. 22–71.

Lombardi 1996. Beth Lombardi. "Raymond Pitcairn and the Collecting of Medieval Stained Glass in America." In *Medieval Art in America: Patterns of Collecting, 1800–1940*, edited by Elizabeth Bradford Smith, pp. 185–88. Exh. cat. University Park, Pa.: Palmer Museum of Art, Pennsylvania State University, 1996.

Marincola, forthcoming. Michele D. Marincola. "The Cloisters' Romanesque Crucifix from Northern Spain: A Reconstruction and Interpretation." In *Striking Images: Christ on the Cross and the Emergence of Medieval Monumental Sculpture*, edited by Gerhard Lutz, Marietta Cambareri, and Shirin Fozi. Washington, D.C.: Brepols/Harvey Miller, forthcoming.

Mayor 1966. A. Hyatt Mayor. "James J. Rorimer." *Burlington Magazine* 108 (September 1966), p. 484.

McClintock 1996a. Kathryn McClintock. "'Arts of the Middle Ages' and the Swarzenskis." In *Medieval Art in America: Patterns of Collecting, 1800–1940*, edited by Elizabeth Bradford Smith, pp. 203–8. Exh. cat. University Park, Pa.: Palmer Museum of Art, Pennsylvania State University, 1996.

McClintock 1996b. Kathryn McClintock. "The Earliest Public Collections and the Role of Reproductions (Boston)." In *Medieval Art in America: Patterns of Collecting, 1800–1940*, edited by Elizabeth Bradford Smith, pp. 55–60. Exh. cat. University Park, Pa.: Palmer Museum of Art, Pennsylvania State University, 1996.

Mecklenburg, Tumosa, and Erhardt 1998. Marion F. Mecklenburg, Charles S. Tumosa, and David

Erhardt. "Structural Response of Painted Wood Surfaces to Changes in Ambient Relative Humidity." In *Painted Wood: History and Conservation—Proceedings of a Symposium Organized by the Wooden Artifacts Group of the American Institute for Conservation of Historic and Artistic Works and the Foundation of the AIC, Williamsburg, Va., 11–14 November 1994*, edited by Valerie Dorge and F. Carey Howlett, pp. 464–83. Los Angeles: J. Paul Getty Trust, 1998.

Milliken 1929. William Mathewson Milliken. "A German Wood Carving." *Bulletin of the Cleveland Museum of Art* 16, no. 2 (1929), pp. 23–25.

Milliken 1939. William Mathewson Milliken. "Late Gothic Sculpture." *Bulletin of the Cleveland Museum of Art* 26, no. 4 (1939), pp. 43–46.

Modestini 2003. Dianne Dwyer Modestini. "Approaches to Retouching and Restoration: Imitative Restoration." In *Early Italian Paintings—Approaches to Conservation: Proceedings of a Symposium at the Yale University Art Gallery, April 2002*, edited by Patricia Sherwin Garland, pp. 208–24. New Haven: Yale University Art Gallery, 2003.

Molinier 1889. Émile Molinier. *Collection Émile Gavet: Catalogue raisonné précédé d'une étude historique et archéologique sur les œuvres d'art qui composent cette collection.* Paris: Imprimerie de D. Jouaust, 1889.

"Museum's Work" 1953. "A Museum's Work Also Never Done: Metropolitan, in the Midst of Rebuilding, Pushes Cleaning and Preservation Chores." *New York Times*, July 29, 1953, p. 25.

Nadolny 2003. Jilleen Nadolny. "The First Century of Published Scientific Analyses of the Materials of Historical Painting and Polychromy, circa 1780–1880." *Reviews in Conservation* 4 (2003), pp. 1–13, 39–51.

Nielsen 2008. Christina Nielsen. "To Step into Another World: Building a Medieval Collection at the Art Institute of Chicago." In *To Inspire and Instruct: A History of Medieval Art in Midwestern Museums*, edited by Christina Nielsen, pp. 25–38. Newcastle: Cambridge Scholars, 2008.

Noble 1959. Joseph V. Noble. "A New Gallery of Models and Casts." *Metropolitan Museum of Art Bulletin* 18, no. 4 (1959), pp. 138–43.

Packard 1967. Elisabeth C. G. Packard. "The Preservation of Polychromed Wood Sculpture by the Wax Immersion and Other Methods." *Museum News* 46, no. 2 (October 1967), pp. 47–52.

Packard 1971. Elisabeth C. G. Packard. "Consolidation of Decayed Wood Sculpture." In *Preprints of the Contributions to the New York Conference on Conservation of Stone and Wooden Objects, 7–13 June 1970*, vol. 2, pp. 13–22. London: International Institute for Conservation of Historic and Artistic Works, 1971.

Panzanelli 2008. Roberta Panzanelli. "Beyond the Pale: Polychromy and Western Art." In *The Color of Life: Polychromy in Sculpture from Antiquity to the Present*, edited by Roberta Panzanelli, with Eike D. Schmidt and Kenneth D. S. Lapatin, pp. 2–17. Exh. cat. Los Angeles: J. Paul Getty Museum and Getty Research Institute, 2008.

Peck 1991. William H. Peck. *The Detroit Institute of Arts: A Brief History.* Detroit: Detroit Institute of Arts, 1991.

Pératé and Brière 1908. André Pératé and Gaston Brière. *Notices des Collections Georges Hoentschel: Acquises par M. J. Pierpont Morgan et offertes au Metropolitan Museum de New York.* 4 vols. Paris: Librairie Centrale des Beaux-Arts, 1908.

Perkins 1870. Charles C. Perkins. "American Art Museums." *North American Review* 111, no. 228 (July 1870), pp. 1–29.

Philippot 1971. Paul Philippot. "Problèmes esthétiques et archéologiques de conservation des sculptures polychromes." In *Preprints of the Contributions to the New York Conference on Conservation of Stone and Wooden Objects, 7–13 June 1970*, vol. 2, pp. 59–62. London: International Institute for Conservation of Historic and Artistic Works, 1971.

Philippot 1985. Paul Philippot. "La conservation des œuvres d'art: Problème de politique culturelle." *Annales d'histoire de l'art et archéologie: Publication annuelle de la Section d'histoire de l'art et d'archéologie de l'Université libre de Bruxelles* 7 (1985), pp. 7–14.

Philippot (1990) 1996. Paul Philippot. "La restauration dans la perspective des sciences humaines." In *Pénétrer l'art, restaurer l'œuvre—Une vision humaniste: Hommage en forme de florilège*, edited by Catheline Périer-d'Ieteren, pp. 491–500. Kortrijk (Courtrai): Groeninghe Ed., 1990. Translated in *Historical and Philosophical Issues in the Conservation of Cultural Heritage*, edited by Nicholas Stanley Price, M. Kirby Talley Jr., and Alessandra Melucco Vaccaro, pp. 216–29. Los Angeles: Getty Conservation Institute, 1996.

Philippot 1998. Paul Philippot. "La restauration des sculptures polychromes: Introduction historique." In *Zum Thema Gefasste Skulpturen—Mittelalter*, vol. 1, edited by Manfred Koller and Rainer Prandtstetten, pp. 23–30. Restauratorenblätter 18. Klosterneuburg: Mayer, 1998.

Phillips 1997. David Phillips. *Exhibiting Authenticity.* Manchester: Manchester University Press, 1997.

"Pierpont Morgan Gift" 1918. "The Pierpont Morgan Gift." *Metropolitan Museum of Art Bulletin* 13, no. 1 (1918), pp. 1–20.

Piña 1990. Leslie A. Piña. *Louis Rorimer: A Man of Style.* Kent, Ohio: Kent State University Press, 1990.

Plenderleith and Cursiter 1934. Harold J. Plenderleith and Stanley Cursiter. "The Problem of Lining Adhesives for Paintings: Wax Adhesives." *Technical Studies in the Field of the Fine Arts* 3, no. 2 (1934), pp. 90–113.

Plesters and Brommelle 1974. Joyce Plesters and Norman Brommelle. "Science and Works of Art." *Nature* 250, no. 5469 (August 1974), pp. 767–70.

Poncelet 2008. François Poncelet. "Regards actuels sur la muséographie d'entre-deux-guerres." *CerROArt* 2 (2008), http://ceroart.revues.org/565 (accessed October 7, 2013).

Powell and Madson 1972. G. M. Powell and Willard H. Madson. *Vinyl Resins.* Federation Series on Coatings Technology 19. Philadelphia: Federation of Societies for Coatings Technology, 1972.

Preising 2007. Dagmar Preising. "Der Sammler, Restaurateur und Bildschnitzer Richard Moest: Eine Einführung in Leben und Werk." In *Collectionieren, Restaurieren, Gotisieren: Der Bildschnitzer Richard Moetz, 1841–1906*, pp. 11–24. Aachen: Suermondt-Ludwig-Museum, 2007.

Preprints **1971.** *Preprints of the Contributions to the New York Conference on Conservation of Stone and Wooden Objects, 7–13 June 1970.* 2 vols. London: International Institute for Conservation of Historic and Artistic Works, 1971.

Randall 1995. Richard H. Randall. "A King Reinstated." *Metropolitan Museum of Art Bulletin* 13, no. 10 (1995), pp. 294–97.

Rorimer 1935. James J. Rorimer. "A Twelfth-Century Crucifix." *Metropolitan Museum of Art Bulletin* 30, no. 12 (1935), pp. 236–39.

Rorimer 1936. James J. Rorimer. "The Restoration of Medieval Sculpture." *Metropolitan Museum Studies* 5, no. 2 (1936), pp. 170–81.

Rorimer 1938. James J. Rorimer. "The Opening of The Cloisters." *Metropolitan Museum of Art Bulletin* 33, no. 4 (1938), pp. 89–97.

Rorimer 1948. James J. Rorimer. "Recent Reinstallations of Medieval Art." *Metropolitan Museum of Art Bulletin* 6, no. 7 (1948), pp. 198–206.

Rosen 1934. David Rosen. "Note: A Wax Formula." *Technical Studies in the Field of the Fine Arts* 3, no. 2 (October 1934), pp. 114–15.

Rosen 1950–51. David Rosen. "The Preservation of Wood Sculpture: The Wax Immersion Method." *Journal of the Walters Art Gallery* 13–14 (1950–51), pp. 45–71.

Rubin 1963. Ida E. Rubin, ed. *Studies in Western Art: Acts of the 20th International Congress of the History of Art.* New York, September 7–12, 1961. 4 vols. Princeton: Princeton University Press, 1963.

Sauerländer 2002. Willibald Sauerländer. "Quand les statues étaient blanches: Discussion au sujet de la polychromie." In *La couleur et la pierre—Polychromie des portails gothiques: Actes du colloque, Amiens, 12–14 Octobre 2000*, edited by Denis Verret and Delphine Steyaert, pp. 27–34. Paris: Picard, 2002.

"Saw Art Treasures Sunday" 1914. "Saw Art Treasures Sunday." *New York Times*, March 10, 1914, p. 11.

Schädler 1992. Alfred Schädler. "Niclaus Weckmann: Bildhauer zu Ulm." *Münchner Jahrbuch der bildende Kunst* 43 (1992), pp. 39–92.

Schrader 1979. J. L. Schrader. "George Grey Barnard: The Cloisters and the Abbaye." *Metropolitan Museum of Art Bulletin* 37, no. 1 (1979), pp. 2–52.

Schulze-Senger et al. 1987. Christa Schulze-Senger, Bernhard Matthäi, Ernst Hollstein, and Rolf Lauer. "The Gero Crucifix in Cologne Cathedral." *Jahrbuch der rheinischen Denkmalpflege* 32 (1987), pp. 11–54.

Scientific Examination of Art 2005. *Scientific Examination of Art: Modern Techniques in Conservation and Analysis.* Arthur M. Sackler Colloquium, "Scientific Examination of Art: Modern Techniques in Conservation and Analysis," Washington, D.C., March 19–21, 2003. Washington, D.C.: National Academies Press, 2005.

Secrest 2004. Meryle Secrest. *Duveen: A Life in Art.* Chicago: University of Chicago Press, 2004.

Seidel and Caglioti 2010. Max Seidel and Francesco Caglioti. *Da Jacopo della Quercia a Donatello: Le arti a Siena nel primo Rinascimento.* Exh. cat. Milan: Federico Motta, 2010.

Seligman 1961. Germain Seligman. *Merchants of Art, 1880–1960: Eighty Years of Professional Collecting.* New York: Appleton-Century-Crofts, 1961.

Serck-Dewaide 1995. Myriam Serck-Dewaide. "Exemples de restauration, dé-restauration, re-restauration de quelques sculptures: Analyse des faits et réflexions." In *Restauration, dé-restauration, re-restauration: Colloque sur la conservation, restauration des biens culturels, Paris, 5, 6 et 7 Octobre 1995*, pp. 213–21. Paris: Association des Restaurateurs d'Art et d'Archéologie de Formation Universitaire, 1995.

Serck-Dewaide 1996–98. Myriam Serck-Dewaide. "Bref historique de l'évolution des traitements des sculptures." Spécial 50 ans, *Bulletin de l'Institut Royal du Patrimoine Artistique* 27 (1996–98), pp. 157–73.

Shestack 1965. Alan Shestack. "A Romanesque Wooden Sculpture of the Madonna and Child Enthroned." In *Fogg Art Museum Acquisitions, 1964*, pp. 20–26. Cambridge, Mass.: Harvard University, 1965.

Siegl 1966. Theodor Siegl. "Conservation." *Philadelphia Museum of Art Bulletin* 62, no. 291 (1966), pp. 127–56.

Smith 1996. Elizabeth Bradford Smith. "George Grey Barnard: Artist/Collector/Dealer/Curator." In *Medieval Art in America: Patterns of Collecting, 1800–1940*, edited by Elizabeth Bradford Smith, pp. 133–42. Exh. cat. University Park, Pa.: Pennsylvania State University, 1996.

Sox 1987. David Sox. *Unmasking the Forger: The Dossena Deception.* London: Unwin Hayman, 1987.

Spitzer 1890–93. Frédéric Spitzer. *La Collection Spitzer: Antiquité, moyen âge, renaissance.* 6 vols. Paris: Maison Quantin, 1890–93.

Stavroudis 2009. Chris Stavroudis. *The Modular Cleaning Program (MCP),* 2009, http://cool.conservation-us.org/byauth/stavroudis/mcp/ (accessed May 9, 2013).

Sterne 1980. Margaret Sterne. *The Passionate Eye: The Life of William R. Valentiner.* Detroit: Wayne State University Press, 1980.

"Stop-Watches" 1927. "Stop-Watches Held on Museum Visitors: Average Person Tarries Three Seconds before a Work of Art, Investigator Finds." *New York Times,* October 9, 1927, p. 13.

Stout and Pease 1938–39. George L. Stout and Murray Pease. "A Case of Paint Cleavage." *Technical Studies in the Field of the Fine Arts* 7, no. 1 (1938–39), pp. 33–45.

Suhr 1932. William Suhr. "A Built-Up Panel for Blistered Paintings on Wood." *Technical Studies in the Field of the Fine Arts* 1, no. 1 (1932), pp. 29–34.

G. Swarzenski 1940. Georg Swarzenski. *Arts of the Middle Ages: A Loan Exhibition.* Exh. cat. Boston: Museum of Fine Arts, 1940.

H. Swarzenski 1960. Hanns Swarzenski. "A Vierge d'Orée." *Bulletin of the Museum of Fine Arts* 58, no. 313–14 (1960), pp. 64–83.

Taubert 1961. Johannes Taubert. "Zur Restaurierung von Skulpturen." *Museumskunde* 1, no. 30 (1961), pp. 7–21.

Taubert 1971. Johannes Taubert. "The Conservation of Wood." In *Preprints of the Contributions to the New York Conference on Conservation of Stone and Wooden Objects, 7–13 June 1970,* vol. 2, pp. 81–85. London: International Institute for Conservation of Historic and Artistic Works, 1971.

Taubert 1978. Johannes Taubert. *Farbige Skulpturen: Bedeutung, Fassung, Restaurierung.* Munich: Callwey, 1978.

Taylor 1929. Francis Henry Taylor. "The Study Collections of Wood-Carving." *Bulletin of the Pennsylvania Museum* 24, no. 127 (1929), pp. 4, 7–15, ills. pp. 16–20.

Taylor 1931. Francis Henry Taylor. "Handbook of the Display Collection of the Art of the Middle Ages." *Bulletin of the Pennsylvania Museum* 26, no. 140 (1931), pp. 2–47.

Taylor 1942. Francis Henry Taylor. "Suspension of the WPA Museum Project." *Metropolitan Museum of Art Bulletin* 37, no. 6 (1942), pp. 164–65.

Theiss, Soultanian, and Kargère 2011. Harald Theiss, Jack Soultanian, and Lucretia Kargère. "The Cloisters' So-Called Rothschild Madonna (1996.14)." In *Niclaus Gerhaert: Der Bildhauer des Späten Mittelalters,* edited by Stefan Roller, pp. 277–82. Exh. cat. Petersberg: Imhof, 2011.

Thomson 1957. Garry Thomson. "Some Picture Varnishes." *Studies in Conservation* 3, no. 2 (1957), pp. 64–75.

Tomkins 1970a. Calvin Tomkins. "The Cloisters . . . The Cloisters . . . The Cloisters" *Metropolitan Museum of Art Bulletin* 28, no. 7 (1970), pp. 308–20.

Tomkins 1970b. Calvin Tomkins. *Merchants and Masterpieces: The Story of The Metropolitan Museum of Art.* New York: E. P. Dutton, 1970.

Ulmann 2010. Arnulf von Ulmann. "The Virtual Reconstruction of Medieval Polychromy." In *Circumlitio: The Polychromy of Antique and Mediaeval Sculpture,* edited by Vinzenz Brinkmann, Oliver Primavesi, and Max Hollein, pp. 382–92. Proceedings of the Johann David Passavant Colloquium at the Liebieghaus Skulpturen Sammlung, Frankfurt am Main, December 10–12, 2008. Schriftenreihe der Liebieghaus Skulpturensammlung. Munich: Hirmer, 2010.

Unger, Schniewind, and Unger 2001. Achim Unger, Arno P. Schniewind, and Wibke Unger. *Conservation of Wood Artifacts.* Berlin: Springer, 2001.

Valentiner 1908. William R. Valentiner. "The Hoentschel Collection: Gothic Section, I, Sculpture." *Metropolitan Museum of Art Bulletin* 3, no. 7 (1908), pp. 129–33.

Vermeule, Cahn, and Hadley 1977. Cornelius Clarkson Vermeule, Walter Cahn, and Rollin van N. Hadley. *Sculpture in the Isabella Stewart Gardner Museum.* Boston: The Trustees, 1977.

Walker 1995. Dean Walker. *Philadelphia Museum of Art: Handbook of the Collections.* Philadelphia: Philadelphia Museum of Art, 1995.

Walters Art Gallery 1934. Walters Art Gallery. *First Annual Report of the Trustees of Walters Art Gallery to the Mayor and City Council of Baltimore for the Year 1933.* Baltimore: Walters Art Gallery, 1934.

Walters Art Gallery 1935. Walters Art Gallery. *Second Annual Report of the Trustees of Walters Art Gallery to the Mayor and City Council of Baltimore for the Year 1934.* Baltimore: Walters Art Gallery, 1935.

Weinberger 1941. Martin Weinberger. *The George Grey Barnard Collection.* New York: Robinson Gallery, 1941.

Wendland 1999. Ulrike Wendland. *Biographisches Handbuch deutschsprachiger Kunsthistoriker im Exil: Leben und Werk der unter dem Nationalsozialismus verfolgten und vertriebenen Wissenschaftler.* 2 vols. Munich: Saur, 1999.

Whiting 1929. Frederic Allen Whiting. "The Dossena Forgeries." *Bulletin of the Cleveland Museum of Art* 16, no. 4 (1929), pp. 66–67.

Willemsen 1960. Ernst Willemsen. "Berichte über die Tätigkeit der Restaurierungswerkstatt in den Jahren 1953–59." *Jarhbuch der rheinischen Denkmalpflege* 23 (1960), pp. 323–46.

Wilm 1938. Hubert Wilm. *Sammlung Georg Schuster, München.* Sale cat. Julius Böhler, Munich, March 17–18, 1938.

Wixom 1988–89. William D. Wixom. "Medieval Sculpture at The Cloisters." *Metropolitan Museum of Art Bulletin* 46, no. 3 (1988–89), entire issue.

Wixom 1999a. "The Cleveland Museum of Art, Cleveland, Ohio." In *Romanesque Sculpture in American Collections*, vol. 2, *New York and New Jersey, Middle and South Atlantic States, the Midwest, Western and Pacific States*, edited by Walter Cahn and Linda Seidel, pp. 147–70. Turnhout: Brepols, 1999.

Wixom 1999b. William D. Wixom. *Mirror of the Medieval World.* New York: Metropolitan Museum of Art, 1999.

Wixom 1999c. William D. Wixom. "Riemenschneider in America." In Julien Chapuis, *Tilman Riemenscheider: Master Sculptor of the Late Middle Ages*, pp. 145–58. Exh. cat. Washington, D.C.: National Gallery of Art; New Haven: Yale University Press, 1999.

Wixom 2007. William D. Wixom. "Late Medieval Sculpture in the Metropolitan, 1400 to 1530." *Metropolitan Museum of Art Bulletin* 64, no. 4 (Spring 2007), entire issue.

Woodward 1985. Carla Mathes Woodward. "Acquisition, Preservation, and Education: A History of the Museum." In *A Handbook of the Museum of Art, Rhode Island School of Design*, edited by Carla Mathes Woodward and Franklin W. Robinson, pp. 10–60. Providence: Rhode Island School of Design, 1985.

Young 1958. William J. Young, ed. *Application of Science in Examination of Works of Art: Proceedings of the Seminar, September 15–18, 1958*. Boston: Research Laboratory, Museum of Fine Arts, 1958.

Young 1965. William J. Young, ed. *Application of Science in Examination of Works of Art: Proceedings of the Seminar, September 7–16, 1965*. Boston: Research Laboratory, Museum of Fine Arts, 1965.

Young 1973. William J. Young, ed. *Application of Science in Examination of Works of Art: Proceedings of the Seminar, June 15–19, 1970*. Boston: Research Laboratory, Museum of Fine Arts, 1973.

PICTURE CREDITS

Unless otherwise indicated, archival images and photographs of works in the Metropolitan Museum's collection are by the Photograph Studio, The Metropolitan Museum of Art.

Achim Bunz: Figure 2

The Cloisters' Library and Archives, The Metropolitan Museum of Art: Figure 18

Demotte Archives, Paris: Figures 3 (SP.4869), 5c (no. 27.04), 7b (no. 10.16)

Department of Medieval Art, The Metropolitan Museum of Art: Figure 5b

Department of Objects Conservation, The Metropolitan Museum of Art: Figure 19

Dagmar Frinta: Figure 16

Estate of Yousuf Karsh: Figure 8

Philadelphia Museum of Art: Figure 7a

Walters Art Museum, Baltimore: Figures 12–14

W. M. van der Weyde, courtesy of The Cloisters Archives: Figure 4

Andrew Winslow, courtesy of The Metropolitan Museum of Art: Figures 1, 5a, 15

Stone Materials Used for Lintels and Decorative Elements of Khmer Temples

◆

Federico Carò, Martin Polkinghorne, and Janet G. Douglas

ABSTRACT

Intricately carved lintels occupy a privileged and symbolic position in Khmer temples. Their production was commissioned to highly specialized craftsmen with specific material and carving traditions. The stone of seven decorative lintels in The Metropolitan Museum of Art has been characterized by means of petrographic and textural analyses, together with the stone of twenty-nine other lintels and ornamental elements dating from the seventh to the thirteenth century now in the National Museum of Cambodia, Phnom Penh; the Musée National des Arts Asiatiques–Guimet, Paris; and the Arthur M. Sackler Gallery, Smithsonian Institution, Washington, D.C. Results suggest that particular stone types were selected by Khmer carvers for certain elements in the temple structure. Whereas blocks of sandstone from the Terrain Rouge Formation of Cambodia were used to build and clad the Angkor temples and for decorative lintels and other ornaments, quartz-rich sandstone was reserved exclusively for these decorated elements. This sandstone may originate from the Grès Supérieures Formation, a sedimentary sequence that extends into Thailand, Laos, and Vietnam.

The Metropolitan Museum of Art holds several stone decorative lintels produced during the time of the Khmer Empire (sixth–fifteenth centuries). These objects belong to a special variety of Khmer sculptural arts that differ in several ways from freestanding sculpture. A true lintel is the upper horizontal component in the framework of a doorway, which is usually formed of four independent stone blocks held together by mortise and tenon fittings. A decorative lintel, on the contrary, is rarely load bearing and is located above the true lintel, supported by two similarly decorated colonnettes. Decorative lintels occupy privileged positions above the entryways of Khmer temples, watching over all those who pass through from the secular to the divine realms. In this role they define an important boundary. The forms and iconographies of the decorative lintels sought to maintain the temple in a permanent state of festival. Often they represent ephemeral decorations of garlands and *rinceaux* that gave the impression of a building alive with celebrations.[1] The lintels are thought to have been carved in situ by specialized craftsmen employing a particularly time-consuming and expensive process, following established artistic conventions.[2]

Table 1 ◆ Key Compositional and Textural Parameters of the Lintels and Carved Architectural Elements. The samples are listed in order of accession number and stone type (Type 1, white to light brown quartz arenite; Type 2, reddish quartz arenite; Type 3 and 3b, greenish-gray feldspathic arenite). Q = quartz; F = feldspar; L = rock fragments. Sorting (σ): see note 28.

Accession Number	Collection	Description	Provenience	Date	Q (%)	F (%)	L (%)	Mean (mm)	Median (mm)	Sorting (σ)	Stone Type
1972.214	The Metropolitan Museum of Art	Lintel	Thailand, exact provenience unknown	1st half 11th c.	85.7	13.1	1.2	0.16	0.16	0.46	1
1985.390.1	The Metropolitan Museum of Art	Lintel (see Figure 1)	Cambodia or Vietnam, exact provenience unknown	7th c.	91.6	7.7	0.7	0.26	0.27	0.67	1
1992.192	The Metropolitan Museum of Art	Lintel	Cambodia or Thailand, exact provenience unknown	1st half 11th c.	96.2	3.1	0.8	0.26	0.27	0.60	1
1994.94	The Metropolitan Museum of Art	Lintel (see Figure 5)	Cambodia or Thailand, exact provenience unknown	1st quarter 11th c.	83.9	13.3	2.8	0.21	0.21	0.56	1
Ka1791	National Museum of Cambodia	Lintel	Wat Ang Kh	7th c.	78.7	14.8	6.6	0.20	0.20	0.51	1
Ka2096	National Museum of Cambodia	Lintel	Exact provenience unknown	7th c.	88.9	8.6	2.5	0.18	0.18	0.69	1
Ka3175	National Museum of Cambodia	Lintel (see Figure 9)	Wat Preah Theat	7th c.	94.7	3.1	2.3	0.32	0.34	0.46	1
MG17860	Musée Guimet	Lintel	Phnom Da	beginning 12th c.	95.9	2.3	1.8	0.26	0.27	0.57	1
MG18218	Musée Guimet	Lintel	Wat Baset	end 11th–beginning 12th c.	90.1	3.5	6.4	0.17	0.17	0.53	1
MG18324	Musée Guimet	Colonnette	Phnom Da	beginning 12th c.	97.5	0.6	1.9	0.25	0.24	0.70	1
S1987.953	Arthur M. Sackler Gallery	Lintel	Cambodia or Thailand, exact provenience unknown	mid-11th c.	97.0	2.0	1.0	0.17	0.17	0.86	1
36.96.6	The Metropolitan Museum of Art	Lintel (see Figure 2)	Kôk Sla Ket	mid-10th c.	93.4	4.7	1.9	0.12	0.12	0.60	2
1994.111	The Metropolitan Museum of Art	Lintel	Cambodia or Thailand, exact provenience unknown	mid-10th c.	88.2	7.5	4.3	0.11	0.11	0.63	2
1996.473	The Metropolitan Museum of Art	Lintel (see Figure 4)	Cambodia, exact provenience unknown	2nd half 10th c.	80.1	18.2	1.7	0.11	0.10	0.52	2
1997.434.2	The Metropolitan Museum of Art	Colonnette	Cambodia, exact provenience unknown	mid-10th c.	88.5	9.9	1.6	0.10	0.09	0.58	2
2003.142	The Metropolitan Museum of Art	Antefix	Cambodia, exact provenience unknown	3rd quarter 10th c.	87.6	12.0	0.4	0.11	0.10	0.63	2
MG17488	Musée Guimet	Lintel (see Figure 6)	Wat Kralanh	mid-11th c.	82.9	12.8	4.3	0.11	0.11	0.67	2
MG18913	Musée Guimet	Pediment	Banteay Srei	late 10th c.	87.8	7.7	4.4	0.12	0.13	0.68	2
Ka1748	National Museum of Cambodia	Lintel	Sambor Prei Kuk	7th c.	47.1	44.6	8.3	0.19	0.19	0.55	3
Ka1802	National Museum of Cambodia	Lintel	Preah Kô	9th c.	51.7	39.7	8.6	0.15	0.16	0.61	3
Ka2712	National Museum of Cambodia	Lintel (see Figure 3)	Kompong Cham Province, exact provenience unknown	mid-10th c.	43.0	49.0	8.0	0.16	0.17	0.50	3
Ka2763	National Museum of Cambodia	Lintel	Preah Vihear Province, exact provenience unknown	late 10th c.	37.6	52.6	9.8	0.16	0.17	0.53	3
Ka2844	National Museum of Cambodia	Lintel	Preah Khan of Kompong Svay/Bakan	end 12th–beginning 13th c.	51.7	38.3	10.0	0.18	0.18	0.53	3
MG14898	Musée Guimet	Frieze	Exact provenience unknown	last quarter 10th–beginning 11th c.	66.5	29.4	4.0	0.17	0.17	0.44	3b
MG18120	Musée Guimet	Pilaster	Beng Mealea	mid-12th c.	53.7	40.3	6.0	0.12	0.13	0.70	3
MG18121	Musée Guimet	Colonnette	Beng Mealea	mid-12th c.	52.4	42.1	5.6	0.18	0.18	0.56	3
MG18197	Musée Guimet	Pediment	Preah Khan of Kompong Svay/Bakan	3rd quarter 12th c.	40.9	50.7	8.4	0.18	0.19	0.82	3
MG18219	Musée Guimet	Lintel	Bayon	end 12th–beginning 13th c.	46.0	45.5	8.5	0.18	0.18	0.64	3
MG18220	Musée Guimet	Lintel	Kapilapura	last quarter 9th c.	50.2	41.4	8.4	0.13	0.15	0.70	3
MG18853	Musée Guimet	Lintel	Sambor Prei Kuk	1st half 7th c.	55.8	38.7	5.5	0.10	0.10	0.73	3
MG18854	Musée Guimet	Lintel	Prasat Prei Khmeng	2nd half 7th c.	67.3	29.4	3.3	0.10	0.10	0.58	3b
MG18855	Musée Guimet	Lintel	Prasat Koki	early 9th c.	59.1	34.3	6.5	0.10	0.10	0.62	3
MG18857	Musée Guimet	Colonnette	Prasat Prei Khmeng	2nd half 7th c.	66.5	29.2	4.2	0.10	0.10	0.60	3b
MG18858	Musée Guimet	Colonnette	Kulen	early 9th c.	54.0	38.1	7.9	0.11	0.11	0.59	3
MG18879	Musée Guimet	Pediment	Prasat Sok Kraup	end 9th–beginning 10th c.	54.7	38.9	6.4	0.16	0.17	0.58	3
MG18890	Musée Guimet	Colonnette	Wat Choeng Ek	1st half 7th c.	52.6	39.9	7.5	0.16	0.17	0.74	3

In support of this hypothesis, previous technical studies suggest that specific stone materials were purposefully chosen for the production of these architectural elements, which are characterized by deeply carved, intricate details.[3] However, given the complex history of Khmer temples and the vast production of decorative elements,[4] it is difficult to draw any conclusion about patterns of stone choice and usage without considering a comprehensive and representative database of provenienced objects. Toward this end, this study aims to characterize by means of scientific analyses the stone materials used in the production of a selection of decorative lintels and other architectural ornamental elements, and ultimately to help unveil connections between Khmer artistic production and the geological sources of construction materials.

The twenty-four lintels and twelve decorative elements (colonnettes, friezes, and pediments, as well as one antifix and one pilaster) examined for this study are in the collections of The Metropolitan Museum of Art, New York; the National Museum of Cambodia, Phnom Penh; the Musée National des Arts Asiatiques–Guimet, Paris; and the Arthur M. Sackler Gallery, Smithsonian Institution, Washington, D.C. They were produced over a range of dates consistent with the pre-Angkor (sixth–eighth centuries) and Angkor (ninth–fifteenth centuries) periods. Although rarely dated on the basis of epigraphic evidence, decorative lintels are particularly respected chronological markers for Khmer art historians and archaeologists.[5]

The studied lintels and decorative elements originate from various locations in Cambodia, Thailand, and Vietnam. Those in the Musée Guimet and National Museum of Cambodia come with certain provenience, and most can be associated with specific sites (Table 1). From a stylistic perspective alone it is difficult to be precise about the origins of the lintels and decorative elements in The Metropolitan Museum of Art and the Arthur M. Sackler Gallery, but they are logically associated with temple sites north of the Tonlé Sap (Great Lake) and may even have come from what today is Thailand.

ICONOGRAPHY AND DECORATIVE MOTIFS

Five lintels from The Metropolitan Museum of Art have been selected for discussion, as they illustrate the iconography and decorative motifs common to classical Khmer sculptures. They range in dates from the seventh century to the early eleventh century.

The lintel with a mask of Kāla (1985.390.1; Figure 1) is of exceptional interest; its motifs indicate that it likely dates to the seventh century, making it the earliest included in this study.[6] Its central and dominating motif is the Kāla or Kīrtimukha (face of glory), an extremely common central motif on decorative lintels thought to represent an aspect of Shiva

Figure 1 ◆ Lintel with a mask of Kāla. Cambodia or Vietnam, exact provenience unknown, 7th century. White to light brown quartz arenite (Type 1 sandstone), H. 47.0 cm (18½ in.), L. 142.2 cm (56 in.), D. 25.4 cm (10 in.). The Metropolitan Museum of Art, Gift of Margery and Harry Kahn, 1985 (1985.390.1)

Figure 2 ◆ Lintel with carved figures. Kôk Sla Ket, mid-10th century. Reddish quartz arenite (Type 2 sandstone), H. 51.4 cm (20¼ in.), L. 124.5 cm (49 in.). The Metropolitan Museum of Art, Fletcher Fund, 1936 (36.96.6)

as time, who devours himself and destroys all things.[7] Kāla in this role is known by the Khmer as Rahu.[8] Rahu is associated with funerary and cremation rites and also possesses a bivalent nature as the first step toward new life. In this manifestation, Rahu is regarded as the demon of the eclipse, causing the darkness to make new light appear.[9]

In 1930, Victor Goloubew of the École Française d'Extrême-Orient (EFEO) proposed that the Kāla motif was adopted by the Khmer from Java.[10] Subsequent scholars have commented on this possible connection[11] but point to many examples of Khmer architectural decoration that predate those from Java. Mireille Bénisti argues that the indigenous influence from early Khmer art on the appearance and composition of the Kāla has been underestimated at the willing acceptance of a

Javanese inspiration and cites seventeen examples that predate the Javanese examples,[12] particularly those at Borobudur mentioned by Gilberte de Coral-Rémusat.[13] The Metropolitan Museum's Kāla lintel corroborates the theory that the motif as it developed in both Cambodia and Java most likely derives from a common source of influence in India.[14]

The Kāla motif on the Metropolitan Museum's lintel is distinctive in that it dominates the entire surface. Although different in representation, this Kāla is analogous in size to that on a lintel from Sala Prambei Lveng, in Thala Borivat, Stung Treng Province.[15] Between the Kāla's eyes is a fleuron emblem common to central motifs in other pre-Angkorian lintels.[16] The conscious transformation of motifs from simple to complex, or vice versa, may be defined as a form of stylization and was part of the

Figure 3 ◆ Lintel depicting Indra riding Airāvata. Kompong Cham Province, exact provenience unknown, mid-10th century. Greenish-gray feldspathic arenite (Type 3 sandstone), H. 49.0 cm (19¼ in.), L. 180.0 cm (70⅞ in.), D. 11.0 cm (4⅜ in.). National Museum of Cambodia (Ka2712)

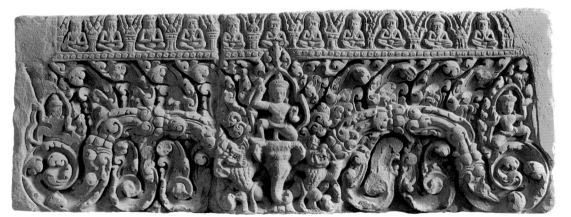

CARÒ, POLKINGHORNE, AND DOUGLAS

repertoire of classical Khmer artists.[17] The interplay between the Kāla and fleuron suggests that the motifs were interchangeable and perhaps share a similar or double meaning. Below the Kāla mask are series of motifs common to pre-Angkorian lintels, including colonnette capitals with fleuron medallions, lotuses of the species *Nelumbo nucifera*, and hanging pendants that establish a seventh-century date for this work.[18]

The Khmer collection of The Metropolitan Museum of Art includes three examples of decorative lintels dating to the second half of the tenth century. One of these (36.96.6; Figure 2) comes from the Angkorian site of Kôk Sla Ket, located 4 kilometers south of the West Baray. The sculpture is dated stylistically to the mid-tenth century, which is consistent with an inscription found at the site.[19] According to photographs taken by the EFEO in 1933, the lintel is from the east facade of the north tower.[20] After being removed to the Conservation d'Angkor,[21] the lintel was acquired by The Metropolitan Museum of Art in February 1936 with six additional Khmer sculptures, including a bust of Hevajra (36.96.4) found outside the Gate of the Dead at Angkor Thom.[22]

This lintel's central motif of a caryatid lion flanked by additional lions issuing foliage branches from their mouths is reminiscent of the early tenth century, and it is possible that the lintel was carved by artists who had also worked at the early tenth-century capital

northeast of Angkor.[23] The top frieze captures seven *ṛṣi* or ascetics in prayer. Lintels from the mid-tenth century display a consistency in the division of decoration on their surface. Arched foliage branches terminating in leafy curls, a regular and symmetrical number of offshoots above and below the branches, and the distinctive frieze are components also observed on a lintel from the National Museum of Cambodia (Ka2712; Figure 3).

A second lintel (1996.473; Figure 4) from the second half of the tenth century in the Metropolitan Museum is in the style of Banteay Srei. The fine carving and complexity of decorative motifs from this period have led numerous scholars to consider the period between approximately 940 and 990 as among the pinnacles of Khmer art.[24] The central motif depicts Yama, the god of death, atop his Vāhana, the buffalo, holding a *danda*, or club. In this context Yama is designated as a Lokapāla or Dikpāla, both directional deities. This identification confirms that the lintel originally faced south in the configuration of the temple tower.

A third tenth-century lintel in the Metropolitan Museum collection (1994.111) depicts a Kāla face ridden by Indra holding a *vajra* (thunderbolt).[25] Of particular interest are the motifs of celestial beings praying in fleurons forming the lintel frieze. Each of these small representations depicts the torso of a crowned figure with hands together in a gesture of praying, positioned within a triangular vegetal

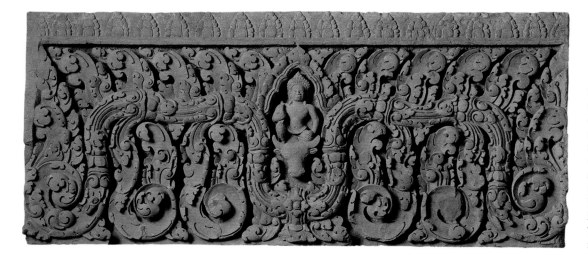

Figure 4 ◆ Lintel with Yama on buffalo. Cambodia, exact provenience unknown, second half of the 10th century. Reddish quartz arenite (Type 2 sandstone), H. 59.7 cm (23½ in.), L. 137.2 cm (54 in.). The Metropolitan Museum of Art, Gift of The Kronos Collections, 1996 (1996.473)

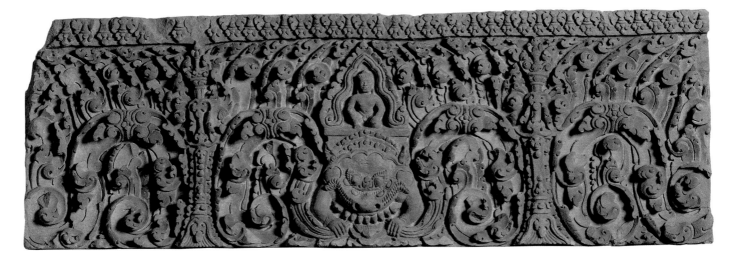

Figure 5 ◆ Lintel with a mask of Kāla and Dikpāla. Cambodia or Thailand, exact provenience unknown, first quarter of the 11th century. White to light brown quartz arenite (Type 1 sandstone), H. 58.4 cm (23 in.), L. 170.2 cm (67 in.). The Metropolitan Museum of Art, Gift of R. Hatfield Ellsworth, in honor of Florence and Herbert Irving, 1994 (1994.94)

frame. Nearly identical celestial beings praying in fleurons make their first appearance in lintels from Koh Ker, the Khmer capital from about 921 to 944, approximately 85 kilometers northeast of Angkor. These motifs recur for the next fifty years, continuing even after the court returned to Angkor (Yaśodharapura) from Koh Ker. The same artistic workshop that contributed to the foundations of the king Jayavarman IV at Koh Ker followed the new sovereign back to Angkor, suggesting that despite political change or instability, the artisans shadowed the center of power and were not tied to a particular administration.[26]

The last decorative lintel at The Metropolitan Museum of Art under consideration here (1994.94; Figure 5) dates to the first decades of the eleventh century and can be associated

with lintels from the Khleangs and the Royal Palace of Angkor Thom. The principal motif is again the Kāla, which issues from its mouth two garlands that terminate in curls of foliage. The monster supports a seated brahmanic divinity, perhaps the most common motif on decorative lintels but whose details are often confused and indistinct and therefore difficult to identify. From their seated position known as *rājalilāsansa* (Sanskrit, meaning "pose of royal ease"), the figures are usually associated with Dikpāla and are identified with a monarch, as can be seen on the lintel in Figure 5. Iconographically, this lintel is similar to a lintel from the Musée Guimet (MG17488; Figure 6), especially in the Kāla face with extended arms and the frieze of pendants and fleurons. Variation of the central motif (Umāheśvara) and

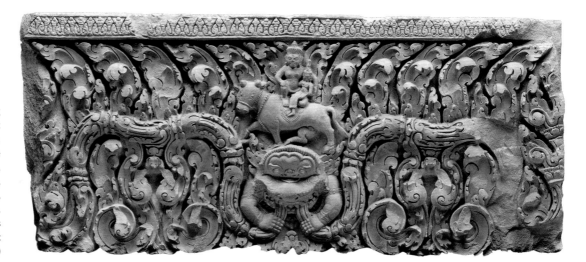

Figure 6 ◆ Lintel depicting Umāheśvara on Kāla. Wat Kralanh, mid-11th century. Reddish quartz arenite (Type 2 sandstone), H. 79.0 cm (31⅛ in.), L. 174.0 cm (68½ in.), D. 52.0 cm (20½ in.). Musée National des Arts Asiatiques–Guimet (MG17488)

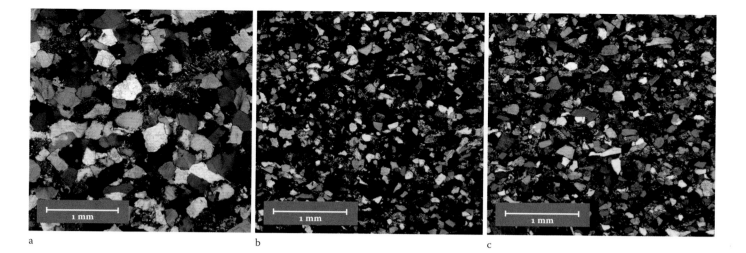

a b c

additional depth of carving suggest an affinity to the Baphuon style and a slightly later date in the mid-eleventh century.

PETROGRAPHY OF THE STONE MATERIALS

The addition of petrographic analysis to the suite of interpretive tools applied to Khmer sandstone sculpture has considerable potential to answer questions raised by art-historical studies. Petrographic analysis requires that a small fragment of stone be removed for thin-section preparation, that is, mounted on a glass slide and polished to a thickness of 30 microns. For this study fragments were removed from already damaged areas, generally located at the bottom edges of the lintels.

For each thin section, the nature, dimensions, and abundance of the various constituent grains were assessed using a polarized light microscope.[27] The number of grains analyzed varied with each sample according to its size and also depended on grain size and sorting,[28] but usually at least 300 points were counted. The classification scheme adopted is that proposed by Paolo Gazzi and by William R. Dickinson, which uses the relative abundance of quartz (Q), feldspar (F), and rock fragments (L) to assign specific names to different species of sandstone.[29] Further information regarding the texture of the rock was recorded, including the size, sorting, shape, and arrangement of the constituent elements. With few exceptions, the objects studied were carved from three main types of sandstone, designated herein as Types 1, 2, and 3 (Figures 7, 8; see also Table 1).

WHITE TO LIGHT BROWN QUARTZ ARENITE

Type 1 sandstone varies in color from white to light brown, depending on the amount of iron oxides present, and has a crisp appearance. Using petrography, this sandstone is classified as a fine- to medium-grained, moderately well-sorted to well-sorted quartz arenite. Grains are subrounded to subangular in shape and are cemented by abundant authigenic quartz. Kaolinite cement arranged in coarse stacks of pseudohexagonal plates is also abundant and postdates the quartz overgrowth. The shapes of the original grains are often revealed by a thin hematite coating on their surfaces.

Monocrystalline undulose quartz grains are the most abundant constituent. The quartz often appears cloudy from inclusions. Poly-crystalline quartz is subordinate and mostly strained and foliated, with sutured contacts. Also present but rare are grains of crypto-crystalline quartz. Feldspar content is generally low but can reach 15 percent of the total grains. Feldspars are often weathered or kaolinized.

Rock fragments do not exceed 7 percent of the framework grains. Among them, most characteristic are aphanitic volcanic rock fragments, low-grade metamorphic rocks

Figure 7 • Micrographs of the three main identified lithotypes (crossed Nicols): (a) medium-grained, white to light brown quartz arenite (Type 1 sandstone); (b) very fine-grained, reddish quartz arenite (Type 2 sandstone); (c) very fine- to fine-grained, greenish-gray feldspathic arenite (Type 3 sandstone)

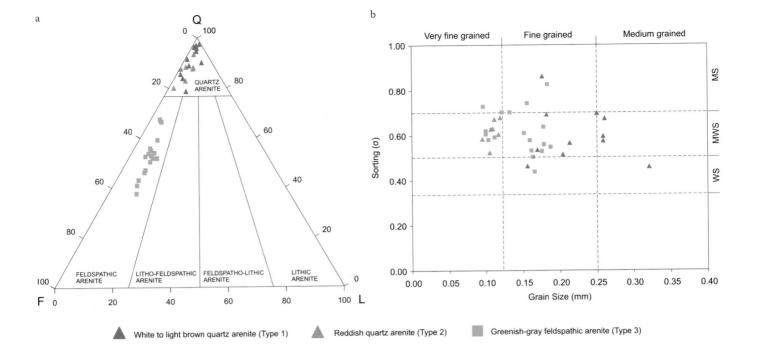

Figure 8 • Petrographic and textural characteristics of the lintels studied: (a) framework grain composition grouped according to the relative abundance of quartz (Q), feldspar (F), and rock fragments (L) following Gazzi 1966 and Dickinson 1970; (b) classification of the sandstone types according to sorting and grain size of the constituent grains following Folk and Ward 1957. WS = well sorted; MWS = moderately well sorted; MS = moderately sorted

White to light brown quartz arenite (Type 1) Reddish quartz arenite (Type 2) Greenish-gray feldspathic arenite (Type 3)

(phyllite), and fragments of argillaceous mudstone. Some of the sedimentary rock fragments, such as the argillaceous component, have been squeezed to form pseudomatrix. Heavy minerals[30] are rare and include grains of rutile, tourmaline, zircon, and epidote. A fine-grained matrix, often pigmented by the abundant iron oxides, is present in variable amounts between the framework grains.

When the sandstone is extremely quartz-rich and devoid of iron oxides, opaque minerals, and matrix, it is white to light gray, as in the lintel from the National Museum of Cambodia depicting Indra riding Airāvata (Ka3175; Figure 9). With the increase of the above-mentioned accessory minerals, the sandstone attains a reddish-brown color, like the Metropolitan Museum's lintel with a mask of Kāla and Dikpāla (1994.94; see Figure 5) and the Musée Guimet's lintel depicting scenes from the *Rāmāyana* (MG18218).

REDDISH QUARTZ ARENITE

Type 2 sandstone has a characteristic reddish color. Petrographically, this rock is classified as very fine-grained, moderately well-sorted quartz arenite. Grains are subrounded to rounded in shape and are cemented by fine-grained

kaolinite and authigenic quartz in variable proportions. Characteristic is the abundant hematite cementation that occurs as grain-coating and pore-filling and accounts for the color of this sandstone.

Undulose and nonundulose monocrystalline quartz grains dominate the framework, while feldspar is subordinate and usually weathered. Polycrystalline strained quartz and cryptocrystalline quartz are also present. Rock fragments are sparse and include aphanitic volcanics, phyllite, siltstone, and mudstone. Fragments of igneous rock with micrographic texture are present but very rare. Accessory muscovite is often bent between the grains. Heavy minerals are rare and include ilmenite, rutile, tourmaline, and zircon. A fine, brown matrix of clay-size particles rich in iron oxides is occasionally deposited between the grains, possibly as a result of mechanical compaction of preexisting rock fragments.

GREENISH-GRAY FELDSPATHIC ARENITE

Type 3 sandstone is a greenish-gray feldspathic arenite; it constitutes almost half of the samples. This sandstone is composed of very fine to fine, moderately well-sorted to well-sorted, subangular to rounded grains, cemented

CARÒ, POLKINGHORNE, AND DOUGLAS

predominantly by chlorite. Calcite and authigenic quartz and feldspar can be also present in variable amounts. The degree of compaction and cementation varies.

Mono-, poly- and microcrystalline quartz grains, both undulose and nonundulose, are the most abundant framework constituents. Feldspar makes up about 40 percent of the framework grains and is dominated by plagioclase, with minor alkali feldspar. Both fresh and altered feldspars are present.

The abundance of rock fragments is typically about 4 percent and only rarely exceeds 10 percent. Characteristic lithic fragments are volcanic (andesite), metamorphic (phyllite, quartzite, micaceous schist), and sedimentary (argillite, shale, siltstone) in origin. The heavy minerals assemblage consists mostly of hematite, magnetite, ilmenite, rutile, titanite, garnet, epidote, zircon, apatite, monazite, and tourmaline, in varying proportions. This assemblage reflects a mixed provenience with strong metamorphic and felsic igneous influence, as other authors have pointed out.[31] Within the Type 3 group it is possible to distinguish a small subset (Type 3b) of very fine-grained, quartz-rich feldspathic arenite characterized by abundant biotite.

GEOLOGICAL PROVENIENCE

This study of the mineral composition and texture of the sandstones used for lintels and other decorative architectural elements helps to correlate the lithotypes identified to specific geological formations[32] and, in turn, to more narrowly defined geographic regions within the territory of the Khmer Empire.

All three lithotypes have strong affinities with sedimentary rocks constituting part of the Khorat Group,[33] a nonmarine Mesozoic sedimentary sequence that outcrops in the Khorat Plateau of Thailand and extends into Cambodia and Laos. In Cambodia the sandstones are well represented by the Dangrek Range in the north, where its steep flanks form a natural border with Thailand; in the central region by Phnom Kulen and Phnom Tabeng (in Khmer, *phnom* means "mountain" or "hill"), in Siem Reap and Preah Vihear Provinces respectively; and in the southwest by the Cardamom Mountains (Figure 10). Numerous scattered outcrops of sandstones and conglomerates with similar characteristics are exposed in subhorizontal beds in isolated hills of low altitude and limited extension in central and eastern Cambodia. This sequence was described in detail by various

Figure 9 ◆ Lintel depicting Indra riding Airāvata. Wat Preah Theat, 7th century. White to light brown quartz arenite (Type 1 sandstone), H. 68.0 cm (26¾ in.), L. 154.0 cm (60⅝ in.). National Museum of Cambodia (Ka3175)

Figure 10 ◆ Simplified geological map of Cambodia based on United Nations 1993, with locations of major Khmer archaeological sites

geologists in the late 1960s during early attempts to complete a systematic geological mapping of Cambodia. The overall stratigraphy has been variously interpreted, but the most often cited Mesozoic formations of the Khorat Group in Thailand from the Late Triassic to the Middle Cretaceous are Nam Phong, Phu Kradung, Phra Wihan, Sao Khua, Phu Phan, and Khok Kruat (Figure 11).[34] In Cambodia, the last four formations of the Khorat Group are known as

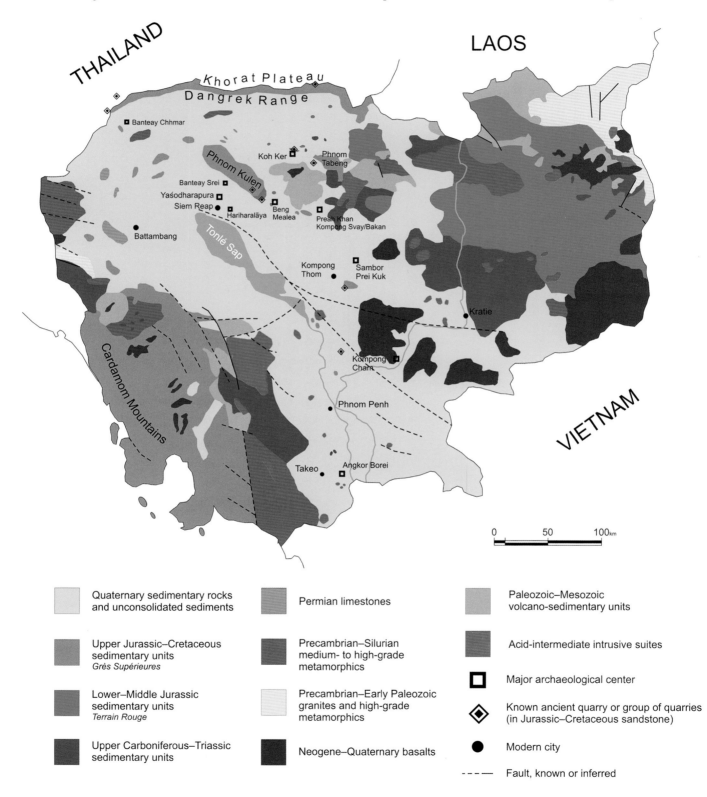

CARÒ, POLKINGHORNE, AND DOUGLAS

Ma	PERIOD		KHORAT GROUP	CAMBODIA (Sotham 1997)	THAILAND (Workman 1977)	(DMR 1992)	Major lithologies (Racey et al. 1996)
65	CRETACEOUS	Upper		Grès Supérieures Formation	Maha Sarakham Formation	Maha Sarakham Formation	Light brown arkosic sandstone and evaporites
		Middle			Khok Kruat Formation	Khok Kruat Formation	Fine- to coarse-grained, reddish-brown arkosic sandstone, siltstone and conglomerate
		Lower				Phu Phan Formation	Medium- to coarse-grained, white to brown, quartz-rich sandstone
144	JURASSIC	Upper			Phra Wihan Formation	Sao Khua Formation	Fine grained, red-brown to purple sandstone
		Middle		Terrain Rouge Formation		Phra Wihan Formation	Fine- to coarse-grained, white to yellow-brown, quartz-rich sandstone
		Lower			Phu Kradung Formation	Phu Kradung Formation	Red-brown sandstone, siltstone and mudstone
206						Nam Phong Formation	Red-brown conglomerate, sandstone and mudstone
	TRIASSIC	Upper		Indosinian Triassic Formation		Huai Hin Lat Formation	Greenish-gray, immature sandstone with shale interbeds
		Middle					
248		Lower					

Figure 11 • Mesozoic stratigraphy of Cambodia (based on Sotham 1997) correlated to the Khorat Group formations of Thailand. Two published interpretations of the stratigraphy in Thailand are presented (Workman 1977; DMR 1992), with the most representative lithologies for each formation. Modified after Racey et al. 1996, p. 8. A wavy line indicates an unconformity; a dashed line indicates an uncertain sedimentary boundary.

the Grès Supérieures Formation, a designation introduced by French geologists to indicate the subhorizontal continental sediments occupying the highlands of western and northern Cambodia.[35] These rocks, mostly quartz-rich sandstones and conglomerates, are considered separately from the Lower–Middle Jurassic fluvial and lacustrine sequence known as the Terrain Rouge Formation, roughly corresponding to the Phu Kradung Formation, and from the Indosinian Triassic sequence that occupies the lowermost unit of the Khorat Group and is known in Thailand as the Nam Phong Formation. In this framework, the well-known quarries at the foot of Phnom Kulen are located at the upper portion of the Terrain Rouge Formation, close to the contact with the Grès Supérieures Formation, which is in turn quarried on top of Phnom Kulen, close to Prasat Rong Chen.[36]

At the present time, a geological provenience of the quartz arenite (Types 1 and 2) used for lintel production cannot be identified with precision. However, geological and petrographic data confine the source of these lithotypes to the upper members of the Khorat Group, corresponding to the Grès Supérieures Formation of Cambodia. The medium-grained, white to light brown quartz arenite (Type 1 sandstone) may originate from the Phra Wihan and the Phu Phan Formations. These formations are known to include white to light-buff, very fine- to coarse-grained sandstones, tightly cemented by authigenic quartz and characterized by extensive kaolinitization.[37] Furthermore, these sandstones are often iron stained and differently colored, as can be seen in modern quarries in Banteay Meanchey Province, as well as in the ancient quarries of Ban Khao Luk Chang, Ta Phraya, and Preah Vihear, scattered along the Dangrek Range.

The mineralogy of Phra Wihan sandstones is dominated by monocrystalline, mostly

undulose quartz, while feldspars and rock fragments are sparse. Heavy minerals, including rutile, tourmaline, and zircon, are also rare. Similar medium- to coarse-grained, quartz-rich sandstone that is light in color is also abundant in the Phu Phan Formation and is difficult to distinguish from Phra Wihan lithotypes even at the microscopic scale.

The very fine-grained, hematite-rich, reddish sandstone (Type 2) identified in this study could originate from either the Phra Wihan or the Sao Khua Formations. Similar lithotypes dominated by quartz grains, scarce feldspar, and rock fragments cemented by abundant hematite and kaolinite occur in both these formations;[38] they could potentially be found on top of Phnom Kulen, although there are currently no petrographic data to confirm this possibility.

Finally, petrographic analysis indicates that the greenish-gray feldspathic arenite in this study (Type 3 sandstone) belongs to the upper portions of the Terrain Rouge Formation, considered equivalent to the Lower–Middle Jurassic Phu Kradung Formation of Thailand. This subcontinental sequence is characterized in its upper section by very fine to fine, moderately well-sorted sandstone, intercalated with mudstones and calcrete horizons. The sandstone is mineralogically and texturally quite homogeneous and comparable to sandstone found in the provinces of Siem Reap and Preah Vihear, where this formation constitutes extensive portions of the foothills of Phnom Kulen and crops out in isolated hills and numerous riverbeds of northern Cambodia.[39]

Because Terrain Rouge sandstones with similar petrographic characteristics are widely distributed throughout the regions, it is almost impossible to identify the geographic provenience for any of the Type 3 lintels studied. One of the possible sources of feldspathic arenite (Type 3 sandstone) is the well-known and well-studied quarry district active in the Angkor period, located at the eastern foothills of Phnom Kulen, about 40 kilometers northeast of Angkor. This area is scattered with open quarries of variable size and geometry that follow the sandstone attitude and form a complex system of stone exploitation. Stepped surfaces with clear chisel marks, wedge holes, and channels indicative of the removal of sandstone blocks are evidence of quarrying activity that most likely relates to the construction of the Angkor temples.[40] Several quarries of feldspathic arenite are known also in Koh Ker[41] and close to Prasat Kdak,[42] and it is highly probable that others exist in locations still unknown.

KHMER PRODUCTION OF LINTELS AND DECORATIVE ELEMENTS

The current article reports results for a corpus of twenty-four lintels and twelve decorative elements of various dates and origins and provides the basis for further research on Khmer practices of stone sourcing and usage. This pilot study shows that the sandstones used belong to Mesozoic sandstone formations readily available in Cambodia, especially in the northern part of the country. Half of the analyzed objects are made with the same sandstone (Type 3), a greenish-gray feldspathic arenite, extensively used in the construction of Angkor temples.[43] The remaining objects are carved from other lithotypes (Types 1 and 2 sandstone) rarely employed in the temples for structural purposes, suggesting that these stones were deliberately selected by Khmer carvers for the production of decorative lintels. The findings for the twelve ornamental architectural elements included in the study are similar.

Numerous technical studies of Angkor temples indicate that the majority of the stone blocks were quarried from the Terrain Rouge Formation (Type 3 sandstone in this study).[44] Conversely, the use of quartz-rich sandstones from the Grès Supérieures Formation (Types 1 and 2 sandstones in this study) as the predominant building material is reported for monuments situated in Thailand close to the Khorat Plateau, where the choice of stone seems to be influenced by the surrounding geology.[45]

The occurrence of quartz arenite (Types 1 and 2 sandstones) lintels in many temples in

present-day Cambodia, where other lithotypes were more accessible and abundant or where no sandstone at all was available in the vicinity, clearly demonstrates that the choice of a specific building material is not necessarily based on its local availability. Understanding how and why specific lithotypes have been used in lintel production and whether the selections differ from standard Khmer temple building practices is a complex task that needs to take into account a number of variables.

One fruitful approach may be to investigate the organization of stone workshops and artisans in charge of the ornamentation of the temples. Recognizing similarities and differences in large quantities of decorative material might allow some of it to be attributed to individual sculptors or workshops. For instance, decorative lintels and colonnettes were usually fixed in place before being carved.[46] The correlation of these elements from specific temple sites to a specific lithotype (e.g., Phnom Da: MG17860, MG18324, Type 1 sandstone; Beng Mealea: MG18120, MG18121, Type 3 sandstone; Prasat Prei Khmeng: MG18854, MG18857, Type 3b sandstone) suggests that both were sourced from the same quarry and supplied at the same time. By comparing stone type, carving methods, and finishing techniques of decorated elements from various sites, it is possible to infer some general trends of stone usage and learn about frequent practices of stone workshops.

Three lintels and a colonnette from the Musée Guimet and the National Museum of Cambodia (MG18855, MG18220, MG18858, Ka1802) were created in close succession in the ninth century. These objects and others from the period are demonstrative of a rise in artistic standardization at a time of continuity in stone provisioning. An increase in artistic standardization is evident in materials produced at the time when the administrative center of the region shifted from Mahendrapavarta (Phnom Kulen) back to Hariharālaya (Roluos). There were concurrent settlements at Mahendrapavarta and Hariharālaya,[47] but the lintels

and temples appear to have been produced only when each city was the abode of the reigning monarch and the focus of the burgeoning empire.[48] During this period lintels show increased usage of the same repertoire of motifs across the city and throughout Khmer-controlled territory. Two different sites in Hariharālaya even appear to have identical lintel designs.[49] Although there were developments in iconography, the uniform lithotype (Type 3 sandstone) used for lintels from Mahendrapavarta and Hariharālaya is suggestive of an ongoing workshop tradition using the same stone sources as Phnom Kulen.

During the early to mid-tenth century the number of monuments constructed in durable materials (brick and sandstone) increased markedly,[50] and a proliferation of homogeneous lintel designs emerged that identified these foundations. Uniformity of motifs and composition are observed on the lintel friezes, which illustrate the implementation of a design repertoire that had likely been committed to memory in a workshop environment. From the combination of three or four distinctive motifs that characterize the work of a particular workshop, one motif in particular—the celestial being praying in a fleuron—was perhaps the most idiosyncratic.[51] This and associated motifs of polylobe fleurons and *romyuol* flowers appear on the friezes of three of the lintels in the Metropolitan Museum (1994.111; 36.96.6, see Figure 2; 1996.473, see Figure 4).[52] That these lintels, likely originating from sites separated by large geographical distances, share the same lithotype (Type 2 sandstone) supports the suggestion that they are the product of a tenth-century tradition characterized by a preference for a specific type of stone.

Among the lintels that were studied, those from the early and mid-eleventh century possibly originating in present-day Thailand and now in the Metropolitan Museum (1972.214; 1992.192; 1994.94, see Figure 5) and the Arthur M. Sackler Gallery (S1987.953) are rendered in white to light brown quartz arenite (Type 1 sandstone). This sandstone is consistent with

sedimentary formations widely exposed in northern Cambodia, along the Dangrek Range, and on the Khorat Plateau, which is the region the lintels are thought to come from. In this case, workshops may have been influenced by the surrounding geology in the choice of the stone for their various commissions.[53]

Undoubtedly, a large dataset on stone materials from provenienced objects can offer valuable support to current studies on material usage and building practices during the Khmer Empire. However, given the fragmentary information available regarding the provenience of many of the lintels in museum collections, as well as the large spatial distribution of the sandstone outcrops, conclusions for now remain speculative.

It is clear that the three identified types of sandstone were used simultaneously across the Khmer Empire and within the same temple complexes, and it is likely that their concurrence was determined by several concomitant factors, including geography, geology, technical knowledge and skill, and, more generally, building traditions. A better understanding of building materials and traditions, as well as the specific organization of workshops, can best be achieved by focusing the investigation on individual structures in situ for which building phases and dates have been established. Such an approach would reveal the distribution of the stone materials in the temple structure and help establish the relationship among stone types, typology of surface finishing, functions within the temple, and building phases.

The study of the stone materials used for sculpture has significant potential to enhance understanding of the provisioning, production, and distribution of classical Khmer art. Stone characterization is useful for addressing specific questions about the authenticity and provenience of carved architectural elements and can complement archaeological studies that consider networks of control and acquisition of resources, the relationships among the state, temples, and artistic workshops, and aspects of the economy of the Khmer Empire.

FEDERICO CARÒ

Associate Research Scientist
Department of Scientific Research
The Metropolitan Museum of Art

MARTIN POLKINGHORNE

Australian Research Council
Postdoctoral Fellow
Department of Asian Studies
University of Sydney

JANET G. DOUGLAS

Conservation Scientist
Department of Conservation and
Scientific Research
Smithsonian Institution, Freer Gallery of Art/
Arthur M. Sackler Gallery

ACKNOWLEDGMENTS

This research was supported by an Andrew W. Mellon Fellowship at The Metropolitan Museum of Art, by a Forbes Fellowship at the Freer Gallery of Art and Arthur M. Sackler Gallery, Smithsonian Institution, and by an Australian Research Council Post Doctoral Fellowship (DP110101968). The authors are grateful to their colleagues in Cambodia: HE Chuch Phoeurn, secretary of state, Ministry of Culture and Fine Arts; HE Bun Narith, director general of the Authority for the Protection and Management of Angkor and the Region of Siem Reap (APSARA); HE Khuon Khun Neay and HE Seung Kong, deputy directors general of APSARA; Im Sokrithy, Ea Darith, and all the APSARA staff who contributed directly to the fieldwork in Cambodia; HE Hab Touch, director general for Museums, Antiquities and Monuments, Ministry of Culture and Fine Arts, and former director of the National Museum of Cambodia; Kong Vireak, director of the National Museum of Cambodia, and to the museum for granting permission to use photographs of works from the collection; Bertrand Porte, l'École Française d'Extrême-Orient, which provided the samples from the National Museum of Cambodia; John Guy, Florence and Herbert Irving Curator of the Arts of South and Southeast Asia, and Donna Strahan, Sherman

Fairchild Center for Objects Conservation, The Metropolitan Museum of Art; Anne Bouquillon, Centre de Recherche et de Restauration des Musées de France (C2RMF), and Pierre Baptiste, Musée National des Arts Asiatiques–Guimet; and the Freer Gallery of Art and Arthur M. Sackler Gallery, Smithsonian Institution.

NOTES

1 Dagens 2002, p. 236.
2 Polkinghorne 2007a; Polkinghorne 2007b, pp. 187–202; Polkinghorne 2008.
3 Baptiste et al. 2001, pp. 137–38; Carò 2009; Douglas, Carò, and Fischer 2010.
4 Polkinghorne 2007b, pp. 234–36.
5 Coral-Rémusat 1940; Stern 1927.
6 The lintel with a mask of Kāla is unique and warrants separate study for its relevance to issues relating to the dating of Khmer art and decorative lintels between the seventh and ninth centuries, a subject of considerable academic discourse. Presently, the principal issue is the chronology and duration of decorative elements attributable to the Kompong Preah style (see especially Bénisti 2003; Boisselier 1968; Woodward 2010b). A new synthesis is required that critically appraises decorative material linked to epigraphic material, recent absolute dates from archaeological contexts (e.g., Pottier and Bolle 2009), and analogous sculpture in the round. Similarly it must consider archaism, innovation, and peripheral and parallel artistic developments. Though the stylized fleuron emblem between the Kāla's eyes on the Metropolitan Museum lintel (1985.390.1) is associated with the central motif of Kompong Preah style, the majority of motifs can be ascribed to the Prei Khmeng style; therefore it is likely the lintel was produced in the first half of the seventh century.
7 Snodgrass 1985, pp. 307, 312–13.
8 Marchal 1951, p. 32; Ang 2004, pp. 85–98.
9 Ang 2004, pp. 85–98.
10 Coral-Rémusat 1951, p. 43.
11 Bosch 1960; Coral-Rémusat 1933, p. 190; Coral-Rémusat 1936, pp. 427–35; Coral-Rémusat 1940, pp. 48–50; Marchal 1938; Stern 1934, p. 253; Stern 1938b, p. 127.
12 Bénisti 1973, pp. 119–38.
13 Coral-Rémusat 1933, p. 190; Coral-Rémusat 1936, pp. 427–35; Coral-Rémusat 1940, pp. 48–50.
14 More recently Woodward (2010a, pp. 44, 145 n. 20) suggested decorative influences from China.
15 Thanks to Heng Piphal, student at the University of Hawai'i at Manoa, for alerting the authors to this similarity. See Carte Interactive des Sites Archéologiques Khmers (CISARK), http://www.site-archeologique-khmer.org/core/showsite.php?id=637 (accessed September 27, 2013).
16 For example, at Kuk Roka (see CISARK, http://www.site-archeologique-khmer.org/core/showsite.php?id=1595 [accessed September 27, 2013]), Olok (see Boisselier 1968, figs. 11–13; Stern 1938a, pl. LVII), Prei Khmeng (see Christian Pottier, Alexandrine Guerin, Heng Than, Im Sokrithy, Koy Tchan, and Eric Llopis, "Mission Archéologique Franco-Khmère sur l'Aménagement du Territoire Angkorien [MAFKATA]," Campagne 2000 Rapport, EFEO, Siem Reap; Angkor National Museum, N.526), Sambor (see National Museum of Cambodia, Ka1778; Boisselier 1968, fig. 23), Yeay Poan (S1, Sambor Prei Kuk, see Bénisti 1977, fig. 5).
17 Polkinghorne 2007b, pp. 160–63.
18 For example, at Ak Yum (see Boisselier 1968, figs. 18–22; Stern 1938a, pl. LVI), Ampil Rolum (see Parmentier 1927, fig. 53), Kompong Preah (see Boisselier 1968, fig. 1), Kuk Roka (see CISARK, http://www.site-archeologique-khmer.org/core/showsite.php?id=1595 [accessed September 27, 2013]), Tuol Kuhear (see Boisselier 1968, fig. 33), Yeay Poan (S1, Sambor Prei Kuk, see Bénisti 1977, fig. 5).
19 Inscription K.522. See Cœdès 1953, p. 119.
20 EFEO photo cliché fonds Cambodge INVLU12404.
21 "Chronique" 1933, p. 1134; see also EFEO photo cliché fonds Cambodge INVLU16242.
22 Singaravélou 1999, pp. 251–56; see also Sharrock 2007, pp. 277–81.
23 Polkinghorne 2008.
24 For example, Giteau 1965, pp. 79–84.
25 Included in this study but not illustrated. For an image, see http://www.metmuseum.org.
26 Polkinghorne 2008.
27 A Zeiss Axioplan 2 polarized light microscope was used at The Metropolitan Museum of Art, and a Nikon Eclipse E600 polarized light microscope was used at the Freer Gallery of Art and Arthur M. Sackler Gallery.
28 The sorting (σ) of a sandstone refers to the distribution of the grain-size values around the mean grain size. The higher the sorting (σ), the more dispersed are the values around the mean.
29 Gazzi 1966; Dickinson 1970.
30 Heavy minerals are detrital minerals having a specific gravity greater than about 2.9.
31 Contri 1972, p. 7; Kučera et al. 2008, p. 305.
32 A formation is a body of rock strata that can be distinguished from others by specific physical characteristics.
33 A group includes two or more formations that are related to one another.
34 Dating such sedimentary formations is problematic and has been the subject of much debate. It is important to bear in mind that evidence for their reported ages is not conclusive. However, this study follows ages and stratigraphy reported in the available 1:200000 geological map of Cambodia published by the Bureau de Recherches Géologiques et Minières and later used by other authors (United Nations 1993; Sotham 1997).
35 Contri 1972, pp. 10–11; Dottin 1972, p. 8; Alabouvette 1973, p. 8.
36 See CISARK, http://www.site-archeologique-khmer.org/core/showsite.php?id=460 (accessed September 30, 2013). Other quarries in the Grès Supérieures Formation can be seen at Phnom Santuk (see CISARK, http://www.site-archeologique-khmer.org/core/showsite.php?id=191 [accessed September 27, 2013]), and Phnom Batheay (see CISARK, http://www.site-archeologique-khmer.org/core/showsite.php?id=1189 [accessed September 27, 2013]).
37 Racey et al. 1996, pp. 20–24.
38 Ibid., pp. 20–26; Uchida, Ito, and Shimizu 2010, p. 562.
39 Contri 1972, p. 9; Alabouvette 1973, p. 9.
40 Delvert 1963, pp. 479–84.

41 Evans 2009; Carò and Im 2012.

42 See CISARK, http://www.site-archeologique-khmer.
 org/core/showsite.php?id=1170 (accessed September 27,
 2013).

43 Delvert 1963, pp. 469–76; Uchida, Ito, and Shimizu
 2010, pp. 551–58.

44 For example, Saurin 1954, p. 621; Delvert 1963,
 pp. 453–54; Uchida et al. 2007, pp. 294–95; Kučera et
 al. 2008, p. 299.

45 Uchida, Ito, and Shimizu 2010, pp. 572–73.

46 The many unfinished and partially finished lintels in
 temples throughout the Khmer world suggest that this
 carving was one of the final tasks of temple decoration.
 See Polkinghorne 2007b, pp. 205–9; Polkinghorne
 2008, pp. 25–26.

47 Penny et al. 2006; C. Pottier, A. Bolle, E. Llopis,
 D. Soutif, C. Tan, J. B. Chevance, V. Kong, S. Chea,
 S. Sum, F. Demeter, A.-M. Bacon, N. Bouchet,
 C. Souday, and M. Frelat, "Mission archéologique
 Franco-Khmère sur l'aménagement du territoire
 angkorien (MAFKATA)," Campagne 2005 Rapport,
 EFEO, Siem Reap.

48 Polkinghorne 2013.

49 O Ka-aek (IK589.07) has a lintel design identical to
 four examples from Preah Kô temple. It depicts Aśvin
 (cavaliers) with weapons riding three-headed crowned
 Nāga (mythical serpents). The distinctiveness of this
 design indicates that the same artist, from the same
 workshop, who worked upon Preah Kô lintels also
 fashioned the O Ka-aek lintel. See Polkinghorne 2007a.

50 The increase in construction during this period is
 marked by an increase in inscriptions, which are often
 placed on doorjambs (see, e.g., Lustig 2009, esp. fig. 42).

51 Polkinghorne 2007a.

52 *Romyuol* is a traditional Khmer floral decorative
 motif (*Kbach*) similar to a water lily (*Nyphaea lotus*)
 or a hibiscus flower (*Hibiscus sagittifolius*).

53 Uchida, Ito, and Shimizu 2010, p. 572.

REFERENCES

Alabouvette 1973. Bruno Alabouvette. "Notice
explicative sur la feuille Stung Treng." *Carte
Géologique de Reconnaissance à 1/200000*. Paris:
Editions du Bureau de Recherches Géologiques et
Minières, 1973.

Ang 2004. Chouléan Ang. "La mort: Renaissance en
abstraction iconographique." *Udaya: Journal of
Khmer Studies* 5 (2004), pp. 85–98.

Baptiste et al. 2001. Pierre Baptiste, Catherine
Chevillon, Clémence Raynaud, Anne Bouquillon,
Sandrine Pagès, Alain Leclaire, and Philippe
Recourt. "La restauration des sculptures khmères
du musée Guimet." *Technè* 13–14 (2001), pp. 131–40.

Bénisti 1973. Mireille Bénisti. "Recherches sur le
premier art khmer V: La face de monstre." *Arts
Asiatiques* 28 (1973), pp. 119–38.

Bénisti 1977. Mireille Bénisti. "Recherches sur le
premier art khmer VII: Le problème de Sambor
S. 1." *Arts Asiatiques* 33 (1977), pp. 25–56.

Bénisti 2003. Mireille Bénisti. *Stylistics of Early
Khmer Art*. 2 vols. New Delhi: Indira Gandhi
National Centre for the Arts and Aryan Books
International, 2003.

Boisselier 1968. Jean Boisselier. "Les linteaux khmers
du VIIIe siècle nouvelles données sur le style de
Kompong Prah." *Artibus Asiae* 30, no. 2–3 (1968),
pp. 101–44.

Bosch 1960. Frederik David Kan Bosch. *The Golden
Germ: An Introduction to Indian Symbolism*.
Indo-Iranian Monographs 2. New York: Humani-
ties Press, 1960.

Carò 2009. Federico Carò. "Khmer Stone Sculptures:
A Collection Seen from a Material Point of View."
Metropolitan Museum of Art Bulletin 67, no. 1
(2009), pp. 26–32.

Carò and Im 2012. Federico Carò and Sokrithy Im.
"Khmer Sandstone Quarries of Kulen Mountain
and Koh Ker: A Petrographic and Geochemical
Study." *Journal of Archaeological Science* 39, no. 5
(2012), pp. 1455–66.

"Chronique" 1933. *Bulletin de l'École Française
d'Extrême-Orient* 33, no. 1 (1933), pp. 1045–46.

Cœdès 1953. George Cœdès, ed. and trans. *Les inscrip-
tions sanskrites estampées par . . . [Aymonier]
mais non encore traduites . . . [et] les inscriptions
découvertes après 1900 par l'École française
d'Extrême-Orient et restées inédites*, vol. 5, *Inscrip-
tions du Cambodge*. École Française d'Extrême-
Orient, Collections de textes et documents sur
l'Indochine 3. Paris: E. de Boccard, 1953.

Contri 1972. Jean P. Contri. "Notice explicative sur
la feuille Tbeng-Meanchey." *Carte Géologique de
Reconnaissance à 1/20000*. Paris: Editions du Bureau
de Recherches Géologiques et Minières, 1972.

Coral-Rémusat 1933. Gilberte de Coral-Rémusat.
"Influences javanaises dans l'art de Rolûoh
(IXe siècle) et influences de l'art de Rolûoh sur le
temple de Banteay Srei (fin du Xe siècle)." *Journal
Asiatique* 223 (1933), pp. 190–92.

Coral-Rémusat 1936. Gilberte de Coral-Rémusat.
"Animaux fantastiques de l'Indochine, de l'Insulinde
et de la Chine." *Bulletin de l'École Française
d'Extrême-Orient* 36, no. 2 (1936), pp. 427–35.

Coral-Rémusat 1940. Gilberte de Coral-Rémusat.
L'art khmer: Les grandes étapes de son évolution.
Études d'art et d'ethnologie asiatiques 1. Paris:
Éditions d'Art et d'Histoire, 1940.

Coral-Rémusat 1951. Gilberte de Coral-Rémusat.
L'art khmer: Les grandes étapes de son évolution.
2nd ed. Études d'art et d'ethnologie asiatiques 1.
Paris: Vanoest, Éditions d'Art et d'Histoire, 1951.

Dagens 2002. Bruno Dagens. *Les Khmers*. Guides
belles lettres des civilisations 10. Paris: Les Belles
Lettres, 2002.

Delvert 1963. Jean Delvert. "Recherches sur l'érosion
des grès des monuments d'Angkor." *Bulletin de
l'École Française d'Extrême-Orient* 51, no. 2 (1963),
pp. 453–534.

Dickinson 1970. William R. Dickinson. "Interpreting
Detrital Modes of Greywacke and Arkose." *Journal*

of Sedimentary Petrology 40, no. 2 (1970), pp. 695–707.

DMR 1992. Department of Mineral Resources. *1:2.500.000 Scale Geological Map of Thailand.* Bangkok, Thailand: Department of Mineral Resources, 1992.

Dottin 1972. Olivier Dottin. "Notice explicative sur la feuille Siem Reap." *Carte Géologique de Reconnaissance à 1/200000.* Paris: Editions du Bureau de Recherches Géologiques et Minières, 1972.

Douglas, Carò, and Fischer 2010. Janet Douglas, Federico Carò, and Christian Fischer. "Evidence of Sandstone Usage for Sculpture during the Khmer Empire in Cambodia through Petrographic Analysis." *Udaya: Journal of Khmer Studies* 9 (2010), pp. 1–18.

Evans 2009. Damian H. Evans. "Towards a Landscape Archaeology of Koh Ker: Methods, Issues and Recent Research." In *Jaya Koh Ker Project: Annual Report 2009*, edited by János Jelen, Róbert Kuszinger, and I. Farago, pp. 25–63. Budapest: Royal Angkor Foundation, 2009.

Folk and Ward 1957. Robert L. Folk and William C. Ward. "Brazos River Bar (Texas): A Study in the Significance of Grain Size Parameters." *Journal of Sedimentary Research* 27, no. 1 (1957), pp. 3–26.

Gazzi 1966. Paolo Gazzi. "Le arenarie del flysch sopracretaceo dell'Appennino modenese: Correlazioni con il Flysch di Monghidoro." *Mineralogica and Petrographica Acta* 12 (1966), pp. 69–97.

Giteau 1965. Madeleine Giteau. *Khmer Sculpture and the Angkor Civilisation.* Translated by Diana Imber. London: Thames & Hudson, 1965.

Kučera et al. 2008. J. Kučera, J. K. Novák, K. Kranda, J. Poncar, I. Krausová, L. Soukal, O. Cunin, and M. Lang. "INAA and Petrological Study of Sandstones from the Angkor Monuments." *Journal of Radioanalytical and Nuclear Chemistry* 278, no. 2 (2008), pp. 229–306.

Lustig 2009. Eileen Lustig. "Power and Pragmatism in the Political Economy of Angkor." PhD diss., Department of Archaeology, University of Sydney, 2009.

Marchal 1938. Henri Marchal. "The Head of the Monster." *Journal of the Indian Society of Oriental Art* 6 (1938), pp. 97–104.

Marchal 1951. Henri Marchal. *Le décor et la sculpture khmers.* Études d'art et d'ethnologie asiatiques 3. Paris: Vanoest, 1951.

Parmentier 1927. Henri Parmentier. *L'art khmer primitif.* Publications de l'École Française d'Extrême-Orient 21–22. Paris: EFEO, 1927.

Penny et al. 2006. Dan Penny, Christophe Pottier, Roland Fletcher, Mike Barbetti, David Fink, and Quan Hua. "Vegetation and Land-Use at Angkor, Cambodia: A Dated Pollen Sequence from the Bakong Temple Moat." *Antiquity* 80, no. 309 (2006), pp. 599–614.

Polkinghorne 2007a. Martin Polkinghorne. "Artists and Ateliers: Khmer Decorative Lintels of the Ninth and Tenth Centuries." *Udaya: Journal of Khmer Studies* 8 (2007), pp. 219–41.

Polkinghorne 2007b. Martin Polkinghorne. "Makers and Models: Decorative Lintels of Khmer Temples, 7th to 11th Centuries." PhD diss., Department of Art History and Film Studies, Department of Archaeology, University of Sydney, 2007.

Polkinghorne 2008. Martin Polkinghorne. "Khmer Decorative Lintels and the Allocation of Artistic Labour." *Arts Asiatiques* 63 (2008), pp. 21–35.

Polkinghorne 2013. Martin Polkinghorne. "Decorative Lintels and Ateliers at Mahendraparvata and Hariharālaya." In *Materializing Southeast Asia's Past: Selected Papers from the 12th International Conference of the European Association of Southeast Asian Archaeologists*, edited by Marijke J. Klokke and Véronique Degroot, 2:205–17. Singapore: NUS Press, 2013.

Pottier and Bolle 2009. Christophe Pottier and Annie Bolle. "Le Prasat Trapeang Phong à Hariharâlaya: Histoire d'un temple et archéologie d'un site." *Aséanie* 24 (2009), pp. 61–90.

Racey et al. 1996. A. Racey, M. A. Love, A. C. Canham, J.G.S. Goodall, S. Polachan, and P. D. Jones. "Stratigraphy and Reservoir Potential of the Mesozoic Khorat Group, NE Thailand." *Journal of Petroleum Geology* 19, no. 1 (1996), pp. 5–40.

Saurin 1954. Edmond Saurin. "Quelques remarques sur le grès d'Angkor." *Bulletin de l'École Française d'Extrême-Orient* 46, no. 2 (1954), pp. 619–34.

Sharrock 2007. Peter. D. Sharrock. "The Mystery of the Face Towers." In *Bayon: New Perspectives*, edited by Joyce Clark, pp. 230–81. Bangkok: River Books, 2007.

Singaravélou 1999. Pierre Singaravélou. *L'École française d'Extrême-Orient ou l'institution des marges (1898–1956): Essai d'histoire sociale et politique de la science coloniale.* Paris: Éditions L'Harmattan, 1999.

Snodgrass 1985. Adrian Snodgrass. *The Symbolism of the Stupa.* Ithaca, N.Y.: Southeast Asia Program, Cornell University, 1985.

Sotham 1997. Sieng Sotham. "Geology of Cambodia." *Coordinating Committee for GeoScience Programs in East and Southeast Asia Technical Bulletin* 26 (1997), pp. 13–23.

Stern 1927. Philippe Stern. *Le Bayon d'Angkor et l'évolution de l'art khmer: Étude et discussion de la chronologie des monuments khymers.* Annales du Musée Guimet, Bibliothèque de vulgarisation 47. Paris: Paul Geuthner, 1927.

Stern 1934. Philippe Stern. "Évolution du linteau khmer." *Revue des arts asiatiques* 8, no. 4 (1934), pp. 251–56.

Stern 1938a. Philippe Stern. "Hariharalâya et Indrapura." *Bulletin de l'École Française d'Extrême-Orient* 38, no. 1 (1938), pp. 175–98.

Stern 1938b. Philippe Stern. "Le style du Kulên." *Bulletin de l'École Française d'Extrême-Orient* 38, no. 1 (1938), pp. 111–50.

Uchida et al. 2007. Etsuo Uchida, Olivier Cunin, Chiyuki Suda, Akyio Ueno, and Takeshi Kakagawa. "Consideration on the Construction Process and the Sandstone Quarries during the Angkor Period Based on the Magnetic Susceptibility." *Journal of Archaeological Science* 34, no. 6 (2007), pp. 927–35.

Uchida, Ito, and Shimizu 2010. Etsuo Uchida, K. Ito, and N. Shimizu. "Provenance of the Sandstone Used in the Construction of the Khmer Monuments in Thailand." *Archaeometry* 52, no. 4 (2010), pp. 550–74.

United Nations 1993. United Nations. *Economic and Social Commission for Asia and the Pacific: Atlas of Mineral Resources of the Escap Region,* vol. 10, *Cambodia, Explanatory Brochure.* New York: United Nations, 1993.

Woodward 2010a. Hiram Woodward. "Bronze Sculptures of Ancient Cambodia." In *Gods of Angkor: Bronzes from the National Museum of Cambodia,* edited by Louise A. Cort and Paul Jett, pp. 29–75. Washington, D.C.: Arthur M. Sackler Gallery, Smithsonian Institution, 2010.

Woodward 2010b. Hiram Woodward. "Dvaravati, Si Thep, and Wendan." *Bulletin of the Indo-Pacific Prehistory Association* 30 (2010), pp. 87–97.

Workman 1977. David Richard Workman. *Geology of Laos, Cambodia, South Vietnam and the Eastern Part of Thailand.* Overseas Geology and Mineral Resources 50. London: Institute of Geological Sciences, 1977.

PICTURE CREDITS

Unless otherwise indicated, photographs of works in the Metropolitan Museum's collection are by the Photograph Studio, The Metropolitan Museum of Art.

Department of Scientific Research, The Metropolitan Museum of Art: Figures 7, 8, 10, 11

Musée National des Arts Asiatiques–Guimet, Paris: Figure 6

National Museum of Cambodia, Phnom Penh: Figures 3, 9

ថ្មដែលយកមកប្រើប្រាស់សម្រាប់ធ្វើផ្ទែរ និង សម្រាប់គុបតែងលំអក្នុងប្រាសាទខ្មែរ

សង្ខេប

ចម្លាក់ផ្ទែរដ៏ល្អឧត្តគខ្លាះដែលជាបុព្ឥសិទ្ធិ និងជានិមិត្តរបស់ប្រាសាទខ្មែរ។ ចម្លាក់ផ្ទែរសម្រាប់ប្រាសាទមួយៗត្រូវបានគណៈកម្មការជ្រើសរើសនូវជាងឆ្លាក់ដ៏ជំនាញ ដែលមានឧបករណ៍ឆ្លាក់ដ៏ពិសេស និងរបៀបនៃការឆ្លាក់ជាលក្ខណៈប្រពៃណី។ ក្បាច់ចម្លាក់ផ្ទែរភាគទាំងប្រាំពីរនៅសារមន្ទីរ សិល្បៈ Metropolitan ដែលត្រូវបានគេបង្ហាញនូវរូបទេពកោសល្យ និងភាពចុីនប្រសប់ តាមរយៈអត្តន័យនៃការសិក្សាសិលាចារឹក និងស្ទាដែលជាមួយនឹងផ្ទែររម្បៃប្រាំបួនផ្សេងទៀត ហើយនឹងឧបករណ៍កម្មមួយចំនួនទៀត ដែលមានតាំងពីសតវត្សទី៧ ដល់សតវត្សទី១៣។ បច្ចុប្បន្ននេះ ផ្ទែរទាំងនោះគឺនៅសារមន្ទីរជាតិកម្ពុជា ស្ថិតនៅទីក្រុងភ្នំពេញ សារមន្ទីរ Musée National des Arts Asiatiques–Guimet ស្ថិតនៅទីក្រុងប៉ារីស និងសារមន្ទីរ Arthur M. Sackler Gallery, Smithsonian Institution ស្ថិតនៅទីក្រុង Washington, D.C. សហរដ្ឋអាមេរិក។

តាមលទ្ធផលស្រាវជ្រាវបង្ហាញថា ប្រភេទថ្មសម្រាប់ឆ្លាក់ក្នុងប្រាសាទ គឺបានជ្រើសរើសដោយជាងឆ្លាក់ខ្មែរ។ ជាការពិតណាស់ប្រភេទថ្មភាគត់ដែលប្រើប្រាស់ក្នុងការសាងសង់ប្រាសាទគឺមានលក្ខណៈ ជាផ្សេងៗ ដែលកកើតឡើងពីដីក្រហម (from the Terrain Rouge Formation) ក្នុងប្រទេសកម្ពុជា ហើយថ្មកក់ ដែលមានលណ្ហាយម៉ដ្ឋ ត្រូវប្រើប្រាស់សម្រាប់ឆ្លាក់លំអ ដូចជាសម្រាប់ឆ្លាក់ផ្ទែរប្រាសាទ និងគ្រឿងលំអផ្សេងៗ។ ថ្មកក់ប្រភេទនេះប្រហែលកើតឡើងពី Grès Supérieures Formation និងកំណកដី ដែលលាតសន្ធឹងដល់ប្រទេសថៃ ប្រទេសឡាវ និងប្រទេសវៀតណាម។

FEDERICO CARÒ

The Metropolitan Museum of Art

MARTIN POLKINGHORNE

University of Sydney

JANET G. DOUGLAS

Smithsonian Institution, Freer Gallery of Art/ Arthur M. Sackler Gallery

ABSTRACT TRANSLATED BY SO MALAY AND THO THON

The Retable of *Saint Anne with the Virgin and Child* at The Cloisters: Insights into Fifteenth-Century Working Practices in the Kingdom of Aragon

◆

Karen E. Thomas and Silvia A. Centeno

ABSTRACT

A gift to The Metropolitan Museum of Art in 1938, the fifteenth-century retable of Saint Anne with the Virgin and Child *has had only minimal conservation or restoration intervention since entering the collection. Believed to have been from the chapel of an unidentified monastery in the region of Teruel, Spain, the retable is complete, with six central panels, seven dust guard panels, a five-scene* banco, *and a pedestal with an inscription. This study offers insights into the construction of the retable, reveals evidence of artistic collaboration, and provides information about the techniques and materials used. Infrared examination revealed extensive underdrawing by more than one hand. Samples were analyzed to identify materials and methods used to achieve different visual effects, including several methods of gilding used on areas of low relief.*

In *Saint Anne with the Virgin and Child,* The Metropolitan Museum of Art is fortunate to have a well-preserved, unusually complete example of a fifteenth-century Aragonese retable (38.141a–o; Figure 1). It is believed to have been removed from the chapel of an unidentified monastery in the region of Teruel, Spain. Its stepped configuration, artistic techniques, and iconography are all representative of its presumed place of origin and date of manufacture.[1]

The once-accepted notion of the so-called Hispano-Flemish style as a derivative appropriation of the arts of the Netherlands is now better understood as a rather more complex expression of Iberian artistic culture. The *Saint Anne* retable provides an opportunity to explore the notion of an inherent style that was more than an amateurish shadow of the artistic glories of Northern Europe and Italy. Commercial trade between Spain and Flanders, England, and France, including the importation of artworks, facilitated the introduction of Northern painting styles to Spain.[2] This was soon followed by the arrival of Northern artists themselves, from whom Aragonese painters learned and absorbed ideas and techniques. Over time, Aragonese artists integrated Northern stylistic influences with their own practices, synthesizing a new and local painting style.

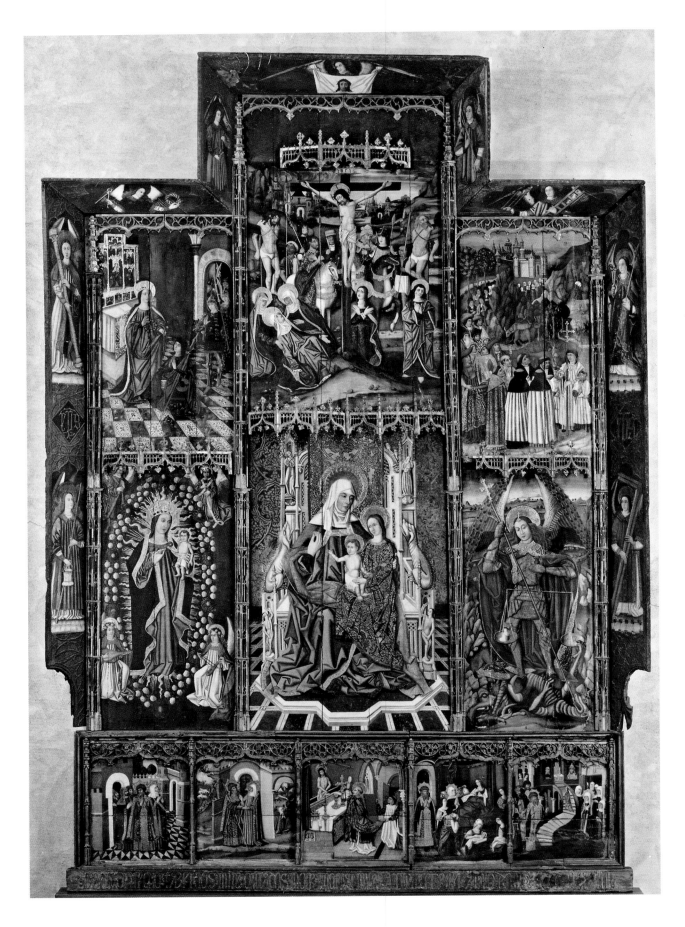

It is unusual to find complete altarpieces outside of Europe, and restoration and conservation of the *Saint Anne* retable prior to its entry into The Cloisters' collection at The Metropolitan Museum of Art appear to have been minimal.[3] When in 2007–8 the retable underwent conservation in preparation for exhibition at The Cloisters, the opportunity arose to undertake technical examination of the panels in order to gain a better understanding of the materials and techniques used in the creation of the altarpiece and to add to the relatively limited published information on Aragonese painting.

SPANISH RETABLES IN THE FIFTEENTH CENTURY

In fifteenth-century Spain, the upper center panel of every *retablo* contained a visual representation of the central theme of the Mass: the Crucifixion. *Retablos mayores*, retables intended for the high altar, incorporated a physical reference to the Crucifixion as well, for the consecrated host was stored in the tabernacle—a small cabinet in the center panel of the *banco* (predella) upon which the altarpiece rests. All *retablos* were tools for contemplation and instruction. The primary focus was the central "vertical zone"[4] or *calle*, which always included the tabernacle or a devotional image (*Piedad*) of Christ in his tomb at the bottom, the image of the titular saint in the center, and, at the top, a representation of the Crucifixion or Christ on the Cross.[5] As Judith Berg-Sobré summarizes in her extensive study of fourteenth- and fifteenth-century Spanish retables: "In essence, this zone reflected the church itself. The titular saint referred to the church's dedication; the Crucifixion or Christ on the Cross acted as the crucifix essential to the celebration of the Mass; and the tabernacle, of course, was the repository of the host. Everything else in the retable can be seen as embroidering this symbolic core."[6]

Narrative components were placed to the sides of this symbolic core, in smaller and narrower zones.[7] In the Kingdom of Aragon, such narratives were generally read from the top down, in columns from left to right.[8] In the case of a multiple dedication, the flanking panels portraying secondary saints were placed beneath narrative panels depicting their stories. Events in the life of the primary saint were portrayed in the *banco* panels flanking the tabernacle, reading from right to left.[9] In retables intended for use in a chapel, the panel (*casa*) in the center of the *banco* generally depicted a scene with Eucharistic associations (the *Piedad*, Dead Christ in His Tomb, Man of Sorrows, or the Mass of Saint Gregory, for example) to encourage the viewer to reflect on the purpose of the tabernacle, which, in a *retablo mayor*, would have been located in this position.[10]

As it lacks a tabernacle, the *Saint Anne* retable likely served with an altar in a side chapel. Its *banco* consists of five equally sized painted scenes, and it has fewer panels than most *retablos mayores* and less elaborate framing.[11]

CONFIGURATION OF THE *SAINT ANNE* RETABLE

The *Saint Anne* retable closely aligns with the conventions described above (Figure 2). The central body of the altarpiece consists of multiple elements of tracery and six main panels, referred to collectively as a *cuerpo*. A triple dedication is depicted in the three lower panels: *Saint Anne with the Virgin and Child* (center, Figure 3), the *Virgin of the Rosary* (left, Figure 4), and *Saint Michael* (right, Figure 5). Above the *Saint Anne* panel is the *Crucifixion* (Figure 6) and two additional narrative panels: the *Miracle of the Gentlemen of Cologne* (Figure 7) to the left and the *Miracle of Monte Gargano* (Figure 8) to the right. These six main panels are supported by an accompanying five-scene *banco* (Figure 9) and bordered by seven panels that serve as dust guards (*guardapolvos*). In turn, the *banco* rests on a low pedestal with an inscription that records two names, Mosén Miguel Armisén and Atón Incet, with a partially illegible date, either 1473 or 1483.[12]

Opposite:
Figure 1 • *Saint Anne with the Virgin and Child*. Spain, Aragon, 1473 or 1483. Retable, oil and gold on wood (coniferous), H. 467.4 cm (184 in.), W. 337.8 cm (133 in.). The Metropolitan Museum of Art, The Cloisters Collection, Gift of Mrs. Herbert Shipman in memory of her father and mother, Edson and Julia Wentworth Bradley, 1938 (38.141a–o)

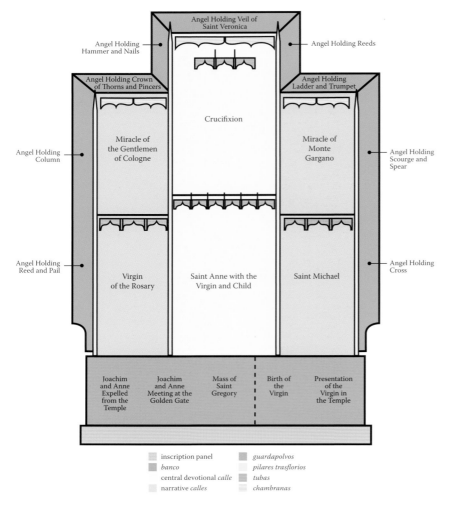

Figure 2 • *Saint Anne* retable. Diagram showing location of panels and decorative elements

The *banco* follows the triple dedication arrangement as described above: *casas* containing scenes relating to the altarpiece's primary saint (Anne) surround the central *casa* depicting the Mass of Saint Gregory, a story intended to remind viewers of the most important moment of the Mass—the consecration of the host—and, by extension, of the tabernacle where, in a *retablo mayor*, it would be kept.

The projecting *guardapolvos* contain depictions of angels bearing the signs of the Passion, a decorative scheme typical for retables in Aragon.[13] The outer edges are painted with a border of alternating dark and light triangles, nearly identical to decorative edging seen on the dust guards of another fifteenth-century Aragonese retable, *Virgin and Child Enthroned with Scenes from the Life of the*

Virgin (41.190.28a–d), in the collection of the Metropolitan Museum. Decorative gilded tracery columns (*pilares trasflorios*) attach to the face where panels abut. Over the lower narrative panels and the paintings in the central *calle* are projecting tracery crowns (*tubas*), while somewhat less elaborate leaf-patterned tracery (*chambranas*) surmounts the remaining paintings. Some of these carved elements appear to be modern replacements.

Of particular note is the fact that the upper left-hand panel in the central body of the retable, the *Miracle of the Gentlemen of Cologne* (see Figure 7) depicts a six-panel retable with a pleated red cloth that appears to be a curtain pulled to the side. A nearly identical curtain is found in the *banco* below, in the central image of the *Mass of Saint Gregory*. Written documentation records the use of curtains in Spain to cover *retablos* when not in use, during Holy Week, and during the celebration of the Holy Eucharist in order to conceal the miracle of Transubstantiation from public view.[14] Yet paintings illustrating this fifteenth-century European practice are very rare,[15] and this may be one of the only known Spanish painted representations of a *retablo* within a *retablo* showing such a curtain.

STYLISTIC INFLUENCES

The retables of fourteenth- and fifteenth-century Spain lack the spatial illusionism found in contemporaneous Italian altarpieces and the combination of sensuality and fine detail of Flemish works. Instead, Spanish retables embody a "fervent religiosity,"[16] expressed through a stylized vision of "saints in patterned garments . . . depicted seated on patterned thrones against patterned and textured gilded backgrounds."[17] They are also notable for continuing to use gilded backgrounds and decorative details into the first decades of the sixteenth century.[18]

The laity did not commonly approach the high altar even on the few occasions during the year when they received the Host, so being able to visually engage with the Holy

Sacrament at a distance through the imagery of the retable was important.[19] As a result, the various components of Spanish altarpieces needed to be broadly painted to ensure ready recognition, and for this reason they have had a reputation of being coarsely executed, particularly when compared with contemporaneous works in Northern Europe.

The landlocked Kingdom of Aragon had a certain insularity, and its fifteenth-century artistic production has been described as the "most consistent stylistic corpus of any place in Spain."[20] Some have dismissed the region as a "neutral artistic sponge,"[21] absorbing style and influences from other areas, but, in fact, by the late 1430s Aragonese painters had developed their own unique regional style, which paralleled and at times even predated developments in other parts of Spain.[22] The early use of gilded relief (*embutido*) decoration and an "emphasis on surface, rather than depth" exemplify the Aragonese manner.[23] An "aggressive spacelessness"[24] is paired with a fondness for large-scale brocade patterns and embellished with many *embutido* ornaments and heavy gilded frames. These tendencies can all be found in the *Saint Anne* retable: the *embutido* ornamentation on all of the panels; the use of large brocades, particularly in the main panel; and an overall sense of surface embellishment.

Although it is difficult to find specific quotations from Mudéjar design or crafts in fifteenth-century Christian altarpieces, the Muslim presence in Aragon had an effect on the region's aesthetics. This can be seen in what is termed *Mudéjarismo*, a general stylistic approach of intricate patterning and flat surfaces that was adopted within Spanish painting practice[25] by incorporating individual paintings within larger units such as altarpieces to create what is essentially a decorated surface on an enormous scale. In the *Saint Anne* retable, whose panels make use of landscape and rudimentary perspective, the overall accumulation of the panels results not in an illusory window into a three-dimensional world as

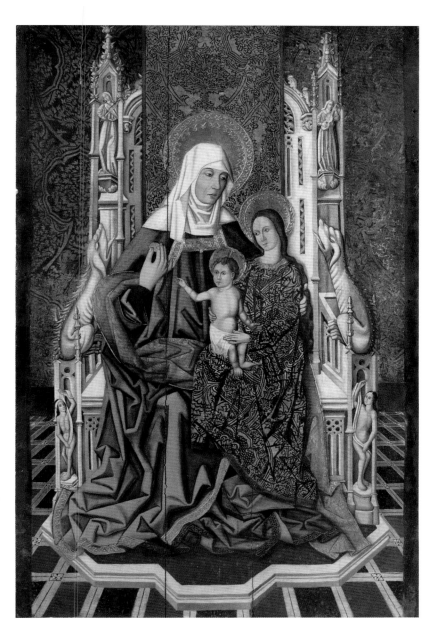

Figure 3 • *Saint Anne retable. Saint Anne with the Virgin and Child*, dedication panel (38.141b). All images of individual panels were captured while the altarpiece was disassembled for examination and treatment.

a Netherlandish retable might, but in an energetic, surface-oriented grouping of images. This spirit of decoration can be found in *retablos* across the Iberian Peninsula.

PAINTERS OF THE *SAINT ANNE* RETABLE

Almost nothing is known about who might have painted the *Saint Anne* retable, but at least two distinct hands can be discerned, confirming at least two collaborating artists. Evidence regarding fifteenth-century Spanish painters and painters' workshops may offer

Figure 4 ◆ *Saint Anne*
retable. *Virgin of the
Rosary* (38.141f)

Figure 5 ◆ *Saint Anne*
retable. *Saint Michael*
(38.141d)

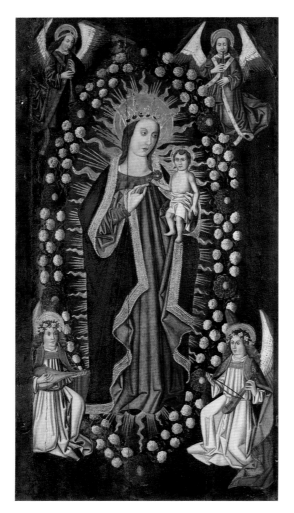

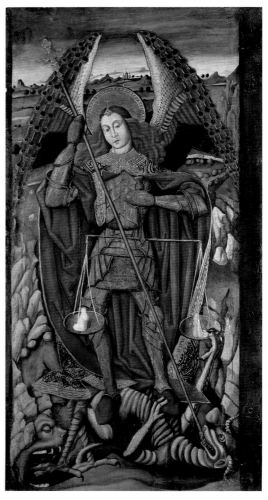

clues to their working relationship. Painters often organized guilds or brotherhoods and drafted ordinances to formalize the craft, maintain a high quality of workmanship, and control prices. Smaller cities and towns, however, often could not muster a large enough contingent of artists to organize a guild or draw up local regulations, so some painters worked without any such formal organization. Whatever the local circumstances, in fourteenth- and fifteenth-century Spain, as elsewhere in Europe, painting was essentially a collective endeavor. The master was far from being the only hand at work on a large retable, and for this reason "it is better to conceive of a master painter of the period as the head of a corporation producing a corporate product rather than as a stylistic 'loner'."[26] Painters were not artists of independent, individualistic expression but worked with a collectively understood artistic vocabulary. In the commission-driven art market of Spain, contracts always stipulated that patrons could request expert opinions to judge the product and included warranties allowing the finished painting to be rejected. Thus painters were sure to work within an accepted range of styles; too much deviation could cost an artist his commission. Contracts directing painters to imitate works by other painters eliminated such potential problems and were not unusual.[27]

Collaboration among master painters was also common throughout Spain in the fourteenth and fifteenth centuries, so it is not surprising to find that more than one artist worked on the *Saint Anne* retable. Painters who worked independently formed temporary

alliances with other painters or workshops and contracted jointly for specific projects.[28] Some working relationships were more permanent, and complicated webs of interconnections were strengthened through intermarriage among painters' families.[29] Reasons for collaborations varied. They may have provided a practical solution to a poor economic situation in which the market simply could not support a large number of individual painters, thereby making job sharing a necessity. This sort of association appears to have been particularly common in Aragon. Collaboration also allowed two masters to share an apprentice or subordinate worker in a tight labor market.[30]

In rare instances, a patron explicitly requested that a retable be the work of two masters. For example, a joint contract dated 1402 for a retable made in Zaragoza, the major city in Aragon, described the division of the work beforehand and an equal division of the cost of pigments and gold leaf, with the expectation that each master would work on his portion independently.[31] Other contracts for work by two masters are not so detailed. Nevertheless, a retable can sometimes offer concrete evidence itself, such as the *retablo mayor* of the Church of Saint Facundus and Saint Primitivus in Cisneros, Palencia, in which the left and right halves of the altarpiece, based on appearance alone, are obviously by two different masters.[32] Another example is the *Santa Marina* retable from Mayorga de Campos, Valladolid, for which the use of infrared reflectography revealed distinctly different underdrawing styles.[33]

As there is no known surviving contract for the *Saint Anne* retable, it was hoped that a technical examination might suggest a similar clear division of labor among the painters involved. However, despite the fact that different styles of underdrawing and paint application were observed, no such division could be established. In fact, this finding is not necessarily surprising because apprentices and junior painters were sometimes assigned specific tasks on a broad scale, such as painting the background, or conversely, the exclusive responsibility for the execution of a single panel or even part of a panel.

PHYSICAL PROPERTIES OF THE *SAINT ANNE* RETABLE

Although well preserved, the *Saint Anne* retable is not in pristine condition. Scattered, discolored retouching on all the panels and fills on the reverse of several panels are evidence of earlier, undocumented restorations. Some tracery elements appear to be replacements.

Figure 6 ◆ *Saint Anne retable. Crucifixion* (38.141a)

Nevertheless, the retable is generally intact. The most significant intervention prior to its entering The Cloisters' collection is that the *banco* was at some point sawn into two pieces, perhaps when the altarpiece was removed from its original setting. In addition, two panels (*Miracle of Monte Gargano* and *Saint Michael*) were exposed to water, which appears to have compromised ground layers and the wood supports. Requisite repairs resulted in large putty fills on the reverse of the panels and left painted surfaces uneven, with large areas in which the paint layers are now compressed.

MATERIALS AND TECHNIQUES
Painting Support

The types of wood used for painted panels varied throughout the Iberian Peninsula.[34] The supports in the *Saint Anne* retable exhibit the macroscopic characteristics of pine, commonly used in Aragon due at least in part to local availability.[35] Whereas Valencian painters also tended to use pine panels, in Castile primarily pine or walnut was used, and the Catalan preference was for poplar. At times, Spanish oak was chosen, and in rare instances Flemish oak was imported specifically for use in a *retablo*.[36]

Once chosen, several wood planks were joined to create panels and a bulked adhesive applied to cover joints and cracks. All six main panels of the *Saint Anne* retable are composed of several vertically oriented boards; the four outer panels are made of four planks each and the two center panels of five planks. The *banco* panel was made using three narrow, horizontally oriented planks. Dust guard panels, by contrast, are each a single piece of wood. X-ray radiographs of panels show metal pins holding the planks together (Figure 10). Invisible from the outside, these pins lie deep within the boards, varying in thickness between 2 and 4 centimeters. The pins are original to the construction and consistent with methods noted in other

Figure 7 ◆ *Saint Anne* retable. *Miracle of the Gentlemen of Cologne* (38.141e). Note the red altar curtain pulled to the side.

Figure 8 ◆ *Saint Anne* retable. *Miracle of Monte Gargano* (38.141m)

THOMAS AND CENTENO

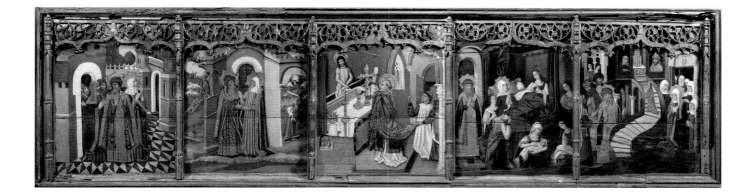

fifteenth-century Spanish panels.[37] In a few instances, where a significant gap has developed in a panel joint, a small portion of the metal pin can be seen.

For additional structural stability, crossbars were attached to the reverse of all panels. These wooden cleats were intended to stabilize the panel and may also have been useful when the retable was being installed. Most of the crossbars are original and were attached with hand-wrought square-shank nails hammered through the obverse of the panel and clinched on the back. Modern replacement crossbars are clearly recognizable by their different appearance and the use of wood screws. All the large composite panels of the *Saint Anne* retable have between two and four horizontal crossbars attached to the reverse, a configuration that is somewhat unusual for an Aragonese panel and has been described as Castilian or Catalan in style.[38]

Panel Preparation

As can be seen on the reverse of most panels, esparto grass[39] was used to reinforce the joints (Figure 11), a practice commonly seen throughout Spain.[40] Although no analysis was undertaken on the adhesive, contemporaneous ordinances related to panel construction required that parchment glue be used for this purpose.[41] Joints that do not have esparto grass reinforcement appear to have been reinforced with putty or strips of coarse-weave fabric prior to the retable's entering The Cloisters. These materials are easily identified as later

Figure 9 • *Saint Anne* retable. *Banco*, from left to right: *Joachim and Anne Expelled from the Temple*, *Joachim and Anne Meeting at the Golden Gate*, *Mass of Saint Gregory*, *Birth of the Virgin*, *Presentation of the Virgin in the Temple* (38.141c). Note the red altar curtain pulled to the side in the *Mass of Saint Gregory*. Although the subject of the central panel is not strictly a *Piedad*, as told in the Golden Legend, Christ appears as the Man of Sorrows to the saint when he is celebrating Mass, so depictions of this miracle include a typical devotional image.

Figure 10 • *Saint Anne* retable. *Virgin of the Rosary* (38.141f). X-ray radiograph, detail showing metal pin joining two wood planks

Figure 11 • *Saint Anne* retable. *Miracle of Monte Gargano* (38.141m). Detail of reverse of panel, showing esparto grass reinforcing joint

Figure 12 ◆ *Saint Anne retable. Saint Anne with the Virgin and Child*, dedication panel (38.141b). Detail of obverse, showing esparto grass preparation in an area of paint loss

Figure 13 ◆ *Saint Anne retable. Miracle of the Gentlemen of Cologne* (38.141e). Detail of obverse, showing an area of paint loss from the cloth preparation adhered to the panel

yeso mate

yeso grueso

a

b

Figure 14 ◆ *Saint Anne retable. Saint Anne with the Virgin and Child*, dedication panel (38.141b). Cross section of sample from the background brocade on the left side, showing the ground preparation consisting of *yeso grueso* and *yeso mate*, below a layer of bole, silver leaf, and a red glaze. Photomicrographs taken with (a) visible illumination and (b) ultraviolet illumination. Original magnifications 200×

additions, for they do not extend beneath crossbars, while the esparto does.

Esparto grass was also applied to the face of most of the panels prior to the application of the ground layer. On all *cuerpo* panels but one, esparto can be seen in radiographs and in locations where joints have opened or paint has been lost (Figure 12). The exception is the *Miracle of the Gentlemen of Cologne* panel, which was instead prepared with a plain-weave cloth beneath the ground layer (Figure 13). Based on

what can be seen of these preparatory materials in areas of paint loss, it appears that both the esparto grass and the woven cloth were soaked in animal glue in order to adhere them to the panel surface.

The ground layers are off-white, and cross sections show the typical coarse lower layer (*yeso grueso*) and fine upper layer (*yeso mate* or *yeso fino*) expected in a Spanish retable of the fifteenth century (Figure 14). Raman spectroscopic analysis[42] of these two layers showed that anhydrite (anhydrous calcium sulfate) is the main component.[43] Fourier transform infrared spectroscopy (FTIR)[44] analyses of two samples removed from the ground on the *Saint Anne* panel showed that a proteinaceous binder had been used for both the *yeso grueso* and the *yeso mate*. Further analysis of the two *yeso* layers in one of the samples by pyrolysis–gas chromatography–mass spectrometry (Py-GC-MS) and by the enzyme-linked immunosorbent assay (ELISA) technique revealed that the proteinaceous binder is collagen.[45]

Significant losses of ground and paint have occurred on the *guardapolvos*. Unlike the *cuerpo* panels, they were not prepared with an esparto substrate. The ground layer was applied directly to the wood, so both ground and paint layers have been more vulnerable to dimensional changes of the wood supports. The *Miracle of the Gentlemen of Cologne* exhibits a craquelure pattern distinctly different from that of the other panels and has proven significantly more prone to cupping of the paint layer, probably due to the different preparation it received. Gilded passages embellished with glazes, and especially with thickly applied paint layers, have been most vulnerable to loss and flaking. All preparation methods noted on the retable are consistent with techniques found on contemporaneous works and described in various Spanish painting treatises.[46]

Underdrawing

A fair amount of underdrawing can be seen with the naked eye, particularly in areas where pigments have faded or the paint has become more transparent through aging (Figure 15). Raman spectroscopic analysis of paint cross sections where the underdrawing is present showed that it is largely a carbon-based black pigment, such as charcoal or lampblack. FTIR and Py-GC-MS analyses of an underdrawing layer isolated from a sample from the hem of Saint Anne's green mantle in the *Saint Anne with the Virgin and Child* panel indicated that the binding medium is proteinaceous.[47] Infrared reflectography (IRR) performed on all panels of the retable revealed different styles of drawing and levels of detail among them. The different techniques seem to suggest at least two hands at work in the underdrawing.

On the *guardapolvos*, broad, thick strokes used to lay out the composition were easily discerned using IRR. This bold underdrawing was used to indicate the faces of figures; the artist made two cursory circles to place the eyes, a summary contour for the nose with thick hatched shading, and a straight slash framed by two short strokes for the mouth (Figure 16).[48]

a

b

c

Figure 15 ◆ *Saint Anne* retable. Details showing underdrawing visible through paint layers: (a) *Saint Anne with the Virgin and Child*, dedication panel (38.141b); (b) *Crucifixion* (38.141a); (c) *Miracle of the Gentlemen of Cologne* (38.141e)

Figure 16 ◆ *Saint Anne* retable. *Angel Holding Reeds* dust guard (38.141i). Infrared reflectogram, detail showing the underdrawing technique used to demarcate faces of the figures, including circles for the eyes

Figure 17 ◆ *Saint Anne* retable. *Crucifixion* (38.141a). Infrared reflectogram, detail showing underdrawing that employs a hatched stroke

Figure 18 ◆ *Saint Anne* retable. *Virgin of the Rosary* (38.141f). Infrared reflectogram, detail showing two styles of underdrawing for the garland of roses

Figure 19 ◆ *Saint Anne* retable. *Saint Michael* (38.141d). Infrared reflectogram, detail of the face showing unidirectional hatch marks in underdrawing

A strikingly similar facial notation is also seen on the main retable from the Cathedral of Tudela, Navarre.[49]

This broad manner using an economy of strokes but with additional refined underdrawing is seen elsewhere in the retable, for example on the *Crucifixion* panel, where the demarcation of a horse's decorative tack with a strong circle is visible to the naked eye (see Figure 15b). The corresponding relief detail in the finished panel was applied offset from the underdrawing, at a slightly lower position. Elsewhere on this panel figures are drawn with detailed faces shaded with a hatched stroke, all executed with a brush or quill with a smaller point (Figure 17). In the *Virgin of the Rosary*, the garland of roses is indicated with both simple donut shapes and more detailed sketches, drawn with a fine-pointed implement, showing the many petals of each bloom (Figure 18). This combination of coarse and fine drawing suggests two passes of underdrawing—one quickly executed with a broad implement to establish the general placement of items and a second using a finer tool to expand upon subjects with more detail.

There is more than one style of finely detailed underdrawing on the retable, as can be most clearly seen in various faces: in some cases, there is parallel hatching to indicate shading; elsewhere there is less confident crosshatching. A comparison of Saint Michael (Figure 19) with the Virgin in *Saint Anne with the Virgin and Child* (Figure 20) provides a

THOMAS AND CENTENO

clear example. While Saint Michael's face has a strongly unidirectional pattern of diagonal hatch marks, the face of the Virgin is shaded with strokes oriented in multiple directions and with additional crosshatching.

There are also many details drawn in outline only, with little or no hatching. The minimum of strokes necessary to lay out the elaborate armor worn by some figures suggests a confident hand at work. Strong lines with little deviation or reworking delineate details of the metal armor in the *Miracle of the Gentlemen of Cologne* (Figure 21). A similarly fluid line is seen in the underdrawing of the dragon beneath Saint Michael's feet (Figure 22).

The underdrawing also provides opportunities to see details that were altered after painting had begun. Many of the faces in the procession in the *Miracle of Monte Gargano* (Figure 23) are tilted or skewed slightly in comparison to the underdrawing. Also, noses were often painted larger than they were drawn.

Because of the differing styles of underdrawing—both broad and detailed, hatched and crosshatched—it is difficult to state with any certainty how many people were responsible

for this phase of production. Nevertheless, it is clear that at least two artists with different skill levels worked on the underdrawings and that at least two types of tools, such as a broad-tipped brush and a quill with a finer point, were employed to complete the task.

Gilding

An array of techniques was used in medieval Europe to apply gold, silver, and tin leaf to flat and relief surfaces on painted panels and sculptural works, and to embellish these metal layers with textured surfaces through the application of opaque and transparent coatings.[50] While Northern European artists moved away from gold backgrounds and other decorative surfaces to focus on landscapes and three-dimensional renderings of luxurious fabrics and other earthly details in a refined oil medium, Iberian artists continued to rely on complex gilding techniques to achieve their unique vision.

Figure 20 ✦ *Saint Anne retable. Saint Anne with the Virgin and Child*, dedication panel (38.141b). Infrared reflectogram, detail of the Virgin's face showing various styles of hatching used to indicate shading. Note, for example, the way the area above her right eyelid is shaded with horizontal strokes while the area above her left eyelid is shaded with vertical strokes, neither of which is consistent with the direction of most hatching elsewhere on her face.

Figure 21 ✦ *Saint Anne retable. Miracle of the Gentlemen of Cologne* (38.141e). Infrared reflectogram showing outlines with no hatching or other shading on body armor

Figure 22 ◆ *Saint Anne*
retable. *Saint Michael*
(38.141d). Infrared
reflectogram, detail of the
dragon illustrating a style
of underdrawing character-
ized by fluid outlines

Figure 23 ◆ *Saint Anne*
retable. *Miracle of Monte
Gargano* (38.141m). Infra-
red photograph, detail
showing compositional
features in the under-
drawing that deviate from
the final painted image

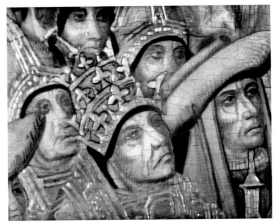

On the *Saint Anne* retable, the central
panel, *Saint Anne with the Virgin and Child*,
displays the virtuosity of the workshop's gild-
ing abilities. The least elaborate use of gold leaf
on this panel is seen on the edges of halos and
on the low-relief pattern on garment hems
(Figure 24). Different metal leafs were analyzed
by scanning electron microscopy–energy dis-
persive X-ray spectrometry (SEM-EDS).[51] A
study by Ainhoa Rodríguez López and co-
authors reconstructs the *embutido* technique
on a retable panel by Bartolomé Bermejo
(act. 1468–95) as follows: a puttylike material
made from a mixture of chalk, linseed oil, and
flax or cotton fibers was rolled out into long,
thin "ropes"; after being coated with animal
glue, the ropes were arranged on the panel
in whatever decorative scheme was desired,
pressed into place, and smoothed along the
edges.[52] The smooth, even hem decorations on
the *Saint Anne* panel, with their flattened tops
(see Figure 24b), suggest a similar technique
was used here, only without plant fibers, as con-
firmed in the cross section shown in Figure 25.
In this sample, a raised *yeso* layer, approxi-
mately 0.50 millimeter thick, is visible above a

black underdrawing applied directly onto the
flat ground preparation of the panel. Raman
analysis performed on the raised *yeso* showed
that its main component is anhydrite, while
FTIR, Py-GC-MS, and ELISA measurements
indicated that the binding medium is an ani-
mal glue.[53] In the *Saint Anne* panel, an orange
bole containing iron earth and also bound by
animal glue was painted onto the raised *yeso*,[54]
onto which gold leaf was then laid and bur-
nished to a brilliant gloss.

The hems of other garments display a
gilding technique known as *esgrafiado*, in
which gold leaf was applied, burnished, and
then further decorated. The entire gilded area
was covered with a paint or glaze, which
was then scratched away—either while still
wet or once dry—creating a pattern by expos-
ing the gold. For the border on the Virgin's
robe, a red glaze was used, allowing the gold
to shimmer through. By contrast, the dark
blue paint used in the execution of the same
technique for the border on the inside of
the Virgin's mantle is completely opaque (see
Figure 24b).

The cloth of honor hanging directly behind
the seated group is made of gold leaf, adhered
to an orange bole and tooled with linear inden-
tations (see Figure 24a). The pattern is com-
pleted with the application of an azurite-rich
paint layer of irregular thickness between
approximately 20 and 50 microns (Figure 26)
that, combined with the inscribed striations,
gives the impression of damask textile.

The red and golden patterned background behind the throne, extending from the top of the panel to the painted floor, was executed in the *corla* (also called *corladura*) technique, in which a transparent colored glaze was applied atop metal leaf (Figure 27). Unfortunately, portions of this passage were damaged before the retable was acquired by the Museum, but the injury does permit an understanding of its application. Although the leaf appears gold, it is in fact silver—now partially converted into silver sulfide—covered by a transparent yellow resinous glaze. The red-orange bole may have been intended to help warm the cool tone of the applied silver leaf. Tooling similar to that on the cloth of honor mimics the texture of a textile, and a translucent red lake glaze was used to complete the damask pattern (Figure 28). A clear organic layer, most likely an aged resinous varnish, was found on top of two layers of glazing and can be most clearly recognized over the red lake in the photomicrograph shown in Figure 28b, taken with ultraviolet illumination.

Glazes applied over silver leaf were often "intentionally colored either to simulate the yellow glow of gold or to create a luminous blue, red, green or other colors with light transmitted through the glaze from the metallic surface underneath."[55] This use of glazed silver leaf on the backdrop may have been a pragmatic choice, a way to cover a large expanse for less than the cost of using gold leaf, while achieving a similar effect. Or perhaps it was an aesthetic decision: an effect intended to visually separate the background from the gold of the figures. A similar technique was used in the *guardapolvos*, where leaf patterns in low relief frame the painted images. In this instance the decorations do not display the flattened appearance of the hem of Saint Anne's mantle mentioned above, suggesting a freehand method of building up *yeso* into a low-relief ornamentation, more akin to *pastiglia*. The *yeso* was coated with an orange bole followed by silver leaf coated with a pigmented glaze, which now appears reticulated

and dull. Atop this gold-colored glaze, details such as veins in the leaves were added with a red glaze.

On the Virgin's robe, the tooled gold is also embellished with a painted pattern. A punchwork design decorates the collar, and the painted

a

b

Figure 24 • *Saint Anne* retable. *Saint Anne with the Virgin and Child*, dedication panel (38.141b): (a) detail showing *embutido* gilding technique for Saint Anne's and the Virgin's halos and the painted brocade pattern in the cloth of honor; (b) detail showing an *embutido* border along the hem of Saint Anne's mantle and an *esgrafiado* gilding technique for the hem of her robe

Figure 25 • *Saint Anne* retable. *Saint Anne with the Virgin and Child*, dedication panel (38.141b). Cross section of a sample from the decorated border along the bottom of the outer hem of Saint Anne's mantle, showing the raised *yeso* used to create the *embutido* decoration. An underdrawing layer is visible between the *yeso* relief and the overall ground preparation. Visible illumination, original magnification 5×

pattern appears black. In cross section, under high magnification, small particles of azurite are bright blue, suggesting that time and possibly the later addition of varnishes or oils may have caused the paint to appear much darker. Rather than interrupting the damask pattern on the Virgin's robe to mimic folds of fabric, a translucent pigmented glaze (now appearing brown) was applied in angular strokes to give the illusion of pleats. The damask pattern appears to have been applied freehand—that is, without the benefit of tracing or stencils. While motifs do recur, there are no exact repeats. Significant portions of the paint have spalled away, often pulling the gold leaf with the paint and exposing the bole beneath. The application of paint to add details to gilding is also seen in Saint Michael's armor (see Figure 5): the silver leaf was embellished with small curved highlights on the chain mail and with reflections on the body armor using white paint, while shadows were added with dark brown brushstrokes and hatching.

Paint Layers

Although the medium was originally listed in museum records as tempera, the application and appearance of the paint layers on the *Saint Anne* retable suggest that it is oil. The fluid, buttery brushstrokes and blended tones seen throughout the retable are more typical of an oil medium than tempera, which usually displays opaque, crisp brushstrokes. FTIR analysis confirms the hypothesis that the retable is painted with an oil medium. Oil was found to be present in samples from a dust guard panel, from the *Saint Michael* panel, and from Saint Anne's green mantle in the *Saint Anne with the Virgin and Child* panel.[56] Py-GC-MS measurements carried out on the *Saint Anne* panel identified the oil as linseed.[57]

While no ultramarine blue was observed, azurite was identified in all the blue samples analyzed. In general, the exceedingly high price of ultramarine meant that it was used only when specified by a patron who could afford the expense; otherwise azurite, a less

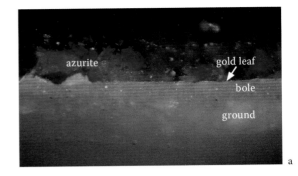

a

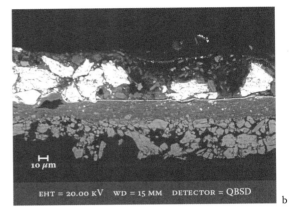

b

brilliant but also far less costly pigment, would be chosen.[58] Several significant contemporaneous paintings from regions neighboring Aragon in the collection of the Museo del Prado have been shown to use only azurite for blue passages, suggesting ultramarine was used rarely.[59] As discussed above, the presence of azurite was confirmed where used in conjunction with gold leaf for the damask pattern on the cloth of honor on the dedication panel (see

Figure 26 ◆ *Saint Anne* retable. *Saint Anne with the Virgin and Child*, dedication panel (38.141b). Cross section of a sample from the cloth of honor showing the use of azurite over gold leaf. This sample does not include the bottom layer of the ground. (a) Visible illumination, original magnification 500×; (b) SEM image showing a bright thin layer of gold leaf over the bole

Figure 27 ◆ *Saint Anne* retable. *Saint Anne with the Virgin and Child*, dedication panel (38.141b). Detail showing patterned background with tooled gilding and red *corla*

THOMAS AND CENTENO

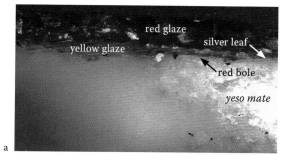

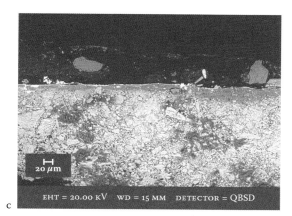

a

b

c

Figure 24a). On the *Miracle of the Gentlemen of Cologne* panel, azurite was mixed with lead white in the blue helmet of the first standing soldier. Azurite was also found in the floor tiles in the same panel. The floor was first prepared with an overall pink layer containing lead white, vermilion, particles of a carbon-based

black, and hematite; dark tiles were finished with reddish-brown glazes containing an addition of azurite for dark veins in the stone, while the lighter tiles were created with a scumble of lead white and a variety of decorations in azurite (Figure 29). Azurite was also identified in the darkened background of the *Virgin of the Rosary* panel, in the borders on all the *cuerpo* panels, and in the blue backgrounds of the *guardapolvos*.

An organic red lake was used throughout the retable not only to embellish the metallic leaves, as discussed above, but also in several other ways. On the *Miracle of the Gentlemen of Cologne* panel, a red lake layer was applied directly over a lead white layer in Mary's dress (Figure 30) and in her wreath of red roses, while for the deeper red cloak of the kneeling soldier in the same panel, the red glaze was painted over vermilion (Figure 31). In this way, subtly different hues of red were achieved; red lake painted atop the reflective white layer resulted in a pinkish, luminous red, while an opaque vermilion underpaint combined with the red lake produced a warmer and darker color. In passages where red lake glaze was used alone over the white ground, underdrawing may often now be seen with the naked eye (see Figure 15c) on account of the pigment's increased transparency and fading over time.

Variations in the way paints were applied also suggest that more than one artist worked on the retable. Such differences in technique and style are most clear in the *guardapolvo* panels. The panels on the left side were painted using a tight, comparatively detailed style, with a greater use of lead white. The thickly applied lead-rich paint causes these panels to appear quite opaque in the radiographs. The hands of the figures depicted here tend to have elongated, tubular fingers (Figure 32a), and their hair is painted with long, winding, deliberate strokes of color (Figure 32b). By comparison, the right side *guardapolvos* were painted with a looser, more blended application of paint and with less reliance on lead white for skin tones and highlights. As a result, the paint

Figure 28 ◆ *Saint Anne* retable. *Saint Anne with the Virgin and Child*, dedication panel (38.141b). Cross section of a sample from an area including red glaze and showing only the *yeso mate*. Photomicrographs taken with (a) visible illumination and (b) ultraviolet illumination, original magnifications 200×; (c) SEM image in which the silver leaf appears as a thin bright layer over the bole

Figure 29 ◆ *Saint Anne* retable. *Miracle of the Gentlemen of Cologne* (38.141e). Cross section of a sample removed from a floor tile at the lower edge of the painting. This sample does not include the ground layer. The white layer over the pink layer at the bottom of the cross section is composed mainly of lead white, and the blue layer at the top contains azurite. Photomicrograph taken with visible illumination. Original magnification 500×

Figure 30 ◆ *Saint Anne* retable. *Miracle of the Gentlemen of Cologne* (38.141e). Cross section of a sample removed from Mary's dress showing the application of a red lake paint directly over a lead white paint layer. The black particles visible over the ground preparation are part of the underdrawing. This sample does not include the bottom layer of the ground. Varnish is visible as a transparent coating on top in (b). Photomicrographs taken with (a) visible illumination and (b) ultraviolet illumination. Original magnifications 200×

Figure 31 ◆ *Saint Anne* retable. *Miracle of the Gentlemen of Cologne* (38.141e). Cross section of a sample removed from the red cloak of the kneeling soldier, showing the application of a red lake glaze over a vermilion paint layer also containing a carbon-based black pigment. This sample does not include the bottom layer of the ground. A transparent organic coating is visible on top in (b). Photomicrographs taken with (a) visible illumination and (b) ultraviolet illumination. Original magnifications 500×

layers on these panels are more radiotransparent. The hands are blockier than on the left side *guardapolvos* (Figure 33a), and the hair is painted with broader, looser strokes, showing less definition of individual strands. Facial features are coarser, with strong highlights and less blended skin tones (Figure 33b).

Distinctions can also be made in the handling of the landscapes and the architecture. In the *Miracle of Monte Gargano*, the landscape has been painted with particular attention to the greenery: the trees are painted in several styles, and some of the trees are fairly detailed, with individual leaves distinguishable. In the *Crucifixion*, trees and bushes have been depicted in a far more summary and generalized manner. On the other hand, the architecture in the *Crucifixion* is nicely detailed with a realistic sense of perspective. By comparison, the tilting buildings depicted in the *Miracle of Monte Gargano* are clumsy in execution and appear awkward.

The remaining *cuerpo* panels show no such clear divisions based on technique, although the paint application in general is closer to the finely detailed manner of the left side *guardapolvos*. While this information does not provide clear insight into the overall division of

a

b

a

b

labor, it is in keeping with practices in a collaborative workshop.

Saint Anne with the Virgin and Child is a fine example of a fifteenth-century Aragonese retable. Unusual in its completeness and relatively undamaged state, the altarpiece is for the most part traditional in its configuration, construction, style, and content. It should also be recognized as one of the only known Spanish retables containing important documentary evidence in the depiction of a curtain used in conjunction with a retable, visible in the *Miracle of the Gentlemen of Cologne* and the *banco* scene of the *Mass of Saint Gregory*.

Although historically categorized as Hispano-Flemish, a dismissive term for a genre cast as essentially derivative, the *Saint Anne* retable is an example of a distinct Aragonese style that arose from an awareness of artistic trends outside of Spain, tempered by Spanish manners and tastes. The probable choice of pine for the supports, the use of esparto grass to reinforce joints, the gilding techniques, and the emphasis on surface decoration are consistent with Aragonese working practices. The arrangement of stepped columns and use of narrow,

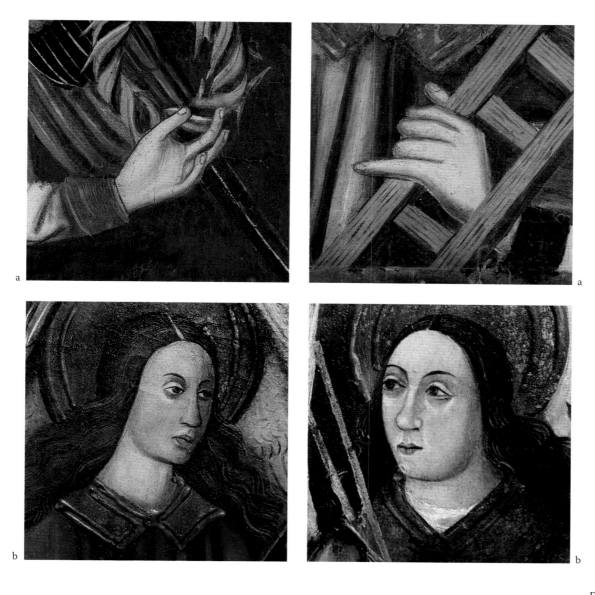

angled *guardapolvos* with painted imagery also reflect the retable's Aragonese origin. Italian techniques are echoed in the use of calcium sulfate in the ground layers, and the inclusion of landscapes implies some influence from neighboring Valencia and elsewhere in Europe. The horizontal crossbars on the reverse of the panels suggest Castilian or Catalan influence, reflecting the transfer of knowledge and taste within Spain or possibly indicating that at least one of the artists had itinerant experience. The depiction of Mudéjar tiles in one panel signifies absorption of Moorish traditions into non-Muslim contexts. Finally, the exuberant use of gilding techniques is typical of the Iberian Peninsula. All these facets add up to a spirited retable that embodies the distinct Aragonese style of the late fifteenth century.

KAREN E. THOMAS

Paintings Conservator
Thomas Art Conservation

SILVIA A. CENTENO

Research Scientist
Department of Scientific Research
The Metropolitan Museum of Art

ACKNOWLEDGMENTS
The authors are grateful to the following individuals at The Metropolitan Museum of Art: Dorothy Mahon, Department of Paintings

Figure 32 ◆ *Saint Anne* retable. (a) *Angel Holding Crown of Thorns and Pincers* (38.141g), from the left side *guardapolvos*, detail showing hand; (b) *Angel Holding Hammer and Nails* (38.141h), also from the left side *guardapolvos*, detail showing face and hair

Figure 33◆ *Saint Anne* retable. (a) *Angel Holding Ladder and Trumpet* (38.141k), from the right side *guardapolvos*, detail showing hand; (b) *Angel Holding Reeds* (38.141i), also from the right side *guardapolvos*, detail showing face and hair

Conservation, for her guidance and wealth of knowledge; Julie Arslanoglu, Department of Scientific Research, for performing the Py-GC-MS analyses; Hae Young Lee, formerly of the Department of Scientific Research, for carrying out the ELISA measurements; Michael Gallagher, Sherman Fairchild Conservator in Charge, Department of Paintings Conservation, and his staff for their support; Lucretia Kargère, Sherman Fairchild Center for Objects Conservation, for generously sharing space and resources at The Cloisters; Peter Barnet, Department of Medieval Art and The Cloisters, and Julien Chapuis, formerly of that department and now at the Skulpturensammlung und Museum für Byzantinische Kunst, Berlin, for permission to treat and examine the retable; Andrew Winslow, Department of Medieval Art and The Cloisters, for photography and for providing repeated access to the dismantled altarpiece; and Alison Gilchrest, Mellon Foundation, formerly Department of Paintings Conservation, for assistance with infrared reflectography. The authors are also indebted to Mark T. Wypyski, Department of Scientific Research, for performing SEM-EDS analyses of the metal leaf decorations. ELISA results are based on work supported by the National Science Foundation under CHE-1041839.

NOTES

1 For an extensive study of fourteenth- and fifteenth-century Spanish retables, see Berg-Sobré 1989.

2 Ibid., p. 10.

3 The only known intervention since the retable entered The Cloisters' collection took place in 2003–4, when all surfaces were cleaned and consolidated and corrective retouching was undertaken.

4 Berg-Sobré 1989, p. 185.

5 Whereas Christ on the Cross refers to a simple iconic image of the crucified Christ, the Crucifixion is more narrative, depicting a scene incorporating additional figures.

6 Berg-Sobré 1989, p. 185.

7 Ibid., p. 184.

8 Ibid., p. 187.

9 Ibid., pp. 185, 187. When a retable contained a single dedication, the *banco* commonly displayed Passion scenes or images of saints. When a *Piedad* was the central image, it was customary to show the mourning Virgin and Saint John the Evangelist to the left and right, respectively.

10 Ibid., p. 184.

11 A *retable mayor* could contain as many as fifty or sixty panels (ibid., p. 3; see also p. 41).

12 The inscription reads SA[B?]EMO A[N] FECHO FAZER LOS MUY ONRADOS MOSE[N] MIGUEL ARMISE[N] IATON INCET ENEL ANYO DEMIL CCCC[L]XX[X?]III (The most honorable Mosén Miguel Armisén and Atón Incet have caused this to be made in the year 1473 [1483?]).

13 Berg-Sobré 1989, p. 100.

14 Nova 1994, pp. 179, 181, 186; Berg-Sobré 1989, pp. 182–83.

15 Berg-Sobré 1989, p. 183.

16 McCorquodale 1994, p. 171.

17 Berg-Sobré 1989, p. 3.

18 Ibid., p. 38.

19 Kroesen 2009, p. 269.

20 Berg-Sobré 1989, p. 236.

21 Ibid.; see also Berg-Sobré and Bosch 1996, p. 9.

22 Berg-Sobré 1989, p. 238; Berg-Sobré and Bosch 1996, p. 10.

23 Berg-Sobré 1989, p. 238. *Embutido* was used earlier in Aragon than in other areas of Spain and in a different manner. While in Catalonia, for example, *embutido* was applied to create patterned backgrounds, Aragonese artists preferred it to decorate garments and to fashion halos and sword hilts in relief (ibid., p. 102).

24 Ibid., p. 238.

25 Ibid., p. 263.

26 Ibid., p. 19.

27 Ibid., p. 48.

28 Hodge et al. 2000, p. 17.

29 Berg-Sobré 1989, p. 23. A particularly confusing situation existed in the city of Calatayud, not far from Teruel, Aragon, between 1465 and 1505. Painters of the Ram family intermarried and collaborated with other local painters, including Pedro de Aranda, Juan Ríus, Bartolomé de Verdeseca, and Jaime Arnaldín, himself the son of the painter Benito Arnaldín, to the extent that distinct styles—even between workshops—are virtually impossible to differentiate (ibid., pp. 20–21).

30 Ibid., p. 21.

31 Ibid.

32 Ibid., p. 22.

33 Hodge et al. 2000, pp. 8–23.

34 Berg-Sobré 1989, p. 51.

35 Véliz 1998, pp. 136–48.

36 Berg-Sobré 1989, p. 51. The unusual example of imported Flemish oak is Lluís Dalmau's *Virgin of the Consellers*, 1443–45, oil on oak, Museu Nacional d'Art de Catalunya, Barcelona (inv. no. 015938-000), which was painted for the chapel of the city hall in Barcelona after Dalmau's trip to Flanders to see the work of Jan van Eyck. While in fifteenth-century Spain oak was sometimes used for small individual panels rather than in retables, most examples of oak panels in Spain date to the sixteenth century.

37 Ineba Tamarit 2001, pp. 350, 352, 472. See also Rodríguez López et al. 2007, pp. 83, 95.

38 A similar crossbar configuration is seen on Bartolomé Bermejo, *Saint Jerome*, Hispanic Society of America, New York (A16), which is thought to be Castilian in origin (Rodríguez López et al. 2007). Berg-Sobré (1989, p. 52) categorizes the crossbar system on the *Saint Anne* retable as Castilian or Catalan,

noting Aragonese retables generally use a vertical center bar with radiating crossbars.

39 Under examination with polarized light microscopy, samples of the fibers showed characteristics consistent with esparto grass.

40 Véliz 1998, p. 139.

41 Ibid., p. 138.

42 For Raman measurements performed on ground layers, pigments, and other materials, spectra were recorded with a Renishaw System 1000 spectrometer, using 785 and 514 nm lasers. The beam was focused on different layers in paint cross sections using a 50× objective attached to the spectrometer, allowing a spatial resolution in the order of 3 microns. A 1200 lines/mm grating was used in conjunction with the 785 nm laser excitation, and a 1800 lines/mm grating was employed with the 514 nm excitation; a thermoelectrically cooled charge-coupled device (CCD) detector was used, with integration times between 10 and 40 seconds and powers between 0.5 and 2.0 mW. All reported pigment identifications are based on Raman analyses unless otherwise indicated.

43 Anhydrite was identified in the ground layers of all samples analyzed. In most Italian and Spanish paintings a layer of *gesso grosso* or *yeso grueso* was first applied on the canvas or wood support, followed by a layer of *gesso sottile* or *yeso mate*. The *yeso grueso* layers were generally composed of coarser gypsum and/or anhydrite. The *yeso mate* was obtained by heating or burning raw gypsum ($CaSO_4 \cdot 2H_2O$) to convert it to so-called plaster of Paris, or calcium sulfate hemihydrate ($CaSO_4 \cdot 1/2\ H_2O$), that would later be slaked in water for a long period of time to produce purer, more porous, and softer gypsum (Gettens and Mrose 1954, p. 174; Santos Gómez et al. 1998, pp. 115–19).

44 FTIR spectra of both samples were acquired in the transmission mode, in one case with a 2 cm^{-1} resolution and 128 scans using a Bio-Rad FTS 40 spectrometer equipped with a UMA microscope, and in the other with a 4 cm^{-1} resolution and 128 to 256 scans using a Hyperion microscope interfaced with a Bruker Vertex 70 spectrometer equipped with a mercury cadmium telluride (MCT) detector. In both cases, the different layers in the samples were mechanically separated, crushed inside a diamond anvil cell, and examined in the range of 4000 to 600 cm^{-1}. The second setup was used for all FTIR analyses except when otherwise indicated.

45 The ELISA method used for all the samples followed a modification of the protocol in Schultz 2006. Following extraction, the samples were tested to determine the presence of collagen I and fish collagen I antigens. These experiments were carried out in triplicate with serial dilutions. Both the *yeso grueso* and the *yeso mate* tested positive for collagen I, the main proteinaceous component in animal glue. The data also suggest that the glue is of mammalian origin, as both *yeso* layers were negative for fish collagen I. The ELISA analyses were carried out by Hae Young Lee. The *yeso* layers were also analyzed by Py-GC-MS and consistently exhibited the presence of compounds characteristic of animal glue and the absence of fatty acids. In both layers, there was also evidence of a small amount of long-chain alkane molecules usually associated with

wax that could be present due to an undocumented intervention. The conditions for the Py-GC-MS measurements cited here are as follows: samples were analyzed with and without derivitization with the agent tetramethyl ammonium hydroxide (TMAH-Py-GC-MS). A Hewlett Packard 6890N gas chromatograph equipped with a Frontier Py-2020iD Double-Shot vertical furnace pyrolyzer fitted with an AS-1020E Auto-Shot autosampler was used. The GC was coupled to an Agilent 5973N single quadrupole mass selective detector. The Py-GC-MS analyses of all samples were carried out by Julie Arslanoglu.

46 Berg-Sobré 1989, p. 52; Pacheco 1986, p. 66; Palomino y Velasco 1986, p. 151.

47 Py-GC-MS and TMAH-Py-GC-MS analysis performed on a sample from the underdrawing showed compounds characteristic of animal glue and no fatty acids. Wax, most likely present due to an earlier conservation treatment, was also detected in the chromatograms.

48 It is possible these panels have thick layers of paint that are not penetrable by infrared radiation, in which case more detailed underdrawings may exist but could not be detected.

49 Fernández-Ladreda Aguadé et al. 2001, p. 238. This distinctive shorthand notation for a face may be a regional norm rather than evidence that a single individual worked on both the Cathedral of Tudela and the *Saint Anne* retables. It is interesting to note, however, that Tudela lies approximately halfway between Teruel, the locale from which the *Saint Anne* retable is believed to have been removed, and Fanlo, the location of the *retablo* by the Armisén Master, which shows distinct similarities to several of the *Saint Anne* panels.

50 Gilding first appears on wood in Northern Europe in the eleventh century but was infrequently used until the twelfth century. Coatings on gilded wood are usually not seen until the thirteenth century (Serck-Dewaide 1991, p. 65; Portell 1992, p. 116).

51 These analyses were performed using an Oxford Instruments INCA analyzer energy dispersive X-ray spectrometer (EDS) equipped with a Link Pentafet SATW detector, attached to a LEO 1455 variable pressure scanning electron microscope (VP-SEM). Analyses were performed on uncoated paint cross sections with the SEM chamber pressurized with 100 Pa of nitrogen to negate charge buildup on the nonconductive materials. A SEM accelerating voltage of 20 kV and a beam current of approximately 0.9 nA were used, with an EDS acquisition rate of approximately 2,000 cps for 200 seconds live-time. The SEM-EDS measurements were carried out by Mark T. Wypyski. SEM-EDS analysis of the gold leafs in the samples removed from the different panels showed that these contain approximately 99% gold and that no silver is present. In the samples where no azurite is present over the gold, it was possible to confirm that the leaf contains traces of copper. The elemental analysis of the silver leaf was more difficult because of its mineralized state; however, it is possible to assert that originally the silver was also relatively pure and that no copper was present.

52 Rodríguez López et al. 2007, pp. 88–89. The retable panel by Bartolomé Bermejo is *Saint Jerome* (see note 38 above).

53 FTIR measurements performed on a sample of the raised *yeso* removed from the gilded decoration along the hem of Saint Anne's green mantle showed the presence of a proteinaceous binder. Py-GC-MS and TMAH-Py-GC-MS analysis demonstrated that this sample contains, in addition to compounds characteristic of animal glue and an absence of fatty acids, a small amount of wax, possibly due to a past conservation treatment. ELISA tests of this sample revealed that the proteinaceous binder contains collagen, from a glue likely to be of mammalian origin as the test for fish collagen I was negative. The FTIR, ELISA, and Py-GC-MS analyses were performed on samples removed as scrapings.

54 FTIR analyses showed that the binding medium in the orange bole is proteinaceous. It was further characterized using ELISA analysis, and collagen I, the main protein in animal glue, was identified. The data also suggest that the glue is of mammalian origin, as the sample tested negative for fish collagen I. These analyses were performed in samples removed as scrapings.

55 Portell 1992, p. 116.

56 In the first two samples, FTIR spectra were acquired using the Bio-Rad FTS 40 spectrometer using experimental conditions similar to those described in note 44 above. The paintings are varnished, so care was taken to remove any such nonoriginal coatings before analysis. The pigment verdigris was also detected in the third sample.

57 TMAH-Py-GC-MS analysis in this green sample showed fatty acid ratios that are consistent with linseed oil and traces of diterpenoid resin, most likely mastic, which could be attributed to residual surface varnish. It is not possible to state whether this varnish is original or is the result of an undocumented treatment.

58 Gettens and FitzHugh 1993, pp. 23–35.

59 Cabrera and Garrido Pérez 1981, pp. 27–48; Garrido Pérez and Cabrera 1982, pp. 15–31.

REFERENCES

Berg-Sobré 1989. Judith Berg-Sobré. *Behind the Altar Table: The Development of the Painted Retable in Spain, 1350–1500*. Columbia: University of Missouri Press, 1989.

Berg-Sobré and Bosch 1996. Judith Berg-Sobré and Lynette M. F. Bosch. "The Artistic Climates of Late Medieval Spain." In Judith Berg-Sobré and Lynette M. F. Bosch, *The Artistic Splendor of the Spanish Kingdoms: The Art of Fifteenth-Century Spain*, pp. 1–12. Exh. cat. Boston: Isabella Stewart Gardner Museum, 1996.

Cabrera and Garrido Pérez 1981. José María Cabrera and María del Carmen Garrido Pérez. "Dibujos subyacentes en las obras de Fernando Gallego." *Boletín del Museo del Prado* 2, no. 4 (1981), pp. 27–48.

Fernández-Ladreda Aguadé et al. 2001. Clara Fernández-Ladreda Aguadé, Alberto Aceldegui Apesteguía, Javier García Vega, Rita Piquero Fernández, Guillermo Torres Llopis, Rocío Bruquetas Galán, Tomás Antelo Sánchez, and Araceli Gabaldón García. *El retablo mayor de la catedral Tudela: Historia y conservación*. Pamplona: Gobierno de Navarra, Departamento de Educación y Cultura, 2001.

Garrido Pérez and Cabrera 1982. María del Carmen Garrido Pérez and José María Cabrera. "El dibujo subyacente y otros aspectos técnicos de las tablas de Sopetrán." *Boletín del Museo del Prado* 3, no. 7 (1982), pp. 15–31.

Gettens and FitzHugh 1993. Rutherford J. Gettens and Elisabeth West FitzHugh. "Azurite and Blue Verditer." In *Artists' Pigments: A Handbook of Their History and Characteristics*, vol. 2, edited by Ashok Roy, pp. 23–35. Washington, D.C., and New York: National Gallery of Art and Oxford University Press, 1993.

Gettens and Mrose 1954. Rutherford J. Gettens and Mary E. Mrose. "Calcium Sulfate Minerals in the Grounds of Italian Paintings." *Studies in Conservation* 1, no. 4 (1954), pp. 174–89.

Hodge et al. 2000. Sam Hodge, Marika Spring, Ray Marchant, and Zahira Véliz. "The Santa Marina Retable from Mayorga, Attributed to the Master of Palanquinos, c. 1490s." *Hamilton Kerr Institute Technical Bulletin* 3 (2000), pp. 7–34.

Ineba Tamarit 2001. Pilar Ineba Tamarit. "Study of the Pictorial Technique through Radiography and Infrared Reflectography." In Fernando Benito Doménech, *La clave flamenca en los primitivos valencianos*, edited by Fernando Benito Doménech and José Gómez Frechina, pp. 335–64. Exh. cat. Valencia: Generalitat Valencia, Consorci de Museus de la Comunitat Valenciana, Museu de Belles Artes de Valencia, 2001.

Kroesen 2009. Justin E. A. Kroesen. *Staging the Liturgy: The Medieval Altarpiece on the Iberian Peninsula*. Louvain: Peeters, 2009.

McCorquodale 1994. Charles McCorquodale. *Renaissance: European Painting, 1400–1600*. London: Studio Editions, 1994.

Nova 1994. Alessandro Nova. "Hangings, Curtains, and Shutters of Sixteenth Century Lombard Altarpieces." In *Italian Altarpieces, 1250–1500: Function and Design*, edited by Eve Borsook and Fiorella Superbi Gioffredi, pp. 177–99. Oxford: Clarendon Press, 1994.

Pacheco 1986. Francisco Pacheco. "Arte de la pintura" (1649). In *Artists' Techniques in Golden Age Spain: Six Treatises in Translation*, edited and translated by Zahira Véliz, pp. 31–106. Cambridge and New York: Cambridge University Press, 1986.

Palomino y Velasco 1986. Antonio Palomino y Velasco. "El museu pictórico y la escala óptica" (1715–24). In *Artists' Techniques in Golden Age Spain: Six Treatises in Translation*, edited and translated by Zahira Véliz, pp. 141–89. Cambridge and New York : Cambridge University Press, 1986.

Portell 1992. Jean D. Portell. "Colored Glazes on Silver-Gilded Surfaces." In *Conservation of the Iberian and Latin American Heritage: Preprints*

of the Contributions to the IIC Madrid Congress, 9–12 September 1992, edited by H.W.M. Hodges, John S. Mills, and Perry Smith, pp. 116–18. London: International Institute for Conservation of Historic and Artistic Works, 1992.

Rodríguez López et al. 2007. Ainhoa Rodríguez López, Narayan Khandekar, Glenn Gates, and Richard Newman. "Materials and Techniques of a Spanish Renaissance Panel Painting." *Studies in Conservation* 52, no. 2 (2007), pp. 81–100.

Santos Gómez et al. 1998. S. Santos Gómez, M. San Andrés Moya, J. L. Baldonedo Rodríguez, O. Conejo Sastre, M. I. Báez Anglio, and A. Rodriguez Muñoz. "Contribution to the Study of Grounds for Panel Painting of the Spanish School in the 15th and 16th Centuries." In *Painting Techniques, History, Materials and Studio Practice: Contributions to the Dublin Congress, 7–11 September 1998*, edited by Ashok Roy and Perry Smith, pp. 115–19. London: International Institute for Conservation of Historic and Artistic Works, 1998.

Schultz 2006. Julia Schultz. "Immunologische Methoden zur Analytik tierischer Bindemittel—Möglichkeiten und Grenzen." MA thesis, HAWK University of Applied Sciences and Arts, Hildesheim, 2006.

Serck-Dewaide 1991. Myriam Serck-Dewaide. "The History and Conservation of the Surface Coating on European Gilded Wood Objects." In Wooden Artifacts Group, American Institute for Conservation of Historic and Artistic Works, *Gilded Wood: Conservation and History*, edited by Deborah Bigelow, Elisabeth Cornu, Gregory A. Landry, and Cornelis van Horne, pp. 65–78. Madison, Conn.: Sound View Press, 1991.

Véliz 1998. Zahira Véliz. "Wooden Panels and Their Preparation for Painting from the Middle Ages to the Seventeenth Century in Spain." In *The Structural Conservation of Panel Paintings: Proceedings of a Symposium at the J. Paul Getty Museum, 24–28 April 1995*, edited by Kathleen Dardes and Andrea Rothe, pp. 136–48. Los Angeles: Getty Conservation Institute, 1998.

PICTURE CREDITS

Unless otherwise indicated, photographs of works in the Metropolitan Museum's collection are by the Photograph Studio, The Metropolitan Museum of Art.

Department of Scientific Research, The Metropolitan Museum of Art: Figures 14, 25, 26a, 28a, 28b, 29–31

Sherman Fairchild Center for Paintings Conservation, The Metropolitan Museum of Art: Figures 2, 10–13, 15–24, 27, 32b, 33b

Mark T. Wypyski, courtesy of the Department of Scientific Research, The Metropolitan Museum of Art: Figures 26b, 28c

Andrew Winslow, courtesy of The Metropolitan Museum of Art: Figures 3–9, 32a, 33a

El retablo de *Santa Ana con la Virgen y el Niño* en The Cloisters: Percepciones sobre las prácticas de trabajo en el Reino de Aragón durante el siglo XV

RESUMEN

El retablo del siglo XV *Santa Ana con la Virgen y el Niño*, donado al Metropolitan Museum of Art en el año 1938, ha tenido solamente intervenciones de conservación o restauración mínimas desde que comenzó a formar parte de la colección del museo. Originalmente perteneciente a una capilla en un monasterio que no ha sido identificado, ubicado en la región de Teruel, España, el retablo esta completo y consiste de seis paneles centrales, siete guardapolvos, un banco con cinco escenas y un pedestal con una inscripción. Varios de los elementos originales de tracería han sido reemplazados. El presente estudio revela detalles de la construcción del retablo y evidencias de colaboración, además de proveer información acerca de las técnicas y los materiales que se usaron. El análisis por reflectografía infraroja mostró la presencia de un extenso dibujo subyacente ejecutado por más de una mano. Se analizaron muestras con el objetivo de identificar los materiales y los métodos usados para lograr diferentes efectos visuales, entre ellos varias técnicas de dorado empleadas en zonas de bajorrelieve.

KAREN E. THOMAS
Thomas Art Conservation

SILVIA A. CENTENO
The Metropolitan Museum of Art

ABSTRACT TRANSLATED BY
SILVIA A. CENTENO

Petrography of Stone Used for Sculpture from the Buddhist Cave Temples of Xiangtangshan Dating to the Northern Qi Dynasty

◆

Janet G. Douglas and John T. Haynes

ABSTRACT

Xiangtangshan in North-Central China is a major Buddhist cave temple complex dating to the Northern Qi dynasty (550–577). Its northern and southern caves once held stone sculptures that were removed from the site, starting in the early twentieth century, and are now in institutional and private collections throughout the world. The 2011 exhibition "Echoes of the Past: The Buddhist Cave Temples of Xiangtangshan" provided an excellent opportunity to study the Freer Gallery of Art's collection of stone sculpture from Xiangtangshan together with related works in other museums. The current study began with petrographic characterization of limestone samples obtained from outside the Northern and Southern Xiangtangshan caves. Systematic description and analysis of the framework grains, cement, matrix, and porosity were then used as a basis for the study of limestone and marble sculptures traditionally associated with these sites. This approach allowed for the proposed sites of origin to be better established for some sculptures and, in a few cases, for specific questions relating to provenience to be addressed. The results, when correlated with attributions based on style and early documentation, will serve as a framework for future study of Buddhist limestone and marble sculpture in museum collections worldwide.

Little has been written about the provenience of stone materials used in Buddhist sculpture from China, so preparation of the 2011 exhibition "Echoes of the Past: The Buddhist Cave Temples of Xiangtangshan" at the Smithsonian Institution's Arthur M. Sackler Gallery in Washington, D.C., provided an excellent opportunity to examine a group of Chinese limestone and marble sculptures currently attributed to Xiangtangshan. These include sculptures on loan from various museums and in the Freer Gallery of Art's collection. Altogether twenty-five objects were included in the detailed petrographic investigation reported here (Table 1).

The Buddhist cave temple sites at Xiangtangshan have great artistic and historical value. The images in these cave temples include those carved directly into the "living rock" and others that are freestanding, carved either from blocks of local stone or from blocks quarried elsewhere and brought to Xiangtangshan. Unfortunately, many of the sculptures now in museum collections were removed from the cave temples in the early twentieth century,[1] and information about their original locations has been lost. This study, undertaken as the sculptures were prepared for exhibition, was intended to augment art-historical studies aimed at reconstruction and recontextualization of the Xiangtangshan cave temples.

Table 1 • Checklist of Sculptures in Current Study

Object	Original Location at Temple Site	Sample Location
Northern Xiangtangshan: Sculptures Thought to Have Been Integral		
Head of a Buddha, Freer Gallery of Art (F1913.67)	South Cave	Right side of broken neck
Head of Disciple Ananda, Freer Gallery of Art (F1913.134)	South Cave	Rough back near top of head
Kneeling winged monster, Freer Gallery of Art (F1916.345) (see Figure 7)	Middle Cave	Right leg area
Kneeling winged monster, Freer Gallery of Art (F1953.86)	North Cave	Upper area of rough back
Kneeling winged monster, Freer Gallery of Art (F1953.87)	North Cave	Left side
Kneeling winged monster, Freer Gallery of Art (F1977.8)	North Cave	Back on right side
Kneeling winged monster, Freer Gallery of Art (F1977.9)	North Cave	Left side
Head of a bodhisattva attendant of Maitreya, University of Pennsylvania Museum of Archaeology and Anthropology (C353)	North Cave	Right side on rough back
Head of a bodhisattva, University of Pennsylvania Museum of Archaeology and Anthropology (C354)	North Cave	Right side on rough back
Head of a Buddha, possibly Prabhutaratna, Buddha of the Past, Victoria and Albert Museum (A.98-1927)	North Cave	Rough back of head
Northern Xiangtangshan: Freestanding Sculptures		
Seated bodhisattva, Freer Gallery of Art (F1913.57) (see Figure 8)	North Cave	Back bottom edge of base
Seated Buddha, Victoria and Albert Museum (A.4-1924)	North Cave	Back bottom edge of base
Stela, University of Pennsylvania Museum of Archaeology and Anthropology (C429) (see Figure 9)	Unknown location; thought to have been carved at or near Northern Xiangtangshan	Bottom of base
Northern Xiangtangshan (provisional association): Funerary Couch (*shichuang*)		
Funerary couch base, Freer Gallery of Art (F1915.110) (see Figure 13)	Unknown location; possibly Middle Cave	Central back area near base
Funerary couch cornice, Freer Gallery of Art (F1915.109)	Unknown location; possibly Middle Cave	Rough edge
Funerary couch cornice, Freer Gallery of Art (F1915.336)	Unknown location; possibly Middle Cave	Rough edge
Southern Xiangtangshan: Sculptures Thought to Have Been Integral		
Head of a Buddha, Freer Gallery of Art (1913.135)	Possibly Caves 4–6	Broken surface of neck
Gathering of Buddhas and Bodhisattvas, Freer Gallery of Art (F1921.1)	Cave 2, upper part of west (front) face of central pillar	Upper left edge near repair
Western Paradise of the Buddha Amitabha, Freer Gallery of Art (F1921.2) (see Figure 11)	Cave 2, interior wall above cave temple entrance	Right edge
Southern Xiangtangshan: Freestanding Sculptures		
Standing bodhisattva, Freer Gallery of Art (F1968.45)	Possibly Cave 2	Back of figure in waist area
Standing Bodhisattva Avalokitesvara (Guanyin), University of Pennsylvania Museum of Archaeology and Anthropology (C113)	Cave 2	Bottom of tang
Standing bodhisattva, possibly Mahasthamaprapta, University of Pennsylvania Museum of Archaeology and Anthropology (C150)	Cave 2	Bottom of tang
Standing Pratyekabuddha, University of Pennsylvania Museum of Archaeology and Anthropology (C151)	Possibly Cave 2	Bottom of tang
Standing bodhisattva, Virginia Museum of Fine Arts (56.9.2) (see Figure 12)	Possibly Cave 1	Bottom of tang
Head of Bodhisattva Mahasthamaprapta (Dashizhi), Freer Gallery of Art (F1916.346)	Possibly Caves 4–6	Broken surface of neck

Note: Historical evidence pointing to the origin of these objects from specific locations at the Xiangtangshan sites is given in Wilson and Wang 2010; images and previous citations appear in catalogue entries in Tsiang 2010.

As the majority of sculptures from Xiang-tangshan were carved directly into living rock, the first step in this petrographic investigation was to collect and study typical samples of the stone from these sites. Petrographic analysis of limestone entails the systematic description of the four components—framework grains, cements, matrix, and porosity. Marbles are characterized by features such as color, overall texture, primary grain shape, and maximum grain size. Other analytical methods were used as needed, including scanning electron microscopy (SEM) and cathodoluminescence (CL) microscopy. This approach allowed for the proposed sites of origin of the sculptures to be better established and, in some cases, for specific questions about provenience to be addressed.

HISTORICAL BACKGROUND

The Xiangtangshan cave temples in North-Central China (Figure 1) date to the Northern Qi dynasty (550–77) and are known to have contained unsurpassed examples of Buddhist stone sculpture of this period.[2] The cave temples are located at two principal sites. Northern Xiangtangshan is high on a slope on Gushan (or Drum) Mountain next to the village of Hecun, in Wu'an County, Hebei Province. Its three main caves, referred to as North, Middle, and South, are the largest in scale and the earliest of the Xiangtangshan caves of the Northern Qi. They are associated with the Gao royal family, and the site was a stopping place between the capital Ye and the family base of Jinyang, near present-day Taiyuan, Shanxi Province. Dating is based largely on inscriptions carved in stone at the cave sites and on other historical evidence. An important inscription was found on a stone stela at the site of the Changle Temple, which appears to have been established during the Northern Qi period, or earlier, at the base of Gushan Mountain. The stela itself was carved later, during the Jin dynasty (1115–1234), when many Buddhist caves were repaired and expanded, and it supplies some detailed information on the origins and construction of the Xiangtangshan caves. The inscription attributes the earliest construction at Northern Xiangtangshan to Emperor Wenxuan, Gao Yang (529–559), the first emperor of the Northern Qi.

Southern Xiangtangshan, sometimes called the Fushan Caves, is about 15 kilometers southeast, near the town of Fengfeng, Henan Province, on the north bank of the Fuyang River. It consists of six caves on two levels—Caves 1 and 2 on the lower level and Caves 3–6 above. An inscription on the carved facade of Cave 2 dates the planning and beginning of construction at the site to 565.

Understanding of these complex sites is still evolving as scholars try to identify when and which sculpted works might have originated there.[3] Much of what is known about Chinese

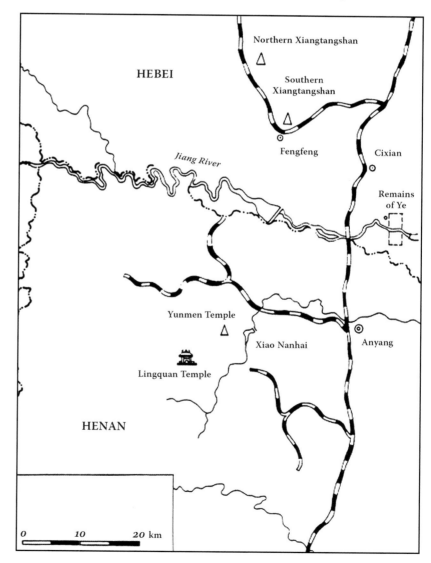

Figure 1 • Map of Northern Qi sites in Hebei and Henan Provinces, from Howard 1996, adapted from *Henansheng gudai jianshu baohu yanjiusuo: Baoshan Lingquansi* (Anyang: Henan wenwu chubanshe, 1991), p. 127, fig. 1

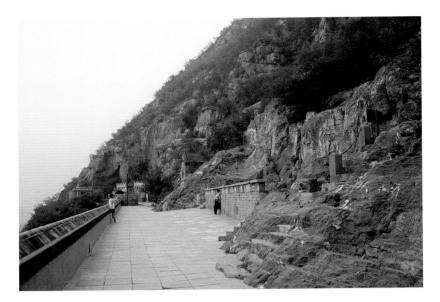

Figure 2 ◆ Exterior of the Buddhist cave temples at Northern Xiangtangshan, Gushan Mountain, Hebei Province

Figure 3 ◆ Exterior of the Buddhist cave temples at Southern Xiangtangshan, Henan Province

Buddhist cave sites was first recorded between 1909 and 1915 by the French sinologist Édouard Chavannes. His *Mission archaéologique dans la Chine septentrionale* (1913–15) includes detailed photographs and descriptions of many Buddhist sites, especially Yungang, Longmen, and Gongxian.[4] Unfortunately, his book led not only to further scholarly study but also to an interest in collecting Buddhist sculpture. Probably around 1910, sculptures began to be removed from Xiangtangshan, leaving the caves severely damaged. Pieces first appeared on the international art market at that time or shortly thereafter, and C. T. Loo has been recognized as a prominent supplier.[5] Chavannes

did not visit or document either Xiangtangshan site, and the caves there were not surveyed until 1922.[6] With the publication of Osvald Sirén's *Chinese Sculpture from the Fifth to the Fourteenth Century* in 1925, modern appraisal of the sculptures and the caves from which they presumably came began.[7]

GEOLOGICAL SETTING

Xiangtangshan is located on the North China Platform, which consists of Lower Cambrian to Upper Ordovician strata that were deposited over a large area, extending about 1,500 kilometers east to west and 1,000 kilometers north to south. It is dominated by shallow-water limestones and dolomites of Early Cambrian age, approximately 542 to 513 million years ago. The geologic setting of the Xiangtangshan sites is not well documented, but the limestones there may belong to the Gushan Formation near Handan, Hebei, which consists primarily of late Middle to Late Cambrian tidal-flat limestones and dolomites, some with well-developed paleo-karst surfaces.[8]

ANALYTICAL METHODS

Representative limestone samples, 4–10 centimeters long, were obtained from the Buddhist cave temple sites with the cooperation of Zhang Lintang, Office for the Management and Preservation of Cultural Properties, Fengfeng Mining District, Hebei, China. These samples were taken from the natural stone outcrops outside of the cave openings (Figures 2, 3)—either from loose material or from areas already damaged—so as not to cause further degradation of the heavily decorated cave interiors. For this study, thirteen stone samples were taken from each site.

Stone samples were also obtained from sculptures in museum collections traditionally associated with the sites, although these samples were typically much smaller. They were removed from inconspicuous locations, usually in areas of previous loss. Prepared thin sections were analyzed using standard petrographic methods,[9] and SEM was used to further characterize the textures and the elemental composition of specific

grains, matrix, and naturally precipitated cements. (See the glossary for definitions of these and other technical terms, pages 111–12.)

A pilot study of instrumental neutron activation analysis (INAA)[10] and stable isotope ratio analysis[11] was undertaken to determine whether these techniques, which have been applied elsewhere in geological provenience studies of limestone and marble sculpture, would be fruitful in the case of Buddhist sculpture from China. Neither technique was found to be a useful discriminating technique for Xiangtangshan limestones.[12] Selected thin sections were also studied using CL at 15 kV and 0.5 μA using standard methods.[13]

LIMESTONE CLASSIFICATION

Limestone classification systems based on petrography are well established. The accurate identification of grains, textures, and other features is critical to the systematic naming of carbonate rocks, and for this study the comprehensive atlas–style guide of Scholle and Ulmer-Scholle was an indispensable reference.[14] Four principal components of limestones and related carbonate rocks are: (1) calcareous framework grains of both skeletal and non-skeletal origin, (2) cement, (3) a carbonate or siliciclastic matrix, and (4) primary or secondary pores that tend to occur in carbonate rocks within and/or between framework grains, cement, and matrix.[15]

The two most widely used limestone classification systems are those devised by Robert J. Dunham of the Shell Development Company[16] and Robert L. Folk at the University of Texas.[17] Both assign much significance to the presence or absence of matrix and to the texture and composition of framework grains because of their implications in limestone formation, with regard to the depositional environment and subsequent diagenetic changes. The Dunham classification system divides limestones on the basis of whether they are grain-supported or matrix-supported (Table 2). The basic names in the Dunham classification system (grainstone, packstone, wackestone, lime mudstone) can be

modified by qualifying terms based on the petrographic identification of their textural components, which readily provide information on composition and origin. Both the Folk and the Dunham systems have strengths and weaknesses, but the Dunham system tends to be more widely accepted by carbonate petrographers and is used in this study.

DOLOMITIZATION OF LIMESTONES

Limestones are very susceptible to postdepositional alteration, especially recrystallization, with the sum of these processes known as diagenesis. One particularly important diagenetic process is dolomitization, which can take place in a variety of postdepositional environments.[18] By this process, calcite or aragonite, the primary minerals of carbonate sediments, are partly or completely replaced by dolomite, which almost always occurs as a secondary mineral. One reason dolomitization occurs is that aragonite and high-magnesium calcite, having formed via biomineralization to build and maintain the skeletal components of calcareous organisms in the marine environment (e.g., corals, mollusks, echinoderms, calcareous algae), are metastable or unstable both over time and at the higher temperatures and pressures that accompany burial, compaction, and the ultimate lithification of carbonate sediments.[19]

Dunham's classification system, published in 1962, referred to recrystallized carbonate rocks simply as "crystalline limestone." Since that time, appreciation and understanding of the diagenetic effects on limestone textures have advanced significantly, and revisions have been proposed by A. F. Embry and J. E. Klovan[20] and by V. P. Wright.[21] Wright's expanded classification system proposes using "cementstone" and "sparstone" along with other descriptive subcategories to aid in the identification and classification of carbonate rocks that have recrystallized. He further appreciated the importance of identifying whether the original depositional texture in limestone could be recognized or if it had been completely obliterated

by recrystallization, and if so, whether the recrystallization process had involved dolomitization. His 1992 revision and expansion of the Dunham classification system is important to the work reported herein because some Chinese Buddhist sculptures are carved from limestone that has been moderately to extensively dolomitized.

MARBLE CLASSIFICATION

In this study, all but one of the figures thought to have been freestanding were carved of fine-grained marble of very low metamorphic grade. Thin sections were characterized based on methods adapted by Lorenzo Lazzarini[22] and on various studies on ancient marble quarry sources and sculpture incorporating petrographic methods described by Chandra L. Reedy.[23] Characterization is based on features such as color, overall texture, primary grain shape, and maximum grain size. Further analysis by SEM was used to determine grain composition and accessory mineral content.

GEOLOGICAL SAMPLES FROM THE XIANGTANGSHAN CAVE TEMPLE SITES

NORTHERN XIANGTANGSHAN LIMESTONES

Petrographic analysis of the geological samples of limestones from Northern Xiangtangshan shows that they are primarily peloidal oolitic grainstones (Figure 4) that have been partly dolomitized but retain many important details of their original depositional texture. The majority of the framework grains are oolites that range in size from 0.5 to 1.5 millimeters in diameter. Most oolites are oval to irregular in shape with no other particular distinguishing features. Some have a distinct and obvious bioclastic fragment as a core. Also present are larger aggregates, known as grapestones, made up of oolites and other grains bound by an early generation of cement that precipitated shortly after deposition. Other framework grains in these limestones include fragmented bioclastic debris, specifically trilobite, brachiopod,

Table 2 • Limestone Classification System

Fabric Category	Rock Name
Depositional Fabric	
Matrix-supported (clay and silt grade < 62.5 μm)	
< 10% grains	Calci-mudstone (or lime mudstone)
> 10% grains	Wackestone
Grain-supported	
With matrix	Packstone
No matrix	Grainstone
Biological Fabric	
In situ organisms (fossils)	
Encrusting binding organisms	Boundstone
Organisms acted to baffle	Bafflestone
Rigid organisms dominant	Framestone
Diagenetic Fabric	
Nonobliterative	
Main component is cement	Cementstone
Many grain contacts are microstylolites	Condensed grainstone
Most grain contacts are microstylolites	Fitted grainstone
Obliterative	
Crystals > 10 μm	Sparstone
Crystals < 10 μm	Microsparstone

Source: Dunham 1962, adapted by Wright 1992.

pelmatozoan, and bryozoan fragments of vary-ing shapes and sizes, as well as peloids and cal-careous clasts up to 4.0 millimeters in length, some with micritized rims.

The primary pore spaces between the frame-work grains have been completely filled by mosaics of calcite spar that in thin section appear unlike the oolites in morphology as well as in color. Whereas most oolites are pale brown, the calcite spar infill is nearly colorless. Some pores were initially reduced in number and size by precipitation of acicular calcite cement, the texture of which has survived recrystallization.

Postdepositional diagenetic features are common in the Northern Xiangtangshan peloidal oolitic grainstones, particularly the evidence of dolomitization (Figure 5). Many of the oolites have been partly to extensively replaced by small clusters of dolomite rhombs. This replacement was selective, as it appears to have targeted the oolites much more than the calcite spar cement that now fills the inter-granular pore spaces. In addition, stylolites and associated solution seams occur in several thin sections of the Northern Xiangtangshan lime-stones, and they are accentuated by the accu-mulation of opaque carbonaceous matter and/or other insoluble residues along their paths.

SOUTHERN XIANGTANGSHAN LIMESTONES

The geological samples of limestone from the Southern Xiangtangshan site are primarily sparsely fossiliferous lime mudstones that consist mostly of micrite (Figure 6a). This micrite is calcareous rather than dolomitic, as

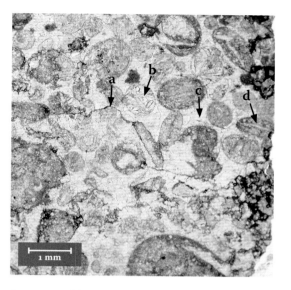

Figure 4 ◆ Peloidal oolitic grainstone from Northern Xiangtangshan (sample NX2), photomicrograph showing typical oolitic texture. Characteristics include: (a) stylolite; (b) dolomitized oolite; (c) calcite spar cement; (d) shell fragment core inside an oolite.

determined by standard staining methods.[24] The few framework grains in these lime mud-stones from Southern Xiangtangshan are typi-cally bioclasts and rare silt-size quartz grains. The bioclasts include thin, often fragmentary shells of ostracodes, trilobites, and brachio-pods. Together, the bioclasts and quartz grains typically make up less than 5 percent of the Southern Xiangtangshan limestone samples.

The most significant nonmicritic component of these mudstones is the very numerous sub-hedral to euhedral "rice-shaped," or commonly rhombohedral, crystals of dolomite about 0.01–0.05 millimeters in length (Figure 6b). Generally they occur as isolated grains and occasional clusters in the micrite. Their shape and orientation indicate that they are pseudo-morphic, and therefore secondary, after gyp-sum and anhydrite crystals that nucleated and grew within the original lime mud of the depo-sitional environment. Gypsum and anhydrite

Figure 5 ◆ Limestone from Northern Xiangtangshan (sample NX4), photo-micrographs taken in nearby areas in a thin section showing localized effects of dolomitization on its oolitic texture: (a) incipient dolomite formation; (b) approxi-mately 50 percent dolomi-tization (note stylolite); (c) near-complete dolo-mitization with oolite ghosts remaining

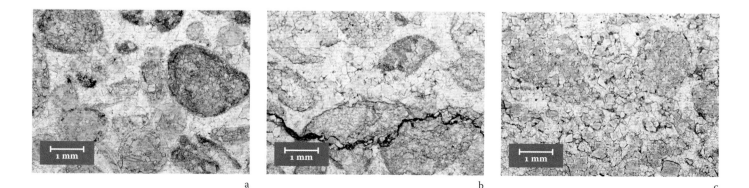

a　　　　　　　　　　　　b　　　　　　　　　　　　c

Figure 6 ◆ Lime mudstone from Southern Xiangtangshan (sample SX2), photomicrographs illustrating: (a) typical fine-grained texture and fractures with calcite spar infill; (b) "rice-grain" texture that is the result of secondary dolomite replacing original gypsum crystals in the depositional environment

a

b

are common primary or very early diagenetic minerals in calcareous muds that deposit along modern semiarid to arid coastlines, for example, in the mudflats on the south and southwest coasts of the Persian Gulf,[25] and they are also seen in ancient limestones composed of lithified sediments formed in similar depositional environments. As with the lime mudstones from Southern Xiangtangshan, at some time after deposition dolomite formed through pseudomorphic replacement of gypsum and anhydrite.[26]

The lime mudstones from Southern Xiangtangshan are also finely laminated. In thin section these laminations are delineated by minute compositional and textural differences that reflect varying proportions of small dolomite rhombs and micrite.

Sometime after lithification, the lime mudstone was severely fractured through stresses associated with geologic deformation. As can be seen in Figure 6a, these fractures have been filled by veins of calcite spar. Another important feature seen in many samples is evidence of postdepositional leaching associated with increased porosity. This leaching may be the result of karst processes and/or of limestone dissolution caused by accelerated weathering that is perhaps attributable to air pollution. Both fracturing and postdepositional leaching have led to inherent weakness, which is reflected in the generally poor condition of the

stone outside the entrance to the Southern Xiangtangshan caves.

STONE SAMPLES OF BUDDHIST SCULPTURE ATTRIBUTED TO XIANGTANGSHAN

PELOIDAL OOLITIC GRAINSTONES

All ten sculptures thought to have been carved in the living rock in the Northern Xiangtang-shan caves are peloidal oolitic grainstones or their dolomitized equivalents. An example is the Freer Gallery's kneeling winged monster (F1916.345), which appears to have been removed from the right corner of the main altar of the central pillar in the Middle Cave (Figure 7a).[27] As seen in the photomicrograph of a thin section (Figure 7b), the limestone consists of irregularly shaped oolites with few peloids, some of which are more than 2 millimeters long. Calcite spar fills the pore spaces between these grains, and some dolomitization has occurred, as evidenced by the clusters of dolomite rhombs throughout the sample.

Among the freestanding statues attributed to Northern Xiangtangshan is a seated bodhi-sattva in the Freer Gallery (F1913.57; Figure 8a) that is thought to have been placed in a niche in an interior wall of the North Cave. Petrographic study shows that it is carved from a similar, partially dolomitized peloidal oolitic grainstone (Figure 8b). Comparable results were reported for a seated Buddha (A.4-1924)

in the collection of the Victoria and Albert Museum, also thought to be from a wall niche inside the North Cave.[28] In both cases, the lithologies are consistent with the geological limestone samples from the Northern Xiangtangshan site, supporting the hypothesis that it was carved from the local stone.

Another important freestanding object, a stela in the University of Pennsylvania Museum of Archaeology and Anthropology (C429; Figure 9a), is thought by some scholars to have been carved at or near Northern Xiangtangshan and placed at an unknown location near Taiyuan, Shanxi Province, about 400 kilometers northwest, during the Northern Qi dynasty. An inscription on the stela includes this passage, "Having obtained from afar precious material from lonely mountain caves and having consulted the best workers nearby," which scholars believe refers to Northern Xiangtangshan.[29]

Petrographic study shows that this stela is carved from a peloidal oolitic grainstone that is again quite similar in texture to the grainstones at Northern Xiangtangshan (Figure 9b), suggesting that it originates from the same geological formation as the grainstones of Northern Xiangtangshan. Furthermore, a macroscopic textural feature known as lenticular bedding links this stela to the native stone of the Northern Xiangtangshan site (Figure 9c), which in some locations is characterized by lenticular bedding (Figure 10). This distinctive type of layering is consistent with sedimentary structures that form in modern arid tidal flats,[30] where repeated cycles of quieter, evaporative periods alternate with flooding and where mats of cyanobacteria (blue-green algae) form.

LIME MUDSTONES

Two wall reliefs in the Freer Gallery—*Gathering of Buddhas and Bodhisattvas* (F1921.1) and *Western Paradise of the Buddha Amitabha* (F1921.2; Figure 11a)—are originally from the Southern Xiangtangshan site. *Western Paradise of the Buddha Amitabha* was removed from the exterior wall of Cave 2, just above its entrance, which is now reconstructed

Figure 7 ◆ (a) Kneeling winged monster. China, Hebei Province, Northern Xiangtangshan, Northern Qi dynasty (550–77). Limestone, H. 88.4 cm (34 13/16 in.), W. 47.3 cm (18 5/8 in.), D. 28.5 cm (11 1/4 in.). Freer Gallery of Art, Smithsonian Institution, Washington, D.C., Gift of Charles Lang Freer (F1916.345); (b) photomicrograph showing texture of peloidal oolitic grainstone

a

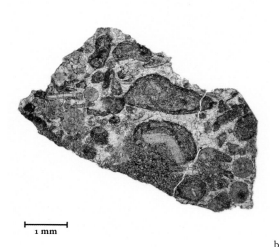

1 mm

b

Figure 8 ◆ (a) Seated bodhisattva. China, Hebei Province, Northern Xiangtangshan, Northern Qi dynasty (550–77). Limestone, H. 118.0 cm (46½ in.), W. 75.7 cm (29¾ in.), D. 47.3 cm (18⅝ in.). Freer Gallery of Art, Smithsonian Institution, Washington, D.C., Gift of Charles Lang Freer (F1913.57); (b) photomicrograph showing texture of peloidal oolitic grainstone

with modern bricks. The limestone is a very fine-grained lime mudstone (Figure 11b) consistent in texture with samples from outside the caves at Southern Xiangtangshan. Few framework grains are present, and the rare bioclasts are fragmentary. The matrix contains numerous "rice-shaped" crystals of secondary dolomite. Like the geological samples, this lime mudstone is also heavily fractured, with the fissures now filled by calcite spar.

MARBLES

Six freestanding figures listed in Table 1, including a head of Bodhisattva Mahasthamaprapta (Dashizhi) (Freer Gallery of Art, F1916.346) thought to be from a standing figure, constitute a significant assemblage of freestanding sculpture traditionally attributed to Southern Xiangtangshan. With the possible exception of the bodhisattva head,[31] all were found to be composed of a similar fine-grained marble. These sculptures have the outward appearance of limestone, with fine layering that appears to be sedimentary in origin, and several had been previously identified as limestone in museum records. The metamorphic grade of this stone is sufficiently low that it would also be correct to classify it as a sedimentary rock, a recrystallized limestone called sparstone in Wright's amended Dunham classification scheme, but herein the stone is classified as fine-grained marble.

The primary sedimentary texture of this marble has been largely obliterated through recrystallization. The stone is calcite-rich with minor amounts of rhombohedral dolomite, and minor accessory euhedral pyrite was observed in most thin sections. Calcite crystal boundaries tend to be curved or embayed, although straight and occasional sutured boundaries were also observed. The maximum grain size in the individual specimens falls between 0.88 and 1.60 millimeters.[32] The marble has a mosaic

a

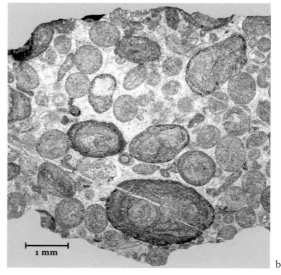

1 mm

b

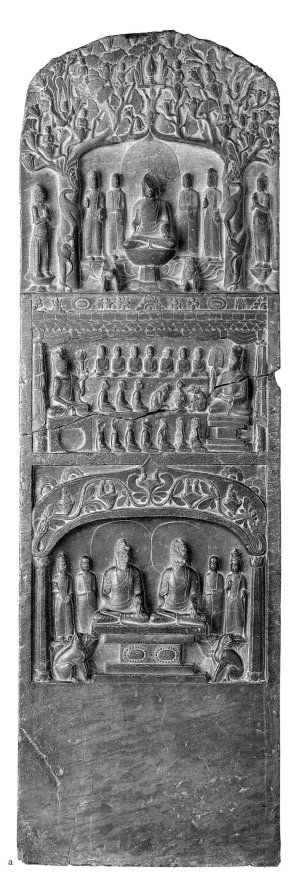

a

b

c

Figure 9 ✦ (a) Stela. Provenience unknown, Northern Qi dynasty (550–77), dated 575. Limestone, H. 213.5 cm (84 in.), W. 25.5 cm (10 in.), D. 62.0 cm (24⅜ in.). University of Pennsylvania Museum of Archaeology and Anthropology (C429); (b) photomicrograph showing texture of peloidal oolitic grainstone; (c) detail of base (obverse) with lenticular bedding

texture, with a fabric that ranges from heteroblastic to homeoblastic. Occasional fine stylolites are present.

An example of this marble is the Virginia Museum of Fine Arts' standing bodhisattva (56.9.2; Figure 12a). In thin section, this fine-grained stone is seen to be composed of a grayish mosaic of calcite crystals on average 0.60 millimeters in length, with minor rhombohedral crystals of dolomite (Figure 12b). The texture is obliterative with no remaining evidence of its prediagenetic appearance. No outlines of oolites, bioclasts, or mineralogically distinct domains remain that might allow for reconstruction of the depositional and early diagenetic history. The texture and composition of the fine-grained marble are dissimilar to those seen in other dolomitized or otherwise recrystallized limestones of Northern and Southern Xiangtangshan, which usually retain important clues to their original character, as described above.

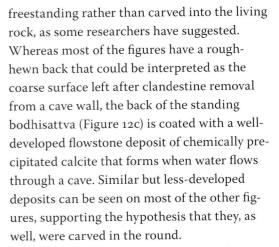

Figure 10 ♦ Life-size "impression" of the Buddha's hand on the south exterior wall at Northern Xiangtangshan, polished smooth intentionally or through wear, revealing characteristic lenticular bedding

Figure 11 ♦ (a) Detail of *Western Paradise of the Buddha Amitabha*. China, Henan Province, Southern Xiangtangshan, Northern Qi dynasty (550–77). Limestone, H. 159.3 cm (62¾ in.), W. 334.5 cm (131⅝ in.). Freer Gallery of Art, Smithsonian Institution, Washington, D.C., Gift of Charles Lang Freer (F1921.2); (b) photomicrograph showing fine-grained, thinly laminated texture of mudstone with calcite spar–filled fractures

The remaining standing figures display similar petrographic characteristics, suggesting they might have been carved from a similar or the same marble. The stone is quite unlike the heavily fractured lime mudstone of Southern Xiangtangshan, which may have been unsuitable for creating three-dimensional sculpture. The Virginia Museum's standing bodhisattva is also important because it shows some of the strongest evidence that these figures were

freestanding rather than carved into the living rock, as some researchers have suggested. Whereas most of the figures have a rough-hewn back that could be interpreted as the coarse surface left after clandestine removal from a cave wall, the back of the standing bodhisattva (Figure 12c) is coated with a well-developed flowstone deposit of chemically precipitated calcite that forms when water flows through a cave. Similar but less-developed deposits can be seen on most of the other figures, supporting the hypothesis that they, as well, were carved in the round.

A second significant subgroup of sculpture in the Freer Gallery carved from fine-grained marble includes a funerary couch base (F1915.110) and two cornices (F1915.109, F1915.336), thought to be elements of a single couch (*shichuang*) with both Central Asian and Chinese Buddhist motifs. Following initial research undertaken by the Museum für Ostasiatische Kunst in Cologne in the early 1970s, a possible connection to Xiangtangshan was proposed.[33] A more recent evaluation of the historical and stylistic evidence has suggested that these fragments come from the funerary couch that was in a niche in the Middle Cave of Northern Xiangtangshan.[34] Whereas ongoing research of these three elements as well another five in other museum collections supports the theory that they originally were part of the same couch, its association with Northern Xiangtangshan

a

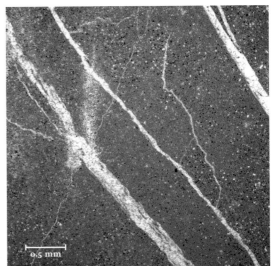

0.5 mm

b

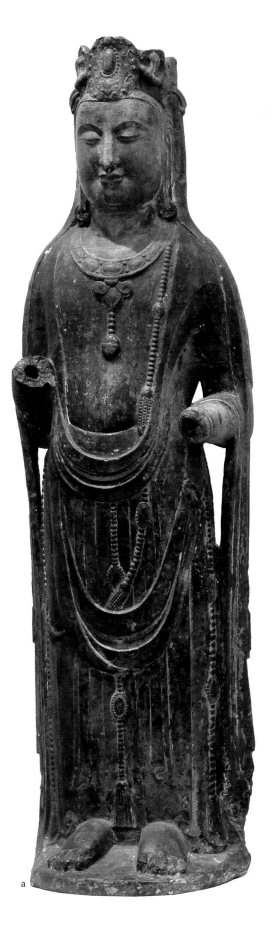

remains to be established. Regardless, the petrographic examination of the stone material of these objects is of interest here.

Figure 13 shows the funerary couch base (F1915.110) along with a photomicrograph demonstrating that it is a fine-grained marble. Thin sections from the cornices show features similar to the funerary couch base, supporting other evidence that the three pieces were carved from the same type of stone, possibly from the same quarry. Yet neither the free-standing figures nor the funerary couch elements were carved from the limestone characteristic of the Xiangtangshan caves from which they are said to have originated. The evidence indicates that these objects were worked from stone obtained from a geological source other than the Xiangtangshan sites, but we currently do not know whether they were carved there or at a different location. The similarity of the

Figure 12 ◆ (a) Standing bodhisattva. China, Henan Province, Southern Xiangtangshan, Northern Qi dynasty (550–77). H. 170.1 cm (67 in.), W. 41.9 cm (16½ in.), D. 28.0 cm (11 in.). Virginia Museum of Fine Arts, Richmond, Adolph D. and Wilkins C. Williams Fund (56.9.2); (b) thin section that displays the texture of a fine-grained marble, although the sculpture is described as limestone in museum records; (c) detail of reverse showing flowstone deposit from the cave environment

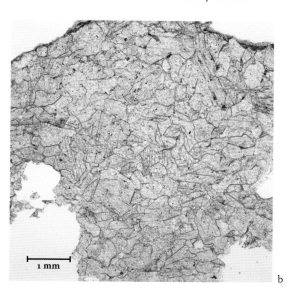

1 mm

b

c

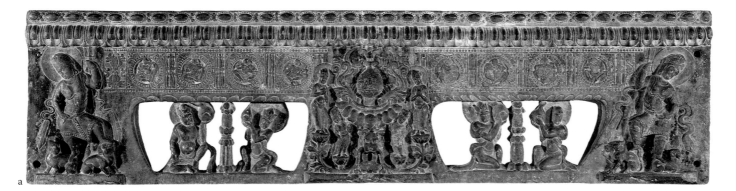

a

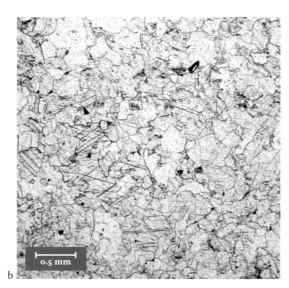

b

Figure 13 ◆ (a) Funerary couch base. China, possibly Northern Xiangtangshan, Northern Qi dynasty (550–77). Gray marble, H. 60.3 cm (23¾ in.), W. 234.0 cm (92⅛ in.), D. 23.5 cm (9¼ in.). Freer Gallery of Art, Smithsonian Institution, Washington, D.C., Gift of Charles Lang Freer (F1915.110); (b) photomicrograph showing fine-grained texture

0.5 mm

fine-grained marble in the standing figures and the elements of the funerary couch suggest a common provenience of the marble itself, a possible connection that deserves to be explored.

ANALYSIS BY CATHODO-LUMINESCENCE MICROSCOPY

Cathodoluminescence (CL) microscopy is an imaging technique for examining thin sections using an optical microscope with a CL-stage attachment. CL emission is achieved by bombarding a material with an electron beam from a cathode ray tube. Emissions from some minerals reveal textures and compositional variations that are not otherwise evident with visible light. Carbonate minerals such as calcite and dolomite, when thus exposed, emit visible light at wavelengths reflecting the presence of impurities within their crystal structure that can be used to recognize differences in trace

elemental composition. CL microscopy allows spatial variations to be recorded and is a reliable discriminant technique that can be rapidly performed.

Selected samples from both temple caves and the sculptures were studied using CL microscopy to determine whether this technique could yield further information that might help identify and differentiate the limestones from one another. In carbonates, manganese (Mn^{2+}) is often a main activator of CL emission. In calcite and dolomite, manganese tends to produce orange and red emissions, respectively, at around 620 and 660 nanometers. Other colors can occur depending on the presence of additional trace element activators, such as rare earth elements, or other factors, such as crystal growth kinetics. In general, trace amounts of iron (ferrous, Fe^{2+}, and ferric, Fe^{3+}) act to dampen or completely quench the CL signal. Some experimental evidence suggests that for carbonate minerals, the color of the CL and its intensity are controlled primarily by the ratio of iron to manganese rather than by the absolute concentrations of either Fe or Mn cations.[35]

For all the limestones examined here, the CL images show textures similar to those observed in the petrographic study (Figures 14, 15). The framework grains, which are primarily oolites and peloids in the Northern Xiangtangshan samples, and a few bioclasts and secondary dolomite crystals pseudomorphic after gypsum in the Southern Xiangtangshan samples, tend to be bright orange-red when imaged using CL microscopy. This finding suggests that they are richer in Mn^{2+} than the cements

DOUGLAS AND HAYNES

a

b

in the limestones from both sites, which are darker and therefore likely to be more Fe-rich. Compositions of these framework grains and of the dolomite pseudomorphs were verified through semiquantitative elemental analyses of samples with an energy dispersive X-ray analyzer in a scanning electron microscope. The Ca to Mg ratio was determined on a number of grains using this method, and the average value for calcite was found to be 97 to 3, and for dolomite, 58 to 42. The latter values given for dolomite are close to the rarely occurring stoichiometric ratio of 50 to 50.[36]

Of particular note are CL photomicrographs of the fine-grained marble samples of the standing figures and the components of the funerary couch (Figure 16). Most of those images show a dark reddish color, with euhedral crystals of dolomite that luminesce a bright orange to orange-red. Here, as well, the dolomite probably is bright because a Mn^{2+}

activator is present, and the calcite is darker due to the quenching effect of iron. This feature was observed consistently on all of the marble samples, a finding that may point to the same or similar geological sources for the standing figures and the funerary couch components.

CL microscopy provided textural information similar to that found using petrography but also contributed compositional data. In every case, the results of the CL microscopy strengthened the proposed correlations between samples obtained from sculptures and those obtained from geological materials from the cave sites.

The present study pioneers the use of petrographic methods for characterizing stone materials used in Chinese Buddhist sculpture and explores their suitability in this context. Problems with identification, characterization, and differentiation invariably arise with

a

b

Figure 14 ◆ Cathodo-luminescence images of thin sections from peloidal oolitic grainstones from Northern Xiangtangshan: (a) site sample NX2; (b) seated bodhisattva (F1913.57). Most of the oolites are primary dolomite that appears medium orange-red; secondary dolomite rhombs are bright orange-red (often zoned); most of the natural cement is Fe-rich and darker than the oolites; minor amounts of interstitial cement are medium orange; late-stage pore-filling calcite spar cement is yellow.

Figure 15 ◆ Cathodo-luminiscence images of thin sections from lime mudstones from Southern Xiangtangshan: (a) site sample SX9; (b) *Western Paradise of the Buddha Amitabha* (F1921.2). The dolomite crystals were formed through pseudomorphic replacement of gypsum and appear medium to bright orange-red; fine-grained Fe-rich micrite is dark; late-stage pore-filling calcite cement is yellow.

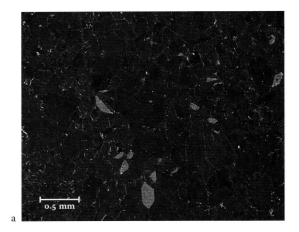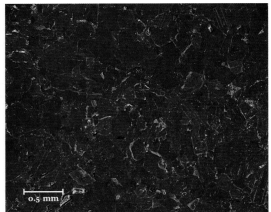

Figure 16 ◆ Cathodo-luminescence images of freestanding objects, fine-grained marbles: (a) standing bodhisattva (F1968.45); (b) funerary couch base (F1915.110). Most of each sample is an idiotopic mosaic composed primarily of euhedral Fe-rich calcite crystals that appear dark; the euhedral Mn-rich dolomite grains are brighter orange-red; small amounts of pore-filling calcite spar are yellow.

limestones that are pervasively recrystallized or dolomitized, and analytical methods that involve chemical analysis are therefore problematic. For limestones that exhibit pervasive diagenetic changes, as well as the effects of weathering, petrographic analysis proved to be the best characterization method. By establishing a petrographic basis for the characterization of limestones from the cave temples of Northern and Southern Xiangtangshan, this study can serve as a guide for future investigations of Chinese Buddhist sculptures in museums worldwide. The approach taken in this study can be used as a first step in all studies of provenience of stone sculpture and has the potential to become the norm for more meaningful comparisons in the future.

Petrography allows for the comprehensive characterization of limestones, and it has shown that exceptional agreement exists between limestone collected from the cave temple sites and Buddhist sculptures in museum collections. At Northern Xiangtangshan, the native peloidal oolitic grainstone was used for sculpture carved in the living rock as well as for the freestanding seated Buddha figures that were placed in the niches in North Cave. The freestanding stela thought to have been carved at Northern Xiangtangshan also shares petrographic and textural features with the grainstones from this site. (For a discussion of comparable oolitic limestones from Longmen, another important Buddhist cave temple complex, see Appendix 1, pages 110–11.)

The native limestone at Southern Xiangtangshan is a lime mudstone that is heavily fractured and partially recemented with numerous veins of calcite spar. Both wall reliefs in the Freer Gallery are carved from this distinctive fractured limestone.

The marble used for several freestanding sculptures in this study originates from a geological source quite different from those at the Northern or Southern Xiangtangshan sites. Their provenience remains undetermined at present, but additional sampling and further petrographic analyses may help to shed more light on this topic. The same holds true for the funerary couch base and cornices, which are also carved from fine-grained marble and thus could have an origin similar to that of the freestanding sculptures.

As an analytical method, CL microscopy was found to be an excellent complement to petrography. It helps confirm the compositional and textural features of limestones and marbles and, in particular, was found useful in the detailed characterization of natural cements. This investigation advances understanding of sculpture from Xiangtangshan and offers valuable support to the ongoing art-historical studies on Buddhist sculpture from China.

JANET G. DOUGLAS

Conservation Scientist
Department of Conservation and
Scientific Research
Smithsonian Institution, Freer Gallery of Art/
Arthur M. Sackler Gallery

JOHN T. HAYNES

*Assistant Professor, Sedimentary Petrology,
Stratigraphy, and Petroleum Geology
Department of Geology and
Environmental Sciences
James Madison University*

ACKNOWLEDGMENTS

This research was supported by the Freer Gallery of Art and Arthur M. Sackler Gallery, Smithsonian Institution, with a grant from the Smithsonian Research Opportunity Fund for travel to China in spring 2009 and a grant from the Faculty Assistance Summer Grant Program in the College of Science and Mathematics of James Madison University in spring 2011. The authors would like to thank Shi Jinming, director of the Shaanxi Museum, for arranging travel and visits to Buddhist cave sites in Central China, and Wang Xiaofeng for translating. We would also like to thank Zhang Lintang of Xiangtangshan and Ma Chaolong of Longmen. Neutron activation analysis was carried out at the National Institute of Standards and Technology by James Blackman, formerly of the Smithsonian Institution; stable isotope analysis was undertaken by Christine A. M. France at the Smithsonian Museum Conservation Institute; and CL and SEM analyses were done with the aid of Timothy Rose in the Department of Mineral Sciences, Smithsonian National Museum of Natural History. The University of Pennsylvania Museum of Archaeology and Anthropology, the Victoria and Albert Museum, and the Virginia Museum of Fine Arts are thanked for graciously allowing the sampling of sculptures in their collections. Federico Carò, Department of Scientific Research, The Metropolitan Museum of Art, and Steve Leslie, Department of Geology and Environmental Science, James Madison University, are thanked for their helpful review and comments.

NOTES

1 Wilson and Wang 2010.
2 The most recent research on the historical context of Xiangtangshan and its sculpture is summarized in Tsiang 2010, pp. 18–22.
3 Wilson and Wang 2010.
4 Chavannes 1913; Chavannes 1915.
5 Wilson and Wang 2010. The art dealer C. T. Loo was the single most important source of works taken from the Xiangtangshan sites. Loo mentions in the preface to his 1940 sales catalogue that he sold a bodhisattva head from Xiangtangshan to a French dealer in 1909 or 1910 (Loo 1940, unpaged).
6 The first detailed survey of Xiangtangshan was started in 1922 and published in Tokiwa and Sekino 1925–38; English translation Tokiwa and Sekino 1926–38, vol. 3, text, pp. 41–58.
7 Sirén 1925.
8 Meng, Ge, and Tucker 1997, pp. 190–92.
9 Standard thin sections having a thickness of about 30 micrometers were prepared by Spectrum Petrographics, Vancouver, Washington.
10 Blackman and Bishop 2007; Matthews 1997; Meyers and van Zelst 1997; Holmes and Harbottle 1994a; Holmes and Harbottle 1994b.
11 Attanasio, Brilli, and Bruno 2008.
12 The pilot study included nine samples from Northern Xiangtangshan, six from Southern Xiangtangshan, and thirteen from sculptures in the Freer Gallery. One hundred milligrams were taken for analysis from homogenized drilled powder samples each weighing approximately 1 gram. Initial results of this study showed overlapping fields of compositional and isotopic data, presumably attributable to chemical changes that result from some combination of stone weathering and postdepositional diagenetic changes, which are severe on the cave exteriors, as well as pervasive dolomitization of some samples, which is common in ancient carbonates dating to the Ordovician and Cambrian periods. The overall lack of diversity in chemical elements typically present in carbonate rocks as compared with siliciclastic mudrocks may be another contributing factor (Taylor and McLennan 1985).
13 Marshall 1988, esp. pp. 76–93.
14 Scholle and Ulmer-Scholle 2003.
15 Tucker and Wright 1990, pp. 1–27.
16 Dunham 1962; Wright 1992.
17 Folk 1974.
18 Machel and Mountjoy 1986.
19 Tucker and Wright 1990.
20 Embry and Klovan 1971.
21 Wright 1992.
22 Lazzarini 2004.
23 Reedy 2008, pp. 87–96.
24 Dickson 1965. The staining method described by Dickson allows for differentiation of iron-poor and iron-rich calcite, and dolomite. Nonferroan calcite accepts a pink stain; ferroan calcite takes a mauve to light purple stain; nonferroan dolomite does not stain; and ferroan dolomite takes a greenish-blue to blue stain, depending on iron content.
25 Al-Sharhan and Kendall 2003.
26 Scholle and Ulmer-Scholle 2003.
27 The kneeling winged monster is one of two originally located on opposite sides of the central pillar in the Middle Cave at Northern Xiangtangshan. Whereas the companion figure appears to have been carved directly in the stone and is largely intact today, the Freer Gallery's monster was probably created separately and set into position during the Northern Qi

dynasty. A large fracture that runs through the cave interior in the monster's former location suggests that the quality of some of the stone in this area may not have been suitable for carving, thereby prompting installation of a freestanding figure (Tsiang 2010, p. 191).

28 The seated Buddha was studied by petrographic methods as reported in R. W. Sanderson, British Museum (Natural History), Geological Museum, London, to John Larson, Sculpture Conservation Department, Victoria and Albert Museum, London, May 20, 1988. Sanderson describes the limestone as a "recrystallized, brownish gray limestone, probably originally an oopelsparite" and documents a mosaic of calcite spar, with ghosts of rounded masses up to about 0.7 millimeters in length. Although the letter does not include photomicrographs, this description indicates that the sample is similar to the peloidal oolitic grainstones from Northern Xiangtangshan.

29 Quoted in Tsiang 2010, p. 233.

30 Collinson, Mountney, and Thompson 2006.

31 Petrographic analysis of the small sample from the bodhisattva head (F1916.346) was inconclusive, but it is consistent in appearance with an extremely weathered area on the marble standing bodhisattva in the University of Pennsylvania Museum of Archaeology and Anthropology (C150).

32 Lazzarini 2004. A maximum grain size of 2 millimeters roughly separates fine-grained marble from medium-grained varieties.

33 Gabbert 1972, pp. 279–85, 414–17. In the files of the Museum für Ostasiatische Kunst, Cologne, is a handwritten comment in the inventory log of 1932–39 by the museum's director, Frieda Fischer, noting a communication from James Mellon Menzies, a professor at the Shandong Christian University, China, stating that he had seen the intact funerary couch in a burial chamber in one of the Northern Xiangtangshan caves. Discussion of the site as a burial place continues today, but no further evidence establishing that the funerary couch was situated at Northern Xiangtangshan has come to light.

34 Priewe 2009.

35 Frank, Carpenter, and Oglesby 1982.

36 Tucker and Wright 1990, p. 370.

APPENDIX 1
LIMESTONES FROM THE LONGMEN CAVE TEMPLE SITE

The Buddhist cave temple site of Longmen, encompassing about 1,400 caves, is near the city of Luoyang, Henan Province, approximately 250 kilometers southwest of the Xiangtangshan sites. Although Longmen is not the focus of this article, it seems worthwhile to briefly discuss some limestone samples obtained from that site because they exhibit some similarities to those from Northern Xiangtangshan. Like the latter, the limestones from Longmen are largely oolitic grainstones. Nonetheless, some important differences in their petrographic characteristics are becoming evident.

Preliminary examination of several limestone samples from Longmen showed that some of their oolites have been appreciably dolomitized (Figure App. 1.1). The oolites in these samples are circular to slightly elliptical in shape and fairly uniform in size. A distinct concentric fabric outlines the original cortices of some of the Longmen oolites, and some have nuclei of unidentifiable micritized grains. Peloids are rare.

Other framework grains in the Longmen limestones include curved, micritized fragments, perhaps of ostracode shells. A few peloids, trilobite and brachiopod fragments, and rare echinoderm fragments identifiable by their characteristic syntaxial overgrowths constitute the remaining framework grains. Most of the framework has dolomitized to some degree, but the grains are still recognizable from their distinct shapes and textures. Rare pyritized grains are also present.

The original pore spaces are reduced in size and number by calcite spar infill, which has been variably dolomitized and recrystallized, as shown by the abundance of euhedral to subhedral dolomite rhombs. The dolomite has selectively replaced the original carbonate minerals that constituted the oolites and other framework grains, as well as the original pore-reducing cement. Occasional stylolites are also present.

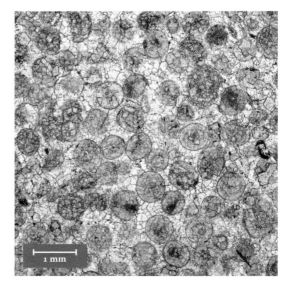

Figure App. 1.1 ◆ Oolitic grainstone from the cave temple site of Longmen, Henan Province (sample L15), photomicrograph showing relatively small oolites (around 0.34 mm in diameter), which are of more uniform size than those found in the limestones of Northern Xiangtangshan

Table App. 1.1 • Oolite Size and Sorting in Geological Samples from the Northern Xiangtangshan (NX) and Longmen (L) Cave Temples

Sample	Mean (mm)	Median (mm)	Sorting (σ)
NX3, n = 37	0.54	0.57	0.78
NX7, n = 108	0.49	0.51	0.76
L14, n = 31	0.35	0.35	0.25
L16, n = 22	0.32	0.34	0.34
L17, n = 31	0.36	0.36	0.18

In marked contrast to these oolitic grainstones, other Longmen samples are sparstones or dolosparstones with obliterative fabrics that are primarily idiotopic in character,[1] a texture that may be the result of an episode of pervasive dolomitization and recrystallization. The individual dolomite crystals range in length from 0.30 to 0.60 millimeters.

Although oolitic grainstones occur at both Northern Xiangtangshan and Longmen, this limited comparative study suggests they are distinguished by measurable differences in the size and distribution of the oolites. As shown in Table App. 1.1 and in photomicrographs of these limestones, the Northern Xiangtangshan oolites tend to be larger and more varied in shape, with an average diameter of 0.51 millimeters and with a sorting of around 0.77. By contrast, the Longmen oolites are generally smaller, about 0.34 millimeters in diameter, and of a more uniform size, with a sorting of around 0.26. Oolites from the Northern Xiangtangshan site tend to be more elliptical and irregularly shaped as compared to the more spherical Longmen oolites.

Given the considerable size of the Longmen site and the small number of samples in the current study, future research is necessary to more precisely characterize the varieties of limestones that occur there.

NOTE

1 Sibley and Gregg 1987.

GLOSSARY OF GEOLOGICAL TERMS

acicular. A crystal habit characterized by a radiating mass of slender, needlelike crystals.

anhydrite. A mineral composed of anhydrous calcium sulfate ($CaSO_4$).

aragonite. One of two common minerals composed of calcium carbonate ($CaCO_3$) usually found in limestone.

bioclast. Clast of skeletal (biological) origin.

calcareous. Formed from or containing a high proportion of calcium carbonate ($CaCO_3$) in the form of calcite or aragonite.

calcite. Mineral composed of calcium carbonate ($CaCO_3$) found in marble, limestone, chalk, etc.

calcite spar. Coarse crystalline cement that fills pore spaces in many limestones. Calcite spar forms by precipitation from carbonate-rich solutions passing through pore spaces in the sediment. It consists of minute vein- or pore-filling crystals that increase in size toward the cavity center. It is coarser than micrite and in thin section can be distinguished by its clarity and crystallinity.

carbonate rock. Rock composed of carbonate minerals, especially limestone and dolomite.

cement. Pore-filling crystals that act to bind grains.

clast. Fragment of an at least partially lithified carbonate sediment that has been transported and redeposited.

compaction. Diagenetic process that involves both physical and chemical changes leading to loss of water and pore space.

diagenesis. Chemical, physical, or biological changes undergone by sediments after initial deposition and during and after lithification, exclusive of surface alteration (weathering) and metamorphism.

dolomite. Mineral composed of calcium magnesium carbonate [$CaMg(CO_3)_2$].

dolomitization. Process by which limestone is altered to dolomite. When limestone comes in contact with magnesium-rich water, the dolomite replaces the calcite, volume for volume. Dolomitization involves recrystallization and therefore causes obliteration of original sedimentary texture.

euhedral. Characterized by well-crystallized faces.

fabric. Spatial and geometric configuration of all elements that constitute a rock, which are usually related to the directional orientation of its grains. A rock's fabric is typically on a larger scale than its texture.

framework grain. Detrital component of sedimentary rock of either skeletal or nonskeletal origin, typically up to about 2 millimeters in diameter.

grain-supported. Descriptor to indicate the dominance of framework grains in a limestone.

grapestone. Aggregate of a small number of recognizable grains cemented together by micrite or calcite spar.

gypsum. Mineral composed of calcium sulfate dihydrate ($CaSO_4 \cdot 2H_2O$).

heteroblastic. Characterized by a nonuniform mosaic of calcite crystals of varying grain size.

homeoblastic. Characterized by an equidimensional mosaic of calcite grains, typically with straight and gently curved boundaries.

idiotopic. Descriptor of a carbonate texture in which most crystals are euhedral.

karst. Terrain, generally underlain by limestone or dolomite, in which the topography is chiefly formed by rock dissolution and may be characterized by sinkholes, closed depressions, subterranean drainage, and caves.

lenticular bedding. Primary sedimentary structure of lens-shaped layers that form in tidal and delta front depositional environments with waters fluctuating between high and low energy. When lenticular bedding occurs in limestones it typically consists of alternating layers of dark gray calcite-rich limestone and light brown dolomite-rich limestone.

limestone. Sedimentary rock consisting primarily of calcium carbonate ($CaCO_3$).

lithification. Various processes whereby sediments are converted into stone.

marble. Metamorphosed limestone composed mainly of recrystallized calcite with dolomite.

matrix. Very fine carbonate or siliciclastic sediment typically less than 62 microns in diameter.

matrix-supported. Descriptor to indicate the predominance of microscopic carbonate or siliciclastic sediment in a limestone.

metamorphic grade. Measure of the relative intensity of metamorphism undergone by a specimen. In general, the presence of mineral assemblages stable at progressively higher pressures and temperatures indicates a higher metamorphic grade.

micrite. Dense, fine-grained carbonate mud (or microcrystalline calcite) with particles usually less than 5 microns in size; sometimes refers to rocks composed of mud formed by erosion of larger carbonate grains or by precipitation of organic materials.

micritization. Precipitation of micrite resulting from the degradation of skeletal carbonate particles by cyanobacteria (blue-green algae).

nonskeletal. Framework grains derived primarily from nonbiological processes.

oolite (also called *ooid*). Coated grain with a calcareous cortex that typically has concentric layers and a nucleolus of variable composition. Oolites tend to be spherical or elliptical and less than 2 millimeters in diameter.

peloid (also called *pellet*). Sand-size framework grain (0.6 to 2.0 millimeters) composed of micrite; one of the four common framework grains in carbonate rocks (the others are bioclasts, intraclasts, and oolites). Peloids can be rounded or subrounded to irregular in shape and are internally structureless. They are either fecal pellets of marine invertebrates or carbonate grains that have been so significantly altered by micritization that their structure and origin are no longer recognizable.

pseudomorph. A mineral that substitutes for another through replacement while the general shape and dimensions remain unchanged.

recrystallization. Diagenetic process causing changes in the crystal fabric of a mineral while its species remains the same.

siliciclastic. Descriptor of noncarbonate sediment or rock that is composed almost exclusively of quartz or other silicate minerals.

skeletal. Derived from organisms that produce calcareous skeletons.

stylolite. Irregular discontinuity or nonstructural fracture in limestones and other sedimentary rocks. Stylolites result from compaction and pressure dissolution during diagenesis.

syntaxial overgrowth. A crystallographically oriented overgrowth of a mineral on a substrate of the same chemical composition.

texture. Relationship between component particles or crystals of a rock and their geometric aspects, such as size, shape, and sorting.

REFERENCES

Al-Sharhan and Kendall 2003. A. S. Al-Sharhan and C.G.S.C. Kendall. "Holocene Coastal Carbonates and Evaporites of the Southern Arabian Gulf and Their Ancient Analogues." *Earth Science Reviews* 61 (2003), pp. 191–243.

Attanasio, Brilli, and Bruno 2008. Donato Attanasio, Mauro Brilli, and Matthias Bruno. "The Properties and Identification of Marble from Proconnesos (Marmara Island, Turkey): A New Database Including Isotopic, EPR and Petrographic Data." *Archaeometry* 50, no. 5 (October 2008), pp. 747–74.

Blackman and Bishop 2007. M. J. Blackman and R. L. Bishop. "The Smithsonian-NIST Partnership: The Application of Instrumental Neutron Activation Analysis to Archaeology." *Archaeometry* 49, no. 2 (May 2007), pp. 321–41.

Chavannes 1913. Édouard Chavannes. *Mission archéologique dans la Chine septentrionale*, vol. 1, pt. 1, *La sculpture à l'époque des Han*. Paris: Ernest Leroux, 1913.

Chavannes 1915. Édouard Chavannes. *Mission archéologique dans la Chine septentrionale*, vol. 1, pt. 2, *La sculpture bouddhique*. Paris: Ernest Leroux, 1915.

Collinson, Mountney, and Thompson 2006. John Collinson, Nigel Mountney, and David Thompson. *Sedimentary Structures.* Harpenden, UK: Terra Publishing, 2006.

Dickson 1965. J.A.D. Dickson. "A Modified Staining Technique for Carbonates in Thin Section." *Nature* 205, no. 4971 (February 6, 1965), p. 587.

Dunham 1962. Robert J. Dunham. "Classification of Carbonate Rocks According to Depositional Texture." In *Classification of Carbonate Rocks: A Symposium*, edited by William E. Ham, pp. 108–21. American Association of Petroleum Geologists Memoir 1. Tulsa, Okla.: American Association of Petroleum Geologists, 1962.

Embry and Klovan 1971. A. F. Embry and J. E. Klovan. "A Late Devonian Reef Tract on Northeastern Banks Island, NWT." *Canadian Petroleum Geology Bulletin* 19 (1971), pp. 730–81.

Folk 1974. Robert L. Folk. *Petrology of Sedimentary Rocks.* Austin, Tex.: Hemphill Publishing, 1974.

Frank, Carpenter, and Oglesby 1982. James R. Frank, Alden B. Carpenter, and Thomas W. Oglesby. "Cathodoluminescence and Composition of Calcite Cement in the Taum Sauk Limestone (Upper Cambrian), Southeast Missouri." *Journal of Sedimentary Petrology* 52, no. 2 (1982), pp. 631–38.

Gabbert 1972. Gunhild Gabbert. *Buddhistische Plastik aus China und Japan.* Wiesbaden: Franz Steiner Verlag, 1972.

Holmes and Harbottle 1994a. Lore L. Holmes and Garman Harbottle. "Compositional Characterization of French Limestone: A New Tool for Art Historians." *Archaeometry* 36, no. 1 (1994), pp. 25–39.

Holmes and Harbottle 1994b. Lore L. Holmes and Garman Harbottle. "Compositional Fingerprinting: New Directions in the Study of the Provenance of Limestone." *Gesta* 33, no. 1 (1994), pp. 10–18.

Howard 1996. Angela F. Howard. "Buddhist Cave Sculpture of the Northern Qi Dynasty: Shaping a New Style, Formulating New Iconographies." *Archives of Asian Art* 49 (1996), pp. 6–25.

Lazzarini 2004. Lorenzo Lazzarini. "Archaeometric Aspects of White and Coloured Marbles Used in Antiquity: The State of the Art." *Periodico di Mineralogica* 73, special issue 3 (2004), pp. 113–25.

Loo 1940. Ch'in-tsai Loo. *An Exhibition of Chinese Stone Sculptures.* Sale cat. C. T. Loo, New York, 1940.

Machel and Mountjoy 1986. H.-G. Machel and E. W. Mountjoy. "Chemistry and Environments of Dolomitization: A Reappraisal." *Earth Science Reviews* 23 (1986), pp. 175–222.

Marshall 1988. D. J. Marshall. *Cathodoluminescence of Geological Materials.* Boston: Unwin Hyman, 1988.

Matthews 1997. K. J. Matthews. "The Establishment of a Data Base of Neutron Activation Analyses of White Marble." *Archaeometry* 39, no. 2 (1997), pp. 321–32.

Meng, Ge, and Tucker 1997. X. Meng, M. Ge, and M. E. Tucker. "Sequence Stratigraphy, Sea Level Changes and Depositional Systems of the North China Carbonate Platform." *Sedimentary Geology* 114 (1997), pp. 189–222.

Meyers and van Zelst 1997. Pieter Meyers and Lambertus van Zelst. "Neutron Activation Analysis of Limestone Objects: A Pilot Study." *Radiochimica Acta* 24 (1997), pp. 197–204.

Priewe 2009. Sascha Priewe. "Das Zhangdefu-Sargbett: Grundlegende Fragen erneut gestellt." *Ostsiatische Zeitschrift* 17 (2009), pp. 15–24.

Reedy 2008. Chandra L. Reedy. *Thin-Section Petrography of Stone and Ceramic Cultural Materials.* London: Archetype, 2008.

Scholle and Ulmer-Scholle 2003. Peter A. Scholle and Dana S. Ulmer-Scholle. *A Color Guide to the Petrography of Carbonate Rocks: Grain, Textures, Porosity, Diagenesis.* American Association of Petroleum Geologists Memoir 77. Tulsa, Okla.: American Association of Petroleum Geologists, 2003.

Sibley and Gregg 1987. Duncan F. Sibley and Jay M. Gregg. "Classification of Dolomite Rock Textures." *Journal of Sedimentary Research* 57, no. 6 (1987), pp. 967–75.

Sirén 1925. Osvald Sirén. *Chinese Sculpture from the Fifth to the Fourteenth Century.* 4 vols. New York: Charles Scribner's Sons, 1925.

Taylor and McLennan 1985. S. R. Taylor and S. M. McLennan. *The Continental Crust: Its Composition and Evolution—An Examination of the Geochemical Record Preserved in Sedimentary Rocks.* Oxford: Blackwell Scientific Publications, 1985.

Tokiwa and Sekino 1925–38, 1926–38. Daijō Tokiwa and Tadashi Sekino. *Shina Bukkyō shiseki hyōkai.* 5 vols. Tokyo: Bukkyô skiseki kenkyûkai, 1925–38. Translated into English as *Buddhist Monuments in China.* 12 vols. Tokyo: Bukkyô skiseki kenkyûkai, 1926–38.

Tsiang 2010. Katherine R. Tsiang. *Echoes of the Past: The Buddhist Cave Temples of Xiangtangshan.* Exh. cat. Chicago: David and Alfred Smart Museum of Art, University of Chicago; Washington, D.C.: Arthur M. Sackler Gallery, 2010.

Tucker and Wright 1990. M. E. Tucker and V. P. Wright. *Carbonate Sedimentology.* Oxford: Blackwell Scientific Publications, 1990.

Wilson and Wang 2010. Keith Wilson and Daisy Y. Wang. "The Early Twentieth Century 'Discovery' of the Xiangtangshan Caves." In Katherine R. Tsiang, *Echoes of the Past: The Buddhist Cave Temples of Xiangtangshan*, pp. 105–30. Exh. cat. Chicago: David and Alfred Smart Museum of Art, University of Chicago; Washington, D.C.: Arthur M. Sackler Gallery, 2010.

Wright 1992. V. P. Wright. "A Revised Classification of Limestones." *Sedimentary Geology* 76, no. 3–4 (1992), pp. 177–85.

PICTURE CREDITS

Department of Conservation and Scientific Research, Freer Gallery of Art and Arthur M. Sackler Gallery, Smithsonian Institution, Washington, D.C.: 2–6, 7b, 8b, 9b, 9c, 10, 11b, 12b, 12c, 13b, 14, 15, 16, App. 1.1

Freer Gallery of Art, Smithsonian Institution, Washington, D.C.: Figures 7a, 8a, 11a, 13a

Travis Fullerton, Virginia Museum of Fine Arts, Richmond: Figure 12a

University of Pennsylvania Museum of Archaeology and Anthropology, Philadelphia: Figure 9a

北齐响堂山佛教石窟雕像石材的岩相学分析

摘要

中国中北部的响堂山是一个重要的佛教石窟寺群，其年代可追溯到北齐时代（550–77）。北响堂山和南响堂山的洞穴内都曾刻有石雕，但自二十世纪初以来，石雕逐渐佚失，现多由世界各地的公共机构和私人所收藏。2011年名为"历史的回响: 响堂山佛寺石窟"的展览，为收藏于弗利尔美术馆的响堂山石雕以及来自其他博物馆的相关收藏提供了一个绝佳的研究机会。本项研究首先对来自南响堂山和北响堂山洞穴外部的石灰岩样品进行了岩相学特征分析。通过颗粒、胶质、基质和和孔隙度的系统性描述和分析，作者研究了与上述区域相关的石灰岩和大理岩石雕。这种方法能够更好地重建一些石雕的原址，甚至还能回答与石雕原址相关的一些具体问题。本项研究结果可与风格、早期文献研究，一同为今后全世界博物馆所收藏的佛教石灰岩和大理岩石雕提供一个研究框架。

JANET G. DOUGLAS

Smithsonian Institution, Freer Gallery of Art/ Arthur M. Sackler Gallery

JOHN T. HAYNES

James Madison University

ABSTRACT TRANSLATED BY WANG RONG

Lebanese Mountain Figures: Advances in the Study of Levantine Anthropomorphic Metal Statuary

◆

Deborah Schorsch

ABSTRACT

Archaeologists have long expressed conflicting opinions concerning the authenticity of thirty-seven statues known as Lebanese Mountain Figures. Collected over a period of 250 years, these unalloyed copper figures are unprovenienced but have long been attributed to the mountains of southwest Lebanon. The investigation described here is based on visual and metallurgical examinations, radiography, and/or elemental analysis of twenty-seven statues. Thirteen have been studied in section, and all demonstrate a degree of intergranular corrosion consistent with great age and extended burial. In fact, in general appearance, unusual composition, highly porous internal structure, and absence of internal oxidation, these thirteen statues constitute a coherent corpus; by extension, it can be concluded that thirteen additional figures examined but not sampled for metallurgical study are also of ancient manufacture. One last figure is probably ancient but may not belong to the Lebanese Mountain Group. Forgeries of the so-called 1908 Group were in part responsible for the unsavory reputation of the originals, and their study in tandem provides insight into evolving perceptions of authentic and not-authentic based on stylistic and technological criteria.

The study of small metal statuary from the Levant is notorious for the many uncertainties it involves.

— P.R.S. Moorey and Stuart Fleming

Elles ont été découvertes, jusqu'ici, entre le fleuve de Damour et la frontière actuelle de la Palestine, sur les deux versants du Liban et jusqu'aux contreforts de l'Hermon, toujours sur les hauteurs, à une altitude qui varie entre 400 et 1.200 mètres.

— Henri Seyrig

Since the beginning of the twentieth century, Bronze Age Levantine metal statues known universally as Lebanese Mountain Figures have elicited among European archaeologists much speculation as to their origins and authenticity. As early as 1752, a female figure (cat. no. 1; Figure 1), the first known of the Lebanese Mountain type, had traveled to France by way of Egypt.[1] Twenty-three male and thirteen additional female figures associated with the group were documented in the intervening years until 1981, although not a single one was excavated under controlled conditions in Lebanon or elsewhere (see Appendix 1, Catalogue of Lebanese Mountain Figures, pages 144–50; all

Figure 1 ◆ Female figure (cat. no. 1), from Anne Claude Philippe Caylus, *Recueil d'antiquités égyptiennes, etrusques, grecques et romaines*, nouv. ed. (Paris: Desaint and Salliant, 1761), vol. 1, pl. X (1). This earliest known female figure belonged to the writer and antiquarian Caylus from at least 1752.

figures discussed in this article are referred to by these catalogue numbers).[2] Their attribution to the southern peaks and slopes of the Lebanon Mountain Range is the work of two French archaeologists resident in Beirut—the Jesuit father Sébastien Ronzevalle (1865–1937) and Henri Seyrig (1895–1973)—and remains to this day undisputed.[3] Both men were closely acquainted with local antiquities dealers and well informed of illicit finds, which they pursued doggedly; their narrative but erudite articles still make for good reading, and although Seyrig's conclusions sometimes reflect a lack of practical knowledge, he was an astute and detailed observer of features related to manufacture and condition. Like earlier archaeologists and collectors, both men expressed their doubts as to the authenticity of individual—although not necessarily the same—figures; later scholars such as Helga Seeden rehabilitated

Figure 2 ◆ Male figure (cat. no. 30). Lebanon, allegedly from Jezzīn, Middle Bronze Age, ca. 2000 B.C. Cast unalloyed copper, H. 41.0 cm (16⅛ in.) with tangs. The Metropolitan Museum of Art, Gift of Norbert Schimmel Trust, 1989 (1989.281.9)

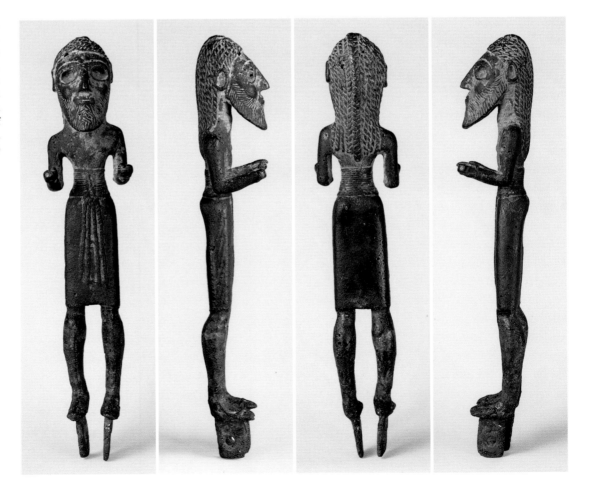

SCHORSCH

some of these statues and designated others as possible fakes.[4] Although style and typology and the figures' colorful history and alleged proveniences are not irrelevant and invite revisiting, the focus of this essay is physical evidence demonstrating the manufacture of the Lebanese Mountain Figures and their state of preservation, and ways in which these observations contribute, pro or con, to the continuing debate over the statues' authenticity.

HISTORY AND PROVENIENCE

Whereas the Lebanese Mountain Figures are distinctive in many regards, the male statues formally resemble other Levantine metal statuary said to represent warriors (e.g., cat. nos. 30, 25; Figures 2, 3) and some females have been likened to "fertility goddesses" (e.g., cat. no. 14; Figure 4).[5] Ronzevalle believed that they date to about 1500 B.C.[6] Seyrig proposed the first half of the second millennium B.C. on the basis of several small objects possibly related to Claude Schaeffer's "porteurs de torques" allegedly found with a group of five Lebanese Mountain Figures near Jezzīn.[7] More recently, scholars such as Roger Moorey and Helga Seeden have suggested that the corpus was produced within a short period at the beginning of the Middle Bronze Age, just before or after the turn of the second millennium B.C.[8] Their assumption that production occurred over a brief span of time is well supported by consistency in manufacture and material.

The male figures are notable for their large size relative to other Near Eastern Bronze Age metal statuary and especially to their own so-called consorts (e.g., cat. nos. 6, 7; Figure 5).[9] Standing erect with bent arms and clenched fists that presumably carried weapons (e.g., cat. no. 24; Figure 6),[10] the figures tend to be high-waisted with broad shoulders and oversize heads.[11] They wear kilts made from a wrapped cloth with a fringe on their right side (see, e.g., Figure 2, right profile view; Figure 3, right profile view; Figure 5, left). Other characteristics shared by most male figures include their prominent noses, forward-jutting chins, large vacant

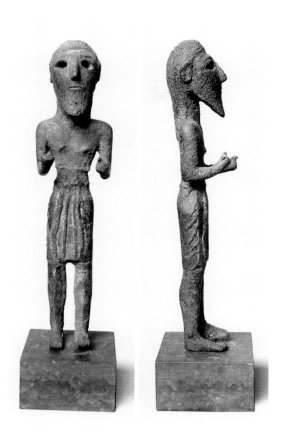

Figure 3 ◆ Male figure (cat. no. 25). Lebanon, Middle Bronze Age, ca. 2000 B.C. Cast unalloyed copper, H. 39.5 cm (15½ in.) with tangs. Ny Carlsberg Glyptotek, Copenhagen (2836)

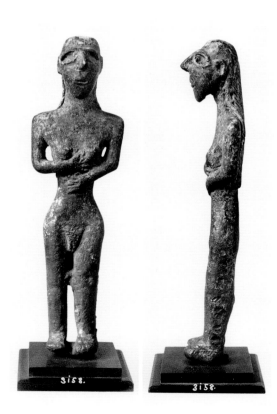

Figure 4 ◆ Female figure (cat. no. 14). Lebanon, Middle Bronze Age, ca. 2000 B.C. Cast unalloyed copper, H. 15.0 cm (5⅞ in). Vorderasiatisches Museum, Berlin (3158)

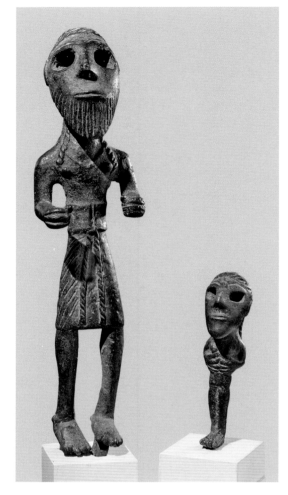

Figure 5 ◆ Male (left) and
female (right) figures
(cat. nos. 6, 7). Lebanon,
allegedly 'Adlūn, Middle
Bronze Age, ca. 2000 B.C.
Cast unalloyed copper,
male: H. 27.0 cm (10⅝ in.)
with tangs; female:
12.5 cm (4⅞ in.) with tang.
Yale Babylonian
Collection, New Haven
(2252, 2250)

eye sockets, hatched beards, long hair in ringlets and a single braid in the back, wide belts, and small feet. Some of the same facial features are also seen on the female figures, although generally they do not conform so closely to a recognizable canon. The issue of authenticity has always been less controversial for the female figures; examples that seem inconsistent have sometimes been assigned to "related groups." The male figures have pierced tangs extending from the bottom of each foot,[12] the females stand with feet placed closely together on a single tang, also pierced,[13] and all presumably were mounted upright on bases. It is not known whether these were made from a perishable material or removed when the figures were retired from use. Early documentation suggests that more than a few figures were found in pairs or larger groups generally of mixed gender.[14]

Little is known of Early and Middle Bronze Age material culture from this remote inland region, but in more recent times some of the Lebanese Mountain Figures have had interesting, well-documented histories. The female figure now in the Cabinet des Médailles et Antiquités in the Bibliothèque Nationale de

Figure 6 ◆ Male figure
(cat. no. 24). Lebanon,
Middle Bronze Age,
ca. 2000 B.C. Cast
unalloyed copper,
H. 35.7 cm (14 in.) with
tangs. Musée d'Art et
d'Histoire, Geneva (18724)

Figure 7 ◆ Male figure
(cat. no. 3). Lebanon(?),
Middle Bronze Age,
ca. 2000 B.C. Cast
unalloyed copper,
H. 14.0 cm (5½ in.) with
tangs. Vorderasiastisches
Museum, Berlin (3159)

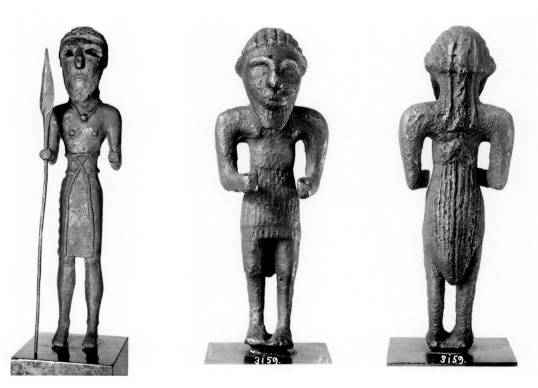

France in Paris (cat. no. 1) entered the former royal collection late in the reign of Louis XV, who received it as a gift from the Comte de Caylus, a French antiquarian and literary figure.[15] Sent from Egypt to the numismatist Joseph Pellerin (1684–1782), the figure was described by Caylus as an outstanding example of Egyptian art.[16] Four male and two female figures (cat. nos. 2–7; Figures 7, 8; see also Figure 5), including a male figure (cat. no. 2), said to be of silver,[17] were published in sales catalogues and scholarly works between 1880 and 1900. Sixteen figures (cat. nos. 8–23; Figures 9–13; see also Figure 4) came to light between 1901 and the end of World War I, when scholars started to express their varying opinions concerning attribution—Hittite, Syrian, Phoenician, among others—and date.[18]

The specter of forgery was raised as early as 1908, with the publication of a male figure in the Ustinov Collection, now in the Ny Carlsberg Glyptotek, Copenhagen (cat. no. 1F; Figure 14), by Louis-Hugues Vincent (1872–1960), a Jesuit father and archaeologist active in Palestine.[19] Unlike various male Lebanese Mountain Figures that still elicit debate, the four statues constituting the so-called 1908 Group are now accepted beyond doubt as forgeries, clearly products of a single modern workshop (see Appendix 2, Catalogue of 1908 Group Figures, pages 150–51).[20]

As he tells his readers in an aside, Ronzevalle completed his groundbreaking work "Bronze libanais" in 1913, but it did not appear in print until 1935, with additions made between 1924 and 1929.[21] His work was undertaken, he says, for the purpose of proving the authenticity of a male figure, said to have been found in southern central Lebanon at Sirjbaʿal (cat. no. 8), that was considered a forgery by "others."[22] The figure had been displayed in an exhibition sale held at the Musée Guimet (now Musée National des Arts Asiatiques–Guimet) in Paris in 1901 that had been organized by the Sidon antiquarian Joseph Durighiello (or Durighello) (1861–1924) and several of his associates.[23]

Joseph-Ange Durighiello's grandfather Angelo was of Corsican descent and had been

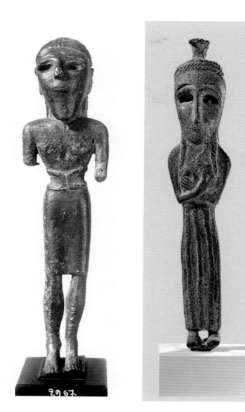

Figure 8 ◆ Male figure (cat. no. 4). Lebanon, Middle Bronze Age, ca. 2000 B.C. Cast unalloyed copper, H. 32.0 cm (12⅝ in.) with tangs. Vorderasiatisches Museum, Berlin (2967)

Figure 9 ◆ Female figure (cat. no. 11). Lebanon, Middle Bronze Age, ca. 2000 B.C. Cast unalloyed copper, H. 30.9 cm (12⅛ in.) with tang. Vorderasiatisches Museum, Berlin (3155)

Figure 10 ◆ Male figure (cat. no. 16). Lebanon, Middle Bronze Age, ca. 2000 B.C. Cast unalloyed copper, H. 36.9 cm (14½ in.) with tangs. Vorderasiatisches Museum, Berlin (3153)

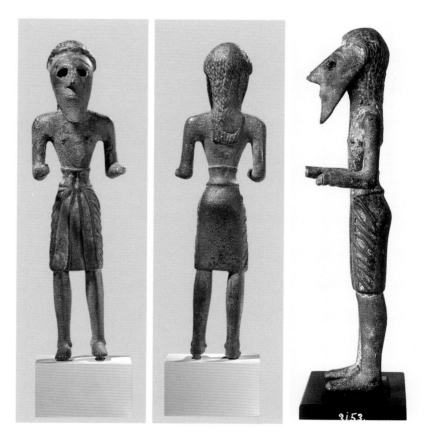

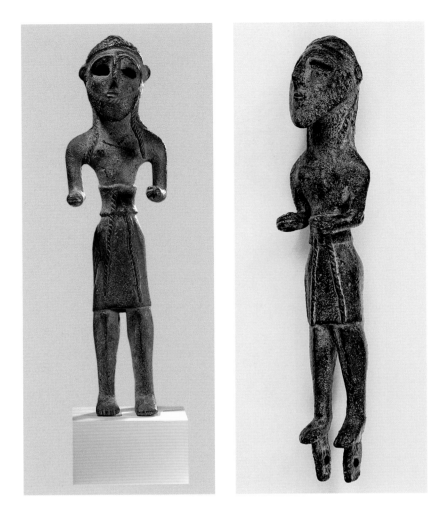

Figure 11 ◆ Male figure (cat. no. 15). Lebanon, Middle Bronze Age, ca. 2000 B.C. Cast unalloyed copper, H. 38.0 cm (15 in.) with tangs. Vorderasiatisches Museum, Berlin (3154)

Figure 12 ◆ Male figure (cat. no. 21). Lebanon, Middle Bronze Age, ca. 2000 B.C. Cast unalloyed copper, H. 27.7 cm (10⅞ in.) with tangs. Museum für Kunst und Gewerbe, Hamburg (1991.131)

appointed consul general at Aleppo by Napoleon Bonaparte. Alphonse, Angelo's son, served as the Spanish consul at Aleppo and later French consul at Sidon,[24] where Joseph was born in 1861. Although also known for its political exploits, the family gained its true livelihood from archaeological exploration and the sale of antiquities. Alphonse served as a guide for Joseph Ernest Renan, the great French orientalist. Joseph followed in their footsteps, taking part in excavations in Syria and Palestine, and he was the source of many important works now in prominent European and American museums.[25]

Ronzevalle asserted that most of the "bronzes" displayed in the Musée Guimet were forgeries made in a workshop maintained for that purpose by Durighiello in Sidon.[26] There appears to have been neither a published catalogue nor a checklist, and therefore not all of the figures that were exhibited can be identified.[27] Whereas eleven of

the fifteen statues offered on the market between 1901 and the beginning of World War I have known or suspected links to Durighiello (cat. nos. 8–16, 21, 22),[28] there is no documentation that connects him with the 1908 Group statues other than Ronzevalle's statement:

> Plus d'une fois, en Syrie et en Palestine, j'ai vu des *Bédouins*, courtiers, essayer de vendre des contrefaçons modernes. Le fait même que [the ex–Ustinov Collection figure] a été acquis d'un Bédouin prouve qu'il appartenait a la collection Durighello.[29]

Ronzevalle "proved" the authenticity of the Sirjba'al figure (cat. no. 8) by comparing it with the male and female pair in the Yale Babylonian Collection, New Haven (cat. nos. 6, 7), and male figures formerly in the Tyszkiewicz Collection (cat. no. 4) and in the Musée du Louvre, Paris (cat. no. 10). The latter had been considered a forgery for unspecified reasons when Ronzevalle first completed his study in 1913, but he included it as ancient in the final publication in spite of its connection to Durighiello, of which he may not have been aware.[30] Ronzevalle based his comparisons on such features as overall size, physical proportions, and hair and beard styles.[31] Of the six other figures known to him, Ronzevalle rejected as a forgery only the small male figure purchased by the Kaiser-Friedrich Museum (today Bode Museum), Berlin, in 1891 (cat. no. 3),[32] but he defended the authenticity of a fragmentary male figure, formerly in the Alphonse Kann Collection (cat. no. 20), against potential but anonymous detractors: "Au reste, pour plus d'un connoisseur, l'object serait un faux: sentiment que je suis loin de partager."[33] He muses on the clandestine operations of the local antiquities market, the avarice of the dealers, and the naïveté of the customers, noting that this fragment was sold to an amateur collector for fr. 19,000, although in his opinion a museum would not have paid even fr. 300, despite his belief in its authenticity.[34]

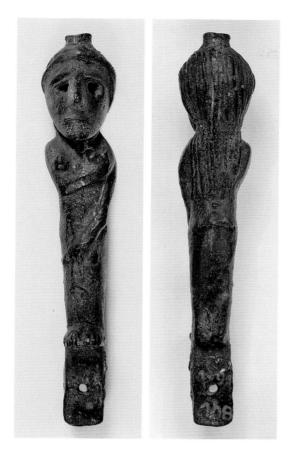

No new statues entered the market until 1948, when two hoards containing between them five male and three female figures were discovered (cat. nos. 24–31; Figures 15, 16; see also Figures 2, 3, 6).[35] By 1953, when Henri Seyrig, then director of the Institut Français d'Archéologie du Proche-Orient (IFAPO) in Lebanon, published his study "Statuettes trouvées dans les montagnes du Liban," he included these new finds plus another male figure (cat. no. 32) allegedly from Marj'ayūn that had appeared in 1951.[36] In 1953, after he saw the male figure later purchased by the Saint Louis Art Museum (cat. no. 33; Figure 17), Seyrig requested that the metal be analyzed, but by then it was already too late to include mention of the figure or the analytical results in his publication.[37]

Seyrig described the small male in the Vorderasiatisches Museum, Berlin (cat. no. 3), doubted by Ronzevalle, as "very strange," but he accepted it as ancient because of its long history reaching back to 1891, when little was

known from which it could have been copied.[38] He rejected a different male figure in the Vorderasiatisches Museum (cat. no. 16; see Figure 10) on the basis of its garment and hairstyle.[39] This latter figure also has no ears, which Seyrig neglects to mention; these three peculiarities may have a broader significance. A figure from the Jezzīn hoard acquired by the British Museum, London, in 1957 (cat. no. 31), although championed by Seyrig and Richard Barnett, then keeper of the Department of Western Asiatic Antiquities, was long doubted in the museum's Research Laboratory because of ostensibly artificially roughened as well as sharp, unworn surfaces lacking archaeological corrosion (see Figure 16), the absence of internal oxidation, and the relatively pure composition of the metal.[40]

As noted earlier, the male figures, with one exception (cat. no. 3), are more or less consistent in their stance, gesture, and general appearance, while their female counterparts exhibit greater variety. They are clothed and unclothed, with different hairstyles, holding their arms in differing positions. In Seyrig's opinion, the figure in the Vorderasiatisches

Figure 13 • Female figure (cat. no. 22). Lebanon, Middle Bronze Age, ca. 2000 B.C. Cast unalloyed copper, H. 20.5 cm (8⅛ in.) with tang. Museum für Kunst und Gewerbe, Hamburg (1991.108)

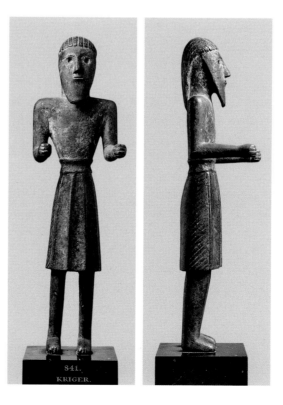

Figure 14 • Male figure (cat. no. 1F). Lebanon, ca. 1908. Cast unalloyed copper, H. 38.5 cm (15⅛ in.) with tangs. Ny Carlsberg Glyptotek, Copenhagen (2760)

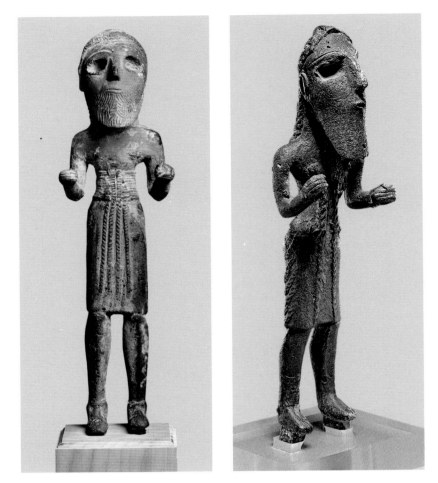

Figure 15 ◆ Male figure
(cat. no. 29). Lebanon,
allegedly from Jezzīn,
Middle Bronze Age,
ca. 2000 B.C. Cast
unalloyed copper,
H. 38.5 cm (15⅛ in.) with
tangs. Private collection

Figure 16 ◆ Male figure
(cat. no. 31). Lebanon,
allegedly from Jezzīn,
Middle Bronze Age,
ca. 2000 B.C. Cast
unalloyed copper,
H. 28.0 cm (11 in.) with
tangs. British Museum,
London (ME 135034)

Museum (cat. no. 14) first published by Valentin Müller in 1929 was closely related to the Lebanese Mountain Group but representative of chronological or regional variation.[41]

In her 1976 catalogue *Canaanite Gods in Metal*, Ora Negbi includes twenty-three previously published Lebanese Mountain Figures without speculating about their authenticity.[42] The male figures are grouped with "male warriors in Anatolian pose," which Negbi describes as standing or marching, arms extended forward with hollow clenched fists, sometimes holding weapons.[43] The females are called "consorts of male figures in Anatolian pose." Negbi also established a separate "Lebanese Group" with three female figures,[44] including the one set aside by Seyrig (cat. no. 14), the one formerly in the Tyszkiewicz Collection (cat. no. 5), and a third, first published in 1954 and later acquired by the Musée Guimet (cat. no. 34).[45] A small female figure entered the collection of the

Ashmolean Museum of Art and Archaeology, Oxford, in 1911 (cat. no. 17) but remained unpublished until many years later.[46] The surfaces and contours of this figure are heavily eroded, but the reverse reveals traces of the distinctive coiffure of the Lebanese Mountain Group.

Two previously unknown male Lebanese Mountain Figures (cat. nos. 35, 36) are included by Seeden in her comprehensive catalogue *The Standing Armed Figurines in the Levant*.[47] Of these, she considers the fragmentary male figure in the National Museum of Beirut (cat. no. 36) a possible forgery. In addition, she rejects as definite or possible forgeries the male figures in the Vorderasiatisches Museum believed to be false by Ronzevalle (cat. no. 3) and Seyrig (cat. no. 16) as well as four other figures, including the male ex–Tyszkiewicz Collection figure (cat. no. 4) used by Ronzevalle to prove the authenticity of the Sirjba'al figure (cat. no. 8), two other figures in the Vorderasiatisches Museum (cat. nos. 12, 15), and a figure currently in a private collection (cat. no. 9).[48] Although Seeden does not consider all of the statues formerly in Durighiello's hands to be forgeries, in her assessments of four of the seven Lebanese Mountain Figures that she does suspect, their connection to Durighiello appears to have been an important factor.[49] In 1981, one year after the publication of Seeden's volume, there appeared the last statue to date, a male figure acquired some time later by a private collection in New York (cat. no. 37; Figure 18).[50]

In addition to these negative and often contradictory opinions based on stylistic or historical evidence, some doubts concerning the authenticity of certain Lebanese Mountain Figures have been raised also on technical grounds, generally focusing on the composition of the metal itself—a relatively pure, unalloyed copper—and the condition of currently exposed surfaces, which in all cases are unusually pitted and for the most part lacking corrosion products typically found on archaeological cupreous artifacts. Still, there is strong physical evidence with a positive bearing on this question.[51] From the group of twenty-seven

Lebanese Mountain Figures in public and private collections available for study, the observations presented here are based on close visual inspection of twenty-five figures, elemental analysis of twenty-two figures, X-ray or gamma radiography of nineteen figures, and metallurgical examination of polished sections from thirteen figures (see Appendix 1).[52]

VISUAL EXAMINATION

Several surface features characteristic of the Lebanese Mountain Figures are easily observed during macroscopic and microscopic examination. First, the surfaces are heavily pitted, and, by any standard, these pits are extremely large. This characteristic was first pointed out by Ronzevalle with reference to the Sirjba'al figure (cat. no. 8) and later by Seyrig, who notes that the figures are uniformly poorly cast.[53] He describes the surfaces of five figures (cat. nos. 1, 10, 24–26; see Figures 3, 6, for cat. nos. 25, 24) as better than the others and wonders if their condition might reflect a higher quality of casting or surface finishing carried out after casting.[54] In addition to faulty manufacture, corrosive attack suffered during burial—or resulting from any combination of modern cleaning processes and preservation measures—may have contributed to the figures' unattractive surface appearance. Modern wax or resin fills used to disguise the pits were observed on the statues in the Museum für Kunst und Gewerbe, Hamburg, when they were examined in 1991 (cat. nos. 21, 22).

It is possible that the male figure in the Saint Louis Art Museum (cat. no. 33) was originally clad with precious metal. Minute fragments of a shiny, yellow metal were removed from the figure's left arm and abdomen in 1958, when it was studied prior to acquisition.[55] Another metal fragment, noted on the kilt in 1985, was analyzed at Washington University in St. Louis and found to be a very silver-rich electrum.[56] No trace of electrum foil or sheet was observed when the figure was examined in the Sherman Fairchild Center for Objects Conservation, The Metropolitan Museum of

Art, New York, in the early 1990s.[57] The typically gaping eye sockets[58] may have been inlaid, but no traces of inlay or adhesive survive on the figures examined by the author or have been reported elsewhere.

Seyrig rightly points out that the figures are lost-wax castings,[59] refuting Ronzevalle, who believed they had been produced in molds that could leave "seams," which he apparently observed on the Sirjba'al statue (cat. no. 8).[60] Seyrig cites traces of gating on the crania of three examples, the allegedly silver figure (cat. no. 2) and female figures in the Vorderasiatisches Museum and the Museum für Kunst und Gewerbe (cat. nos. 11, 22; see Figures 9, 13).[61] He suggests that the location of these gates is unusual, as most ancient anthropomorphic metal sculpture is generally assumed to have been cast upside down, with the gating system attached to the feet or tangs.[62]

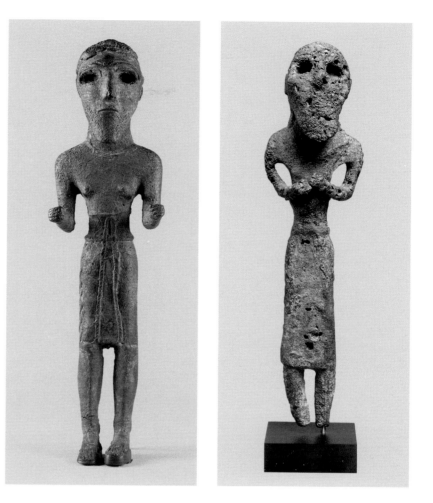

Figure 17 ◆ Male figure (cat. no. 33). Lebanon, Middle Bronze Age, ca. 2000 B.C. Cast unalloyed copper, H. 43.2 cm (17 in.) with tangs. Saint Louis Art Museum, St. Louis, Friends Fund (356:1958)

Figure 18 ◆ Male figure (cat. no. 37). Lebanon, Middle Bronze Age, ca. 2000 B.C. Cast unalloyed copper, H. 32.0 cm (12⅝ in.). Private collection, New York

Particularly problematic to conservators and scientists examining Lebanese Mountain Figures is the consistent absence of archaeological corrosion products. Although in recent times archaeologists and art historians have become more aware of nuances in surface condition that are crucial for understanding the ancient and modern history of archaeological metalwork, their early descriptions tend to be vague. For example, William Hayes Ward describes the two figures now in the Yale Babylonian Collection (cat. nos. 6, 7; see Figure 5) as "green with patination."[63] Such a description overlooks a most important point: copper and copper-alloy objects from burial contexts generally corrode following an established path, and it is the species and structure of the corrosion products, and not their color or perceived volume, that are determinants in establishing authenticity.

The surface of only one Lebanese Mountain Figure examined visually under magnification even superficially approaches in surface appearance uncleaned cupreous metal that has undergone long-term burial (cat. no. 37; see Figure 18). On some of the statuettes, including the earliest known figure in the Cabinet des Médailles (cat. no. 1), the surfaces are virtually metallic, gleaming through a very thin brown oxidation film that is the result of atmospheric exposure. The bottoms and side walls of the surface pits often seem equally devoid of archaeological corrosion products. On figures such as the female in the Yale Babylonian Collection (cat. no. 7; see Figure 5, right), there are thicker and correspondingly darker and denser accumulations of tarnish, also easily scratched to reveal bare metal. Several statuettes—the male figure in the Metropolitan Museum (cat. no. 30; see Figure 2) is one such example—have patches of green corrosion overlying this dark film; others exhibit more or less well-adhered accretions (e.g., cat. no. 29; see Figure 15).[64]

In a number of celebrated cases, cupreous artifacts are said to have been removed from the earth in apparently uncorroded condition, but rarely is there contemporaneous documentation.[65] More commonly, cupreous antiquities,

although subjected to corrosive attack during burial, no longer retain archaeological surfaces because they were cleaned using one or more of a variety of chemical, electrolytic, and mechanical methods. Sometimes evidence of long-term burial is only partly removed, but just as frequently very little survives. A further complication is the practice, not uncommon in the past, of chemically inducing a patina on surfaces that seemed too raw after a particularly thorough cleaning.[66] Surface examination alone cannot be used to distinguish objects manufactured as forgeries that have been treated to appear ancient from those that are genuine but were aggressively cleaned and subsequently patinated using similar means. For artifacts lacking a certifiable provenience and, like the Lebanese Mountain Figures, not easily integrated with existing historical and stylistic patterns, aggressive cleaning and artificial patination practices can produce widespread confusion.

ELEMENTAL ANALYSES

Seyrig pointed out that although the Lebanese Mountain Figures are always described as bronzes, analyses of nine undertaken on his behalf showed that the statues were cast from unalloyed copper of relatively high purity.[67] Those analyses are qualitative, but Seyrig took a major step in providing data that superseded earlier assumptions, and in the sixty years since the publication of his work numerous analyses demonstrating varying degrees of precision have been carried out on these and additional figures, with confirmatory results (see Appendix 1).

For this study, polished sections prepared from samples removed from nine figures (cat. nos. 6, 7, 9, 21, 22, 24, 25, 29, 33) were analyzed using an energy dispersive X-ray spectrometer attached to a scanning electron microscope (SEM-EDS) at the Sherman Fairchild Center for Objects Conservation.[68] Seven were further examined at the Institut für Geowissenschaften, Johannes Gutenberg Universität, Mainz, Germany, using a wavelength dispersive X-ray spectrometer attached to an electron microprobe

(EMP-WDS).[69] In 2012 a tenth section (cat. no. 16) was analyzed using EDS in the Metropolitan Museum's Department of Scientific Research.[70] The reported EDS values for arsenic range from below the minimum detection limit (<0.3%) (cat. no. 25) to 1.1 percent (cat. no. 22); the average arsenic content for the group is 0.7 percent.[71] Therefore, except in one case, the amount of arsenic detected fell below even the most restrictive limits proposed for intentional arsenical copper alloys;[72] there is no indication in the radiographic evidence (discussed below) that the outlier, the female figure in the Museum für Kunst und Gewerbe (cat. no. 22), was in any way manufactured differently from the others. The same can be said for a male figure (cat. no. 29) reported to have 1.0 percent arsenic. The results, along with information regarding secondary phases and inclusions analyzed using WDS, do suggest that at least some of the Lebanese Mountain Figures are not as pure as prior analyses may have indicated.[73]

With EDS analysis, iron at levels of 0.1 percent was detected. WDS analyses were useful in refining these data, with average values calculated from multiple sites per sample ranging from 0.01 to 0.18 percent.[74] These very low levels point to a simple smelting process having been used to refine the copper.[75]

RADIOGRAPHIC EXAMINATION

To date, nineteen Lebanese Mountain Figures have been radiographed, including male and female figures in the Vorderasiatisches Museum (cat. nos. 3, 4, 11–13, 15, 16), the Yale Babylonian Collection (cat. nos. 6, 7), and the Museum für Kunst und Gewerbe (cat. nos. 21, 22), the female figure in the Ashmolean Museum (cat. no. 17), and male figures in the Ny Carlsberg Glyptotek (cat. no. 25), the Metropolitan Museum (cat. no. 30), the British Museum (cat. no. 31), the Saint Louis Art Museum (cat. no. 33), and three private collections (cat. nos. 9, 29, 37).[76] All are solid casts (e.g., cat. nos. 3, 6, 7, 16, 21, 22, 33; Figures 19–24), a feature not unexpected considering their proposed date and Levantine origins.[77] There is no evidence from the radiographic or visual examinations carried out on the female figure in the Museum für Kunst und Gewerbe (cat. no. 22; see Figure 19) to support Seeden's assertion that the head is hollow.[78]

The pitting observed on the surfaces of the figures is reflected in their internal structure. Except for one statue that may fall outside of the Lebanese Mountain Figure corpus (cat. no. 3), the radiographic images are strikingly similar: the casts are extremely porous, exhibiting an overall distribution of large voids that gives them a distinctive spongelike appearance. Porosity in most of the figures is relatively evenly distributed, although a preponderance of pores in the back half of the figure in the British Museum (cat. no. 31) led to the suggestion that it was cast facedown.[79]

Preventing excessive porosity is always a consideration in foundry work, and unalloyed copper, in particular, is prone to this condition. One important reason that copper is alloyed with other metals is to reduce its propensity to absorb gases when molten. The extreme porosity characteristic of the Lebanese Mountain Figures has not generally been observed in radiographs of other types of solid-cast cupreous statuary. Because porosity may relate to size, with larger objects having the potential for more and larger pores, it should be mentioned that solid casts of unalloyed copper as tall and as massive as the male Lebanese Mountain Figures are rare.[80] In any case, abundant coarse porosity is equally present in the smallest figures. The female statue in the Yale Babylonian Collection measures 12.5 centimeters in height (cat. no. 7; see Figure 23) and is also highly porous. Its specific gravity of 6.2 is about 70 percent of the reported value for pure copper (8.96),[81] and also far less than specific gravities ranging from 8.10 to 8.92 reported by D. Hanson and C. B. Marryat and by Paul Budd and Barbara Ottaway for their trial arsenical copper castings.[82] Due to their large size, and despite their internal porosity, the figures are extremely heavy, and, as Seyrig points out, one is impressed by the amount of

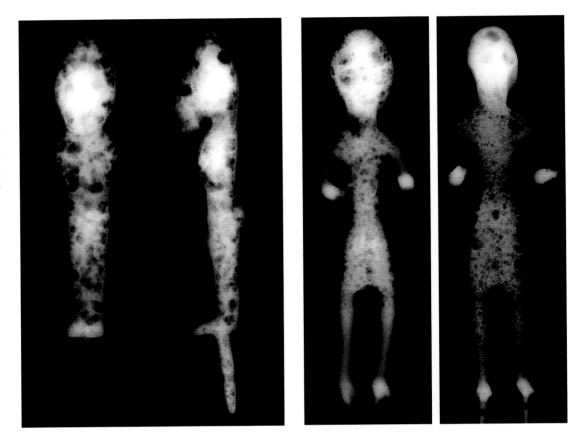

Figure 19 ◆ Female figure (cat. no. 22; see Figure 13). X-ray radiographs

Figure 20 ◆ Male figure (cat. no. 6; see Figure 5, left). X-ray radiograph

Figure 21 ◆ Male figure (cat. no. 16; see Figure 10). Gamma radiograph, digitally manipulated to improve contrast

raw material that these provincial metalworkers had at their disposal.[83]

The small male figure (cat. no. 3; see Figure 24) rejected as a forgery by Ronzevalle and Seeden and described as authentic but "very strange" by Seyrig[84] does not have the idiosyncratic spongelike structure described as typical for the Lebanese Mountain Figures. It is only slightly porous, and in this way comparable to ancient solid-cast copper and copper-alloy objects seen as a whole.

METALLURGICAL EXAMINATION

Metallurgical examinations were carried out at the Sherman Fairchild Center for Objects Conservation on samples from ten figures (cat. nos. 6, 7, 9, 16, 21, 22, 24, 25, 29, 33) prepared as polished sections. The most prominent feature observed in the majority is excessive porosity (e.g., cat. nos. 6, 25; Figures 25, 26), which correlates with their pitted surfaces and the radiographic evidence of their internal structure.[85] Sections from male figures in the

Museum für Kunst und Gewerbe (cat. no. 21; Figure 27) and a private collection (cat. no. 29) are not excessively porous, but this feature can be regarded as incidental because both figures appear in the radiographs as porous as the others (for cat. no. 21, see Figure 22).

Just as the radiographic images of the Lebanese Mountain Figures are distinctive and perhaps unparalleled, ancient cupreous artifacts displaying such a porous structure in section are also seldom seen. The sizes of the pores visible in these sections vary greatly—many are large enough to be seen without magnification—and they are not uniform in appearance. Some have sharp outlines and walls with well-defined dendritic excrescences displaying metallic luster. Other pores, usually those closer to the outer surfaces of the samples, have discolored surfaces, perhaps due to superficial alterations associated with incipient corrosion. Pores closest to or contiguous with the outer surfaces of the statues often are entirely filled with a variety of corrosion

SCHORSCH

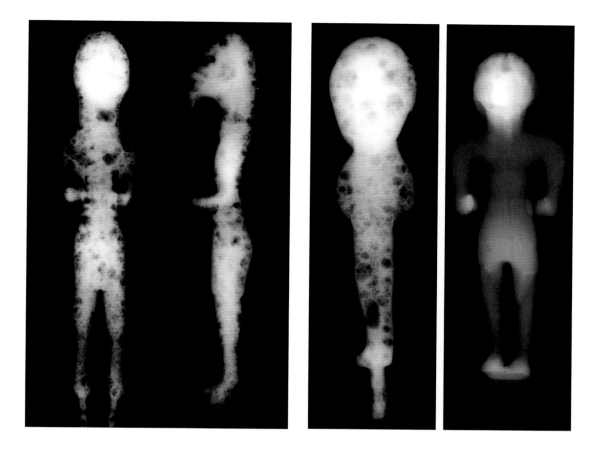

Figure 22 ♦ Male figure (cat. no. 21; see Figure 12). X-ray radiographs

Figure 23 ♦ Female figure (cat. no. 7; see Figure 5, right). X-ray radiograph

Figure 24 ♦ Male figure (cat. no. 3; see Figure 7). Gamma radiograph

products and nonmetallic accretions, including clusters of large lustrous black crystals as yet unidentified.

Leaving aside momentarily a lead-rich phase observed in four cases, seven of the ten samples (cat. nos. 7, 9, 21, 24, 25, 29, 33) are single phase α-copper systems. Surprisingly, in not one case was the metal found to be in as-cast condition. All samples showed some evidence of annealing and/or cold-working. Coring was observed in unannealed specimens, and those that had been heated all exhibit some degree of remnant coring. This latter observation is not unexpected, for the barriers to homogenization in this system are said to be formidable. According to Budd, segregation in copper-arsenic alloys is so severe that modern casts with as little as 1.0 percent arsenic frequently contain a Cu_3As phase.[86] This phase was identified only in the polished section from the female figure in the Museum für Kunst und Gewerbe (cat. no. 22), with an overall arsenic content of 1.1 percent. Several spots of another arsenic-rich phase ($\sim Cu_7As_3$)

were observed in the section from the Yale Babylonian Collection male figure (cat. no. 6), reported to contain only 0.6 percent. A second phase of minute lead-rich globules generally less than 1 micron in diameter was observed in four sections (cat. nos. 6, 22, 24, 25).[87]

To return briefly to Seyrig's question of whether the surfaces had been improved after casting, it is fairly certain that metal tools such as burins were not in use during the Middle Bronze Age. The linear details he remarks on were almost assuredly scored or cut into the wax model. Where observed in the polished sections, cold-working entailed sporadic local deformation of the outer surface, especially around open pores, suggesting that some effort was made to improve the newly cast surfaces of the figures (cat. no. 33; Figure 28a; see also cat. no. 21, Figure 27).

The copper-oxygen eutectic (Cu_2O, analogous to cuprite) was not observed in any of the samples. Many of the sections contain bright gray nonmetallic inclusions distributed primarily

Figure 25 ◆ Male figure (cat. no. 6; see Figure 5, left). Polished section, unetched, bright field illumination, showing abundant internal porosity (composite image of black-and-white instant images)

Figure 26 ◆ Male figure (cat. no. 25; see Figure 3). Polished section, unetched, bright field illumination, showing abundant internal porosity (composite image of black-and-white instant images)

Figure 27 ◆ Male figure (cat. no. 21; see Figure 12). Polished section, unetched, plane-polarized illumination, showing relative absence of internal porosity

along grain boundaries. At least one type was observed in seven of the ten samples examined (cat. nos. 6, 21, 22, 24, 25, 29, 33).[88] Most could be confirmed as copper sulfides using EDS analyses, which also indicated trace amounts of other metals including, in some cases, selenium and tellurium. Sulfide inclusions in four of these samples (cat. nos. 6, 22, 24, 25) were analyzed using WDS and found consistently to contain copper and sulfur in an atomic ratio of 2 to 1. WDS was also employed to quantify selenium and tellurium in the inclusions, but in only one case (cat. no. 24) were these elements present in amounts greater than 1 percent.[89] WDS analysis allowed the identification of occasional amorphous iron-rich inclusions in a

number of sections; the Saint Louis Art Museum figure (cat. no. 33), with countless crystalline iron-rich inclusions, is exceptional.

No matter how uncorroded the surface of a figure in question appeared, when viewed in section the metal in all cases demonstrated some degree of intergranular attack (e.g., cat. nos. 6, 7, 16, 24, 25, 33; Figures 28b, 29, 30a, 31–34). The presence of intergranular corrosion was also noted in an account of the female figure in the Ashmolean Museum (cat. no. 17)[90] and in an unpublished report about a male figure in a private collection (cat. no. 37).[91] Intergranular cuprite is taken by historical metallurgists as virtually unequivocal evidence of substantial age for cupreous metals, even if their surfaces seem corrosion-free. In one significant respect, however, much of the intergranular corrosion in the samples examined differs in appearance from that of typical cuprite when viewed in a polished section on an inverted stage microscope. Under bright field illumination, cuprite has a cool gray color, but it appears red when viewed under plane-polarized light. Under bright field illumination, the intergranular corrosion observed in the sections from the Lebanese Mountain Figures is not visually distinguishable in color or texture from typical archaeological cuprite; however, under plane-polarized illumination, much of the subsurface corrosion is a purple-tinged blue-gray. In some cases, islands of corrosion visually identifiable as cuprite are present below or surrounded by large patches of the darker variant. Blue-gray epitaxial crystals, either isolated or contiguous with the intergranular corrosion, were observed in the polished sections of the male figures in the Saint Louis Art Museum (cat. no. 33; see Figure 28b) and the Museum für Kunst und Gewerbe (cat. no. 21). It should be noted that the coloration of this unusual corrosion product does vary somewhat when the same samples were prepared using different polishing procedures or when viewed under different light sources and at different magnifications.[92]

This blue-gray species may be analogous to

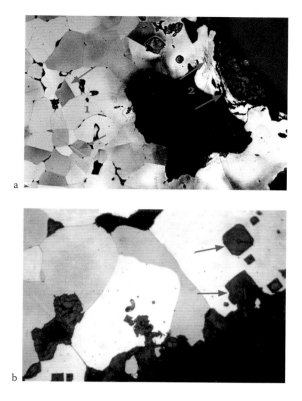

a

b

an alteration of cuprite observed by Hanson and Marryat in polished sections of various arsenical coppers that were cast for an investigation of the effects of arsenic and oxygen impurities on the physical characteristics of copper. When the arsenic content in the samples reached about 1 percent, the cuprite darkened in color and a slate blue component began to appear.[93] They noted:

> It is frequently difficult to distinguish between discoloured Cu_2O and the slaty-blue constituent, as there seems to be a gradual transition from one to the other as far as colour under direct illumination is concerned. The method used to distinguish them has been to examine them by means of oblique light, using a dark ground illuminator. Under this lighting cuprous oxide normally appears a characteristic red colour, whereas the slaty-blue constituent appears uncoloured.[94]

At more elevated levels of arsenic only the blue constituent was present. Unfortunately, Hanson

and Marryat's descriptions are too vague to judge whether the corrosion product observed in the Lebanese Mountain Figure sections is more likely to correspond to the discolored cuprite, to the slate-blue phase, or to a mixture of the two. They provide no elemental analysis of the discolored cuprite or the slate-blue constituent and state only that the latter's varying appearance in different alloys and following different thermal treatments suggests that it does not have a fixed composition.[95] They reject as inconclusive J. Ruhrmann's statement that the bluish constituent is the mixed arsenic-copper oxide ($Cu_2As_2O_5$).[96]

Solid substitution by other elements customarily does not occur in geological cuprite, but it has been demonstrated that artificially induced cuprite will accept gold atoms in its crystal lattice and is thereby discolored.[97] This process forms the basis of the luminous black surfaces on Japanese *shakudō* and other artificially patinated cupreous metals, and it has been suggested that arsenic may have been used to attain similar results.[98] WDS analysis of the bluish-gray corrosion was carried out on polished sections from figures in the Yale

a

b

Figure 28 ◆ Male figure (cat. no. 33; see Figure 17). Polished section, bright field illumination, etched with alcoholic ferric chloride: (a) note (1) annealing twins and (2) surface deformation; (b) arrows indicate location of epitaxial copper corrosion; note the absence of surface deformation.

Figure 29 ◆ Male figure (cat. no. 24; see Figure 6). Polished section, unetched, showing intergranular corrosion: (a) bright field illumination; (b) plane-polarized illumination

a

b

Figure 30 ◆ Male figure
(cat. no. 6; see Figure 5,
left). Polished section:
(a) unetched, plane-
polarized illumination,
showing intergranular
corrosion; (b) etched with
alcoholic ferric chloride,
plane-polarized illumina-
tion, showing banded
corrosion characteristic
of long-term burial

Figure 31 ◆ Male figure
(cat. no. 25; see Figure 3).
Polished section,
unetched, plane-polarized
illumination, showing
intergranular corrosion

Figure 32 ◆ Female figure
(cat. no. 7; see Figure 5,
right). Polished section,
unetched, plane-polarized
illumination, showing
intergranular corrosion

crystal growth or simply reflects the natural color of an unexpected species; the unidentified lustrous black crystals noted in pits in several polished sections also merit attention in the future studies.

In several sections, some yellowish corrosion was observed. Yellow-green copper corrosion products are anecdotally associated with arsenic, but EDS analyses carried out on the section from the Yale Babylonian Collection female figure (cat. no. 7) confirm, at least in this case, that the corrosion does not have an elevated arsenic content. Banded corrosion, observed in large pores in polished sections from the male figures in the Yale Babylonian Collection (cat. no. 6; see Figure 30b) and the Saint Louis Art Museum (cat. no. 33), is evidence of long-term periodic attack, lending further support to the opinion that these figures are of great antiquity.

Babylonian Collection (cat. nos. 6, 7), the Musée d'Art et d'Histoire, Geneva (cat. no. 24), and the Saint Louis Art Museum (cat. no. 33), and in all four cases, excepting nonmetallic elements related to the presence of sand and other accretions, this corrosion product was found to contain only copper.

Another possibility is suggested by a massive black corrosion product identified visually as tenorite that was observed on polished sections from the British Museum figure (cat. no. 31). To judge from the photomicrographs, explanatory drawings, and descriptions included in a photocopy of the original report, it is similar in habit and location to the dark blue-gray intergranular corrosion associated with the other Lebanese Mountain Figures.[99] Tenorite is a copper oxide that forms in thin films on cupreous surfaces at elevated temperatures but is also sometimes found in a thin layer at or near the metal-corrosion interface on archaeological cupreous artifacts.[100] Electron backscatter diffraction used in conjunction with SEM-EDS-WDS analysis might prove useful for identifying the unknown corrosion product and thereby establishing if its color is caused by a distinctive pattern of

THE 1908 GROUP
According to Seeden,

By 1901 wealthy Europeans, craving Palestinian curios with vague but

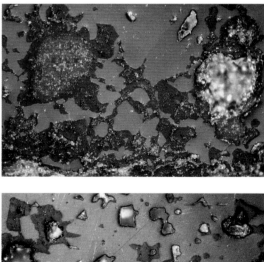

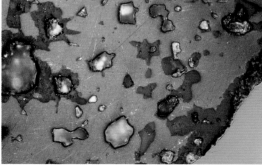

eagerly imagined biblical connotations bought antiquities, particularly figurines both false and original, at stylish antique dealers' exhibitions such as that held in the Musée Guimet in Paris. By this time some urbanized Orientals like the Levantine Joseph Durighiello of Saida were fully equipped to produce and sell (at considerable profit) imitations of such antiquities in order to satisfy the rapidly growing market.[101]

Among these are at least four forgeries after Lebanese Mountain Figures that can be attributed to Durighiello with near certainty.

Three figures assigned to the 1908 Group appeared on the market quite early and were quickly designated forgeries (see Appendix 2). What makes them still interesting is their complicated relationship to a male figure in the Vorderasiatisches Museum (cat. no. 16) rejected as a forgery by Seyrig and Seeden and the insights they offer into evolving perceptions of authenticity based on stylistic and technological criteria over a period of one hundred years.

When Vincent published the first of the three figures (cat. no. 1F; see Figure 14) in 1908,[102] he remained circumspect throughout his brief discussion, mentioning all the reasons why it is not likely to be a forgery and even describing the patina as dissimilar to those observed on statuettes originating from known "antiquity" workshops. Still, his doubts are palpable. The figure belonged at that time to a Russian nobleman, Baron Ustinov, resident in Jaffa 1862–67 and 1878–1913. During his second stay, after he had retired from military service, Ustinov assembled his collection from natural specimens and antiquities acquired locally, including this statue purchased from a Bedouin who said it came from "Transjordan."[103] Twelve years after Vincent's article appeared, Frederik Poulsen uncritically included the figure in his publication of five sculptures in the Ustinov Collection that had been brought by a Norwegian consortium to Christiania (today Oslo) to be sold.[104] In 1928, after Poulsen

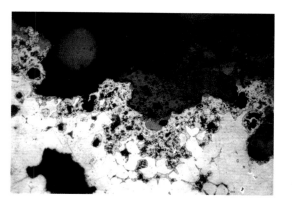

Figure 33 ◆ Male figure (cat. no. 33; see Figure 17). Polished section, unetched, bright field illumination, showing intergranular corrosion

Figure 34 ◆ Male figure (cat. no. 16; see Figure 10). Polished section, unetched, plane-polarized illumination, showing intergranular corrosion

became its director, the Ny Carlsberg Glyptotek acquired the ex-Ustinov figure from the Rastads Collection. Ronzevalle's objections to the statue were noted in a 1940 catalogue, but other grounds for accepting it as ancient were invoked.[105]

The second figure (cat. no. 2F) was donated to Yale University in 1915. There are no accession records in the Yale Babylonian Collection, where it currently resides, or in the Yale University Art Gallery, where the statue was placed on display with the small female from the pair acquired by 1900 (cat. no. 7).[106] Still, it is most assuredly the "Hittite bronze," which, according to James J. Rorimer, was presented to what he called the "Yale University Museum" by Albert T. Clay, professor of Assyriology and Babylonian literature.[107] Rorimer's interest in the Yale statue related to the Metropolitan Museum's having acquired in 1925 the third 1908 Group Figure (cat. no. 3F; Figure 35) as a gift from Philip J. and Alice E. Mosenthal. Said to have been found in southern Syria and called Hittite, it received the endorsement of Hans Henning von der Osten,[108] a noted Hittite

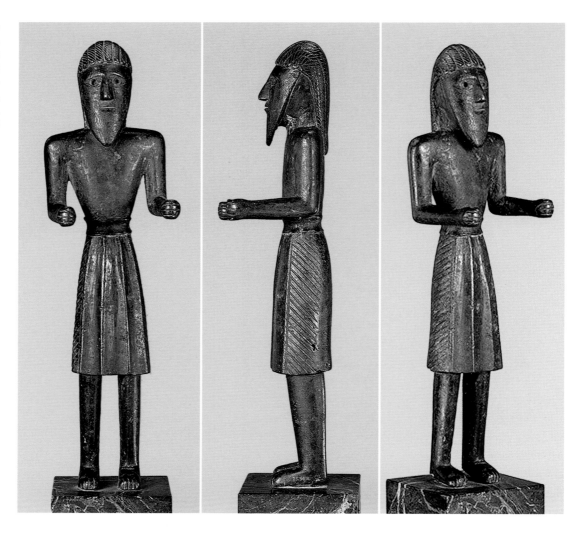

Figure 35 ◆ Male figure (cat. no. 3F). Lebanon, ca. 1908. Cast cupreous metal, H. 38.7 cm (15¼ in.) with tangs. The Metropolitan Museum of Art, Gift of Philip J. and Alice E. Mosenthal, 1925 (25.96)

scholar in his day. It was published soon after by Maurice S. Dimand, then assistant curator of decorative arts, and featured on a Museum postcard.[109] After receiving a letter from Ronzevalle in early 1932, the Museum had the figure examined by Colin G. Fink, a prominent chemistry professor at Columbia University and since 1923 a scientific consultant to the Museum on matters relating to archaeological bronzes.[110] Summing up his observations in the second of two reports from that year, Fink deemed the figure ancient because its surface "compares in every detail with an ancient patina" and because the surface alterations observed "are due to a slow process of corrosion." Fink concluded, "The examination of the metal . . . indicates again that we are dealing with a metal that has been aged for a good many years."[111]

Fink went on to include the figure as genuine in a 1936 publication,[112] although it had officially been "declared of doubtful authenticity" by the Museum in May 1933.[113] This statement was based on the opinions of several Museum curators, including Rorimer, who had gone to New Haven to see the 1908 Group Figure there and, with Gisela M.A. Richter, curator of Greek and Roman art, contested Fink's interpretation of the surface condition and the polished section of the Museum's statue, as well as the correspondence of outside experts such as Ronzevalle, Walter Andrae and Anton Moortgat in Berlin, Georges Contenau in Paris, and Eustache de Lorey, a former director of the French Institute of Archaeology and Museum of Islamic Art in Damascus.[114] Vagn Poulsen (no relation), Frederik Poulsen's successor at the Glyptotek, after visiting the

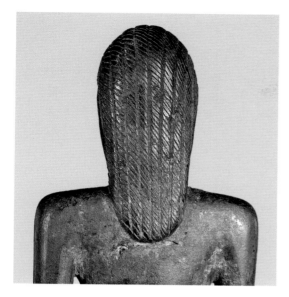

United States in 1950 and seeing the Yale Babylonian Collection figure, acknowledged it and the Metropolitan Museum statue as forgeries, maintaining that the Glyptotek's figure was the ancient original from which the other two had been copied.[115] One year later, after the Glyptotek had acquired a male Lebanese Mountain Figure from the "Syrian hoard" discovered in 1948 (cat. no. 25), the ex-Ustinov figure was declared a forgery[116] and published as such by Gjødesen.[117]

With modern eyes it is easy enough to separate the 1908 Group Figures from those of the Lebanese Mountain Group. However, it is also not difficult to imagine that more than a century ago they were taken seriously by collectors. The 1908 Group Figures are, in a sense, Lebanese Mountain Figures "refined." In scale they fall within the range of the Lebanese Mountain Figures, but their proportions are more naturalistic,[118] their surfaces are not marred by massive pits, and they have more, and more finely drawn, linear detail than can be seen on the prototypes.

One feature present on all three 1908 Group Figures is a pleated kilt, which, as several earlier authors noted, is a misinterpretation of the braided cords that hang from the belts of the male Lebanese Mountain Figures.[119] These kilts also have, illogically, fringes on both sides. One of the male Lebanese Mountain Figures

in the Vorderasiatisches Museum (cat. no. 16; see Figure 10) wears an unpleated garment with two fringed edges and lacks a thick braid on the back of the head, also missing from the 1908 Group Figures (e.g., cat. no. 3F; Figure 36), and partially for this latter reason was rejected as a forgery by Seyrig.[120] Seeden agreed that the Vorderasiatisches Museum figure is a fake, adding that it has no ears (see Figure 10, left profile view),[121] which is also the case for all three 1908 Group Figures (see Figures 14, 35).

In spite of Fink's comments about the Metropolitan Museum statue (cat. no. 3F), the surfaces of the 1908 Group Figures are not characteristic of cupreous artifacts from archaeological contexts. These figures (cat. nos. 1F–3F) are covered with superficial brown tarnish films and easily scratched to reveal bare metal. Overlying this tarnish film are patches of a nonadherent green corrosion product (e.g., cat. nos. 1F, 3F; see Figures 14, 36). Admittedly, the surfaces of some bona fide Lebanese Mountain Figures are not much different, underscoring the need for metallurgical investigation to ascertain the presence or absence of intergranular corrosion when typical archaeological corrosion products are not in evidence on the surface of an allegedly ancient artifact. In fact, the major difference in surface appearance between the figures in the two groups is the paucity of pitting on the 1908 Group Figures. The Metropolitan Museum (cat. no. 3F) and ex-Ustinov (cat. no. 1F) statues both have some pits on the reverse. The Yale Babylonian Collection figure (cat. no. 2F) has one repair improving a casting flaw on its right shoulder, and otherwise hardly any pits.

The radiographs of the 1908 Group Figures are difficult to interpret because the statues are quite radiopaque and have many cracks and cast-in or cast-on repairs. Still, in all internal features the two groups differ radically.[122] The two larger 1908 Group Figures (cat. nos. 1F, 3F; Figures 37, 38) resemble each other in that they both are hollow casts, although it remains unclear if there is a single cavity inside their

Figure 37 • Male figure
(cat. no. 1F; see Figure 14).
X-ray radiographs

Figure 38 • Male figure
(cat. no. 3F; see Figure 35).
X-ray radiographs

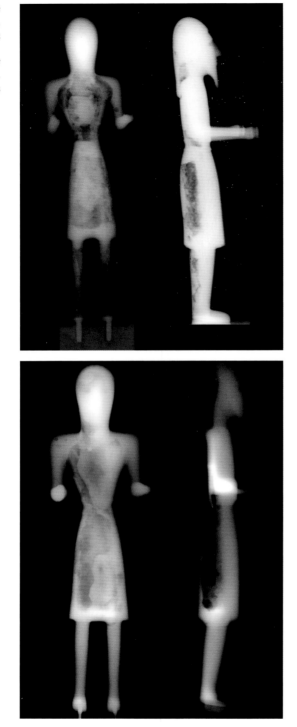

its kilt. The statue has many pores, but in number, size, and distribution they do not at all resemble those associated with the Lebanese Mountain Group. The porosity and pitting on the reverse of the Metropolitan Museum (cat. no. 3F) and the ex-Ustinov (cat. no. 1F) figures appear to be associated with outgassing from the casting core. The general dimensions and overall external appearance of these two figures suggest that they were both indirectly cast using the same piece mold or using different piece molds made from the same master model; it is also possible that one figure was the model for the piece mold used to cast the other. The statue in the Yale Babylonian Collection (cat. no. 2F) is substantially smaller than the two other 1908 Group Figures. It is solid cast and has no internal porosity.

EDS and WDS analyses were carried out on polished sections from the ex–Ustinov Collection (cat. no. 1F) and the Yale Babylonian Collection (cat. no. 2F) figures, and EDS analysis on a surface scraping from the Metropolitan Museum (cat. no. 3F) figure. Knowing that the figures he accepted as authentic were unalloyed copper, Seyrig hypothesized that the former were made of bronze,[123] but the elemental analyses proved him incorrect. The figures in the Metropolitan Museum (cat. no. 3F) and the Yale Babylonian Collection (cat. no. 2F) both contain zinc, tin, and lead at just above trace levels, as well as a trace of iron, but the ex–Ustinov Collection figure (cat. no. 1F)—a relatively pure copper with a small amount of arsenic (0.5 percent)—is similar in composition to the Lebanese Mountain Figures. Still, its iron content (0.3 percent) is greater than that found in the latter group (see Appendix 1).[124]

Metallurgical examinations were also carried out on the two sections. Both exhibit a scattering of small pores unlike those observed in polished sections from the Lebanese Mountain Figures. Some copper sulfide inclusions containing trace amounts of selenium and tellurium are present in both sections. Most significantly, no intergranular corrosion of any kind was observed.

heads and torsos or there are two separate, adjacent cavities separated by metal. Profile view radiographs show that the cavities in both figures are located toward the back. The Metropolitan Museum figure (cat. no. 3F) was probably executed in two pours, with the legs cast over stumps extending from the bottom of

DISCUSSION

Relatively soon after their appearance, the figures of the 1908 Group were recognized by archaeologists as forgeries. Seen from a historical point of view, this early but legitimate discrediting is partly responsible for the tarnished reputation, ultimately unjustified, from which the Lebanese Mountain Figures have suffered ever since. Unfortunately, knowledge of the intrinsic differences between the figures of the 1908 Group and the Lebanese Mountain Group does not provide guidelines for determining the authenticity of members of the latter. For example, the somewhat disconcerting similarity in metal composition between the 1908 Group ex-Ustinov figure (cat. no. 1F) and the Lebanese Mountain Figures neither improves the chances of the former being ancient nor changes verdicts for the latter.[125]

Archaeologists and art historians have often expressed doubts about one or another of the Lebanese Mountain Figures on the basis of small formal differences. In the absence of a pedigree conferred by a documented provenience, it is difficult to conclusively prove the authenticity of any single specimen. Still, solid evidence of an extended period of burial, in the form of intergranular corrosion, can be demonstrated for the ten figures in the Yale Babylonian Collection (cat. nos. 6, 7), the Vorderasiatisches Museum (cat. no. 16), the Museum für Kunst und Gewerbe (cat. nos. 21, 22), the Musée d'Art et d'Histoire (cat. no. 24), the Ny Carlsberg Glyptotek (cat. no. 25), the Saint Louis Art Museum (cat. no. 33), and two private collections (cat. nos. 9, 29) that were examined in section. Based on unpublished metallurgical examinations, the female figure in the Ashmolean Museum (cat. no. 17) and a male figure in a private collection (cat. no. 37) may also be added to this group. In fact, the sections from the British Museum figure (cat. no. 31), seen in photocopies of archival images, also have a degree of intergranular corrosion commensurate with sections from the first-mentioned ten figures, although Research Laboratory examiners in 1957 and 1967 found it lacking.[126]

Furthermore, the characteristic elemental composition, the coarse internal porosity rarely seen in other cupreous statuary,[127] the absence of the copper-oxygen eutectic in the form of stringers or in direct association with the plentiful pores, and the persistent occurrence of an atypical form of intergranular corrosion, taken together, demonstrate a degree of internal consistency rarely observed among a group of similar artifacts, even those excavated at a single site. Cypriot copper oxhide ingots from the Uluburun shipwreck studied by Andreas Hauptmann and colleagues are also extremely porous, but unlike the lost-wax-cast Lebanese Mountain Figures, these ingots were produced presumably in univalve molds and the porosity in the individual pours has tended to segregate along the upper surfaces that were exposed while solidification proceeded.[128] The casts also contain stringers of copper oxide throughout and substantially concentrated in patches around pores. Whereas oxygen clearly was present in the molten metal when the Cypriot ingots were cast, the porosity in the Lebanese Mountain Figures reflects a different mode of processing that led to the introduction of hydrogen to the copper, presumably resulting from excessive poling and its subsequent rejection by the cast metal as it solidified in the investment. Other than as a point of comparison, what is significant about the Uluburun material is that the authors see their characteristic porosity as a defining feature of a local industry, a feature not observed in oxhide ingots originating from other regions. This can also be said for the Lebanese Mountain Group on the basis of its porosity, coupled with the absence of the copper-oxygen eutectic.

The authenticity of the thirteen figures examined in section is therefore secure, and by extension, strong evidence supports the assertion that twelve additional figures (cat. nos. 1, 10–15, 24, 26–28, 30) included in this study are products of the same ancient tradition. The internal consistency in manufacture and material, which sets these figures apart from their chronological and geographical peers, also

supports the validity of Moorey's and Seeden's contentions that they were produced within a short period of time. How one would define such a span in remote antiquity is not obvious. In any case it is hardly possible that a homogeneous corpus of more than thirty figures could represent the work of a series of forgers active over a period of more than two hundred years.

Despite fringes on both sides of its kilt and lack of a central braid and ears, it is no longer justifiable to dismiss as false the male figure in the Vorderasiatisches Museum (cat. no. 16) that was rejected by Seyrig and Seeden. In composition, in the coarseness and extent of its internal porosity (see Figure 21) and surface pitting, and most important because it displays a fair amount of intergranular corrosion in section (see Figure 34), it is the equal of the twelve other figures for which authenticity is assured by the nature of the corrosive attack they have sustained. One is therefore inclined to attribute these incongruous details to a careless ancient craftsman and to designate the Vorderasiatisches Museum figure as the direct prototype for the 1908 Group Figures.[129] It is more than likely that Durighiello was involved in the production of the 1908 Group Figures, for he had this presumptive model used to produce the statues in his possession until 1902, as well as most of the other Lebanese Mountain Figures that were known before 1907.

The small male figure (cat. no. 3), rejected as false by Ronzevalle and Seeden and described as authentic but "very strange" by Seyrig, differs from the others in several ways. Its interior is only slightly porous. Of diminutive size, with convex eyes, his feet placed together on a single tang, and wearing an odd kilt with no fringe on either side and a drapery hanging in the back like a tail (Figure 39), the figure may well come from a different workshop, and perhaps if it came to light today it might not be assigned to the Lebanese Mountain Group at all. Quantitative elemental analysis and metallurgical examination might help settle this case. As for the female figure (cat. no. 14) that Seyrig cites and then excludes from the corpus,

judgment must be delayed until more technical information is available.[130]

If the majority of documented Lebanese Mountain Figures are accepted as authentic, what do they add to our knowledge of metal industries in the ancient Levant? Perhaps the most important reasons that the figure in the British Museum (cat. no. 31) was sidelined as a forgery following the two technical examinations undertaken by Robert Organ and Harold Plenderleith when it was acquired in 1957 are the relative purity of the copper, as ascertained by emission spectroscopy, and the absence of the copper-oxygen eutectic in a polished section made from a sample removed from one of the tangs.[131] At that time it simply seemed implausible that a work thought to date to the mid-second millennium B.C.—when arsenical copper and early bronze alloys had ostensibly replaced unalloyed copper in the Near East, Egypt, and the Aegean—would have been made of copper and, if so, that copper oxide had not formed in the porous cast when it solidified. What apparently finally convinced the scientists who took part in the third investigation, led by A.E.A. Werner in the late 1960s, was not different analytical results but new knowledge of other "objects of known provenance and great age . . . made of similar oxygen-free high purity copper."[132] It is not clear which data they were referring to, for few published analyses of excavated statuary from the Near East had appeared during those intervening years. Furthermore, the current research has demonstrated that bulk analyses alone do not accurately reflect the relative purity or impurity of the figures because most of the trace elements present are segregated in secondary phases or inclusions.

The corpus of Syro-Palestinian figural statuary in metal is quite large: Negbi catalogues more than seventeen hundred figures, and Seeden, restricting herself to male warrior figures, includes some two thousand examples.[133] A review of the very few published analyses of cupreous Syro-Palestinian human figures of the Bronze Age prior to 1984 appears in the

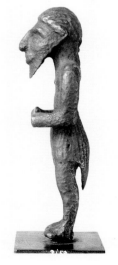

Figure 39 • Male figure (cat. no. 3; see Figure 7), left profile view

SCHORSCH

work of Roger Moorey and Stuart Fleming.[134] Evidence of early bronzes, such as the figures from Tel el Judeideh, as well as unalloyed copper figures dating to the late Middle Bronze Age or early Late Bronze Age, is cited. The analyses of unprovenienced metal statues in the Ashmolean Museum reported by Moorey and Fleming reveal that five of the ten Early Bronze Age to Middle Bronze Age figures, including the female Lebanese Mountain Figure (cat. no. 17), were cast from unalloyed copper, another four from arsenical copper, and a tenth figure from a bronze containing 2.5 percent tin.[135]

Seyrig proposed that the makers of the Lebanese Mountain Figures were unaware of the working methods and technical advances known to their neighbors because they used unalloyed copper and their statues were cast "right-side up." In fact, despite much speculation, there is little direct evidence of the lost-wax casting techniques in use in the Levant during the Bronze Age. The wax models would have been destroyed in the process, investment fragments rarely survive, and relatively few ancient failed or unfinished castings still in their investments are known.[136]

To return to the second feature that Seyrig attributes to unsophisticated casting methods—the use of unalloyed copper—one might consider that some of the characteristic properties conferred on copper through alloying, such as increased hardness and the possibility of hardening the metal further with cold-working, were important for tools and weapons but not necessarily for cast objects, whereas other properties—a substantially lower melting point and decreased porosity in the finished product, for example—would surely be desired.[137] It is conceivable that unalloyed copper was used more frequently for the casting of nonutilitarian objects at the beginning of the Middle Bronze Age than is currently recognized, a possibility that Seyrig suggested in a footnote.[138] Proper assessment of this thesis is hampered by the lack of analyses of excavated contemporaneous figures from neighboring regions. For now, perhaps a clearer reflection of a

"homegrown" casting process is the extreme porosity of the figures and their consequently grossly pitted surfaces.

Just as Ronzevalle's article took nearly twenty-five years to reach his public, this study is based on research substantially completed in the early 1990s. Although the original text was updated, some desired amplifications were not possible. For example, in the intervening years several prepared sections have been misplaced and therefore could not be repolished or rephotographed, and the earlier photographs were taken using an aged metallurgical microscope discarded long ago along with the equations for calculating magnification through its various camera attachments. Still, this study provides justification for reevaluating opinions put forth by various earlier scholars.

Crucial to a broader understanding of the Lebanese Mountain Figures, but almost entirely absent, is information about their cultural context. According to current understanding, this rugged mountainous region to which they are attributed was less advanced in material culture and social organization than the urban settlements of the Lebanese coast. There are no reports of ancient copper mining or smelting in the mountains of southern Lebanon, and the region on the whole is believed to be poor in copper ores—virtually no mention of copper appears in nineteenth- and twentieth-century geological surveys—in spite of large finds of cupreous metal figures and utilitarian objects at coastal sites, particularly Byblos. The use of a generic Levantine formal vocabulary, in conjunction with the exploitation of an imported raw material, implies significant contact with distant cultures, just as the size of the figures suggests wealth and ambition.

According to Leila Badre, metal statuary from Syria and Lebanon is known mostly from coastal sites, whereas figural terracottas are generally found inland. The Lebanese Mountain Figures would be among the exceptions. Furthermore, Badre finds that figures cast in metal are commonly male, and figures of

terracotta and hammered precious metal sheet even more consistently female.[139] But recovered in male and female pairs or groups, the Lebanese Mountain Figures confound Badre's correlations of gender to findspot and material. Excavated Levantine metal statues have been found primarily in temples or deposited with other discarded ritual objects, and they seem, according to Moorey and Fleming, "to serve for purposes of public religion, of conspicuous display, perhaps predominantly by male donors," whereas less expensive terracotta figures, found overwhelmingly in domestic contexts, "provided for the rituals of home and private daily life, commonly expressing the hopes and fears of the female members of the household."[140]

Roger Moorey, who in his published work based his conclusions on excavated materials, informally favored interpreting the figures as representations of human beings rather than of deities, as has often been assumed, and proposed that they were deposited in mountain shrines serving local villagers.[141] If comparable data for ore sources were to become available, it might be possible in the future to source the metal used to cast the figures. Further characterization of the corrosion product has the potential to provide insights into unusual pathways of copper deterioration in terrestrial environments. Unfortunately, the accuracy of the alleged proveniences given for many of the figures can never be indisputably confirmed, despite Ronzevalle's and Seyrig's energetic efforts. Barring future finds derived from scientific excavations in the mountains of southern Lebanon, there is no way to know the figures' true significance or to explain how and why the largest pieces of cupreous statuary known from the expansive ancient Levant came to be produced without local precedent in a remote rural area devoid of metal resources.

DEBORAH SCHORSCH

Conservator
Sherman Fairchild Center for
Objects Conservation
The Metropolitan Museum of Art

ACKNOWLEDGMENTS

The research for this article was undertaken in the 1990s and then laid aside. It is dedicated to the memory of Roger Moorey (1937–2004), a kind and generous man and an eminent scholar whose 1984 article (written with Stuart Fleming) on Syro-Palestinian anthropomorphic statuary stands as a most eloquent presentation of the many issues central to their understanding. After so many years, not a few scholars also instrumental with their aid and counsel have left their respective institutions but remain greatly deserving of my thanks: Arthur Beale, Museum of Fine Arts, Boston; Evelyn Klengel, Vorderasiatisches Museum, Berlin; Josef Riederer, Rathgen-Forschungslabor, Berlin; Flemming Johansen, Ny Carlsberg Glyptotek, Copenhagen; Yvette Mottier and François Schweizer, Musée d'Art et d'Histoire, Geneva; Wilhelm Hornbostel, Museum fur Künst und Gewerbe, Hamburg; the late Ingo Keesmann and Peter Maier, Johannes Gutenberg Universität, Mainz; Tony Frantz and Oscar White Muscarella, The Metropolitan Museum of Art, New York; Annie Caubet and Françoise Tallon, Musée du Louvre, Paris; and Sidney Goldstein, Saint Louis Art Museum.

I am also most grateful to Helga Seeden, American University of Beirut; Richard Newman, Museum of Fine Arts, Boston; John Curtis and Duncan Hooke, British Museum, London; Anna Bennett, London; George Ortiz, Geneva; Ulla Kasten, Yale Babylonian Collection, New Haven; Lawrence Becker, Sherman Fairchild Conservator in Charge, Sherman Fairchild Center for Objects Conservation, and Mark T. Wypyski, The Metropolitan Museum of Art; Judy Steinhardt and Michael Steinhardt, the late Leon Levy and Shelby White, and Robert Haber and Laura Siegel, New York; Mark Norman, Ashmolean Museum of Art and Archaeology, Oxford; Irène Aghion, Cabinet des Médailles et Antiquités, Bibliothèque Nationale, Paris; Laure Feugère, Musée National des Arts Asiatiques–Guimet, Paris; Cornelia Ewigleben, Landesmuseum Württemberg, Stuttgart, formerly at the Museum für

Künst und Gerwerbe; and Suzanne Hargrove, Toledo Museum of Art, formerly at the Saint Louis Art Museum.

For springing into action to help with updating this research and documentation, much thanks to Alrun Gutow, Gert Jendritzki, and Ralf-Bernhardt Wartke, Vorderasiatisches Museum; Kerstin Volker-Saad, Berlin; Rebecca Hast and Mogens Jørgensen, Ny Carlsberg Glyptotek; Frank Hildebrandt, Museum für Kunst und Gewerbe; Julia Scott, London; Christian Eckmann, Römisch-Germanisches Zentralmuseum, Mainz; Zahra Herzarkhani, Mainz; Joan Aruz, Barbara File, Tim Healing, Lucretia Kargère, Paul Lachenauer, and Yelena Rakic, The Metropolitan Museum of Art; and Pat Boulware, Lisa Cakmak, and Shannon Sweeney, Saint Louis Art Museum. With special thanks to Paul Craddock, British Museum.

NOTES

The epigraphs are from Moorey and Fleming 1984, p. 67, and Seyrig 1953, p. 47.

1 Caylus 1752, pp. 35–36, pl. X (1).
2 The thirty-seven figures in Appendix 1 are listed in the order in which they first became known. Of these, nearly thirty figures are in known public or private collections in Europe, the United States, Turkey, and Lebanon. The most complete catalogue of then-known male Lebanese Mountain Figures appears as "Group 2" in Seeden's volume (1980, pp. 2, 10–15) on warrior figures from the Levant. The male figure purchased by the Saint Louis Art Museum, St. Louis, Mo. (cat. no. 33), in 1958 (Hoopes 1958) was omitted in Seeden (1980). Another male figure (cat. no. 37) was unknown to scholars until it was sold at auction in 1981 (Hôtel Drouot 1981, no. 23). Seeden assigns four female figures associated with specific males the same catalogue numbers followed by an "A"; additional examples are listed in a footnote (Seeden 1980, p. 25 n. 25). Seeden omits female figures (cat. nos. 5, 17, 23) first published by Froehner 1898, Moorey and Fleming 1979, and Schuchhardt 1917–18, respectively. Since their inclusion in Seeden's volume, several figures in private collections have changed hands (cat. nos. 9, 26, 29, 30); see Appendix 1 for details.
3 Ronzevalle 1935; Seyrig 1953.
4 Seeden 1980.
5 For a discussion of possible identities of Bronze and Iron Age metal figures from the Levant, see Moorey and Fleming 1984, pp. 78–80.
6 Ronzevalle 1935, pp. 17–18.
7 Seyrig 1953, pp. 38–39; Schaeffer 1948, pl. XII (Ras Shamra), fig. 59 (Byblos).
8 Roger Moorey, keeper, Department of Antiquities, Ashmolean Museum of Art and Archaeology, Oxford, personal communication, January 8–9, 1991; Seeden 1980, p. 15.

9 The average height of the seventeen complete male figures whose dimensions are accurately known is 33 cm. The largest female figure (cat. no. 11) is 30.9 cm with tangs, and most of the others are substantially smaller.
10 Although the spear held by the Musée d'Art et d'Histoire figure in its right fist (cat. no. 24) is not attached, there is no reason to believe that it is not original to the figure. A statue in a private collection (cat. no. 9) previously held a spear in its right fist (see Weber 1922, no. 30) that was removed by a previous owner who believed it to be a modern addition (Seeden 1980, p. 12, no. 13). See also Hoopes 1958, p. 58, fig. 5.
11 Art-historical analysis has focused on the juxtaposition of abstracted forms with naturalistic details, noting, for example, "slab-like" torsos sporting limbs that exhibit some measure of three-dimensional form (Kawami 1990).
12 The one exception (cat. no. 3) is discussed below, pp. 126, 136.
13 The Cabinet des Médailles et Antiquités, Bibliothèque Nationale de France, female figure (cat. no. 1) is not easily removed from its modern stone base, so the tang(s) could not be assessed. Exceptionally, a female figure in the Beirut National Museum (cat. no. 28) has two tangs (Negbi 1976, pp. 72–73, fig. 87).
14 A male and female pair in the Yale Babylonian Collection (cat. nos. 6, 7) is said to be from 'Adlūn (Ward 1900, p. 289). A second pair, in the Museum für Kunst und Gewerbe, Hamburg (cat. nos. 21, 22), according to the dealer who offered them to Friedrich Wilhelm von Bissing around 1901, was "found together in Lebanon, with a third figure of a different type" (von Bissing 1939, p. 752 n. 1; Seyrig 1953, p. 34 n. 1). The hoard allegedly found near Jezzīn in 1948 (Seyrig 1953, p. 35) contained three male figures (cat. nos. 29–31) and two female figures (cat. nos. 27, 28). A second hoard that appeared on the market in the same year, allegedly from Syria (Seyrig 1953, p. 29, nos. 15, 16, p. 30, no. IV, pp. 37–38), included one female and two male figures (cat. nos. 24–26). A figure, found apparently in very poor condition with the male figure (cat. no. 8) at Sirjba'al, was discarded, gender unrecorded (Ronzevalle 1935, pp. 4–5). Two female figures in the Istanbul Archaeological Museums (cat. nos. 18, 19) are said to have been found together at Kfar Shūba in about 1913 (Seyrig 1953, p. 35).
15 Babelon and Blanchet 1895, vol. 1, no. 752; Seyrig 1953, pp. 24–25.
16 Caylus 1752, pp. 35–36, pl. X (1).
17 There is no evidence to corroborate this assertion. The small figure (cat. no. 2) is known only from a drawing in Lortet (1884, p. 611, right), and its current location is unknown.
18 For example, in the late nineteenth century Furtwängler (1892, p. 110, sec. III, no. 2) called the male statue (cat. no. 3) newly acquired by the Kaiser-Friedrich Museum (today Bode Museum) in Berlin and generally considered with the Lebanese Mountain Figures, an "alt-etruskische-phönikisierende Statuette." It is possible that this figure does not belong to the group, as discussed in the text below. Twenty years later Poulsen (1912, p. 61, fig. 59) published a different male figure (cat. no. 4) as Phoenician, and Weber (1922, pp. 17–18, nos. 10, 11, 30, illus.)

included the two male figures published by Furt-wängler (cat. no. 3) and Poulsen (cat. no. 4) and a third (cat. no. 9) in his volume on Hittite art. Müller (1929, pp. 107–12) placed the Lebanese Mountain Figures in his "Asiano-Syrian" group.

19 Vincent 1908, pp. 126–27.

20 Ronzevalle 1935, p. 3 n. 2; Seyrig 1953, pp. 26–27, esp. p. 27 n. 1; Seeden 1980, p. 14 n. 17. The term "1908 Group" was first used by Schorsch 1994, p. 117. One additional 1908 Group Figure, omitted from Appendix 2, was in an American private collection in the late 1990s, but its current whereabouts and further details are not known.

21 Ronzevalle 1935, p. 3 n *. In those intervening years, the only new figure to appear on the market was the 1908 Group Figure now in The Metropolitan Museum of Art (cat. no. 3F).

22 Ronzevalle (ibid., pp. 3–4, 3 n. 1) writes that the Egyptologist Ludwig Borchardt sent the figure to Berlin, where it was rejected by the Kaiser-Friedrich Museum, presumably because it was considered a fake, and returned to its owner.

23 Seyrig 1953, p. 25 n. 3. Ronzevalle (1935, p. 3 n. 1) does not mention the year of the sale.

24 Kornrumpf and Kornrumpf 1998, p. 101, s.v. "Durighiello."

25 For further details of the family's archaeological and political activities, see Sambon 1924.

26 According to Ronzevalle (1935, p. 3 n. 1), the 1901 exhibition was reported in an unnamed Paris illustrated weekly, of which no trace has been found. He may have confused it with an exhibition of Durighiello's ancient glass collection at the Musée Guimet, Paris, in that same year, that had been noted in the July 27, 1901, issue of the weekly *Monde illustré* (Sambon 1924, p. 6). It is also possible that the notice appeared in a daily newspaper (von Bissing 1939, p. 272 n. 1).

27 There are no extant museum records concerning this exhibition (Laure Feugère, curator, Musée Guimet, written communication, June 19, 1991, Lebanese Mountain Figures, ANE [special projects], Sherman Fairchild Center for Objects Conservation, The Metropolitan Museum of Art).

28 Seyrig (1953, pp. 25 n. 3, 34 n. 1) enumerates the figures that Joseph Durighiello is believed to have sold to various collections, giving Rudolf Naumann as his source concerning five in the Vorderasiatisches Museum, Berlin. In fact, Durighiello, referred to as "Joseph Anastassiadis," was the vendor of six figures (cat. nos. 11–16) purchased in 1902 (Evelyn Klengel, director, Vorderasiatisches Museum, written correspondence, August 14, 1987, Lebanese Mountain Figures, ANE [special projects], Sherman Fairchild Center for Objects Conservation), and he is the dealer of record for the male figure in the Louvre (cat. no. 10) (departmental records, Département des antiquités orientales, Musée du Louvre, Paris). Durighiello (not referred to by name) is also said to be the source for the male and female pair (cat. nos. 21, 22) in the Museum für Kunst und Gewerbe (von Bissing 1939, p. 752 n. 1). Seyrig (1953, p. 34 n. 1) mistakenly publishes the male figure twice, and Seeden (1980, p. 12, no. 14), misinformed that the ex–von Bissing male statue was purchased in 1974 from a Syrian dealer named Jacob Awadis and said to come from Hamidieh

near Homs, comments on its puzzling provenance. The figure (formerly 1927.138) had been confused in museum records with an entirely unrelated Syrian statuette and has since been assigned a new inventory number: 1991.131. It is still unclear when the figure and its female companion (1929.35 = 1991.108, given without accession number in Seeden 1980) actually entered the museum's collection. Also the male figure (cat. no. 9) first published by Weber (1922, p. 18, no. 30, illus.) was probably displayed in Durighiello's Musée Guimet exhibition.

29 Ronzevalle 1935, p. 3 n. 2.

30 Ibid., p. 5.

31 After presenting his evidence based on formal and stylistic features, Ronzevalle (ibid., p. 15 n. 1) places great emphasis on the presence of some hard, calcareous accretions on the feet and tangs of the Sirjba'al figure (cat. no. 8) as evidence for its authenticity.

32 In 1902, the figure was transferred to the newly founded Vorderasiatische Abteilung der Königlichen Museen zu Berlin, precursor to the Vorderasiatisches Museum.

33 Ronzevalle 1935, pp. 13–14, 13 n. 2.

34 Ibid., p. 13 n. 2. By way of comparison, the six intact figures purchased from Durighiello by the Vorderasiatische Abteilung in 1901 together cost fr. 4,500 (Evelyn Klengel, written correspondence, August 14, 1990, Lebanese Mountain Figures, ANE [special projects], Sherman Fairchild Center for Objects Conservation).

35 The so-called Jezzīn hoard contained three male figures, now in the British Museum, London (cat. no. 31), The Metropolitan Museum of Art (cat. no. 30), and a private collection (cat. no. 29), and two female figures, one in the National Museum of Beirut (cat. no. 28) and one whose location is unknown (cat. no. 27). The second group, said to have been found in Syria, included two male figures now in the Musée d'Art et d'Histoire, Geneva (cat. no. 24) and the Ny Carlsberg Glyptotek (cat. no. 25), and a female figure now in the Ortiz Collection, Geneva (cat. no. 26).

36 Seyrig 1953, p. 29.

37 The results are noted in Suzanne Hargrove, "Condition Report and Proposed Treatment," December 12, 1984, Collection Document File 356:58 Standing Male Figure, Objects Conservation Department, Saint Louis Art Museum.

38 Furtwängler 1892, p. 110; Seyrig 1953, p. 25 n. 1.

39 Seyrig 1953, pp. 27–28, 40 n. 2, 41 n. 2.

40 Robert M. Organ and Harold J. Plenderleith, "Syrian Bronze Figure," April 12, 1957, Research Laboratory, British Museum; A.E.A. Werner, "Report on Further Examination of Syrian Metal Statuette Alleged to Be of 1500 B.C.," R.L. file 2406, 1967, Research Laboratory, British Museum. See also Mendleson 1990.

41 Seyrig 1953, pp. 25 n. 5, 40 n. 2.; Müller 1929, p. 123, no. 1, pl. XLIV (420–22).

42 Negbi 1976, pp. 16, 61–62, 148–50, 180–81.

43 Negbi's "Anatolian pose" designation is discussed in Moorey and Fleming 1984, p. 69.

44 Negbi 1976, p. 181.

45 Fogg Art Museum 1954, no. 67; Amiet 1973, pp. 46–49.

46 Moorey and Fleming 1979, p. 74, table 1 n. †; Moorey and Fleming 1984, p. 84, no. 9, pl. XXII (9).

47 Seeden 1980, p. 13, nos. 17, 20.

48 Ibid., p. 11, no. 7, p. 12, nos. 13, 13bis, p. 13, nos. 16F, 22, p. 14, no. 23F.

49 In at least three publications Seeden (1978; 1980, pp. 10–14; 1986) discusses Durighiello as a vendor of fake Lebanese Mountain Figures and other types of metal statuary.

50 Hôtel Drouot 1981, no. 23.

51 Some preliminary results appear in Schorsch 1994.

52 These tallies include polished sections from three figures known from written reports and/or photocopied images, but not the visual, radiographic, metallurgical, or compositional analyses that were carried out on the three 1908 Group Figures.

53 Ronzevalle 1935, p. 6; Seyrig 1953, pp. 30–31.

54 Seyrig 1953, p. 33. Seyrig raises the possibility that a burin was used but in the end reports no evidence at all of original surface finishing.

55 Thomas T. Hoopes to Herbert A. Potratz, June 27, 1958, Collection Document File 356:58 Standing Male Figure, Saint Louis Art Museum. One fragment removed from the abdominal region, having probably been assayed using a touchstone, is described as "above the rank of silver."

56 Suzanne Hargrove, "Treatment Report," ca. 1985, Collection Document File 356:58 Standing Male Figure, Saint Louis Art Museum.

57 The figure in the Ny Carlsberg Glyptotek (cat. no. 25) was examined in 1957 at the request of Richard Barnett of the British Museum. Surface scrapings were analyzed using emission spectroscopy and reported to contain copper with 7 percent silver, in addition to small amounts of aluminum and silica that were considered to be surface accretions (Poul Wøldike, Paul Bergsøe & Søn, "Analysis of Syrian Statuette [I.N. 2838]," n.d., NCG Archives, Ny Carlsberg Glyptotek, Copenhagen). Wøldike states that it is not possible on the basis of his analysis to decide whether the silver is present in a surface layer or was added to the copper. E. Knuth-Winterfeldt, who carried out a metallographic examination, assumed the latter, but there is no evidence that he actually analyzed the section to confirm the presence of silver (E. Knuth-Winterfeldt to Mogens Gjødesen, September 12, 1957, NCG Archives, Ny Carlsberg Glyptotek). Gjødesen, who had facilitated Barnett's request, believed that the silver might have come from a silver-rich ore but was more likely to be an intentional addition (Mogens Gjødesen to Richard Barnett, August 2, 1957, NCG Archives, Ny Carlsberg Glyptotek). Analyses by energy dispersive X-ray spectroscopy (EDS) and wavelength dispersive X-ray spectroscopy (WDS) undertaken in the early 1990s (see Appendix 1) on the polished section originally studied by Knuth-Winterfeldt indicated only a trace of silver, suggesting that both possibilities put forth by Gjødesen are moot. No evidence of silver cladding was observed during the metallurgical examination of the section also carried out in 1990, or on the object itself, when examined in 2013.

58 Two exceptions are the small male figure in the Vorderasiatisches Museum (cat. no. 3) and a figure (cat. no. 23), described as female, known only from early photographs (Schuchhardt 1917–18).

59 Seyrig 1953, p. 31.

60 Ibid., 1953, p. 31 n. 2; Ronzevalle 1935, p. 6. Seyrig did not personally examine the Sirjba'al figure.

61 Seyrig 1953, p. 31. The male figure in the Saint Louis Art Museum (cat. no. 33), which Seyrig saw too late to include in his article, has a similar protrusion on the top of its head. This was first noted in print by Hoopes (1958, p. 58, fig. 3). What appears to be an ingate is located on the proper right tang of the Ny Carlsberg Glyptotek figure (cat. no. 25).

62 Seyrig 1953, p. 31.

63 Ward 1900, p. 289.

64 The surface of the Sirjba'al figure (cat. no. 8) is described by Ronzevalle (1935, p. 6) as "une patine uniforme de couleur brune très foncée, presque noire . . . sur cette patine s'étend une couche légère d'efflorescence de vert-de-gris, qui a persisté, partout où les manipulations récentes n'ont pas fini par l'enlever." From Ronzevalle's description, Seyrig (1953, p. 32, 32 n. 1) interpreted this material as traces of casting investment.

65 A Chalcolithic deposit containing 416 allegedly uncorroded cupreous artifacts was found in a cave at Naḥal Mishmar in Israel's Judean Desert in 1961 (Bar-Adon 1980). The artifacts were reported as unalloyed copper and arsenical copper (Key 1980), but these data are now disputed (Shalev and Northover 1993). The extremely dry burial environment and the fact that the objects were in a niche and not covered with soil may have played a role. No scientific investigation into the cause of their fine state of preservation has been undertaken. Because the outer contours of the samples do not appear in their published photomicrographs, it is not possible to judge from the polished sections prepared by Shalev and Northover (1993) whether or how much intergranular corrosion is present. Potaszkin and Bar-Avi (1980) do not discuss corrosion, absent or present, in their material investigation of two Naḥal Mishmar artifacts, and there appears to be no superficial or intergranular corrosion along the edges of the one section shown with an exterior surface (fig. 9). Cupreous artifacts from the Heraion at Samos have been described as found in a pitted condition, but without any surface corrosion or tarnish films (Kyrieleis 1979, p. 35; Kyrieleis and Röllig 1988, pp. 37–38); no plausible explanation for their condition was suggested.

66 For example, according to the undated document "Laboratory No. 87: Bronze Statuette: Isis and Horus" (Department of Egyptian Art, The Metropolitan Museum of Art) describing the treatment of a cupreous statue sent by the Museum to the chemist Colin Fink (see p. 132): "The cleaning was satisfactory from the first, but the patina was not, and the statuette went back to Dr. Fink fourteen times before [it] was finally accepted by Mr. Robinson [the Museum's director] on Sept. 28, 1927."

67 Seyrig 1953, p. 30, 30 n. 1. Based on their color, Ronzevalle (1935, p. 6) had previously suggested that the figures probably contained relatively little tin. Although Ronzevalle was correct in his assumption, it should be stressed that it is not possible to accurately determine metal composition on the basis of visual inspection. This practice is just one factor of several that have led to confusion in describing ancient cupreous materials. Even in recent

archaeological and art-historical literature, unanalyzed artifacts, because of their date or provenience, are sometimes simply presumed to be bronze, by definition an alloy of copper and tin. There are also cases in which elemental analyses have been undertaken and the true composition is known but ignored in museum displays and publications. Particularly in descriptions of figural sculpture, the term "bronze" is used as a synonym for "copper-based statuary" even when the piece is known not to be a copper-tin alloy. For example, the Research Laboratory report by Organ and Plenderleith (see note 40 above) describing the British Museum figure as "high purity copper" on the basis of spectroscopic analyses is itself entitled "Syrian Bronze Figure." Finally, imprecision stems from the fact that archaeologists rightfully consider the introduction of bronze an enormous cultural advance, sometimes failing to recognize that the introduction of copper-tin alloys represents one large step in the ongoing history of metallurgy and to appreciate that the shift from unalloyed copper to arsenical copper also represents a significant advance.

68 SEM-EDS analyses were carried out by Mark T. Wypyski on a Kevex model Delta IV energy dispersive X-ray spectrometer coupled to a modified Amray 1100 (1600T) scanning electron microscope operating at a voltage of 30 kV. The raw data were quantified with Kevex software using MAGIC IV ZAF corrections for standardless analysis. The results are reported as relative weight percentages and represent averages of measurements taken in three different locations.

69 In the early 1990s, when the sections were analyzed, the Metropolitan Museum did not have the instrumentation for effectively quantifying trace elements in metal substrates. Facilitated by the kind invitation of Ingo Keesman, professor of mineralogy, wavelength dispersive X-ray spectroscopy (WDS) was carried out in 1992 by Peter Maier and Zahra Herzarkhani, then doctoral candidates, at the Microsondelabor at the Institut für Geowissenschaften, Johannes Gutenberg Universität, Mainz, Germany, on a Cameca Camebax Microbeam electron microprobe (EMP) using a four crystal system (LIF, TAP, PET, ODPB) and calibrated with pure-element standards. Analyses were performed at an accelerating voltage of 20 kV, with a beam current of approximately 10 mA. The mounted sections were examined in multiple spots for the following elements: copper, arsenic, tin, zinc, antimony, iron, selenium, sulfur, tellurium, gold, and silver. Compositions expressed as weight percentages were obtained with ONPAQT corrections following the PAP model.

70 SEM-EDS analyses were carried out by Mark T. Wypyski using an Oxford Instruments INCA Energy 300 Microanalysis system equipped with a Link Pentafet high resolution Si(Li) SATW energy dispersive X-ray detector attached to a LEO Electron Microscopy model 1455VP variable pressure scanning electron microscope. Analyses were conducted under high vacuum conditions at an accelerating voltage of 20 kV, with a beam current of approximately 1 nA. Compositions are expressed as relative weight percentages.

71 An additional figure (cat. no. 30) examined in the Sherman Fairchild Center for Objects Conservation using X-ray fluorescence spectroscopy (XRF) produced similar, though nonquantitative, results. Analyses were carried out using a Bruker Artax 400 unit equipped with a rhodium X-ray target and a Peltier-cooled silicon drift detector (SDD). Energy channels were calibrated to the copper Kα line using Bruker AXS standard reference RC 36/16 (high alloy Cubase). Spectra were obtained directly from the surface of the statue with a voltage of 50 kV and current of 700 μA for 60 seconds of live-time acquisition in an air atmosphere with a 1.500 mm collimator and no added filtration (inherent filtration = 0.2 mm beryllium). Figures in the Ashmolean Museum (cat. no. 17) and the British Museum (cat. no. 31) were both found to contain under 0.2 percent arsenic (see Appendix 1).

72 Cowell (1986, p. 265) and Craddock (1976, p. 98) have suggested that copper-arsenic alloys containing 1 or more percent arsenic are products of intentional alloying. Others, such as Branigan (1974, pp. 71–77) and Gilmore (1986, p. 450) contend that as much as 2 percent could be fortuitous. As for the efficacy of arsenic, in terms of inhibiting oxidation and improving mechanical properties, according to Eaton and McKerrell (1976–77, pp. 169–70) good working alloys contain 1 to 5 percent arsenic; Hauptmann writes (2007, p. 291), without citations, "It is well known that As concentrations, even < 1%, may positively affect the casting properties of copper."

73 The presence and nature of secondary phases and inclusions are discussed in the text below; elemental compositions of selected inclusions analyzed using WDS appear in Appendix 1.

74 The iron contents in the British Museum male figure (cat. no. 31) and the female figure in the Ashmolean Museum (cat. no. 17), determined using emission spark spectroscopy and proton-induced X-ray fluorescence analyses, respectively, were found to be much higher (see Appendix 1).

75 The presence of iron at more or less than 0.3 percent is used to distinguish between coppers smelted using simpler or more complex refining processes (Craddock and Meeks 1987, esp. pp. 189–90).

76 With the exception of the statues in the Vorderasiatisches Museum, the figures were radiographed using conventional X-rays. The Museum für Kunst und Gewerbe, the Ny Carlsberg Glyptotek, the British Museum, and the Ashmolean Museum generously provided radiographs of their respective figures. The others were radiographed in the Sherman Fairchild Center for Objects Conservation. Dependent on the figure's size and thickness, informative radiographs were produced in the different laboratories at a wide range of settings for kilovoltage, milliamperage, target-to-film distance, and exposure time. Seven figures in the Vorderasiatisches Museum were radiographed at the Bundesanstalt für Materialforschung und -prüfung in Berlin using gamma radiation from an iridium source. These radiographs tend to lack contrast. Hoopes published a radiograph made with a betatron (called a skiagraph) of the Saint Louis Art Museum figure (cat. no. 33) and commented on its internal porosity (Hoopes 1958, p. 58, fig. 2; Thomas Hoopes to Hans Gustav Güterbock, June 25, 1958, Collection Document File 356:58 Standing Male Figure, Saint Louis Art Museum).

77 For X-ray radiographs of the male figures in the Ny Carlsberg Glyptotek (cat. no. 25) and the Saint Louis Art Museum (cat. no. 33), see Schorsch 1994, p. 115, figs. 7, 8.

78 Seeden 1980, p. 13, no. 14A.

79 Organ and Plenderleith, "Syrian Bronze Figure."

80 The tallest, at 43.2 centimeters, is the male figure in the Saint Louis Art Museum (cat. no. 33). The male figure in the Metropolitan Museum (cat. no. 30), stated by Muscarella (1992) to be the largest, is several centimeters smaller. A statue that provides a measure of comparison, although it is Egyptian in origin and dates to at least a millennium later, is a solid-cast unalloyed copper figure of the god Seth (Ny Carlsberg Glyptotek, ÆIn 614), which measures approximately 53 centimeters from head to midcalf (Schorsch and Wypyski 2009). (The crowns were separately cast, and the lower calves and feet are modern restorations.) As expected, the figure exhibits some internal porosity but not the characteristic spongelike texture of the Lebanese Mountain Figures (ibid., p. 191, figs. 11, 12).

81 Lynch 1974, p. 14.

82 Hanson and Marryat 1927, p. 124; Budd and Ottaway 1991, pp. 135–36.

83 According to Seyrig (1953, p. 48, 48 n. 3), who describes the Lebanese Mountain Group as the heaviest "idols" of the Near East, the male figures in the Musée du Louvre (cat. no. 10), the Musée d'Art et d'Histoire (cat. no. 24), and a private collection (cat. no. 9) weigh, respectively, 1.460, 2.092, and 3.230 kilograms.

84 Ronzevalle 1935, p. 18; Seeden 1980, p. 14, no. 23F; Seyrig 1953, pp. 25 n. 2, 41 n. 2.

85 The figure in the Musée d'Art et d'Histoire (cat. no. 24) was examined visually and studied in section but not radiographed. The highly porous texture of the Yale Babylonian Collection female figure (cat. no. 7) can be seen in Schorsch 1994, fig. 12.

86 Budd 1991, pp. 37–38.

87 Lead globules noted in a section from a figure in a private collection (cat. no. 9) (Arthur Beale and Richard Newman, "Examination Report," November 13, 1987, Research Laboratory, Museum of Fine Arts, Boston) were not observed when the same sample was examined at the Metropolitan Museum.

88 The inclusions are extremely small, and, in all but one case, relatively few inclusions were observed in individual sections.

89 Rehren and Northover (1991) compare selenium- and tellurium-rich sulfide inclusions in Bronze Age copper ingots from the British Isles, Sardinia, and Crete. They suggest that at values above 1 percent the ratio between the two elements is stable and characteristic of a specific ore deposit.

90 Moorey and Fleming 1979, p. 75, table 1 n. †; Moorey and Fleming 1984, p. 84. Neither the original report nor the section is extant, but the examiners concluded that the figure is ancient because they observed intergranular corrosion.

91 Anna T. N. Bennett and Nigel J. Seeley, "Laboratory Report," n.d., Department of Archaeological Conservation and Scientific Research, Institute of Archaeology, London.

92 Before it was acquired by a New York private collector in 1990, a section from a male figure (cat. no. 29) was described as being penetrated by corrosion with a layered structure; the occurrence of cuprite is mentioned several times, but not how it was identified or whether the section had been viewed with plane-polarized illumination (Anna T. N. Bennett, "Laboratory Report" [laboratory number 89090], September 28, 1989, Department of Archaeological Conservation and Scientific Research, Institute of Archaeology). There is no mention in this report of the massive corrosion products, appearing dark purple under plane-polarized illumination, that were observed on a different polished section of this figure during the current investigation.

93 Hanson and Marryat 1927, pp. 154–59.

94 Ibid., p. 157.

95 Ibid., p. 158.

96 Ibid.; Ruhrmann 1925, pp. 341–42.

97 Murakami, Niiyama, and Kitada 1988; Notis 1988.

98 La Niece et al. 2002, pp. 102–3. This study, which hypothesizes that an artificial patination process based on the presence of arsenic in cuprite corrosion layers was developed in ancient Egypt and the Near East, is noted here not to imply that a chemical treatment of this kind was ever carried out on the Lebanese Mountain Figures but to reference how the presence of arsenic in the underlying substrate may alter cuprite's appearance.

99 Organ and Plenderleith, "Syrian Bronze Figure"; Werner, "Report on Further Examination of Syrian Metal Statuette." A black surface scraping examined in 1967 was identified as tenorite using X-ray diffraction, but the subsurface corrosion was not analyzed.

100 The presence of massive tenorite on the surface of an ancient Egyptian bronze cat head has been attributed to the thermal disintegration of malachite (Schorsch 1988, p. 49). There is no evidence in their microstructure suggesting that the Lebanese Mountain Figures were subjected en masse to elevated temperatures in recent times.

101 Seeden 1986, p. 131.

102 Vincent 1908, pp. 126–27.

103 See p. 120, for Ronzevalle's statement.

104 Poulsen 1920, pp. 4–8.

105 Poulsen 1940, pp. 580–81.

106 Ulla Kasten, curator, Yale Babylonian Collection, personal communication, 1987. Illustrated in Gjødesen 1951, fig. 3.

107 James J. Rorimer to Maurice S. Dimand, May 2, 1932, James J. Rorimer Papers, folder 2, correspondence "D," The Cloisters Archives, The Metropolitan Museum of Art. Rorimer, then an assistant in the Department of Decorative Arts and who later became curator of medieval art and The Cloisters and eventually director of the Metropolitan Museum, had a strong interest in technical issues (Becker and Schorsch 2010, pp. 23, 27–28; see also Lucretia Kargère and Michele D. Marincola, "Conservation in Context: The Examination and Treatment of Medieval Polychrome Wood Sculpture in the United States," in this volume), pp. 11–49.

108 Ludlow S. Bull to Edward Robinson, April 16, 1925, Philip J. Mosenthal correspondence file, Office of the Secretary Records, Archives, The Metropolitan Museum of Art. Bull was at the time acting curator of the Department of Egyptian Art.

109 Dimand 1925–26, pp. 280–81. Dimand, an Islamicist, went on to be curator of Near Eastern art.

110 Becker and Schorsch 2010, pp. 24–25.

111 Colin G. Fink, "Examination of the Hittite Statue Accession No. 25.98 from The Metropolitan Museum of Art," April 11, 1932, and "Accession No. 25.98–Hittite Statue," April 20, 1932, Department of Objects Conservation, The Metropolitan Museum of Art. The whereabouts of a polished section examined in 1932 by Fink is not known.

112 Fink and Polushkin 1936, p. 2.

113 Dimand to H. E. Winlock, May 5, 1933, in Winlock, "Report on Objects of Doubtful Authenticity," Supplement to the Resolution adopted by the Executive Committee, May 15, 1933, p. 17, Office of the Secretary Records, Archives, The Metropolitan Museum of Art.

114 Sébastien Ronzevalle to an unknown recipient, January 17, 1932. Despite receiving a letter from Dimand on May 20 of that year, sharing Fink's observations and conclusions, Ronzevalle (1935, p. 18 n. 2) maintained his belief that the Metropolitan Museum figure was a forgery. For Eustache de Lorey, see Makariou 2008.

115 Gjødesen 1951, pp. 12–22, figs. 20–21.

116 Flemming Johansen, director, Ny Carlsberg Glyptotek, written correspondence, July 30, 1990, Lebanese Mountain Figures, ANE (special projects), Sherman Fairchild Center for Objects Conservation; Ronzevalle (1935, pp. 3 n. 2, 18–19) mistakenly asserts that there were two false Lebanese Mountain Figures in the Ustinov Collection.

117 Gjødesen 1951.

118 One reason that the ex–Ustinov Collection figure (cat. no. 1F) was rejected by Ronzevalle (1935, p. 6) was its large size. Since that time, several Lebanese Mountain Figures as large or larger have appeared.

119 Seyrig 1953, p. 41; Seeden 1980, pp. 13–14.

120 Seyrig 1953, p. 40 n. 2; the raised braid is often absent from the female figures.

121 Seeden 1980, pp. 13–14.

122 The Yale Babylonian Collection (cat. no. 2F) and Metropolitan Museum (cat. no. 3F) figures were radiographed in the Sherman Fairchild Center for Objects Conservation, and the Ny Carlsberg Glyptotek supplied an X-ray radiograph of the ex-Ustinov figure (cat. no. 1F).

123 Seyrig 1953, p. 31.

124 For exceptions, see note 74 above.

125 The same can be said for the presence of copper sulfide inclusions containing trace amounts of selenium and tellurium found in figures from both groups.

126 Organ and Plenderleith, "Syrian Bronze Figure"; Werner, "Report on Further Examination of Syrian Metal Statuette."

127 Extremely coarse porosity sometimes has been observed in radiographs of statues cast of arsenical copper, but the voids tend to be concentrated in specific areas rather than dispersed throughout. A Chalcolithic mace head from the northern Negev shows a high degree of porosity in section (Shalev et al. 1992). This mace head, unlike the Lebanese Mountain Figures, is heavily alloyed with arsenic and antimony and is an extremely thick-walled hollow cast. The porosity is not uniformly distributed but rather seems to concentrate in areas directly adjacent to the casting core.

128 Hauptmann, Maddin, and Prange 2002, pp. 7–12.

129 Muscarella (2000, p. 195) "reserves judgment" on this opinion, which was first expressed in Schorsch (1994, p. 117), published before a sample of the Vorderasiatisches Museum figure had been submitted for study.

130 To these can be added the two other female figures (cat. nos. 5, 34) assigned by Negbi (1976, p. 181) to her "Lebanese Group."

131 Organ and Plenderleith, "Syrian Bronze Figure."

132 Werner, "Report on Further Examination of Syrian Metal Statuette"; see also Mendleson 1990, p. 292.

133 Negbi 1976; Seeden 1980.

134 Moorey and Fleming 1984, p. 81.

135 Ibid., pp. 82–84. Whereas unalloyed copper is believable for statuary dating to the early second millennium B.C., its use in the early twentieth century is curious. It is conceivable but not very likely that the ex-Ustinov figure was cast from recycled ancient metal. Another possibility is that the founder, like Ronzevalle, made a lucky guess. Perhaps most credible is that the composition simply reflects the quality of metal available in Lebanon at that moment.

136 Fragments of investments and other casting debris are known from ancient Greek foundries (Mattusch 1988, pp. 219–30). For failed lost-wax casting from Late Period Egypt, see Garland and Bannister 1927, p. 45. Unused investments for lost-wax casting, failed casts still in their investments, stone molds for preparing wax models, and actual wax models were all found at Qubbet el-Hawa near Aswan (Edel 2008, vol. 3, pp. 1869–79; Kockelmann 2004). The plaster investment on an ancient miscast Harpokrates figure in the Brooklyn Museum (37.364E) is a modern addition (Bianchi 1990, p. 64, fig. 1, p. 80 n. 34).

137 For properties of arsenical copper alloys, see, e.g., Budd and Ottaway 1991, p. 134.

138 Seyrig 1953, p. 49 n. 1.

139 Badre 1980. Other exceptions noted by Badre (1980, p. 142) are all from Syria, which may reflect the paucity of excavated artifacts from Lebanon.

140 Moorey and Fleming 1984, pp. 77–78.

141 Roger Moorey, personal communication, January 8–9, 1991.

APPENDIX 1
CATALOGUE OF LEBANESE MOUNTAIN FIGURES

This catalogue includes statues currently or formerly attributed to the Lebanese Mountain Group, with the exception of the 1908 Group Figures (see Appendix 2), listed in the order in which they first became known. Visual examinations of the figures and the radiographs were all carried out by the author. The sources cited for radiography refer to the facilities where the radiographs were produced. Citations for metallurgical examinations not undertaken at The Metropolitan Museum of Art refer to investigators. The results and details of elemental analyses are cited by source or facility. Metropolitan Museum (MMA) and Johannes

Guttenberg Universität (JGU) citations indicate the year in which these analyses were undertaken. Published sources appear in the References (pages 151–55); unpublished sources are indicated with an * and appear below (page 150) with a key to abbreviations.

1. Female, H. 17.7 cm without tang (Figure 1)
Paris, Bibliothèque Nationale de France, Cabinet des Médailles et Antiquités (752)
Known since 1752; first published: Caylus 1752, vol. 1, pp. 35–36, pl. X (1)
Provenience: unknown
Provenance: purchased in Egypt; Joseph Pellerin Collection, France; Comte de Caylus Collection, Paris; Louis XV Collection, Paris
Ronzevalle: not cited
Seyrig: no. I, pp. 24–25, 29, 30 n. 1, 33, 33 n. 1, 34, 39, 40, pl. X (1)
Negbi: no. 1553, p. 180, fig. 86
Seeden: p. 15 n. 25 (a)
Investigative methods:
 Visual examination
 Elemental analysis: Seyrig 1953, p. 30, 30 n. 1: "nearly pure copper" (method unknown)

2. Male, H. unknown
Location unknown
Known since 1880 (Lortet); first published: Lortet 1884, p. 611, right (described as silver)
Provenience: unknown
Provenance: purchased in Ba'albek; Lortet Collection
Ronzevalle: p. 14, pl. VI (1)
Seyrig: no. 1, pp. 25, 25 n. 2, 27, 31, 36
Negbi: no. 74, pp. 148–49
Seeden: no. 21S, p. 13, pl. 9

3. Male, H. 12.5 cm without tangs, 14.0 cm with tangs (Figure 7)
Berlin, Vorderasiastisches Museum (3159)
Known since 1891 (Furtwängler); first published: Furtwängler 1892, p. 110, sec. III, no. 2
Provenience: unknown
Provenance: purchased in Rome; Kaiser-Friedrich Museum, Berlin
Ronzevalle: p. 18, pl. X (1) (published as forgery)
Seyrig: no. 2, pp. 25 n. 1, 26–27, 32, 34, 41 n. 2
Negbi: no. 92, p. 149
Seeden: no. 23F, p. 14, pl. 9 (published as forgery)
Investigative methods:
 Visual examination
 Gamma radiography: BAM (Figure 24)
 Elemental analysis: Klengel 1987*: "copper, with no trace elements detected" (XRF surface analysis)

4. Male, H. 29.5 cm without tangs, 32.0 cm with tangs (Figure 8)
Berlin, Vorderasiastisches Museum (2967)
Known since 1897; first published: Clermont-Ganneau 1897, pl. 49 (6)
Provenience: unknown

Provenance: purchased in Beirut; Comte Michel Tyszkiewicz Collection
Ronzevalle: pp. 4–6, pl. II
Seyrig: no. 3, pp. 27–28, 37, 41 n. 3
Negbi: no. 90, p. 149
Seeden: no. 7, p. 11, pls. A, 4 (published as possible forgery)
Investigative methods:
 Visual examination
 Gamma radiography: BAM
 Elemental analysis: Klengel 1987*: "copper with trace amounts of arsenic and iron" (XRF surface analysis)

5. Female, H. 15.0 cm
Location unknown
Known since 1898; first published: Froehner 1898, p. 40, pl. VIII
Provenience: unknown
Provenance: Comte Michel Tyszkiewicz Collection
Ronzevalle: not cited
Seyrig: not cited
Negbi: no. 1565, p. 181 (published as "Lebanese" Group, incorrect size)
Seeden: not cited

6. Male, H. 24.5 cm without tangs, 27.0 cm with tangs (Figure 5, left)
New Haven, Yale Babylonian Collection (2252)
Known since 1900; first published: Ward 1900, pp. 289–92, pl. I
Provenience: allegedly found near 'Adlūn (companion to cat. no. 7)
Provenance: unknown
Ronzevalle: pp. 5–13, pl. III (1)
Seyrig: no. 4, pp. 28, 33, 33 n. 1, 37, 40, 41 n. 3
Negbi: no. 79, p. 149, pl. 61
Seeden: no. 12, p. 12, pl. 6
Investigative methods:
 Visual examination
 X-ray radiography: MMA (Figure 20)
 Metallurgical examination: MMA (Figures 25, 30)
 Elemental analysis: MMA 1990*: Cu 99.3%, Fe 0.1%, As 0.6%, Sn n.d., Pb n.d., copper sulfide inclusions (SEM-EDS on prepared section); JGU 1992*: secondary arsenic-rich phase, lead-rich globules with elevated Sn, Sb, As, copper sulfide inclusions (EMP-WDS on prepared section)

7. Female, H. 10.5 cm without tang, 12.5 cm with tang (Figure 5, right)
New Haven, Yale Babylonian Collection (2250)
Known since 1900; first published: Ward 1900, pp. 289–92, pl. II
Provenience: allegedly found near 'Adlūn (companion to cat. no. 6)
Provenance: unknown
Ronzevalle: pp. 5–6, pl. III (2)
Seyrig: no. II, pp. 29, 37, 39
Negbi: no. 1556, p. 180, pl. 41 (cited with two accession numbers)
Seeden: no. 12A, p. 12, pl. 6 (incorrect accession number)
Investigative methods:
 Visual examination

X-ray radiography: MMA (Figure 23)
Metallurgical examination: MMA (Figure 32)
Elemental analysis: MMA 1989*: Cu 99.5%, Fe 0.1%,
As 0.4%, Sn n.d., Pb n.d. (SEM-EDS on prepared
section)

8. Male, H. 32.0 cm with tangs
Location unknown
Known since 1901 (Ronzevalle); first published: Ronzevalle
1935
Provenience: allegedly found near Sirjba'al (with a now-lost
second figure)
Provenance: Nicolas Dumâni; Selim Asfar; Alexander
Asfar; exhibited at the Musée Guimet, 1901
Ronzevalle: pp. 3–13 passim, pl. I
Seyrig: no. 14, pp. 29, 32 n. 1, 34–35, 40
Negbi: no. 81, p. 149
Seeden: no. 8, p. 11, pl. 4

9. Male, H. 35.0 cm without tangs, 38.5 cm with tangs
New York, White-Levy Collection
Known since 1901?; first published: Weber 1922, p. 107,
no. 30, illus.
Provenience: unknown
Provenance: said to have been first acquired from
Durighiello; probably exhibited at the Musée Guimet,
1901; Pomerance Collection, New York (Brooklyn
Museum 1966, pp. 22–23, no. 15); George Ortiz
Collection, Geneva
Ronzevalle: pp. 17–18, pl. IX (1)
Seyrig: no. 7, pp. 25 n. 3, 28, 30 n. 1, 33, 33 n. 1, 34 n. 1,
37–38, 40, 41, 41 n. 1, 48 n. 3
Negbi: no. 83, p. 149, fig. 18
Seeden: no. 13, p. 12, pl. 7 (published as possible forgery)
Investigative methods:
Visual examination
X-ray radiography: MMA
Metallurgical examination: Beale and Newman 1987*;
MMA
Elemental analysis: Seyrig 1953, p. 30, 30 n. 1: "nearly
pure copper" (method unknown); Beale and Newman
1987*: "copper with approximately 0.1% tin and
unquantified amount of lead" (electron microprobe
on polished section); MMA 1990*: Cu 99.0%, Fe
0.1%, As 0.8%, Sn 0.1%, Pb n.d. (SEM-EDS on pre-
pared section)

10. Male, H. 25.5 cm without tangs, 28.0 cm with tangs
Paris, Musée du Louvre (AO 3951)
Known since 1902 (museum inventory); first published:
Ronzevalle 1935
Provenience: allegedly found near Sidon
Provenance: acquired from Durighiello; probably exhibited
at the Musée Guimet, 1901
Ronzevalle: pp. 5–6, pl. IV
Seyrig: no. 5, pp. 28, 30 n. 1, 32, 34 n. 1, 37–38, 40, 41 n. 3,
48 n. 3, pl. IX (1)
Negbi: no. 75, p. 149, pl. 11
Seeden: no. 4, p. 11, pl. 2
Formerly suspected to be forgery (Musée du Louvre, n.d.*)

Investigative methods:
Visual examination
Elemental analysis: Seyrig 1953, p. 30, 30 n. 1: "nearly
pure copper" (method unknown)

11. Female, H. 30.9 cm with tang (Figure 9)
Berlin, Vorderasiastisches Museum (3155)
Known since 1902 (museum inventory); first published:
Weber 1922, p. 17, no. 11, illus.
Provenience: allegedly from Adana
Provenance: acquired from Joseph Anastassiadis
(Durighiello); probably exhibited at the Musée Guimet,
1901
Ronzevalle: pl. X (2)
Seyrig: no. III, pp. 25 n. 3, 30, 31, 33, 34, 34 n. 1, 37–38, 39,
40, 42
Negbi: no. 1561, p. 180, pl. 41 (incorrect inventory number)
Seeden: p. 15 n. 25 (b) (incorrect inventory number)
Investigative methods:
Visual examination
Gamma radiography: BAM
Elemental analysis: Klengel 1987*: "copper with possible
trace amounts of arsenic and iron" (XRF surface
analysis)

12. Male, H. 23.2 cm without tangs, 26.7 cm with tangs
Berlin, Vorderasiatisches Museum (3156)
Known since 1902 (museum inventory); first published:
Müller 1929, p. 107
Provenience: unknown
Provenance: acquired from Joseph Anastassiadis
(Durighiello); probably exhibited at the Musée Guimet,
1901
Ronzevalle: not cited
Seyrig: no. 9 (repeated as no. 21), pp. 28, 29, 34 n. 1, 37–38, 40
Negbi: no. 86, p. 149 (repeated as no. 87)
Seeden: no. 16F, p. 13, pl. 8 (published as probable forgery)
Investigative methods:
Visual examination
Gamma radiography: BAM

13. Male, H. 15.0 cm without tangs, 16.6 cm with tangs
Berlin, Vorderasiatisches Museum (3157)
Known since 1902 (museum inventory); first published:
Müller 1929, p. 107, no. 11 (inventory number errone-
ously assigned to no. 15), pl. XXXVII (376, 377)
Provenience: allegedly from Adana
Provenance: acquired from Joseph Anastassiadis
(Durighiello); probably exhibited at the Musée Guimet,
1901
Ronzevalle: not cited
Seyrig: no. 10, pp. 25 n. 3, 28, 34, 34 n. 1, 37–38, 40, 41 n. 3
Negbi: no. 91, p. 149
Seeden: no. 15, p. 13, pl. 8
Investigative methods:
Visual examination
Gamma radiography: BAM

14. Female, H. 15.0 cm (Figure 4)
Berlin, Vorderasiatisches Museum (3158)
Known since 1902 (museum inventory); first published:
Müller 1929, p. 123, no. 1, pl. XLIV (420–22)

Provenience: unknown
Provenance: acquired from Joseph Anastassiadis
(Durighiello); probably exhibited at the Musée Guimet,
1901
Ronzevalle: not cited
Seyrig: pp. 25 n. 5, 40 n. 2 (published as "related to Lebanese
Mountain Group")
Negbi: no. 1564, p. 181 (published as "Lebanese" Group)
Seeden: p. 15 n. 25 (h)
Investigative method:
Visual examination

15. Male, H. 33.5 cm without tangs, 38.0 cm with tangs
(Figure 11)
Berlin, Vorderasiatisches Museum (3154)
Known since 1902 (museum inventory); first published:
Müller 1929, p. 107
Provenience: unknown
Provenance: acquired from Joseph Anastassiadis
(Durighiello); probably exhibited at the Musée Guimet,
1901
Ronzevalle: not cited
Seyrig: no. 8, pp. 28, 34 n. 1, 37–38
Negbi: no. 85, p. 149
Seeden: no. 13bis, p. 12, pls. C, 7 (published as probable
forgery)
Investigative methods:
Visual examination
Gamma radiography: BAM
Elemental analysis: Klengel 1987*: "copper, with trace
amounts of arsenic and iron" (XRF surface analysis)

16. Male, H. 33.4 cm without tangs, 36.9 cm with tangs
(Figure 10)
Berlin, Vorderasiatisches Museum (3153)
Known since 1902 (museum inventory); first published:
Müller 1929, p. 107, no. 15 (incorrect inventory
number), pl. XXXVIII (381–83)
Provenience: allegedly from Adana
Provenance: acquired from Joseph Anastassiadis
(Durighiello); probably exhibited at the Musée Guimet,
1901
Ronzevalle: not cited
Seyrig: no. 11, pp. 25 n. 3, 27, 28–29, 34, 34 n. 1, 37–38,
40 n. 2, 41 n. 3 (published as forgery)
Negbi: not cited
Seeden: no. 22F, pp. 13–14, pls. C, 9 (published as forgery)
Investigative methods:
Visual examination
Gamma radiography: BAM (Figure 21)
Metallurgical examination: MMA (Figure 34)
Elemental analysis: MMA 2013*: Cu 99.2%, Fe n.d.,
As 0.8%, Sn n.d., Pb n.d. (SEM-EDS on prepared
section)

17. Female, H. 7.5 cm (fragment)
Oxford, Ashmolean Museum of Art and Archaeology
(1911.125)
Known since 1911 (museum inventory); first published:
Moorey and Fleming 1979, p. 75
Provenience: unknown
Provenance: purchased in Aleppo

Ronzevalle: not cited
Seyrig: not cited
Negbi: not cited
Seeden: not cited
Investigative methods:
Visual examination
X-ray radiography: AM
Metallurgical examination: Moorey and Fleming 1979,
p. 75, table 1 n. †
Elemental analysis: Moorey and Fleming 1979, p. 75,
table 1: Cu 99.7%, Fe <1.64%, As 0.13%, Sn 0.040%,
0.05% Pb, also detected Zn, Ni, Ag, Sb (PIXE,
expressed as wt%, not normalized to 100%)

18. Female, H. 23.5 cm without tang
Istanbul, Istanbul Archaeological Museums (4513)
Known since 1913 (museum inventory); first published:
Müller 1929, p. 107, no. 5
Provenience: allegedly found near Kfar Shūba (companion
to cat. no. 19)
Provenance: unknown
Ronzevalle: not cited
Seyrig: no. V, pp. 30, 35, 38, 39, 40, 41 n. 3, 42, pl. XI (4), fig. 1
Negbi: no. 1557, p. 180
Seeden: p. 15 n. 25 (d)

19. Female, H. 19.8 cm without tang, 22.3 cm with tang
Istanbul, Istanbul Archaeological Museums (4514)
Known since 1913 (museum inventory); first published:
Müller 1929, p. 107, no. 6
Provenience: allegedly found near Kfar Shūba (companion
to cat. no. 18)
Provenance: unknown
Ronzevalle: not cited
Seyrig: no. VI, pp. 30, 35, 38, 42, fig. 2
Negbi: no. 1558, p. 180
Seeden: p. 15 n. 25 (e)

20. Male, H. 17.0 cm (fragment)
Private collection
Known since 1914 (Seyrig); first published: Ronzevalle 1935
Provenience: allegedly found near 'Alma el-Sha'ab
Provenance: Alphonse Kann Collection, Paris
Ronzevalle: pp. 13–14, 13 n. 2 ("doubted by others"), pl. VI (2)
Seyrig: no. 13, pp. 29, 33, 35, 40, 48, pl. XI (3)
Negbi: no. 80, p. 149
Seeden: no. 18, p. 13, pl. 8

21. Male, H. 25.1 cm without tangs, 27.7 cm with tangs
(Figure 12)
Hamburg, Museum für Kunst und Gewerbe (1991.131)
(formerly 1927.138)
Known since 1914 (von Bissing); first published: Müller
1929, p. 107, no. 10, pl. XXXVII (379, 380)
Provenience: unknown (companion to cat. no. 22)
Provenance: said to have been acquired from Durighiello;
possibly exhibited at the Musée Guimet, 1901; Freiherr
Wilhelm von Bissing Collection
Ronzevalle: not cited
Seyrig: no. 6 (repeated as no. 12), pp. 25 n. 3, 28, 34 n. 1, 37,
38, 40, 41 n. 3
Negbi: no. 93, pp. 149–50 (incorrect size; also cited as no. 84)

Seeden: no. 14, p. 12, pl. 7
Investigative methods:
 Visual examination
 X-ray radiography: MPA (Figure 22)
 Metallurgical examination: MMA (Figure 27)
 Elemental analysis: MMA 1990*: Cu 99.1%, Fe 0.1%,
 As 0.8%, Sn n.d., Pb n.d., copper sulfide inclusions
 (SEM-EDS on prepared section)

22. Female, H. 16.0 cm without tang; 20.5 cm with tang
 (Figure 13)
Hamburg, Museum für Kunst und Gewerbe (1991.108)
 (formerly 1929.35)
Known since 1914 (von Bissing); first published: von Bissing
 1939, pp. 753–54, figs. 3a, 4c, 5e
Provenience: unknown (companion to cat. no. 21)
Provenance: said to have been acquired from Durighiello;
 possibly exhibited at the Musée Guimet, 1901; Freiherr
 Wilhelm von Bissing Collection
Ronzevalle: not cited
Seyrig: no. IX, pp. 25 n. 3, 30, 31, 34 n. 1, 37–38, 39
Negbi: no. 1559, p. 180
Seeden: no. 14A, p. 13, pl. 7
Investigative methods:
 Visual examination
 X-ray radiography: MPA (Figure 19)
 Metallurgical examination: MMA
 Elemental analysis: MMA 1992*: Cu 98.8%, Fe 0.1%,
 As 1.1%, Sn n.d., Pb n.d., copper sulfide inclusions
 (SEM-EDS on prepared section); JGU 1992*: lead-
 rich phase with elevated Ag, arsenic-rich phase,
 copper sulfide inclusions (EMP-WDS on prepared
 section)

23. Female(?), H. 11.0 cm (fragment)
Location unknown
Known since 1917–18; first published: Schuchhardt
 1917–18, cols. 227–34, figs. 81, 82
Provenience: unknown
Provenance: private collection, Berlin
Ronzevalle: not cited
Seyrig: no. X, pp. 30, 34
Negbi: no. 1562, pp. 180–81 (incorrect collection)
Seeden: not cited

24. Male, H. 32.7 cm without tangs, 35.7 cm with tangs
 (Figure 6)
Geneva, Musée d'Art et d'Histoire (18724)
Known since 1948; first published: Deonna 1948, pp. 4–7,
 fig. 1
Provenience: allegedly found in Syria (together with
 cat. nos. 25, 26)
Provenance: unknown
Seyrig: no. 15, pp. 29, 30 n. 1, 33 n. 1, 37–38, 40, 41, 42,
 48 n. 3, pl. IX (2)
Negbi: no. 88, p. 149, pl. 11
Seeden: no. 6, p. 11, pl. 3
Investigative methods:
 Visual examination
 Metallurgical examination: MMA (Figure 29)
 Elemental analysis: Seyrig 1953, p. 30, 30 n. 1: "nearly
 pure copper" (method unknown); MMA 1990*:
 Cu 99.4%, Fe 0.1%, As 0.5%, Sn n.d., Pb n.d., copper

sulfide inclusions (SEM-EDS on prepared section);
JGU 1992*: lead-rich phase with elevated Sn, Sb, Fe,
As, tin-rich spot with Fe, Pb, copper sulfide inclu-
sions with Se and Te >1% (EMP-WDS on prepared
section)

25. Male, H. 36.0 cm without tangs, 39.5 cm with tangs
 (Figure 3)
Copenhagen, Ny Carlsberg Glyptotek (2836)
Known since 1948; first published: Gjødesen 1951,
 pp. 21–25, figs. 4–7
Provenience: allegedly found in Syria (together with
 cat. nos. 24, 26)
Provenance: unknown
Seyrig: no. 16, pp. 29, 33, 37–38, 40, 41 n. 3
Negbi: no. 89, p. 149
Seeden: no. 5, p. 11, pl. 3
Investigative methods:
 Visual examination
 X-ray radiography: NKJ
 Metallurgical examination: Knuth-Winterfeldt 1957;
 MMA (Figures 26, 31)
 Elemental analysis: Wøldike n.d.*: "copper with 7% silver"
 (emission spectroscopy); MMA 1990*: Cu 99.8%,
 Fe 0.1%, As <0.3%, Sn n.d., Pb n.d. (SEM-EDS on
 prepared section, not normalized to 100%); JGU
 1992*: lead-rich phase with elevated Sn, Sb, Fe, As,
 sulfide inclusions (EMP-WDS on prepared section)

26. Female, H. 27.5 cm without tang, 31.0 cm with tang
Geneva, Ortiz Collection (Ortiz 1996, no. 24)
Known since 1948; first published: Gjødesen 1951,
 pp. 24–26, figs. 10–11
Provenience: allegedly found in Syria (together with
 cat. nos. 24, 25)
Provenance: Morley Collection (Gjødesen 1951); Frederick
 Stafford Collection, Paris (Isaac Delgado Museum of
 Art 1966, p. 146, no. 50, plates on pp. 34–35)
Seyrig: no. IV, pp. 30, 33, 37, 38–39, 40, 41 n. 3, 42
Negbi: no. 1560, p. 180
Seeden: p. 15 n. 25 (c)
Investigative method:
 Visual examination

27. Female, H. 9.2 cm without tang, 10.7 cm with tang
Location unknown (Beirut market?)
Known since 1948; first published: Seyrig 1953
Provenience: allegedly found near Jezzīn (together with
 cat. nos. 28–31)
Provenance: unknown
Seyrig: no. VIII, pp. 30, 30 n. 1, 33, 35, 39, 40, 40 n. 1,
 pl. X (3)
Negbi: no. 1554, p. 180
Seeden: no. 11A, p. 12, pl. 6
Investigative method:
 Elemental analysis: Seyrig 1953, p. 30, 30 n. 1: "nearly
 pure copper" (method unknown)

28. Female, H. 17.3 cm without tangs, 20.5 cm with tangs
Beirut, Beirut National Museum (acc. no. unknown)
Known since 1948; first published: Seyrig 1953
Provenience: allegedly found near Jezzīn (together with
 cat. nos. 27, 29–31)

Provenance: unknown

Seyrig: no. VII, pp. 30, 30 n. 1, 32, 33, 33 n. 1, 35, 39, 40, 40 n. 2, pl. X (2)

Negbi: no. 1555, pp. 72–73, 180, fig. 87

Seeden: no. 10A, p. 12, pl. 6

Investigative method:

 Elemental analysis: Seyrig 1953, p. 30, 30 n. 1: "nearly pure copper" (method unknown)

29. Male, H. 38.5 cm with tangs (Figure 15)

Private collection

Known since 1948; first published: Seyrig 1953

Provenience: allegedly found near Jezzīn (together with cat. nos. 27, 28, 30, 31)

Provenance: Schuster Collection; Steinhardt Collection, New York

Seyrig: no. 19, pp. 29–30, 30 n. 1, 35, 40, 40 n. 3, 41, pl. XI (2), fig. 4

Negbi: no. 78, p. 149

Seeden: no. 10, p. 12, pl. 6

Investigative methods:

 Visual examination

 X-ray radiography: MMA

 Metallurgical examination: Bennett 1989*; MMA

 Elemental analysis: Seyrig 1953, p. 30, 30 n. 1: "nearly pure copper" (method unknown); Bennett 1989*: "copper with 'small amounts' of tin, lead, and iron" (SEM-EDS on prepared section); MMA 1990*: Cu 98.6%, Fe 0.1%, As 1.0%, Sn 0.3%, Pb n.d., copper sulfide inclusions (SEM-EDS on prepared section)

30. Male, H. 36.5 cm without tangs, 41.0 cm with tangs (Figure 2)

New York, The Metropolitan Museum of Art (1989.281.9)

Known since 1948; first published: Seyrig 1953

Provenience: allegedly found near Jezzin (together with cat. nos. 27–29, 31)

Provenance: Norbert Schimmel Collection, New York (Hoffmann 1964, no. 60)

Seyrig: no. 17, pp. 29–30, 30 n. 1, 32, 35, 40, 40 n. 3, 41, 41 n. 3, 42, pl. XI (1), fig. 4

Negbi: no. 76, p. 149, pl. 12

Seeden: no. 9, p. 11, pl. 5

Investigative methods:

 Visual examination

 X-ray radiography: MMA

 Elemental analysis: Seyrig 1953, p. 30, 30 n. 1: "nearly pure copper" (method unknown); MMA 2011*: copper, with trace amounts of arsenic, iron, lead, and tin (XRF surface analysis)

31. Male, H. 25.5 without tangs, 28.0 cm with tangs (Figure 16)

London, British Museum (ME 135034)

Known since 1948; first published: Seyrig 1953

Provenience: allegedly found near Jezzīn (together with cat. nos. 27–30)

Seyrig: no. 18, pp. 29, 30 n. 1, 35, 40, 42

Provenance: unknown

Negbi: no. 77, p. 149

Seeden: no. 11, p. 12, pl. 6

Investigative methods:

 Visual examination

X-ray radiography: BMRL

Metallurgical examination: Organ and Plenderleith 1957*; Werner 1967*

Elemental analysis: Seyrig 1953, p. 30, 30 n. 1: "nearly pure copper" (method unknown); Organ and Plenderleith 1957*: "practically pure copper" (ESS); Werner 1967*: "high purity copper containing nickel, silver, lead, iron, and silicon at concentrations well below 0.2 percent" (ESS); Hooke 1989*: Cu 85.9%, Fe 1.29%, As 0.054%, Sn <0.2%, Pb 0.02%, also detected Zn, Ni, Ag, Co, Bi, Sb, Au, Mn, Cd (AAS, expressed as wt%, not normalized to 100%)

32. Male, H. unknown

Location unknown (Beirut market?)

Known since 1951; first published: Seyrig 1953

Provenience: allegedly found near Marj'ayūn

Provenance: unknown

Seyrig: no. 20, pp. 29, 32 n. 2, 33, 36, 40, 41 n. 2, 42 n. 3, fig. 3

Negbi: no. 82, p. 149

Seeden: no. 19, p. 13, pl. 9

33. Male, H. 43.2 cm with tangs (Figure 17)

St. Louis, Saint Louis Art Museum (356:1958)

Known since 1953 (Hargrove 1984*); first published: Hoopes 1958

Provenience: unknown

Provenance: J. J. Klejman, New York (Aronson 1990)

Negbi: not cited

Seeden: not cited

Investigative methods:

 Visual examination

 X-ray radiography: GSCC; MMA

 Metallurgical examination: MMA (Figures 28, 33)

 Elemental analysis: Hoopes 1958*: "96% copper with less than 1% tin, slight trace of iron with silica probably as residue" (gravimetric analysis of surface scrapings); Hargrove 1984*: "unalloyed copper" (method unknown, analyzed on behalf of Seyrig in 1953); MMA 1990*: Cu 99.5%, Fe 0.1%, As 0.4%, Sn n.d., Pb n.d. (SEM-EDS on prepared section); JGU 1992*: iron-rich inclusions with elevated Pb (EMP-WDS on prepared section)

34. Female, H. 22.8 cm

Paris, Musée National des Arts Asiatiques–Guimet (AO 25190)

Known since 1954; first published: Fogg Art Museum 1954, no. 67

Provenience: unknown

Provenance: Vladimir Golschmann Collection, St. Louis (Negbi 1976, p. 181)

Negbi: no. 1563, p. 181, pl. 42 (published as "Lebanese Group")

Seeden: p. 15 n. 25 (g)

Investigative method:

 Visual examination

35. Male, H. 32 cm (fragment)

London, private collection

Known since 1980; first published: Seeden 1980

Provenience: allegedly found in southern Lebanon

Provenance: unknown

Seeden: no. 17, p. 13, pl. 8

36. Male, H. 9.5 cm (fragment)
Beirut, Beirut National Museum (acc. no. unknown)
Known since 1980; first published: Seeden 1980
Provenience: unknown
Provenance: unknown
Seeden: no. 20, p. 13, pl. 9 (published as possible forgery)

37. Male, H. 32.0 cm (Figure 18)
New York, private collection
Known since 1981; first published: Hôtel Drouot 1981, no. 23
Provenience: unknown
Provenance: unknown
Investigative methods:
 Visual examination
 X-ray radiography: MMA
 Metallurgical examination: Bennett and Seeley n.d.*
 Elemental analysis: Bennett and Seeley n.d.*: "unalloyed
 copper" (EMP-WDS on prepared section)

ANALYTICAL METHODS

AAS = atomic absorption spectroscopy
EMP-WDS = electron microprobe–wavelength dispersive
 X-ray spectroscopy
ESS = emission spark spectroscopy
SEM-EDS = scanning electron microscopy–energy
 dispersive X-ray spectroscopy
PIXE = proton-induced X-ray emission spectroscopy
XRF = X-ray fluorescence spectroscopy

RADIOGRAPHY FACILITIES

AM = Ashmolean Museum of Art and Archaeology,
 Oxford
BAM = Bundesanstalt für Materialforschung und
 -prüfung, Berlin
BMRL = British Museum Research Laboratory, London
GSCC = General Steel Casting Corporation, Granite City,
 Ill.
MMA = Sherman Fairchild Center for Objects Conserva-
 tion, The Metropolitan Museum of Art, New York
MPA = Materialprüfungsanstalt, Hamburg
NKJ = Nationalmuseet Konservering for Jordfund,
 Copenhagen

UNPUBLISHED SOURCES

Beale and Newman 1987*. Arthur Beale and
 Richard Newman, "Examination Report,"
 November 13, 1987, Research Laboratory,
 Museum of Fine Arts, Boston.
Bennett 1989*. Anna T. N. Bennett, "Laboratory
 Report (laboratory number 89090)," September
 28, 1989, Department of Archaeological Conser-
 vation and Scientific Research, Institute of
 Archaeology, London.
Bennett and Seeley n.d.* Anna T. N. Bennett and
 Nigel J. Seeley, "Laboratory Report," n.d., Depart-
 ment of Archaeological Conservation and Scien-
 tific Research, Institute of Archaeology, London.
Hargrove 1984*. Suzanne Hargrove, "Condition and
 Proposed Treatment," December 12, 1984, Collec-
 tion Document File 356:58 Standing Male Figure,

Objects Conservation Department, Saint Louis
 Art Museum, St. Louis.
Hooke 1989*. Duncan R. Hooke, "BMRL 2406-
 33739-W," 1989, Department of Conservation and
 Scientific Research, British Museum, London.
Hoopes 1958*. Thomas T. Hoopes to Herbert A.
 Potratz, June 27, 1958, Collection Document File
 356:58 Standing Male Figure, Saint Louis Art
 Museum, St. Louis.
JGU 1992*. Institut für Geowissenschaften, Johannes
 Guttenberg Universität, Mainz (see note 69 on
 page 142).
Klengel 1987*. Evelyn Klengel, director, Vorderasia-
 tisches Museum, Berlin, written correspondence,
 November 26, 1987, Lebanese Mountain Figures,
 ANE (special projects), Sherman Fairchild Center
 for Objects Conservation, The Metropolitan
 Museum of Art.
MMA 1989*, 1990*, 1992*. Sherman Fairchild Cen-
 ter for Objects Conservation, The Metropolitan
 Museum of Art, New York (see note 68 on
 page 142).
MMA 2011*. Sherman Fairchild Center for Objects
 Conservation, The Metropolitan Museum of Art,
 New York (see note 71 on page 142).
MMA 2013*. Department of Scientific Research, The
 Metropolitan Museum of Art, New York (see note
 70 on page 142).
Musée du Louvre n.d.* Departmental records,
 Département des antiquités orientales, Musée du
 Louvre, Paris.
Organ and Plenderleith 1957*. Robert M. Organ
 and Harold J. Plenderleith, "Syrian Bronze Figure,"
 April 12, 1957, Research Laboratory, British
 Museum, London.
Werner 1967*. A.E.A. Werner, "Report on Further
 Examination of Syrian Metal Statuette Alleged To
 Be of 1500 B.C.," R.L. file 2406, 1967, Research
 Laboratory, British Museum, London.
Wøldike n.d.* Poul Wøldike, Paul Bergsøe & Søn,
 "Analysis of Syrian Statuette (I.N. 2838)," n.d., NCG
 Archives, Ny Carlsberg Glyptotek, Copenhagen.

APPENDIX 2
CATALOGUE OF 1908 GROUP
FIGURES

This catalogue includes three 1908 Group Fig-
ures universally accepted as early twentieth-
century forgeries believed to originate from
the workshop of Joseph Durighiello in Sidon,
listed in the order in which they first became
known. For a fourth figure, see note 20 on
page 140. All visual examinations of the figures,
the polished sections, and the radiographs
were carried out by the author. The sources

cited for radiography refer to the facilities where the radiographs were produced. The results and details of elemental analyses are cited by facility and the year in which the analyses were undertaken. Published sources appear in the References (pages 151–55); unpublished sources are indicated with an * and appear below with a key to abbreviations.

1F. Male, H. 38.5 cm with tangs (Figure 14)
Copenhagen, Ny Carlsberg Glyptotek (2760)
Known since 1907; first published: Vincent 1908, pp. 126–27
Provenience: probably from Sidon; said to be from Transjordan
Provenance: purchased in Palestine; Ustinov Collection, Jaffa; Rastads Collection, Oslo
Ronzevalle: pp. 3, 3 n. 3, 8, 11, 12, 18–19, pl. XI (1)
Seyrig: p. 27 n. 1
Negbi: not cited
Seeden: p. 14, 14 n. 17
Investigative methods:
　X-ray radiography: NKJ (Figure 37)
　Metallurgical examination: MMA
　Elemental analysis: MMA 1990*: Cu 99.1%, Fe 0.3%, As 0.5%, Sn n.d., Pb n.d., Ni 0.1%, copper sulfide inclusions (SEM-EDS on prepared section); JGU 1992*: lead-rich phase with high Ag, copper sulfide inclusions, some with elevated Fe, Fe inclusion with elevated Zn, Sn, possibly Pb (EMP-WDS on prepared section)

2F. Male, H. 22.2 cm without tangs, 23.8 cm with tangs
New Haven, Yale Babylonian Collection (2251)
Known since: 1915 (museum inventory); first published: Gjødesen 1951, p. 20, fig. 3
Provenience: probably Sidon
Provenance: Albert T. Clay Collection, New Haven
Ronzevalle: not cited
Seyrig: p. 27 n. 1
Negbi: not cited
Seeden: p. 14, 14 n. 17
Investigative methods:
　Visual examination
　X-ray radiography: MMA
　Metallurgical examination: MMA
　Elemental analysis: MMA 1990*: Cu 97.1%, Fe 0.3%, As n.d., Sn 0.7%, Pb 0.9%, Zn 1.0%, copper sulfide inclusions (SEM-EDS on prepared section); JGU 1992*: lead-rich phase with high Ag, copper sulfide inclusions, some with high Fe, Sb, Sn, elevated Zn (EMP-WDS on prepared section)

3F. Male, H. 38.1 cm with tangs (Figure 35)
New York, The Metropolitan Museum of Art (25.96)
Known since 1925; first published: Dimand 1925–26, pp. 280–81.
Provenience: probably Sidon; said to be from the Hauran
Provenance: Philip J. and Alice E. Mosenthal Collection, New York

Ronzevalle: pp. 8, 11, 12, 18–19, 18 n. 1, pl. XI (2)
Seyrig: p. 27 n. 1
Negbi: not cited
Seeden: p. 14, 14 n. 17
Investigative methods:
　Visual examination
　X-ray radiography: MMA (Figure 38)
　Elemental analysis: MMA 1990*: Cu 96.5%, Fe 0.3%, As n.d., Sn 0.8%, Pb 0.5%, Zn 1.9% (SEM-EDS of surface scraping)

ANALYTICAL METHODS

EMP-WDS = electron microprobe–wavelength dispersive X-ray spectroscopy
SEM-EDS = scanning electron microscopy–energy dispersive X-ray spectroscopy

RADIOGRAPHY FACILITIES

MMA = Sherman Fairchild Center for Objects Conservation, The Metropolitan Museum of Art, New York
NKJ = Nationalmuseet Konservierung for Jordfund, Copenhagen

UNPUBLISHED SOURCES

JGU 1992*. Institut für Geowissenschaften, Johannes Guttenberg Universität, Mainz (see note 69 on page 142).
MMA 1990*. Sherman Fairchild Center for Objects Conservation, The Metropolitan Museum of Art, New York (see note 68 on page 142).

REFERENCES

Amiet 1973. Pierre Amiet. "Part 1, Les Antiquités du Proche et du Moyen-Orient." *Revue du Louvre et des Musées de France* 21, no. 1 (1973), pp. 46–52.

Aronson 1990. Deborah K. Aronson. "God or Warrior." In Sidney M. Goldstein, "Egyptian and Near Eastern Art." *Saint Louis Art Museum Bulletin*, n.s., 19, no. 4 (Summer 1990), pp. 36–37.

Babelon and Blanchet 1895. Ernest Babelon and J. Adrien Blanchet. *Catalogue des bronzes antiques de la Bibliothèque Nationale, publie sous les auspices de l'Académie des Inscriptions et Belles-lettres.* 2 vols. Paris: Ernest Leroux, 1895.

Badre 1980. Leila Badre. *Les figurines anthropomorphes en terre cuite a l'âge du bronze en Syrie.* Bibliothèque archéologique et historique, 103. Paris: Librairie Orientaliste Paul Geuthner, 1980.

Bar-Adon 1980. Pessaḥ Bar-Adon. *The Cave of the Treasure: The Finds from the Caves in Naḥal Mishmar.* Judean Desert Studies. Jerusalem: Israel Exploration Society, 1980.

Becker and Schorsch 2010. Lawrence Becker and Deborah Schorsch. "The Practice of Objects Conservation in The Metropolitan Museum of Art (1870–1942)." *Metropolitan Museum Studies in Art, Science, and Technology* 1 (2010), pp. 11–37.

Bianchi 1990. Robert S. Bianchi. "Egyptian Metal Statuary of the Third Intermediate Period (circa 1070–656 B.C.), from Its Egyptian Antecedents to Its Samian Examples." In *Small Bronze Sculpture from the Ancient World: Papers Delivered at a Symposium Organized by the Departments of Antiquities and Antiquities Conservation and Held at the J. Paul Getty Museum, March 16–19, 1989,* edited by Marion True and Jerry Podany, pp. 61–84. Malibu, Calif.: J. Paul Getty Museum, 1990.

von Bissing 1939. Friedrich Wilhelm von Bissing. "Sur un petit bronze appartenant a l'art de l'Asie antérieure." In *Mélanges syriens offerts à Monsieur René Dussaud, secrétaire perpétuel de l'Académie des inscriptions et belles-lettres, par ses amis et ses élèves,* vol. 2, pp. 751–54. Bibliothèque archéologique et historique, 30. Paris: Librairie Orientaliste Paul Geuthner, 1939.

Branigan 1974. Keith Branigan. *Aegean Metalwork of the Early and Middle Bronze Age.* Oxford Monographs on Classical Archaeology. Oxford: Clarendon Press, 1974.

Brooklyn Museum 1966. Brooklyn Museum. *The Pomerance Collection of Ancient Art.* Exh. cat. New York: Brooklyn Museum, 1966.

Budd 1991. Paul Budd. "Eneolithic Arsenical Copper: Heat Treatment and the Metallographic Interpretation of Manufacturing Processes." In *Archaeometry '90: 27th International Symposium on Archaeometry, Heidelberg, April 2–6, 1990,* edited by Ernst Pernicka and Günther A. Wagner, pp. 25–44. Basel and Boston: Birkhäuser Verlag, 1991.

Budd and Ottaway 1991. Paul Budd and Barbara S. Ottaway. "The Properties of Arsenical Copper Alloys: Implications for the Development of Eneolithic Metallurgy." In *Archaeological Sciences 1989: Proceedings of a Conference on the Application of Scientific Techniques to Archaeology, Bradford, September 1989,* edited by Paul Budd, Barbara Chapman, Caroline Jackson, Rob Janaway, and Barbara S. Ottaway, pp. 132–42. Oxbow Monograph 9. Oxford: Oxbow, 1991.

Caylus 1752. Anne Claude Philippe Caylus. *Recueil d'antiquités égyptiennes, etrusques, grecques et romaines,* vol. 1. Paris: Desaint and Salliant, 1752.

Clermont-Ganneau 1897. Charles Clermont-Ganneau. *Album d'antiquités orientales: Recueil de monuments inédits ou peu connus—Art, archéologie, épigraphié.* Paris: Ernest Leroux, 1897.

Cowell 1986. R. Michael Cowell. "The Composition of Egyptian Copper-Based Metalwork." In *Science in Egyptology: Proceedings of the "Science in Egyptology" Symposia, 1979 and 1984,* Manchester, edited by A. Rosalie David, pp. 463–68. Manchester, UK: Manchester University Press, 1986.

Craddock 1976. Paul T. Craddock. "The Composition of the Copper Alloys Used by the Greek, Etruscan and Roman Civilizations, pt. 1, The Greeks before the Archaic Period." *Journal of Archaeological Science* 3, no. 2 (1976), pp. 93–113.

Craddock and Meeks 1987. Paul T. Craddock and Nigel D. Meeks. "Iron in Ancient Copper." *Archaeometry* 29, no. 2 (1987), pp. 187–204.

Deonna 1948. Waldemar Deonna. "Genève—Musée d'art et d'histoire: Statuettes de bronze syriennes." *Musées Suisses–Schweizer Museen* 1 (November 1948), pp. 4–7.

Dimand 1925–26. Maurice S. Dimand. "Sammlungen—Neuerwerbung des Metropolitan Museum in New York." *Kunstchronik und Kunstmarkt,* n.s., 35, no. 59 (1925–26), pp. 280–82.

Eaton and McKerrell 1976–77. E. R. Eaton and Hugh McKerrell. "Near Eastern Alloying and Some Textual Evidence for the Early Use of Arsenical Copper." *World Archaeology* 8, no. 2 (1976–77), pp. 169–91.

Edel 2008. Elmar Edel. *Die Felsgräbernekropole der Qubbet el-Hawa bei Assuan,* Abteilung I, edited by Karl-J. Seyfried and Gerd Vieler. 3 vols. Paderborn: F. Schöningh, 2008.

Fink and Polushkin 1936. Colin G. Fink and Eugene P. Polushkin. *Microscopic Study of Ancient Bronze and Copper.* American Institute of Mining and Metallurgical Engineers, Technical Publication 693. New York: American Institute of Mining and Metallurgical Engineers, 1936.

Fogg Art Museum 1954. Fogg Art Museum. *Ancient Art in American Private Collections: A Loan Exhibition at the Fogg Art Museum of Harvard University, December 28, 1954–February 15, 1955, Arranged in Honor of the 75th Anniversary of the Archaeological Institute of America.* Exh. cat. Cambridge, Mass.: President and Fellows of Harvard College, 1954.

Froehner 1898. Wilhelm Froehner. *Collection d'antiquités du Comte Michel Tyszkiewicz.* Sale cat., Hôtel Drouot, Paris, June 8–10, 1898.

Furtwängler 1892. Adolf Furtwängler. "Erwerbungen der Antikensammlung in Deutschland, Berlin, 1891." *Archäologischer Anzeiger: Beiblatt zum Jahrbuch des Archäologischen Instituts* 7 (1892), pp. 99–115.

Garland and Bannister 1927. Herbert Garland and Charles Olden Bannister. *Ancient Egyptian Metallurgy.* London: C. Griffin and Company, 1927.

Gilmore 1986. G. R. Gilmore. "The Composition of the Kahun Metals." In *Science in Egyptology: Proceedings of the "Science in Egyptology" Symposia, 1979 and 1984,* Manchester, edited by A. Rosalie David, pp. 447–62. Manchester, UK: Manchester University Press, 1986.

Gjødesen 1951. Mogens Gjødesen. "Deus ex Machina." *Meddelelser fra Ny Carlsberg Glyptotek* 8 (1951), pp. 12–32.

Hanson and Marryat 1927. D. Hanson and C. B. Marryat. "Investigation of the Effects of Impurities

on Copper, pt. 3, The Effect of Arsenic on Copper; pt. 4, The Effect of Arsenic Plus Oxygen on Copper." *Journal of the Institute of Metals* 37 no. 1 (1927), pp. 121–68.

Hauptmann 2007. Andreas Hauptmann. *The Archaeometallurgy of Copper: Evidence from Faynan, Jordan*. Natural Science in Archaeology, edited by Bernd Herrmann and Günther A. Wagner. Berlin and Heidelberg: Springer, 2007.

Hauptmann, Maddin, and Prange 2002. Andreas Hauptmann, Robert Maddin, and Michael Prange. "On the Structure and Composition of Copper and Tin Ingots Excavated from the Shipwreck of Uluburun." *Bulletin of the American Schools of Oriental Research*, no. 328 (November 2002), pp. 1–30.

Hoffmann 1964. Herbert Hoffmann. *Beauty of Ancient Art: Classical Antiquity, Near East, Egypt—Exhibition of the Norbert Schimmel Collection, November 15, 1964 to February 14, 1965.* Exh. cat. Mainz: von Zabern, 1964.

Hoopes 1958. Thomas T. Hoopes. "A Lonely God." *Bulletin of the City Art Museum of St. Louis* 43, no. 4 (April 1958), pp. 54–61.

Hôtel Drouot 1981. *Bronzes et terres cuites: Louristan, Amlash, et autres sites iraniens du 3e millénaire av. J.C. au 1er millénaire; Glyptique, cachets et cylindres du 5e millénaire au 1er millénaire av. J.C.* Sale cat., Hôtel Drouot, Paris, July 7–8, 1981.

Isaac Delgado Museum of Art 1966. Isaac Delgado Museum of Art. *Odyssey of an Art Collector: Unity in Diversity, 5000 Years of Art.* Exh. cat. New Orleans: Isaac Delgado Museum of Art; Paris: Imprimerie Union, 1966.

Kawami 1990. Trudy S. Kawami. "Copper Statuette of a Male Figure." In *Glories of the Past: Ancient Art from the Shelby White and Leon Levy Collection*, edited by Dietrich V. Bothmer, p. 73. Exh. cat. New York: Metropolitan Museum of Art, 1990.

Key 1980. C. A. Key. "The Trace-Element Composition of the Copper and Copper Alloys [sic] Artifacts of the Naḥal Mishmar Hoard." In Pessaḥ Bar-Adon, *The Cave of the Treasure: The Finds from the Caves in Naḥal Mishmar*, pp. 238–43. Judean Desert Studies. Jerusalem: Israel Exploration Society, 1980.

Kockelmann 2004. Holger Kockelmann. "Gußform für eine Bronzefigur des Harpokrates." In *Ägyptisches Museum: Bonner Sammlung von Aegyptiaca*, edited by Silke Grallert and Isabel Stünkel, pp. 44–45. Bonn: Ägyptisches Museum, 2004.

Kornrumpf and Kornrumpf 1998. Hans-Jürgen Kornrumpf and Jutta Kornrumpf. *Fremde im osmanischen Reich 1826–1912/13: Bio-bibliographisches Register.* Stutensee: Kornrumpf, 1998.

Kyrieleis 1979. Helmut Kyrieleis. "Babylonische Bronzen im Heraion von Samos." *Jahrbuch des Deutschen Archäologischen Instituts* 94 (1979), pp. 32–48.

Kyrieleis and Röllig 1988. Helmut Kyrieleis and Wolfgang Röllig. "Ein altorientalischer Pferdeschmuck aus dem Heraion von Samos." *Mitteilungen des Deutschen Archäologischen Instituts Athenische Abteilung* 103 (1988), pp. 37–75.

La Niece et al. 2002. Susan La Niece, Fleur Shearman, John Taylor, and Antony Simpson. "Polychromy and Egyptian Bronze: New Evidence for Artificial Coloration." *Studies in Conservation* 47, no. 2 (2002), pp. 95–108.

Lortet 1884. Louis Lortet. *La Syrie d'aujourd'hui, voyages dans la Phénicie, le Liban et la Judée, 1875–1880.* Paris: Hachette, 1884.

Lynch 1974. Charles T. Lynch, ed. *CRC Handbook of Materials Science*, vol. 1, *General Properties*. Boca Raton, Fla.: CRC Press, 1974.

Makariou 2008. Sophie Makariou. "Eustache de Lorey (XXe siècle), historien d'art." In *Dictionnaire des orientalistes de langue française*, edited by François Pouillon, pp. 365–66. Paris: ISMM–Éditions Karthala, 2008.

Mattusch 1988. Carol C. Mattusch. *Greek Bronze Statuary: From the Beginnings through the Fifth Century B.C.* Ithaca, N.Y., and London: Cornell University Press, 1988.

Mendleson 1990. Carole N. Mendleson. "Warrior God." In *Fake? The Art of Deception*, edited by Mark Jones, with Paul T. Craddock and Nicolas Barker, pp. 291–92. Exh. cat. London: Published for the Trustees of the British Museum by British Museum Publications, 1990.

Moorey and Fleming 1979. P.R.S. Moorey and Stuart Fleming. "Re-appraisal of a Syro-Palestinian Bronze Female Figurine." *MASCA Journal* 1, no. 3 (December 1979), pp. 73–75.

Moorey and Fleming 1984. P.R.S. Moorey and Stuart Fleming. "Problems in the Study of the Anthropomorphic Metal Statuary from Syro-Palestine before 330 B.C." *Levant* 16 (1984), pp. 67–90.

Müller 1929. Valentin Müller. *Frühe Plastik in Griechenland und Vorderasien: Ihre Typenbildung von der neolithischen bis in die griechisch-archaische Zeit (Rund 3000 bis 600 v. Chr.).* Augsberg: B. Filser, 1929.

Murakami, Niiyama, and Kitada 1988. Ryu Murakami, Sakae Niiyama, and Masahiro Kitada. "Characterization of the Black Surface Layer on a Copper Alloy Coloured by Japanese Traditional Surface Treatment." In *Conservation of Far Eastern Art: Preprints of the Contributions to the Kyoto Congress, 19–23 September 1988*, edited by John S. Mills, Perry Smith, and Kazuo Yamasaki, pp. 133–36. London: International Institute for Conservation of Historic and Artistic Works, 1988.

Muscarella 1992. Oscar White Muscarella. "Statuette of a Warrior." *Metropolitan Museum of Art Bulletin* 49, no. 4 (1992), p. 5.

Muscarella 2000. Oscar White Muscarella. *The Lie Became Great: The Forgery of Ancient Near Eastern Cultures.* Groningen: Styx, 2000.

Negbi 1976. Ora Negbi. *Canaanite Gods in Metal: An Archaeological Study of Ancient Syro-Palestinian Figurines.* Tel Aviv: Tel Aviv University, Institute of Archaeology, 1976.

Notis 1988. Michael R. Notis. "The Japanese Alloy *Shakudo*: Its History and Its Patination." In *The Beginning of the Use of Metals and Alloys, Papers from the Second International Conference on the Beginning of the Use of Metals and Alloys, Zhengzhou, China, 21–26 October 1986,* edited by Robert Maddin, pp. 315–27. Cambridge, Mass.: MIT Press, 1988.

Ortiz 1996. George Ortiz. *In Pursuit of the Absolute: Art of the Ancient World: The George Ortiz Collection.* Rev. ed. Exh. cat. Berne: Benteli, 1996.

Potaszkin and Bar-Avi 1980. R. Potaszkin and K. Bar-Avi. "A Material Investigation of Metal Objects from the Naḥal Mishmar Treasure." In Pessaḥ Bar-Adon, *The Cave of the Treasure: The Finds from the Caves in Naḥal Mishmar,* pp. 235–37. Judean Desert Studies. Jerusalem: Israel Exploration Society, 1980.

Poulsen 1912. Frederik Poulsen. *Der Orient und die frühgriechische Kunst.* Leipzig: B. G. Teubner, 1912.

Poulsen 1920. Frederik Poulsen. "La Collection Ustinow, La Sculpture." *Videnskapsselskapets Skrifter II: Historisk-Filosofiske Klasse* 3, pp. 3–28. Oslo: En Commission Chez Jacob Dybwad, 1920.

Poulsen 1940. Frederik Poulsen. *Katalog over antike skulpturer.* Copenhagen: Nielsen & Lydiche (A. Simmelkiær), 1940.

Rehren and Northover 1991. Thilo Rehren and J. Peter Northover. "Selenium and Tellurium in Ancient Copper Ingots." In *Archaeometry '90: 27th International Symposium on Archaeometry, Heidelberg, April 2–6, 1990,* edited by Ernst Pernicka and Günther A. Wagner, pp. 221–28. Basel and Boston: Birkhäuser Verlag, 1991.

Ronzevalle 1935. Sébastien Ronzevalle. "Bronze libanais." *Mélanges de l'Université St. Joseph* 19, no. 1, Notes et études d'archéologie orientale, 3rd ser., vol. 1 (1935), pp. 3–21.

Ruhrmann 1925. J. Ruhrmann. "Über Arsen und Nickel sowie deren Sauerstoffverbindungen im Kupfer und ihren Einfluß in geringen Mengen auf seine mechanischen Eigenschaften." *Metall und Erz: Zeitschrift für Metallhütten und Erzbergbau einschl. Aufbereitung* 22, no. 14 (1925), pp. 339–48.

Sambon 1924. Arthur Sambon. "La Collection Durighello." In *Catalogue des objets d'art antiques, égyptiens, grecs et romain: Collection de Madame Xav. Durighello,* pp. 5–6. Sale cat., Galerie Georges Petit, Paris, June 12, 1924.

Schaeffer 1948. Claude F.-A. Schaeffer. *Stratigraphie comparée et chronologie de l'Asie occidentale (IIIe et IIe millénaires),* vol. 1, *Syrie, Palestine, Asie mineure, Chypre, Perse et Caucase.* London: Oxford University Press, published on behalf of the Griffith Institute, Ashmolean Museum, 1948.

Schorsch 1988. Deborah Schorsch. "Technical Examinations of Ancient Egyptian Theriomorphic Hollow Cast Bronzes: Some Case Studies." In *Conservation of Ancient Egyptian Materials: Preprints of the Conference Organised by the United Kingdom Institute for Conservation, Archaeology Section, Held at Bristol, December 15–16, 1988,* edited by Sarah C. Watkins and Carol E. Brown, pp. 41–50. London: Institute of Archaeology Publications, 1988.

Schorsch 1994. Deborah Schorsch. "Lebanese Mountain Figures: Eine technologische Betrachtung." In *Handwerk und Technologie im alten Orient: Ein Beitrag zur Geschichte der Technik im Altertum—Internationale Tagung Berlin, 12–15 März 1991,* edited by Ralf-Bernhard Wartke, pp. 111–18. Mainz: von Zabern, 1994.

Schorsch and Wypyski 2009. Deborah Schorsch and Mark T. Wypyski. "Seth, 'Figure of Mystery.'" *Journal of the American Research Center in Egypt* 45 (2009), pp. 177–200.

Schuchhardt 1917–18. Carl Schuchhardt. "Vorgeschichtliche Abteilung: Eine weibliche Bronzestatuette." *Amtliche Berichte aus den königlichen Kunstsammlungen* 39 (1917–18), cols. 227–34.

Seeden 1978. Helga Seeden. "Some Old and New Bronzes: True or False." *Berytus* 26 (1978), pp. 5–25.

Seeden 1980. Helga Seeden. *The Standing Armed Figurines in the Levant.* Prähistorische Bronzefunde, Abteilung 1, Bd. 1. Munich: C. H. Beck'sche Verlagsbuchhandlung, 1980.

Seeden 1986. Helga Seeden. "The Commerce in Palestinian Antiquities: A Recent Case of Two Metal Figurines of 'Canaanite Gods' from Jerusalem and Beirut." In *Studies in the History and Archaeology of Palestine, Proceedings of the First International Symposium on Palestine Antiquities, Aleppo, September, 19–24, 1981,* edited by Shawqi Shaath, vol. 2, pp. 131–37. Aleppo: Aleppo University Press, 1986.

Seyrig 1953. Henri Seyrig. "Statuettes trouvées dans les montagnes du Liban." *Syria* 30, no. 1–2 (1953), pp. 24–50.

Shalev and Northover 1993. Sariel Shalev and J. Peter Northover. "The Metallurgy of the Nahal Mishmar Hoard Reconsidered." *Archaeometry* 35, no. 1 (1993), pp. 35–47.

Shalev et al. 1992. Sariel Shalev, Yuval Goren, Thomas E. Levy, and J. Peter Northover. "A Chalcolithic Mace Head from the Negev, Israel: Technological Aspects and Cultural Implications." *Archaeometry* 34, pt. 1 (1992), pp. 63–73.

Vincent 1908. Louis-Hugues Vincent. "Chronique." *Revue Biblique Internationale*, n.s., 5 (1908), pp. 114–27.

Ward 1900. William Hayes Ward. "Two Idols from Syria." *American Journal of Archaeology*, 2nd ser., 3, no. 3 (1900), pp. 289–92.

Weber 1922. Otto Weber. *Die Kunst der Hethiter.* Orbis-Pictus-Weltkunst-Bücherei 9. Berlin: E. Wasmuth, 1922.

PICTURE CREDITS

Unless otherwise indicated, photographs of works in the Metropolitan Museum's collection are by the Photograph Studio, The Metropolitan Museum of Art.

Department of Objects Conservation, The Metropolitan Museum of Art: Figures 20, 23, 25–34, 38

Robert Haber, New York: Figures 15, 18

Musée d'Art et d'Histoire, Geneva: Figure 6

Museum für Kunst und Gewerbe, Hamburg: Figures 12, 13, 19, 22

Ny Carlsberg Glyptotek, Copenhagen: Figures 3, 14, 37

Saint Louis Art Museum, St. Louis: Figure 17

Olaf M. Teßmer/SMB-Vorderasiatisches Museum, Berlin: Figures 9, 10 left and center, 11

Trustees of the British Museum, London: Figure 16

Vorderasiatisches Museum, Berlin: Figures 4, 7, 8, 10 right, 21, 24, 39

Thomas J. Watson Library, The Metropolitan Museum of Art: Figure 1

Yale Babylonian Collection, New Haven: Figure 5

رموز الجبل اللبناني: دراسة متقدمة في المجسمات المعدنية المنحوتة في بلاد الشام

ملخص

يوجد تضارب قديم في الأراء بين علماء الآثار حول أصالة أجزاء من مجموعة مكونة من سبعة وثلاثين تمثالاً لذكور وإناث والتي تعرف برموز الجبل اللبناني. هذه المجموعة من التماثيل المصبوبة من النحاس الخالص والصلب، والتي جمعت على مدى فترة ٢٥٠ سنة، كلها وجدت في غير سياقها الآثاري وغير موثقة آثارياً، ولكنها تنسب منذ فترة طويلة لجبال جنوب لبنان. يستند الفحص التقني الموصوف هنا على الفحوصات البصرية، والمعدنية، والتصوير بالأشعة السينية وأشعة جاما، و/ أو تحليل العناصر لسبعةٍ وعشرين تمثالاً. كشفت الدراسات التي أجريت بشكل مقطعي على ثلاثة عشر تمثالاً قدراً من تآكل حبيبات المعدن بما يتناسب مع عمرها الكبير ودفنها المتواصل. في الواقع، من خلال المظهر العام لهذه التماثيل الثلاثة عشر ، فإن تركيبتها غير العادية وبنيتها الداخلية ذات المسامية العالية، إضافة إلى غياب الأكسدة الداخلية، أدى ذلك إلى تماسك أجسامها، وبالتالي، يمكن الإستنتاج بأن إثنا عشر تمثالاً آخر أجريت عليها فحوصات بصرية وشعاعية و/ أو حللت ، ولكن لم يؤخذ منها عينات لإجراء فحوصات معدنية، هي أيضاً مصنوعة قدماً. التمثال الأخير ضمن هذه المجموعة على الأغلب أنه قديم أيضاً ولكنه ربما لا ينتمي إلى مجموعة رموز الجبل اللبناني. وأما ما تدعى بمجموعة ١٩٠٨ التي زورت في وقت مبكر والتي على الأغلب أنها قد أنتجت في صيدا، فقد كانت مسؤولة جزئياً عن السمعة السيئة للمجموعة الأصلية، في حين تقدم دراستهم بالتزامن، فكرة عن تطور مفاهيم الأصيل وغير الأصيل بناءً على معايير الشكل والتقنية.

DEBORAH SCHORSCH
The Metropolitan Museum of Art

ABSTRACT TRANSLATED BY MAJED SEIF

Silver Surface Decoration on Limoges Painted Enamels

◆

Gregory H. Bailey and Robyn E. Hodgkins

Examination and treatment at The Metropolitan Museum of Art of eleven late sixteenth- and early seventeenth-century Limoges painted enamels attributed to Suzanne de Court (act. 1575–1625) revealed instances of silvering on the surfaces of nine of them. The silver, which is fused to the enamel in a process similar to that employed for adjacent areas of gilding, currently appears matte gray and in many cases has suffered losses due to abrasion or corrosion. Analysis and microscopic examination of extant silvering, in combination with a review of modern and historical treatises on silvering techniques, suggest that although these details now appear faint, they would have originally been bright and reflective, offering a strong visual contrast to the dark-colored enamels to which they were applied. The deterioration and decreased visibility of silvered decoration have in many instances significantly altered the original appearance of the enamels, obscuring once-prominent details of iconography and composition.

The process of fusing silver powder to enamel surfaces has occasionally been described in modern literature,[1] yet few examples from Limoges have been published. This decorative technique may have been uncommon in any period, although the present study indicates that it is likely more widespread among the enamels of Suzanne de Court than previously acknowledged.

Relatively little is known about de Court, but she is believed to have been active in Limoges around 1600.[2] Her exuberant work is characterized by the use of colorful, translucent enamels, often applied over silver or gold foils to achieve glittering, coloristic effects. She also made extensive use of gold fused to the enamel surface to define details of her compositions in a manner typical of Limoges painted enamels. Yet certain elements in her enamels are more often represented by metallic silver surface decorations that now appear matte and range in tone from light to dark gray. These include weapon blades and finials (Figures 1–5), writing implements (Figure 6), and rocks or stones (Figure 7).

Investigation of these matte gray layers was undertaken to confirm the presence of silver. Visual examination of all eleven enamels was conducted under various lighting conditions with the aid of a binocular microscope, and material characterization was performed using qualitative X-ray fluorescence spectroscopy (XRF). Metallic surface decoration on one of

Figure 1 ◆ (a) Suzanne de Court (French, act. 1575–1625). *Christ Delivered to the People*. France, Limoges, late 16th–early 17th century. Painted enamel on copper, partially gilded, signed •S•C• in gold lettering in upper left corner, 24.3 × 19.1 cm (9⁹⁄₁₆ × 7½ in.). The Metropolitan Museum of Art, Fletcher Fund, 1945 (45.60.7); (b) detail with silvered weapon blades; (c) detail of silvering. The presence of individual gold particles within the silver is most likely a result of workshop contamination. The compressed surface appears to be consistent with burnishing.

the enamels was further analyzed using Raman spectroscopy.

Examination under binocular magnification indicated that the matte gray details consist of finely ground metallic powder sitting just proud of the enamel surface to which it was sintered. Sintering of silver powder is a process in which the particles are heated to temperatures just below the melting point, fusing them to form a solid mass. Atomic diffusion is believed to play a role in this process, although the exact bonding mechanism is not known. Several examples of sintered silver on the enamels of de Court exhibit compacted surfaces consistent with burnishing, such as those representing spearheads and halberd blades on a plaque depicting *Christ Delivered to the People* (45.60.7; see Figure 1a, b). Reflectance transformation imaging (RTI) confirmed that better-preserved

areas of the sintered metal on this object have flattened surfaces indicative of burnishing.[3]

In all cases, XRF analysis[4] identified silver and traces of gold in association with the matte gray surface decoration.[5] Close inspection under binocular magnification identified individual particles of gold among the silver, suggesting that the material is primarily silver powder containing some small flakes of gold and was not made using a gold-silver alloy (see Figure 1c). Most historical treatises that discuss the preparation of powdered metals note that silver and gold powders can be prepared in the same manner by grinding metal leaf in water with a mortar and pestle.[6] As silver and gold films on these enamels were probably prepared and applied in similar fashion, possibly with the same sets of tools, it is likely that the gold particles in the silver layers are present due to workshop contamination.

The combined evidence of visual examination and XRF spectroscopy suggests that the now matte gray decorations are indeed made

BAILEY AND HODGKINS

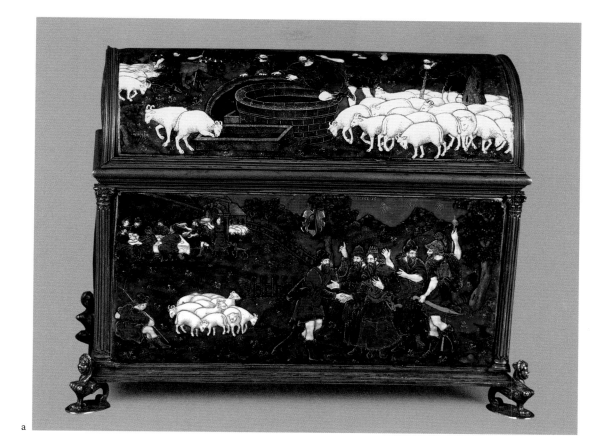

Figure 2 ◆ (a) Suzanne de Court. Casket. France, Limoges, ca. 1600. Painted enamel on copper, partially gilded silver mounts, signed SVSANNE•COVRT in gold lettering on top plaque, H. 19.7 cm (7¾ in.), W. 24.1 cm (9½ in.), D. 13.3 cm (5¼ in.). The Metropolitan Museum of Art, Gift of Mr. and Mrs. Walter Mendelsohn, 1980 (1980.203.2); (b) detail with shepherd's silvered crook finial. The casket is set with seven plaques depicting Old Testament scenes.

a

b

a

b

Figure 3 ◆ (a) Suzanne de Court. Mirror: *Venus Mourning the Dead Adonis.* France, Limoges, early 17th century. Painted enamel on copper, mounted in gilded silver mirror frame, signed •S•C• in gold lettering at upper right, H. 11.5 cm (4½ in.), W 8.1 cm (3³⁄₁₆ in.), D. 0.9 cm (⅜ in.). The Metropolitan Museum of Art, Robert Lehman Collection, 1975 (1975.1.1236); (b) detail with Adonis's silvered spearhead or finial

Figure 4 ◆ (a) Suzanne de Court. Mirror: *Minerva Visits the Muses on Mount Helicon*. France, Limoges, early 17th century. Painted enamel on copper plaque, mounted in gilded silver mirror frame, signed ◆S◆C◆ in gold lettering at upper left, H. 12.5 cm (4⅞ in.), W. 8.5 cm (3⁵⁄₁₆ in.), D. 1.2 cm (½ in.). The Metropolitan Museum of Art, Robert Lehman Collection, 1975 (1975.1.1237); (b) detail with Minerva's silvered spearhead. The better-preserved areas appear bright and reflective.

a

b

from particulate silver sintered to the enamel surface in a process analogous to that employed for the gilded elements.[7] This manner of sintered silvering is unusual for a number of reasons, primary among them the technical challenge of its execution.

Preparations of silver, dissolved in acids and applied to glass, have been known since antiquity to give rise to yellow staining or various luster effects upon heating, qualities that were used to aesthetic advantage in the production of stained-glass windows and luster-glazed ceramics.[8] Accurately gauging the firing temperatures and times necessary to sinter powdered metallic silver to enamel surfaces without melting the metal or giving rise to unintentional staining of the enamel would have required tightly controlled workshop practices. The precariousness of this sintering procedure—one of the last in the time-consuming and costly production process—may account for the small size and sparing use of silvered decorations.

These challenges were not insurmountable, however, to enamelers of the period. Application of flesh tints to the opaque white of the figures' limbs and faces on these same enamels would have required similarly strict control of the timing, temperature, and other conditions of firing,[9] evidence that de Court was proficient in producing exacting surface finishes.

It is noteworthy that this method of sintering silver is not closely related to any of the more common historical enamel and glassmaking techniques for producing silvered effects. These include sandwiching silver foil between glass layers,[10] covering silver leaf or powder with a layer of transparent enamel,[11] and applying reflective tin-amalgam preparations.[12] Most of these techniques were known to be more durable and would have been within the capabilities of the enamel ateliers of Limoges in the late sixteenth and early seventeenth centuries. Yet de Court chose to employ a form of silvering that was both chemically and physically more vulnerable.

This preference may have been motivated in part by the aesthetic potential of the technique. Although the silver currently appears matte gray, it would have been bright and reflective when first applied and burnished (see Figure 4b). A mid-twentieth-century description of the process notes that powdered silver on enamel surfaces initially fires to a "mat white" and is best finished to a "high gloss" by rubbing with an agate burnisher.[13]

The importance of burnishing applied metals to achieve a brilliant shine is emphasized by a number of historical treatises that discuss the use of silver and gold powders in illuminated miniatures.[14] Similar importance is given to burnishing in historical treatises on gilding glass; one author even goes so far as to advocate the use of less durable methods for gilding in order to obtain the "rich metalline look" and "true lustre" imparted by burnishing.[15] It is likely that in choosing to employ sintered silver powder on her enamels, de Court may have made a similar calculation, eschewing the duller, more permanent silvering techniques in favor of more highly reflective burnished metal.

The presence of silver surface decoration on painted enamels presents a number of

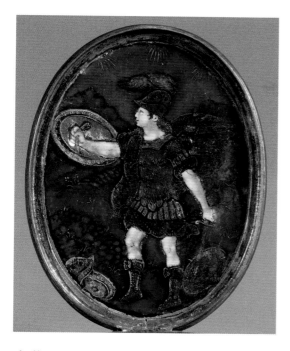

challenges to modern conservators and curators, not least of which is the fact that it is often difficult to recognize. Darkened silver on dark-colored enamel is most visible under the strong, direct illumination that is generally avoided in museum exhibitions and photographs, and is therefore easy to overlook.[16]

Silvering may also visually resemble areas of abraded gilding, which sometimes appear gray or brown due to the scattering of light or the accumulation of dirt on the uneven surface (see Figure 6b). It should be noted that silvering on enamel does not exhibit visible fluorescence under long-wave ultraviolet (UVA) radiation, whereas most gilding, even when poorly preserved, exhibits a faint yellowish fluorescence.[17] Although UVA-induced visible fluorescence is not a reliable method of identifying silver layers, it may aid in selecting areas for further investigation.

Previous treatments of Limoges painted enamels may have led to unintentional removal or alteration of original silvered surfaces. Sintered and burnished silver powder is susceptible to abrasion during routine cleaning and handling, especially if it is heavily tarnished or corroded (see Figure 7). When reheated, silver layers may diffuse into the underlying enamel and cause it to discolor,[18] raising the possibility

that prior "hot" repairs to enameled objects, such as soldering, obscured or altered silvered surfaces.[19]

Raman analysis[20] of corrosion products on the silvered details on the reverse of an enameled mirror by de Court (1975.1.1237; see Figure 4) identified silver sulfide, silver oxide, and silver chloride compounds.[21] Similar corrosion products have been cited in studies of the deterioration of daguerreotype images.[22] Silver corrosion is produced in the presence of moisture and environmental pollutants such as hydrogen sulfide or chlorine-containing compounds.[23] Silver chloride and silver sulfide corrosion products on thin silver films are photosensitive and may therefore undergo photoreduction in the presence of ultraviolet and visible light to form metallic silver.[24] These finely divided silver particles are in turn susceptible to further corrosive attack.

a

b

Figure 5 ◆ Suzanne de Court. Watch cover interior depicting Mars holding a sword with a silvered blade. France, Limoges, first quarter of the 17th century. Double-sided painted enamel on copper plaque, mounted to gilded brass watchcase, signed •S•C• in gold lettering on exterior at top, watchcase H. 8.0 cm (3⅛ in.), W. 4.4 cm (1¾ in.), D. 2.8 cm (1⅛ in.). The Metropolitan Museum of Art, Robert Lehman Collection, 1975 (1975.1.1241)

Figure 6 ◆ (a) Suzanne de Court. *St. Mark*. France, Limoges, late 16th–early 17th century. Painted enamel on copper, mounted in gilded brass frame, signed •S•C• in gold lettering at upper left, 7.5 × 5.6 cm (2¹⁵⁄₁₆ × 2³⁄₁₆ in.). The Metropolitan Museum of Art, The Friedsam Collection, Bequest of Michael Friedsam, 1931 (32.100.265); (b) detail of silvered stylus. Note that the silvered surface appears similar to adjacent surfaces with abraded gilding.

a

b

c

d

Figure 7 ◆ (a) Suzanne de Court. *Orpheus Attacked by the Maenads.* France, Limoges, late 16th–early 17th century. Double-sided painted enamel on copper plaque, mounted to gilded brass frame, 4.1 × 3.8 cm (1⅝ × 1½ in.). The Metropolitan Museum of Art, The Friedsam Collection, Bequest of Michael Friedsam, 1931 (32.100.266). This fragment has been identified as a watchcase cover; (b–d) details with silvered rocks showing varying degrees of deterioration.

At present, there are no practical or ethically acceptable treatments for deteriorated silver films, and therefore conservators rely on preventive conservation recommendations to inhibit the progressive corrosion and disruption of silvering on enameled surfaces that include eliminating environmental pollutants—especially sulfur and chlorine compounds—and lowering relative humidity and light levels in storage and exhibition areas. Digitally altered images of the enamels could be used to help convey a sense of their original appearance to museum visitors.

The extent to which sintered silver surface decoration may have been employed by other enamelers of Limoges is uncertain, although visual inspection and XRF spectroscopy confirm that at least one enamel signed •I•D•C• in the Metropolitan Museum's collections employs this technique.[25] Furthermore, there is evidence that an enamel bowl attributed to the early seventeenth-century Laudin workshop may have been silvered in this manner.[26] Further investigation of metallic surface decorations on late sixteenth- and early seventeenth-century Limoges painted enamels—particularly those attributed to the related Court/Vigier families—may yield additional instances of this technique.

GREGORY H. BAILEY

Andrew W. Mellon Fellow
Division of Conservation and
Technical Research
Walters Art Museum

ROBYN E. HODGKINS

Charles E. Culpeper Fellow
Scientific Research Department
National Gallery of Art

ACKNOWLEDGMENTS

Sincere thanks to Pete Dandridge, Sherman Fairchild Center for Objects Conservation, The Metropolitan Museum of Art, for his invaluable guidance in the examination of Limoges painted enamels, and as well as to Clare Vincent, European Sculpture and Decorative Arts, and Dita Amory, Robert Lehman Collection, for graciously facilitating the study of objects considered in this note. Thanks also to Silvia A. Centeno, Department of Scientific Research, for her assistance in the analysis of silver corrosion products. The support of the Samuel H. Kress Foundation and the Andrew W. Mellon Foundation is gratefully acknowledged.

NOTES

1. Leo 1845; Bates 1951.
2. For a discussion of Suzanne de Court (also spelled Susanne and called Decourt, Court, and possibly Vigier), see Vincent 2007.
3. Highlight images were captured using a Canon EOS 5D Mark II camera tethered to a desktop PC. Illumination was provided by a Nikon Speedlight SB 900 handheld flash unit. The reflectance transformation imaging (RTI) file was built using RTI Builder software (beta version), via highlight detection in hemispheric harmonics mode. Examination of the finished RTI files was conducted in RTI Viewer software (beta version), using enhanced specular illumination.
4. Qualitative analyses were performed with a Bruker Artax 400 energy dispersive X-ray fluorescence spectrometer equipped with a rhodium X-ray target and a Peltier-cooled silicon drift detector (SDD). Before each session of measurements, energy channels were calibrated to the copper Kα line using Bruker AXS standard reference RC 36/16 (high alloy Cu-base). Spectra were obtained directly from the surfaces of the nine enamels with a voltage of 40 kV and current of 700 µA for 100 seconds of live-time acquisition with a 0.65 mm collimator and no added filtration (inherent filtration = 0.2 mm beryllium). For each object, three spectra were obtained from the background enamel, three from the matte gray surface decoration, and three from adjacent gilded areas.
5. In all cases, spectra of the matte gray surface decoration contained peaks for silver and gold that were not present in spectra of the background enamels. Spectra of gilded areas were found to contain strong peaks for gold and none for silver.
6. Ox gall, honey, or plant gums are sometimes mentioned as additives that prevent the reagglomeration of metal flakes during the process of grinding. See the *Mappae Clavicula*, chap. 92, in Smith and Hawthorne 1974, p. 40; Theophilus 1979, bk. 1, chap. 28, pp. 34–36; Cennini 1954, chap. 155, p. 102; Dossie 1758, pt. 3, chap. 5, p. 386.
7. Historical processes for applying gilding to enamel and glass typically rely on the use of a temporary binder, which may be water or an essential oil such as spike oil of lavender, to adhere suspensions of powdered gold applied with a brush or stylus. The binder is first "smoked," or fumed off by the application of gentle heat. Then the enamel is placed in a furnace and fired to sinter the gold powder to the surface. For early descriptions of methods of gilding glass, see Theophilus 1979, bk. 2, chap. 14, p. 60; Dossie 1758, pt. 1, chap. 11, pp. 320–24. For further discussion of the traditions of gilding enamel, see Maryon 1971; Fisher 1906.
8. Silver lusters may also be produced on glass (Klein and Lloyd 2000, p. 60). For an overview of silver stain in relation to enamels, see Richter 1994.
9. Speel 2004.
10. Klein and Lloyd 2000, p. 35.
11. Theophilus 1979, bk. 2, chap. 13, p. 59.
12. This technique is mentioned by Robert Dossie in 1758 (Dossie 1758, pp. 402–3), but a similar process is known to have been in use for the production of mirrors since at least the fifteenth century (Hadsund 1993).
13. Bates (1951, p. 104) mentions the use of "newly created conductive coating materials containing a specially prepared silver powder" for the creation of silver surface decorations on enamels, evidently unaware of a tradition of related techniques. He is probably referencing colloidal dispersions of metallic silver in solvent carriers used in industry as coatings on electrical components to increase conductivity. Fused silvering remains uncommon on modern enamels; many artists have adopted commercially prepared "lusters" consisting of colloidal platinum or palladium dispersions that appear silvery when sintered to the surface but do not tarnish or corrode over time (Darty 2004).
14. See note 6 above.
15. Dossie 1758, pp. 323–24.
16. For this reason, a small LED flashlight is useful for identifying silvering when examining enamel objects.
17. This effect is best observed in UVA-induced visible fluorescence photographs with long exposure times. Gilding may exhibit fluorescence because of colloidal gold particles that have diffused into the enamel surface during firing (Richter 1994).
18. Ibid.
19. Historically, solder has been used for structural repairs and for the insertion of newly made enamel "patches" to replace areas of damaged enamel. Birgit Schwahn (2010), investigating a painted enamel bowl

(Museum für Angewandte Kunst, Cologne, inv. no. H 1210) attributed to the workshop of Jean Laudin (1616–1688) or Jacques Laudin (1627–1695), concluded that a band of a peculiar greenish enamel in the center of a polychrome coat of arms within a dark field was likely the result of surface silvering that had diffused into the underlying enamel and "stained" it when structural alterations were executed using solder. For a discussion of soldered patches added to a set of plaques attributed to de Court, see Tait and Freestone 2004.

20 Raman spectroscopy was carried out by Robyn E. Hodgkins during her tenure as an Andrew W. Mellon Fellow in the Metropolitan Museum's Department of Scientific Research on a Renishaw System 1000 spectrometer coupled to a DM LM Leica microscope. The spectra were recorded by focusing a 785 nm laser beam on glass and metal surfaces using a 20× long-range working objective lens. Neutral density filters were employed to set the laser power at the sample to 0.2 mW. A 1200 lines/mm grating and a thermoelectrically cooled CCD detector were used, with integration times of 10–40 seconds.

21 Centeno et al. 2011; Martina et al. 2012.

22 Centeno et al. 2011; Hodgkins, Centeno, and Schrott 2012.

23 Graedel 1992.

24 $AgCl \xrightarrow{hv} Ag$. See Centeno et al. 2008; Centeno et al. 2011; Sone et al. 2006.

25 The enamel in question is an oval plaque (32.100.263) depicting Diana and Proserpina, probably by Jean Court (1598–1631) or Jean Court the Younger (act. 1614–27). Examination of the stylistic and technical similarities among the signed works of the Court family suggests they shared certain traits; however, the relationships among family members, including Suzanne, remain unclear. See Vincent 2007 for further discussion.

26 Schwahn 2010.

REFERENCES

Bates 1951. Kenneth F. Bates. *Enameling Principles and Practice.* New York: Funk & Wagnalls, 1951.

Cennini 1954. Cennino Cennini. *The Craftsman's Handbook: The Italian "Il libro dell'arte."* Translated by Daniel V. Thompson Jr. New York: Dover, 1954.

Centeno et al. 2008. Silvia A. Centeno, Taina Meller, Nora Kennedy, and Mark T. Wypyski. "The Daguerreotype Surface as a SERS Substrate: Characterization of Image Deterioration in Plates from the 19th Century Studio of Southworth & Hawes." *Journal of Raman Spectroscopy* 39, no. 7 (2008), pp. 914–21.

Centeno et al. 2011. Silvia A. Centeno, Franziska Schulte, Nora Kennedy, and Alejandro Schrott. "The Formation of Chlorine-Induced Alterations in Daguerreotype Image Particles: A High Resolution SEM-EDS Study." *Applied Physics A: Materials Science and Processing* 105, no. 1 (2011), pp. 55–63.

Darty 2004. Linda Darty. *The Art of Enameling.* New York: Lark Books, Sterling Publishing, 2004.

Dossie 1758. Robert Dossie. *The Handmaid to the Arts.* London: J. Nourse, 1758.

Fisher 1906. Alexander Fisher. *The Art of Enameling upon Metal.* London: Bradbury, Agnew, 1906.

Graedel 1992. T. E. Graedel. "Corrosion Mechanisms for Silver Exposed to the Atmosphere." *Journal of the Electrochemical Society* 139, no. 7 (1992), pp. 1963–70.

Hadsund 1993. Per Hadsund. "The Tin-Mercury Mirror: Its Manufacturing Technique and Deterioration Processes." *Studies in Conservation* 38, no. 1 (1993), pp. 3–16.

Hodgkins, Centeno, and Schrott 2012. Robyn E. Hodgkins, Silvia A. Centeno, and Alejandro G. Schrott. "Effect of Environmental Pollutants on the Deterioration of the Daguerreotype Image." Paper presented at "Indoor Air Quality 2012," 10th International Conference, Indoor Air Quality in Heritage and Historic Environments, London, June 17–20, 2012.

Klein and Lloyd 2000. Dan Klein and Ward Lloyd, eds. *The History of Glass.* London: Little, Brown, 2000.

Leo 1845. Wilhelm Leo. *Die Schmelzmalerei, oder die Kunst, auf Email, Glas und Porzellan zu malen und die hierzu nöthigen Farben und Flüsse zu bereiten; Für Künstler u. Dilettanten; Nebst dem Unterrichte zur Construction des Brennofens u. zum Einbrennen der Farben.* Quedlinburg and Leipzig: Gottfr. Basse, 1845.

Martina et al. 2012. Irene Martina, Rita Wiesinger, Dubravka Jembrih-Simburger, and Mandred Schreiner. "Micro-Raman Characterisation of Silver Corrosion Products: Instrumental Set Up and Reference Database." *e-Preservation Science* (2012), pp. 1–8, http://www.morana-rtd.com/e-preservationscience/ (accessed October 15, 2013).

Maryon 1971. Herbert Maryon. *Metalwork and Enameling.* 5th ed. New York: Dover, 1971.

Richter 1994. Rainer Richter. "Between Original and Imitation: Four Technical Studies in Basse-Taille Enameling and Re-enameling of the Historicism Period." *Bulletin of the Cleveland Museum of Art* 81, no. 7 (1994), pp. 222–51.

Schwahn 2010. Birgit Schwahn. "Footed Bowl or Only a Bowl? The Investigation of a Seventeenth-Century Limoges Painted Enamel Object." Paper presented at the ICOM-CC Enamel Group of the Glass and Ceramics and Metals Working Groups, 3rd Biennial Experts' Meeting on Enamel on Metal Conservation, The Frick Collection, New York, October 8–9, 2010; video available through the Frick Collection website, http://www.frick.org/interact/birgit_schwahn _footed_bowl_or_only_bowl%3F_investigation (accessed October 15, 2013).

Smith and Hawthorne 1974. Cyril Stanley Smith and John G. Hawthorne. "*Mappae Clavicula*: A Little Key to the World of Medieval Techniques."

Transactions of the American Philosophical Society, n.s., 64, pt. 4 (1974), pp. 1–128.

Sone et al. 2006. Hayato Sone, Takuro Tamura, Ken Miyazaki, and Sumio Hosaka. "Nano-Dots Formation on Silver Sulphide Surface Using Electron Beam Irradiation." *Microelectronic Engineering* 83, no. 4–9 (2006), pp. 1487–90.

Speel 2004. Erika Speel. "Limoges School Painted Enamels: The Methods of Adding Surface Tint for the Flesh Tones of the Figures and Portraits." In *New Research on Limoges Painted Enamels*, edited by Irmgard Müsch and Heike Stege, pp. 48–53. Braunschweig: Herzog Anton Ulrich-Museum, 2004.

Tait and Freestone 2004. Hugh Tait and Ian Freestone. "Painted Enamel 'Patches': A 19th Century Virtuoso Restorer's Technique." In *New Research on Limoges Painted Enamels*, edited by Irmgard Müsch and Heike Stege, pp. 117–22, 152. Braunschweig: Herzog Anton Ulrich-Museum, 2004.

Theophilus 1979. Theophilus. *On Divers Arts: The Foremost Medieval Treatise on Painting, Glassmaking, and Metalwork*. Translated and edited by John G. Hawthorne and Cyril Stanley Smith. New York: Dover Publications, 1979.

Vincent 2007. Clare Vincent. "Some Seventeenth-Century Limoges Painted Enamel Watch-Cases and Their Movements." *Antiquarian Horology* 30, no. 3 (2007), pp. 317–46.

PICTURE CREDITS

Department of Objects Conservation, The Metropolitan Museum of Art: Figures 1–7

A Closer Look at Red Pictorialist Photographs by René Le Bègue and Robert Demachy

◆

Anna Vila, Silvia A. Centeno, and Nora W. Kennedy

At the end of the nineteenth century and the beginning of the twentieth, the Pictorialist movement emphasized photography's place alongside paintings and other art forms through impressionistic, hand-crafted, and unique photographs. By this time, photography had become increasingly accessible to the amateur, and the Pictorialists responded to this popularization of the medium by using processes that were beyond the reach of the masses and allowed them greater flexibility in expressing their creativity.[1] They favored a number of photographic techniques, among them the gum dichromate process, sometimes superimposing it onto other photographic media such as platinum or gelatin silver prints.

The identification of photographic techniques has traditionally been based on stylistic considerations, knowledge of artists' working methods, and visual examination of a print's image and deterioration characteristics. Because of the complex chemistry and physics of various photographic processes and the interest of artists in experimentation, differentiation by visual means alone may yield only partial or inconclusive information.

The study presented here is part of a larger technical investigation of the materials and methods used by artists represented in the impressive collection of Pictorialist works in The Metropolitan Museum of Art's Department of Photographs. This corpus comprises more than six hundred pieces by photographers such as Alvin Langdon Coburn, Gertrude Käsebier, Heinrich Kühn, George Seeley, Edward J. Steichen, and Alfred Stieglitz, among others. The processes used in many of these works are so complex that they remain to be elucidated. The ongoing study is focused on identifying image materials in Pictorialist works through research into the technical literature of the time, through creation of test samples following the nineteenth-century recipes, and by means of noninvasive analyses, with the ultimate goal of better understanding the artists' working methods.

In France, René Le Bègue (1857–1914) and Robert Demachy (1859–1936) were among the leaders of the Pictorialist movement, both well known for using non-silver-based photographic processes and for having a particular interest in the gum dichromate technique and its dissemination.[2] One red print by each will be discussed here, chosen for its potential to refine understanding of how red pigments render images, whether used in isolation or as

part of pigment mixtures. In addition, based on visual observation, these two prints appear to have relatively simple image structures, the artist having used a limited number of pigments and pigment layers. To our knowledge, no analytical studies of red or orange prints achieved using pigment-based photographic processes have been reported.

The gum dichromate technique, also known traditionally but incorrectly as gum bichromate, is based on the use of a light-sensitive colloid, prepared by mixing gum arabic, pigment, and a dichromate solution, which is hand-applied onto a sheet of paper and exposed to light through a large-format negative.[3] Contact printing with a large negative is necessary due to the low light sensitivity of the dichromated

Figure 1 ◆ René Le Bègue (French, 1857–1914). [*Study in Orange*], 1903. Gum dichromate print, 25.7 × 19.7 cm (10⅛ × 7¾ in.). The Metropolitan Museum of Art, Alfred Stieglitz Collection, 1949 (49.55.220)

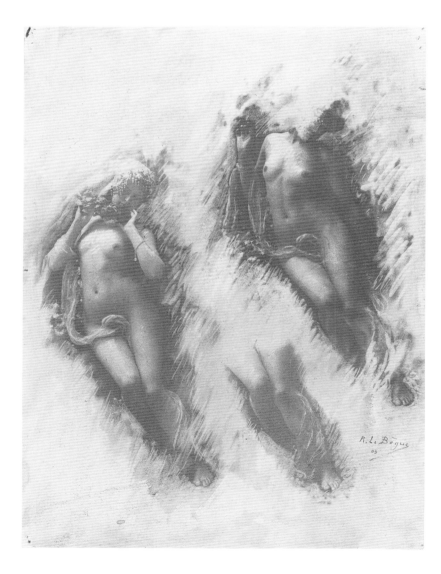

colloid. Exposures are intense and rather long, making use of an enlarger and small negative impractical. The image is developed in a water bath, which dissolves the colloid in the unexposed areas forming the light tones of the photograph, while more or less pigment is retained in the areas where light has caused the colloid to cross-link, rendering it insoluble.[4] With this basic technique as a starting point, Pictorialist photographers were able to achieve results expressing their personal artistic sensibilities by using different papers, sizing, pigments, and colloids, as well as through variations in sensitizing and developing procedures.[5] For example, the dichromate sensitizer could be applied before or after the colloid or added to the pigment-gum mixture. Development of the image could take place "automatically" through the gentle action of the water bath alone, or it could be forced locally by a directed stream of water or judiciously applied brushstrokes.

Although regional differences in the use of any one photographic process are never absolute, the French Pictorialist movement was especially known for manipulating images with local brush development, whereas artists from the English Linked Ring group preferred "automatic development." German and Austrian practitioners were famous for mastering the art of large-format prints and superimposing layers developed automatically; American practitioners favored superimposing the gum dichromate colloid onto prints made with other photographic media such as platinum or gelatin silver.[6]

As part of the larger study mentioned above, recipes for the gum dichromate technique, published in forty sources including journals, manuals, and artists' notes dating from the 1850s to the 1930s, were compiled and reviewed to determine which variations of the process and materials appeared most frequently. For instance, approximately twenty different pigments, most of which contain iron, were recommended for achieving red and orange tones using the gum dichromate process. Whereas brown and red ochers were described as

hard- and coarse-grained, burnt umber and burnt sienna were favored for their transparency. The latter required a higher pigment-to-gum ratio than other pigments to produce rich, dark tones. Lake pigments containing carmine, madder, or alizarin crimson, although recommended for obtaining fine-grained, soft images, were less popular, probably because of the difficulty in obtaining deep tones.[7]

Sometimes mixing two or more iron-containing pigments was recommended. For example, burnt umber could be combined with Venetian red to obtain a "sepia" tone. These two pigments could also be mixed in different proportions, or sometimes with Prussian blue, for browner shades. A sanguine color could be obtained by combining Venetian red, "brown-red" (most likely burnt umber), and a small amount of Vandyke brown.[8] The visual quality of the prints could also be controlled by varying the proportions of different pigments, either in the form of dry powders or as water-color paints in tubes, cakes, or pans.

This historical information was crucial for accurately creating representative gum dichromate print samples in the laboratory. These samples were used for establishing noninvasive analytical protocols for identifying photographic techniques found in original artworks. Results indicate that the presence of chromium is an excellent indicator of the gum dichromate process, but only if the amounts detected correlate with local image densities, that is, if more chromium is present in more densely pigmented areas. Alternatively, comparable amounts of chromium in areas with different image densities may indicate the use of chrome alum[9] to size the paper substrate or an entirely different photographic technique.[10]

[*Study in Orange*] (1903) by René Le Bègue (49.55.220; Figure 1) has three nudes printed on a medium-weight, wove paper. The pigments used to create the image are extremely finely ground, and although they fill some crevices in the paper, they do not do so to the extent that the surface texture of the paper is disguised. The image was manipulated considerably during the water-development stage. Strokes, ranging from fine to more broad and from sharp to softer, delineate each individual nude with the spontaneity one would expect of a chalk drawing (Figure 2). Highlights on the breasts and thighs were lightly dabbed to reveal white paper fibers. The effect is achieved in reverse, however. Rather than applying the pigment as one would in a drawing, here it is removed during development.

The specific tools used are difficult to identify, although it seems likely that brushes were employed. In some cases the implement displaced pigment instead of removing it, creating white highlights surrounded by a buildup of color. These observations point to reliance on a hand tool rather than a directed water jet for localized manipulation of the vulnerable wet surface during processing. Some final shading was achieved with an additional pigment wash, presumably applied after the print had been fully developed and dried. Evidence of this light wash applied by brush is visible around

Figure 2 ◆ [*Study in Orange*]. Photomicrograph showing the surface texture and brushstrokes in the image

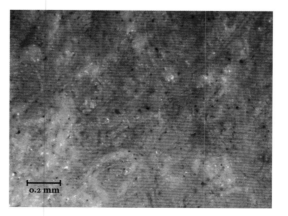

Figure 3 ◆ [*Study in Orange*]. Photomicrograph showing red and black pigment particles in the image

Figure 4 ◆ Robert Demachy (French, 1859–1936). *Struggle*, 1903 or earlier. Gum dichromate print, 17.4 × 11.6 cm (6⅞ × 4⁹⁄₁₆ in.). The Metropolitan Museum of Art, Gift of Isaac Lagnado, in honor of Thomas P. Campbell, 2008 (2008.666.3)

the lower legs and feet of the left nude; the artist signed the print after it had dried using the same pigment. Under high magnification, some black pigment particles, added most likely to darken the tone, are visible dispersed among the fine red pigment (Figure 3).

X-ray fluorescence (XRF) analysis[11] showed characteristic peaks for iron and chromium that were relatively more intense in the high image density areas. Raman analysis[12] identified the red pigment as hematite,[13] while the black particles were found to contain a carbon-based black such as charcoal or lampblack.[14]

The fact that the amounts of chromium and iron present varied in direct correlation with the image density indicates that a gum dichromate photographic process was used.[15]

The areas of minimum image density that are more heavily worked are quite clear of pigment, but others, developed only with a water bath, are pale orange due to remaining finely divided pigment particles. Experiments attempting to replicate the gum dichromate process according to recipes from period manuals and treatises showed that while certain pigments, such as lampblack, could produce almost perfectly white highlights when the print is properly washed,[16] others, such as iron ochers and burnt sienna, lodge within the paper substrate and cannot be completely removed from the highlights during washing. This latter effect is clearly seen in [*Study in Orange*].

Struggle by Robert Demachy (1903 or earlier) is also printed on a medium-weight, wove paper (2008.666.3; Figure 4). This image stands apart in the initial application of the gum-pigment-dichromate mixture, which did not coat the entire paper but was loosely brushed on, leaving ragged image edges and streaks from the brush fibers. After exposure, the image was enhanced by brushing and hand manipulation during development. The central figure of a nude woman is relatively untouched except for a white streak highlighting her shoulder that appears to have been augmented during development but is surrounded by light brushstrokes (Figure 5). Both this brushwork and the orange pigment tonality were likely chosen to evoke a sanguine or other chalk-drawing technique.

Under high magnification, finely dispersed red pigment particles and, in places, some darker ones appear to have settled between and on top of the paper fibers. Iron, chromium, and mercury were detected by XRF, in higher amounts in the areas of maximum image density. Raman analysis allowed the identification of hematite and vermilion.[17] These results combined with the visual evidence discussed above indicate that the image was achieved

VILA, CENTENO, AND KENNEDY

ANNA VILA

Research Conservation Scientist
Centre for Art Technological Studies
and Conservation
Statens Museum for Kunst

SILVIA A. CENTENO

Research Scientist
Department of Scientific Research
The Metropolitan Museum of Art

NORA W. KENNEDY

Sherman Fairchild Conservator of Photographs
Department of Photographs
The Metropolitan Museum of Art

Figure 5 • *Struggle*. Photomicrograph of the sitter's right shoulder, where the artist scraped away the pigmented colloid to achieve a white highlight

using a gum dichromate technique. Due to the difficulty of obtaining perfect whites with the gum process when red pigments are used, for reasons stated above, the artist worked to diminish the movement of pigment into some minimum density areas, leaving the white paper substrate only slightly colored.

Information on the materials and techniques used to achieve the images in pigment-based Pictorialist photographs has usually been derived from historical sources and visual examination. An artist's choice of pigment will relate to many factors such as similarity of image color with drawings and prints, translucency or opacity, as well as the propensity of some pigments to cling to paper fibers, thus softening transitions between light and dark image areas. For the present study, observed image qualities were reproduced using a variety of red pigments, showing that some are less prone to releasing from light areas even with more forceful brush manipulation during development. This investigation of red prints by Le Bègue and Demachy makes it clear that a balance of historical and analytical research, along with replication studies and visual observation, results in the most complete understanding of an artist's working practice. The Pictorialist collection at the Metropolitan Museum presents an enticing source for similar studies given the breadth of its representation of significant artists' oeuvres of the period.

ACKNOWLEDGMENTS

The authors would like to thank Lisa Barro and Katherine Sanderson, Photograph Conservation, Department of Photographs, The Metropolitan Museum of Art, for their timely assistance and helpful comments; Institute of Fine Arts student Amy Hughes for preparing laboratory samples of gum dichromate prints with iron oxide and burnt sienna; the Metropolitan Museum for providing Anna Vila with an Annette de la Renta Fellowship and the opportunity to work on this project; and the staff members of the Department of Scientific Research, Department of Photographs, and Education Department for their support.

NOTES

1 Naef 1978; Crawford 1979.
2 Naef 1978.
3 In the gum dichromate technique, when the sensitized colloid is exposed to light, the dichromate is reduced to chromium oxide and the colloid is oxidized. The reduced chromium (III) ions cross-link with the long organic chains from the gum, making the colloid insoluble and trapping the pigment particles (Kosar 1965).
4 Maskell and Demachy 1898; Demachy 1915.
5 Bennett 1898; Puyo 1904.
6 Anderson 1939.
7 "Bichromate Gum Process" 1897; Carlin 1899; Wall 1902.
8 Tennant 1901; Demachy 1915.
9 Chromium (III) potassium sulfate $[KCr(SO_4)_2 \cdot 12H_2O]$.
10 Kennedy 1999; Vila et al. 2013.
11 Qualitative and semiquantitative XRF measurements were performed on areas of different image density and on the secondary matboard support using a Bruker Artax 400 energy dispersive X-ray fluorescence

spectrometer, equipped with a rhodium target and a Peltier-cooled silicon drift detector (SDD). Spectra were obtained directly from the surfaces of the photographs with a voltage of 50 kV and current of 700 μA for 200 seconds of live-time acquisition with a 1.5 mm collimator and no added filtration (inherent filtration = 0.2 mm beryllium).

12 In situ Raman microspectroscopy analyses were carried out with a Renishaw System 1000, configured with a Leica DM LM microscope, notch filters, and a thermoelectrically cooled charge-coupled device (CCD) detector. A 785 nm laser beam was used for excitation in conjunction with a 1200 lines/mm grating. The photograph was placed on the stage of the microscope and analyzed using a 20× long working distance objective lens achieving a lateral resolution of ~2–3 μm. Neutral density filters were used to adjust the laser power to values between 0.5 and 2.0 mW. In each location, 120 scans were acquired. The wavenumber stability and accuracy were checked by recording the Raman spectrum of a silicon wafer (520 cm^{-1}).

13 Hematite (α-Fe$_2$O$_3$) was identified by its characteristic Raman bands at ca. 224, 245, 291, 411, and 611 cm^{-1}.

14 The black produced broad bands at ca. 1300 and 1590 cm^{-1}. Samples of charred bone have similar features with an additional band at ~961 cm^{-1} resulting from PO$_4^{3-}$ present in hydroxyapatite, the inorganic component in bone and ivory. However, since this additional band was not visible in the Raman spectrum of the pigment and no phosphorus was detected by XRF, bone and ivory blacks could be excluded (Bell, Clark, and Gibbs 1997; Burgio and Clark 2001).

15 Kennedy 1999; Vila et al. 2013.

16 Kennedy 1999; Vila et al. 2013.

17 Broad and weak Raman bands characteristic of red iron oxides were observed at ca. 295 and 410 cm^{-1}, in addition to peaks associated with vermilion (HgS) at ca. 252 and 343 cm^{-1}.

REFERENCES

Anderson 1939. Paul L. Anderson. *The Technique of Pictorial Photography.* Philadelphia and New York: J. B. Lippincott, 1939.

Bell, Clark, and Gibbs 1997. Ian M. Bell, Robin J. H. Clark, and Peter J. Gibbs. "Raman Spectroscopic Library of Natural and Synthetic Pigments (pre- ≈1850 AD)." *Spectrochimica Acta, Part A: Molecular and Biomolecular Spectroscopy* 53, no. 12 (1997), pp. 2159–79.

Bennett 1898. Henry W. Bennett. "The Gum-Bichromate Process." *British Journal of Photography* 45 (January 7, 1898), pp. 14–15.

"Bichromate Gum Process" 1897. "The Bichromate Gum Process." *Wilson's Photographic Magazine* 34, no. 483 (March 1897), pp. 174–76.

Burgio and Clark 2001. Lucia Burgio and Robin J. H. Clark. "Library of FT-Raman Spectra of Pigments, Minerals, Pigment Media and Varnishes, and Supplement to Existing Library of Raman Spectra of Pigments with Visible Excitation." *Spectrochimica Acta, Part A: Molecular and Biomolecular Spectroscopy* 57, no. 7 (2001), pp. 1491–1521.

Carlin 1899. W. E. Carlin. "The Gum-Bichromate Process." *Camera Notes* 3 (October 1899), pp. 66–72.

Crawford 1979. William Crawford. *The Keepers of Light: A History and Working Guide to Early Photographic Processes.* Dobbs Ferry, N.Y.: Morgan & Morgan, 1979.

Demachy 1915. Robert Demachy. "The Gum-Bichromate Process." *Photographic Journal of America* 52, no. 1 (1915), pp. 7–13.

Kennedy 1999. Nora W. Kennedy. "The Reticulation of Gelatine: Observations on the Direct Carbon Process." In *Care of Photographic, Moving Image and Sound Collections: 20th–24th July 1998, University College of Ripon & York St. John, York, England—Conference Papers,* edited by Susie Clark, pp. 102–8. Leigh, UK: Institute of Paper Conservation, 1999.

Kosar 1965. Jaromir Kosar. *Light-Sensitive Systems: Chemistry and Application of Nonsilver Halide Photographic Processes.* New York: John Wiley and Sons, 1965.

Maskell and Demachy 1898. Alfred Maskell and Robert Demachy. *Photo-Aquatint; or, The Gum-Bichromate Process: A Practical Treatise on a New Process of Printing in Pigment Especially Suitable for Pictorial Workers.* Amateur Photographer's Library 13. 2nd ed. London: Hazell, Watson and Viney, 1898.

Naef 1978. Weston J. Naef. *The Collection of Alfred Stieglitz: Fifty Pioneers of Modern Photography.* New York: Metropolitan Museum of Art and Viking Press, 1978.

Puyo 1904. Constant Puyo. *Le procédé à la gomme bichromatée: Traité practique et élémentaire à l'usage commençants.* Paris: Photo Club de Paris, 1904.

Tennant 1901. John A. Tennant. "Gum-Bichromate Printing." *New Photo-Miniature* 2, no. 19–24 (1901), pp. 399–419.

Vila et al. 2013. Anna Vila, Silvia A. Centeno, Lisa Barro, and Nora W. Kennedy. "Understanding the Gum Dichromate Processes in Pictorialist Photographs: A Literature Review and Technical Study." *Studies in Conservation* 58, no. 3 (2013), pp. 176–88.

Wall 1902. Edward John Wall, ed. *The Dictionary of Photography for the Amateur and Professional Photographer.* Revised by Thomas Bolas. 8th ed. London: Hazell, Watson and Viney, 1902.

PICTURE CREDITS

Unless otherwise indicated, photographs of works in the Metropolitan Museum's collection are by the Photograph Studio, The Metropolitan Museum of Art.

Department of Scientific Research, The Metropolitan Museum of Art: Figure 3

Photograph Conservation, Department of Photographs, The Metropolitan Museum of Art: Figures 2, 5

Tracing the Origins of Japanese Export Lacquer on an Eighteenth-Century French Side Table

◆

Christina Hagelskamp

The introduction of Japanese lacquerware to the Western world began at the end of the sixteenth century with the development of sea trade between Japan and Portugal.[1] In the seventeenth century, lacquer items became important trade goods, provided mainly by the Dutch East India Company (Verenigde Oostindische Compagnie or VOC).[2] Especially from the 1630s to 1680s, many types of lacquered furniture, such as chests and cabinets, as well as small items including trays, bowls, and plates, were imported by the VOC. These exotic and luxurious wares were highly appreciated and quickly found their way into wealthy households all over Europe, as is illustrated, for example, in a seventeenth-century painting by Henri Gascard (private collection; Figure 1). In comparison with lacquerware from China and other Asian countries, Japanese lacquer was especially admired for its decoration and elaborate technique.[3] Scarcity and a general fascination with this exotic material further increased its appeal, but while the lacquer itself remained much admired, with time the kinds of imported objects on which it was applied fell out of favor.[4] As a result, a desire developed to combine this precious material with current domestic style, and in the eighteenth century the integration

of lacquerware fragments into both furniture and wall paneling became fashionable. To satisfy this new demand, many outdated export lacquer objects were cut apart to obtain the necessary "raw materials." The production of furniture embellished with Asian lacquerware peaked in mid-eighteenth-century Paris. One

Figure 1 ◆ Henri Gascard (French, 1635–1701). *Madame de Montespan Reclining in Front of the Gallery at the Chateau de Clagny*, ca. 1676. Oil on canvas, 318.0 × 222.0 cm (125 × 87¼ in.). Private collection. In the background, placed in a great hall, is a pair of Japanese lacquer cabinets on European stands.

Figure 2 • The stamp, 0.8 × 3.0 cm, used by the last two generations of Vanrisamburghs, consists of Bernard II's initials, separated by small diamonds. According to French guild regulations, from 1743 on, all new furniture had to be stamped to identify its maker.

Figure 3 • Bernard II Vanrisamburgh (French, after 1696–ca. 1767). Side table. France, Paris, ca. 1755–60. Oak and beech with black japanning and veneered with Japanese black-and-gold lacquer on front and sides, gilded mounts, Sarrancolin marble top, H. 90.2 cm (35½ in.), W. 95.3 cm (37½ in.), D. 53.3 cm (21 in.). The Metropolitan Museum of Art, Gift of Mr. and Mrs. Charles Wrightsman, 1976 (1976.155.101)

of the workshops that specialized in manufacturing such exclusive furniture was that of Bernard II Vanrisamburgh (after 1696–ca. 1767), now often referred to as "BVRB" after his workshop's famous stamp (Figure 2).[5]

The Metropolitan Museum of Art owns a considerable collection of objects from the Vanrisamburgh workshop, of which five are decorated with either Japanese or Chinese lacquer. The object from this group discussed here is a side table (1976.155.101; Figure 3), or *commode en console*, due to the unusual inclusion of a drawer.[6] The table is marked in several places with the workshop's B♦V♦R♦B stamp as well as with the JME guild stamp (Jurande des menuisiers-ébénistes) and dates from about 1755–60.

Two wood species used for the construction of the carcass of the table have been identified

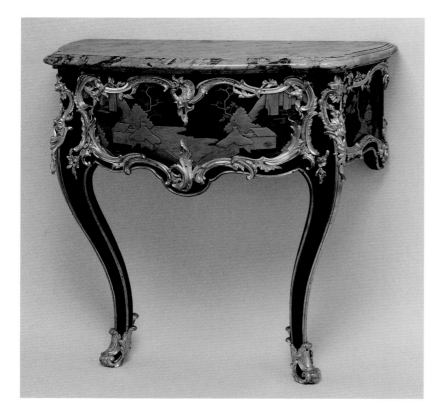

as oak and beech.[7] The fine-grained beech was used for exterior surfaces—the legs and the sides—whereas oak, with its coarser grain, forms the internal construction of the case and drawer. The front and sides of the table are embellished with salvaged Japanese black-and-gold lacquer. The curvilinear nature of the Baroque shapes into which these lacquer elements were to be incorporated forced craftsmen to prepare them as veneers. To this end most of the wooden substrate was removed from the lacquer panels until they were thin enough to be plied into compound curves.[8] These sheets of "lacquer veneer" were carefully arranged on the carcass in combination with black imitation lacquer, so-called japanning.[9] The latter was applied to the beech surfaces around the lacquer veneer to suggest a piece of furniture that is entirely covered with an Asian lacquer finish.[10] The lavish use of gilded mounts helped to frame the decorative scenes while at the same time obscuring the transitions between lacquered and japanned surfaces.

The different sections of lacquer veneer are decorated with landscapes showing trees, houses, and thatched huts along the water in front of a rock mass. Comparable scenes can be found on various export lacquer objects dating from the second half of the seventeenth century to the beginning of the eighteenth century, as can be seen on the proper right door of a cabinet in the Staatliche Münzsammlung München (LK015; Figure 4). Because the joined sections of lacquer veneer on the drawer front as well as the two on the sides of the Metropolitan Museum's side table are nearly mirror images, it has been suggested that the lacquer originated from a pair of cabinets with symmetrical decoration.[11] To confirm this hypothesis, a closer look at such examples as well as an examination of the construction and assembly of the side table itself was undertaken.

Among large-scale export lacquer objects, cabinets were a favored item from the end of the sixteenth to the end of the seventeenth century. Often placed on domestically carved

and gilded stands, they were displayed in the public rooms of noble houses, signaling wealth and good taste, and were especially appealing to Western taste when presented as a pair (Staatliche Münzsammlung München, LK007, LK008; Figure 5; see also Figure 1).[12] The scenes on the fronts of such paired cabinets mirror each other in concept rather than in detail, much as is the case for the landscapes found on the BVRB II side table.

Technical features of the lacquer veneer on the side table were examined by removing the gilded mounts. In addition, computed radiographs were taken to reveal information that might be hidden below the surface.[13] Two sheets of lacquer veneer, carefully chosen and arranged to create a continuous, but also mirrored, design, had been applied to cover almost the entire drawer front (Figure 6). A different approach was used for the sides, where single sections of lacquer veneer were inserted into recesses cut into the side rails of the carcass, ensuring that the veneer was even with the surrounding japanned surfaces. The outlines of these two recesses are similar—though mirrored. However, the sheet of lacquer veneer inserted on the proper left side lacks a corner, which has been compensated for with an additional piece of lacquer veneer (Figure 7).

In the radiographs, a variety of nails and screws, as well as vestigial nail and screw holes, are visible. Whereas all the screws and screw holes observed relate to the attachment of mounts to the side table, extant nails serve to

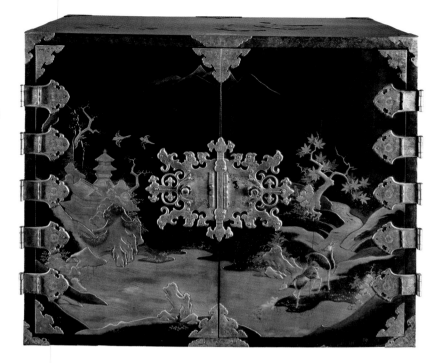

attach the lacquer veneer to its carcass. The vacant nail holes, however, pierce only the lacquer veneer and not the carcass (Figure 8). Reexamination of the lacquer surface confirmed that these holes have been filled and retouched, suggesting that they served a purpose only for the object from which the lacquer originated. Color-coding all attachment points and isolating those nail holes that do not relate to the veneer's current use revealed a recognizable pattern (see Figure 6). Comparison with pairs of export lacquer cabinets that are similar in decoration establishes that this configuration relates to the typical placement of lock plates, hinges, and corner mounts during the

Figure 4 ◆ Export lacquer cabinet. Japan, second half of the 17th century. Wood with black-and-gold lacquer, H. 70.7 cm (27⅞ in.), W. 95.2 cm (37½ in.), D. 52.1 cm (20½ in.). Staatliche Münzsammlung München (LK015)

Figure 5 ◆ Pair of export lacquer cabinets. Japan, second half of the 17th century. Wood with black-and-gold lacquer, H. 57.1 cm/57.3 cm (22½ in./22⅝ in.), W. 75.8 cm/74.9 cm (29¾ in./29½ in.), D. 43.5 cm/44.2 cm (17⅛ in./17⅜ in.). Staatliche Münzsammlung München (LK007 and LK008)

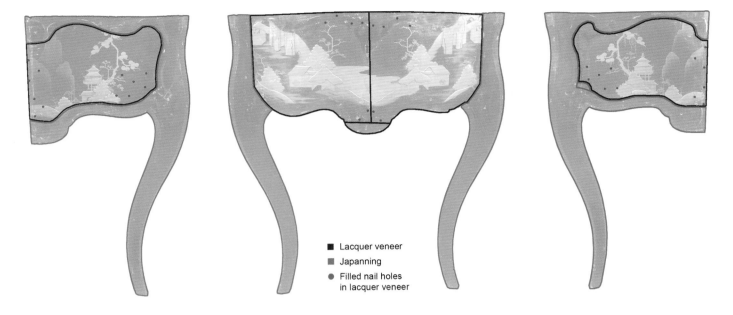

■ Lacquer veneer
■ Japanning
● Filled nail holes
in lacquer veneer

second half of the seventeenth century (see Figures 4, 5). This observation confirmed the hypothesis that the lacquer veneer on the side table originated from such cabinets.[14]

As a result, it is also possible to reconstruct the exact positions of the fragments in their original context and to infer that one section of lacquer veneer from the table's drawer and one from the side originated from a single door of an export lacquer cabinet (Figure 9). And because the decorations on the drawer front as

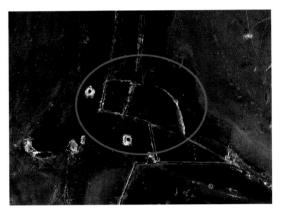

Figure 7 ◆ BVRB II side table (1976.155.101). Detail of proper left side, indicating in red the additional piece of lacquer veneer

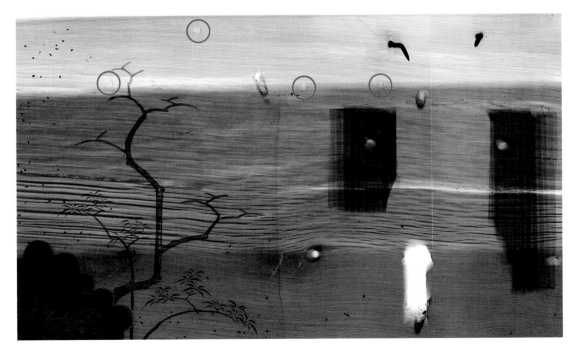

Figure 8 ◆ BVRB II side table (1976.155.101). Detail of computed radiograph of the drawer front, showing in red circles the original nail holes in the lacquer veneer, now filled and retouched

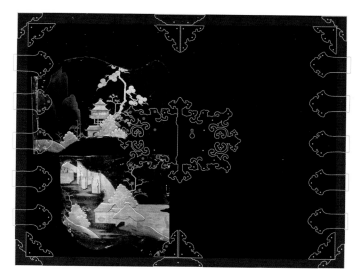

well as the two scenes on the apron sides are symmetrical, it follows that one door was indeed taken from each of a pair of cabinets with mirrored decoration. Finally, the reason for the small separate section of lacquer veneer on the proper left side of the object also becomes clear, as the reconstruction in Figure 9 suggests that the keyhole of the export cabinet was positioned precisely there.

Although its exotic nature was the source of European fascination with Asian lacquerware, seventeenth-century Japanese export lacquer furnishings catered specifically to Western taste and expectations by adding symmetry to decorations and producing forms—such as chests and paired cabinets—that were not common in Japan itself. Even though most importation of lacquerware had ceased by the end of the century, this side table vividly illustrates the continued appreciation of Japanese workmanship and materials during the eighteenth century. While lacquered export furniture from Japan was being discarded as old-fashioned, its surface decorations were reused on new, stylish French forms, and in the process the symmetry of the original designs was sometimes even amplified in order to further satisfy this enduring Western predilection.

CHRISTINA HAGELSKAMP

Assistant Conservator
Sherman Fairchild Center for
Objects Conservation
The Metropolitan Museum of Art

ACKNOWLEDGMENTS
Grateful appreciation is given to Mecka Baumeister and Marijn Manuels, Sherman Fairchild Center for Objects Conservation, and to Daniëlle Kisluk-Grosheide, Department of European Sculpture and Decorative Arts, The Metropolitan Museum of Art, for their generous support during this project and their help in discussing and reviewing this research note. This research was funded by the Andrew W. Mellon Foundation.

NOTES
1 Lacquer is made from the sap of three tree species belonging to the Anacardiaceae family native to East and Southeast Asia. During harvesting, the trees' bark is incised to collect their sap, which consists of a water-oil emulsion. In contrast to Western varnishes that dry by evaporation of the solvent, the lacquer sap cures through polymerization based on an enzymatic reaction induced by oxygen and high relative humidity.

2 Between 1641 and 1853, the Netherlands was the only Western country allowed to trade on Japanese soil. The VOC established a flourishing trading post on the man-made island of Deshima in the Bay of Nagasaki,

Figure 9 ◆ Rendering of a typical pair of Japanese export cabinets, with four lacquer veneer fragments from the side table superimposed onto the doors to illustrate their presumed original configuration. The fragments' original nail holes are indicated in red. As can be seen in the lower left corner of the top right fragment, a separate piece of veneer would have been necessary to compensate for the original keyhole in that location.

created specifically for this purpose (Impey and Jörg 2005, pp. 22–26).

3 Impey and Kisluk-Grosheide 1994, pp. 48, 49.

4 Another factor in the decline of large-scale trade in lacquer objects was the basic incompatibility between the labor-intensive technique and the increasing unwillingness of the VOC to pay the prices demanded. This situation led to a gradual decline in the quality of the lacquerware, which in turn decreased demand. By the end of the seventeenth century the official trade had all but ceased, although private initiative continued verifiably until the end of the following century, providing small amounts of high-quality Japanese lacquerware to Western admirers (Impey and Jörg 2005, pp. 35–63).

5 Bernard I Van Risen Burgh (ca. 1660–1738) was born in the Netherlands and immigrated to Paris in the second half of the seventeenth century, where he established a workshop in the furniture-making district Faubourg Saint-Antoine. His son, Bernard II, and grandson, Bernard III (ca. 1731–1800), both continued the family business. While BVRB I spelled his last name Van Risen Burgh, BVRB II changed it to Vanrisamburgh. This variation in the spelling of the family name has caused much confusion in the literature, and both the Dutch version and its French modulation are common, including several variations of each. Vanrisamburgh was chosen for this article, based on the signature of Bernard II as found on the *inventaire après décès* of his father (Ronfort, Augarde, and Langer 1995, p. 30). Many thanks to Institute of Fine Arts student Grace Chuang for discussing this topic with the author.

6 The other four objects from this group of BVRB furniture with Asian lacquer at the Metropolitan Museum are a commode with Japanese black-and-gold lacquer (58.75.122), a commode with Chinese Coromandel lacquer (1974.356.189), and a pair of corner cupboards with Coromandel lacquer (1983.185.1a, b and 1983.185.2a, b).

7 Oak (*Quercus* sp.) was identified macroscopically. Beech (*Fagus* sp.) was identified microscopically based on thin sections of a sample.

8 On the side table the thickness of the lacquer veneer ranges from 1.5 to 2.5 mm.

9 "Japanning" refers to European imitations of Asian lacquer decoration, including black and colored backgrounds as well as the mainly gold- and silver-colored designs applied to them. As they had no knowledge of the materials and techniques necessary to produce Asian lacquerware, Western cabinetmakers imitated the glossy surfaces and refined decoration by using materials they were familiar with. Still, the characteristic stratigraphy of Asian lacquer finishes, the result of multiple foundation layers and applications of lacquer, each polished to attain a translucent surface, was widely studied and emulated (Ballardie 1994, pp. 179–85).

10 The choice of fine-grained beech for these japanned surfaces is intentional, ensuring a smooth and even substrate.

11 Kisluk-Grosheide, Koeppe, and Rieder 2006, p. 142; Impey and Kisluk-Grosheide 1994, pp. 52–53, figs. 6, 7.

12 Cynthia Viallé (2011, pp. 31–45) states that the shipment of pairs is first mentioned in the records of the VOC in 1660 and that the company started specifically ordering pairs of cabinets from 1680 on. Considering the potential for damage occurring over the years, the high probability that pairs would be split up, and the trend, described here, of dismantling these objects, it is to be expected that only a small number of pairs with mirrored decoration are known in present-day collections. Extant examples can be found in the Staatliche Münzsammlung München and the Wallace Collection, London.

13 Computed radiographs were taken with a Philips MG321 system utilizing a tungsten target, a Philips MGC30 control unit, and Kodak Industrex Flex HR Digital Imaging Plates. The settings were 5 mA and 55 kV for 30 seconds, with a distance of 90 cm between target and digital plate. Plates were scanned using an Industrex HPX-1 scanner, and image files were created and enhanced with Industrex Digital Viewing Software 3.5.

14 Based on the pattern of nail holes, it can be inferred that the shape of the original lock plate matches almost exactly that of a group of examples found on export lacquer cabinets displaying increasingly elaborate decorative schemes. Hans-Ulrich Roßberg (2011, pp. 69–81) proposed that the form, size, and number of mounts on these cabinets increased with time and that the specific design of the lock plate, with eight bird heads in profile, became the predominant form used on furniture of this type during the second half of the seventeenth century.

REFERENCES

Ballardie 1994. Margaret J. Ballardie. "Japanning in Seventeenth- and Eighteenth-Century Europe: A Brief Discussion of Some Materials and Methods." In *Painted Wood: History and Conservation— Proceedings of a Symposium Organized by the Wooden Artifacts Group of the American Institute for Conservation of Historic and Artistic Works and the Foundation of the AIC, Held at the Colonial Williamsburg Foundation, Williamsburg, Virginia, 11–14 November 1994*, edited by Valerie Dorge and F. Carey Howlett, pp. 179–85. Los Angeles: Getty Conservation Institute, 1994.

Impey and Jörg 2005. Oliver R. Impey and Christiaan Jörg. *Japanese Export Lacquer, 1580–1850.* Amsterdam: Hotei, 2005.

Impey and Kisluk-Grosheide 1994. Oliver R. Impey and Daniëlle O. Kisluk-Grosheide. "The Japanese Connection: French Eighteenth-Century Furniture and Export Lacquer." *Apollo*, no. 139 (January 1994), pp. 48–61.

Kisluk-Grosheide, Koeppe, and Rieder 2006. Daniëlle O. Kisluk-Grosheide, Wolfram Koeppe, and William Rieder. *European Furniture in The Metropolitan Museum of Art: Highlights of the Collection.* New York: Metropolitan Museum of Art; New Haven, Yale University Press, 2006.

Ronfort, Augarde, and Langer 1995. Jean-Nérée Ronfort, Jean-Dominique Augarde, and Brigitte Langer. "Nouveau aspects de la vie et de l'oeuvre de Bernard (II) Vanrisamburgh (c. 1700–1766)." *L'Estampille/L'Objet d'Art*, no. 290 (April 1995), pp. 28–52.

Roßberg 2011. Hans-Ulrich Roßberg. "Die Metallbeschläge der japanischen Exportlacke im 16. und 17. Jahrhundert." In *Japanische Lackkunst für Bayerns Fürsten: Die japanische Lacksammlung der Staatlichen Münzsammlung München*, edited by Anton Schweizer, Martin Hirsch, and Dietrich O. A. Klose, pp. 69–81. Munich: Selbstverlag der Staatlichen Münzsammlung, 2011.

Viallé 2011. Cynthia Viallé. "Japanese Lacquer Cabinets in the Records of the Dutch East India Company." In *Japanische Lackkunst für Bayerns Fürsten: Die japanische Lacksammlung der Staatlichen Münzsammlung München*, edited by Anton Schweizer, Martin Hirsch, and Dietrich O. A. Klose, pp. 31–45. Munich: Selbstverlag der Staatlichen Münzsammlung, 2011.

PICTURE CREDITS

Unless otherwise indicated, photographs of works in the Metropolitan Museum's collection are by the Photograph Studio, The Metropolitan Museum of Art.

Bridgeman Art Library/Giraudon: Figure 1

Department of Objects Conservation, The Metropolitan Museum of Art: Figures 2, 6–9

Staatliche Münzsammlung München: Figures 4, 5

A Technical Examination of *Lake Como* by Thomas Moran

◆

Sarah Kleiner

The American paintings collection at The Metropolitan Museum of Art includes *Lake Como* (64.198.5; Figure 1), an oil painting by Thomas Moran (1837–1926). Moran completed this work in August 1867, after returning from Europe on a journey designed to trace the footsteps of J.M.W. Turner, an artist he greatly admired. While abroad, Moran had made two drawings of Lake Como,[1] but neither composition matches that of the Metropolitan Museum's painting. Moran often drew field sketches from nature and then returned to his studio to paint. He developed his own visual vocabulary through life studies that he used as elements when creating his final painted compositions. The result was a picturesque pastiche rather than a clearly identifiable view. *Lake Como* includes architectural ruins, rolling mountains, and tree formations that are similarly rendered in other Moran drawings from the same journey.[2]

Moran noted that *Lake Como* was the first picture to be sold after his return to the United States.[3] By 1933, the painting was in the collection of Emily Buch, who bequeathed it to the Metropolitan Museum in 1963. Although the provenance of the painting is well documented, one long-standing question has remained unanswered: Was the painting significantly reduced in size? Thomas Moran kept what he called an "Opus List" of his early works, those painted between August 1863 and November 1868.[4] *Lake Como* is number 27, and this same number is inscribed in the painting's lower left corner: COMO/THOS. MORAN 1867/OP 27. The corresponding entry in the Opus List, with its two addenda, reads as follows:

No. 27 <u>The Lake of Como</u>
Size 40 x 70 inches. Painted in August 1867. First picture sold after my return from Europe Sold to F. Gutekunst for $400 =

[added in sepia ink] Afterwards repainted many parts. G. dissatisfied with his purchase & traded it off to E. Moran.

[added in purple ink] Afterward E Moran cut the picture into two & repainted the two parts & sold them as mine at his sale in 1877[5]

This intriguing entry implies that the Metropolitan Museum's *Lake Como* is a fragment of Moran's original composition. Its current dimensions are 39¾ × 34⅝ inches (103.5 cm × 87.6 cm), approximately half the width recorded

Figure 1 • Thomas Moran
(American [born England],
1837–1926). *Lake Como*,
1867. Oil on canvas,
103.5 × 87.6 cm
(39¾ × 34⅝ in.).
The Metropolitan
Museum of Art, Bequest
of Emily Buch, 1963
(64.198.5)

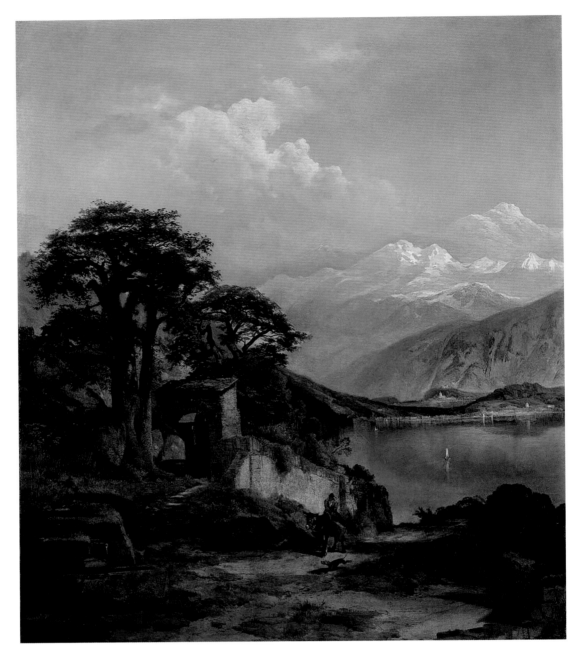

by Moran, meaning that the now-vertical format may originally have been horizontal. Moran listed two campaigns of changes made to the painting, one by himself and the other by his brother, the painter Edward Moran (1829–1901). All the changes, including the division into two independent works, took place within ten years after the oil painting was completed. The Opus List also leaves no doubt that Thomas Moran knew of the changes and allowed the two paintings arising from the original to be sold under his name.

While undergoing conservation treatment in 2010 at the Metropolitan Museum's Sherman Fairchild Center for Paintings Conservation, *Lake Como* was examined for physical evidence that supports what Thomas Moran recorded in his Opus List entry. The technical investigation combined with art-historical evidence offers new insights. Analysis with infrared reflectography and X-ray radiography revealed that the composition was significantly altered. Further visual examination of the painting during treatment coupled with cross-section analysis

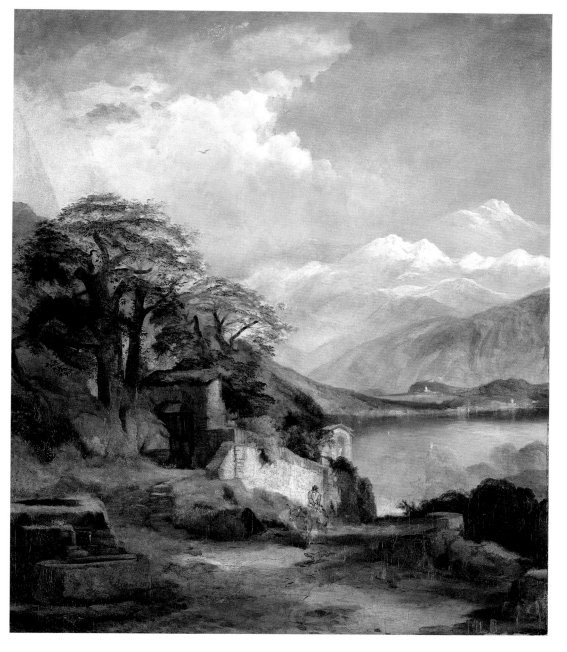

Figure 2 ♦ *Lake Como.*
Infrared reflectogram

confirmed that the format of the painting was changed.

Prior to the conservation treatment, *Lake Como* was examined with a near-infrared (NIR) camera to look for carbon-based underdrawing and pentimenti (compositional changes) not visible on the surface.[6] The infrared reflectogram shows evidence of both (Figure 2). Moran seems to have varied his underdrawing style for different subject matter. He drew the dog in bold, sharp contours, which appear to have been executed in pencil (Figure 3). Beneath the painted mountains, Moran planned the rock formations in faint pencil outlines, carried out in a loose and gestural style. The man and donkey, on the other hand, were indicated with uneven brushed lines.

In addition to the underdrawing, infrared reflectography revealed significant changes made to the painted composition of *Lake Como*. At one time a church was present, fully worked up in paint, above the lake on the left. In fact, a pentimento is visible where the pitch of the roof was changed before the structure

Figure 3 ◆ *Lake Como*. Detail of infrared reflectogram, showing the underdrawing of the dog

was painted out altogether (Figure 4). A dramatic shift was also made to the tree line that runs along the bottom edge of the lake. Once higher, the tree line was lowered by painting over it to broaden the body of water. A third small boat was also present between the two boats that are now visible.

As part of the conservation treatment of *Lake Como*, the failing wax-resin lining was removed. During this process the canvas was taken off its stretcher, providing an opportunity to carry out radiographic examination without interference from the wooden support. Like the infrared reflectogram, the radiograph reveals the church and adjusted tree line (Figure 5). It also illustrates that the edge of the water was previously higher to match the level of the trees. Other changes are visible in the mountain range, which was initially grander in scale; the peak farthest to the left was taller than at present, and the central range was denser. In addition, the large white cloud mass, now toward the center of the painting, was originally farther to the right side of the composition.

To better understand the many changes made in the rendering of the lake, a microscopic sample was taken and prepared for cross-section analysis.[7] The sample comprises fourteen layers from three clearly distinguishable campaigns of painting (Figure 6). The first campaign ends in a blue layer, probably the original lake. The second campaign shows green layers that correspond to the higher tree line of the intermediate composition. The third campaign adds pinkish purple, the final color of the lake. This stratigraphy suggests the painting was reworked twice.

The bottom and left edges of *Lake Como* were slightly trimmed, likely when the painting was lined during a prior treatment. However, both edges include fragments of the original tacking margin, suggesting that little was cut away. The top and right edges of the painting do not include the original tacking margin, with one possible exception: a 1.9 centimeter light-colored strip of paint[8] on the right side near the trees.[9] A cross section was taken from this area to determine whether it is in fact a remnant of the tacking margin or a vestige of the lost half of the composition. For comparison, the left tacking margin was also sampled and found to comprise only the canvas and a white priming layer (Figure 7). The sample from the right side includes these layers plus two colored paint layers, a thin white paint layer, and a possible varnish (Figure 8). The presence of colored paint layers suggests that the light-colored strip is not part of the tacking margin.

The conservation treatment of *Lake Como* provided new access to physical evidence present on the painting. With the lining removed, the back of the original canvas was visible. The canvas has 16 × 14 threads per square centimeter woven in a plain, even, tabby-weave pattern. Cusping—the scalloped pattern that forms when tacks or nails are used to secure a canvas as it is being stretched—is present to a small degree on the left, top, and bottom edges of the painting, but not along the right side. Like the presence of a tacking margin, cusping typically signifies the original edge of a painting.

Figure 4 ◆ *Lake Como*. Detail of infrared reflectogram, showing pentimenti. Evidence of changes made to the church, the raised boundary of trees, and a boat now covered by subsequent painting campaigns, is indicated with arrows.

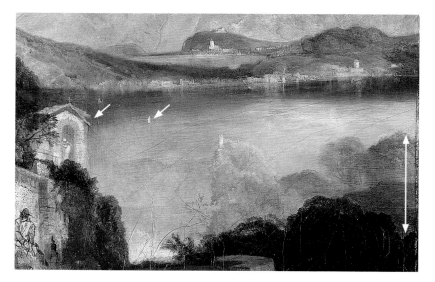

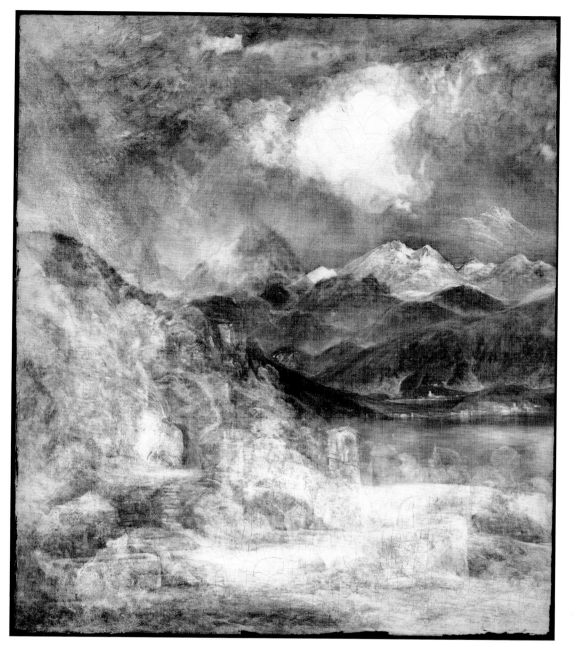

Figure 5 • *Lake Como*. X-ray radiograph

The complete lack of cusping along the right side of *Lake Como* provides further confirmation it was cut along that edge.

The auxiliary support is a bridle joint stretcher made of pine, which may be original to the painting. The stretcher also shows evidence of being cut down. A cutoff inscription applied with a brush in black paint on the top rail was covered by the canvas and discovered only when the painting was removed from its stretcher during treatment. The inscription reads: N NEW YORK (Figure 9). The handwriting resembles the artist's signature on *Lake Como*. It is tempting to assume the stretcher was initially marked THOMAS MORAN NEW YORK, but this cannot be determined from the current evidence.

The physical evidence found during the examination and treatment of *Lake Como* strongly suggests the painting was significantly altered both in its composition and in its format. Infrared reflectography and X-ray radiography show the perimeter of the lake was altered, concealing portions of the architectural

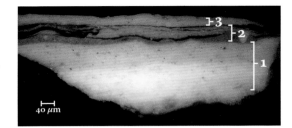

Figure 6 ◆ *Lake Como*. Cross section of paint from the right edge of the lake. The three campaigns of painting indicated by brackets correspond to the Opus List entry for number 27, which documents two sets of changes made to the painting by Thomas Moran and his brother Edward.

Figure 7 ◆ *Lake Como*. Cross section of a sample from the original tacking margin on the left side of the painting, showing canvas support and a white priming layer

Figure 8 ◆ *Lake Como*. Cross section from the right side of the painting, showing canvas support, a white priming layer, two colored paint layers, a thin white paint layer, and a possible varnish layer

elements and trees originally painted along the bottom edge of the lake. In addition, the mountainous landscape was simplified, and the large white cloud mass was shifted to the left. A cross section from the edge of the lake shows three campaigns of paint and therefore

two episodes of reworking, a sequence that appears to correspond to the entry in Moran's Opus List. Unfortunately, cross-section analysis could not be used to attribute the two upper layers to Moran or to his brother Edward.

The lack of a tacking margin on the right side of the painting, coupled with the absence of cusping on the edge of the canvas, contributes to the conclusion that the painting was cut along the right side. The stretcher also exhibits evidence of having been resized, with the left half of the original painting ending up on the right half of the stretcher. The extent to which the canvas and the stretcher were reduced is not possible to deduce from the technical evidence. Here, however, the archival source material fills lacunae in the primary research. Thomas Moran's Opus List entry for *Lake Como* describing the alterations made to the painting parallels physical characteristics found on the work. Moran's precise documentation of the process suggests he approved of the adaptation and viewed what ultimately became the Metropolitan Museum's painting as an independent composition. The missing half of the original painting is unidentified and seems a legitimate avenue for further art-historical research.

SARAH KLEINER

Assistant Paintings Conservator
Fine Arts Museums of San Francisco

ACKNOWLEDGMENTS

I gratefully acknowledge my supervisors in the Sherman Fairchild Center for Paintings Conservation, The Metropolitan Museum of Art: Michael Gallagher, Sherman Fairchild Conservator in Charge, and Charlotte Hale and Dorothy Mahon. Additional thanks to H. Barbara Weinberg, formerly of the American Wing, and to my colleagues in the Department of Scientific Research, Julie Arslanoglu and Silvia A. Centeno. Special thanks to Carole Klein, Gilcrease Museum, Tulsa, Oklahoma, and Anne Morand, National Cowboy and Western Heritage Museum, Oklahoma City, both of whom graciously guided me through the

Figure 9 ◆ *Lake Como*. View of stretcher front with canvas removed. The partial inscription on the top rail is usually covered by the canvas.

Thomas Moran archive. Final thanks to Kristin DeGhetaldi, National Gallery of Art, Washington, D.C., and Amber Kerr-Allison, Smithsonian American Art Museum, Washington, D.C. This research was funded through an Andrew W. Mellon Fellowship in Conservation.

NOTES

1. Morand 1996, pp. 140–41. The two drawings are *Argegno, Lake of Como*, April 1, 1867, graphite and red conté crayon on watermarked wove paper, 29.5 × 24.1 cm (11⅝ × 9½ in.), and *Lake Como*, 1867, graphite on wove paper, 30.8 × 47.6 cm (12⅛ × 18¾ in.). Both drawings are in the collection of the Gilcrease Museum, Tulsa, Oklahoma (1376.919 and 1376.929, respectively).

2. Morand 1996, pp. 134–39. These features were observed in a variety of early Thomas Moran drawings such as *The Aqueduct on the Campagna, Rome*, March 1867, Gilcrease Museum (0276.862); *Lake Nemi*, March 12, 1867, Gilcrease Museum (1376.920); and *Pines in the Villa Borghese, Rome*, March 1867, Gilcrease Museum (0276.868).

3. Anderson 1997, p. 355.

4. Ibid., pp. 350–57. Moran's Opus List was published for the first time in Anderson 1997. The original is in the collection of the Gilcrease Museum.

5. Ibid., p. 355.

6. The Indigo Systems Merlin near-infrared camera has a solid-state InGaAs (indium gallium arsenide) detector sensitive to wavelengths from 0.9 to 1.7 μm. The array format is 320 × 256 pixels. The camera is used in conjunction with a National Instruments IMAQ PCI-1422 Frame Grabber Card and IRvista 2.51 software. The macro lens is custom-made by StingRay Optics, and optimized for wavelengths from 0.9 to 2.5 μm. Images were acquired as 16-bit BIN files, exported as 8-bit TIFF files, and assembled in Adobe Photoshop CS3.

7. Cross sections were cast in Technovit resin and cured with ultraviolet light. The samples were polished with Micro-Mesh cloth and examined under a Zeiss Axioplan 2 microscope, equipped with a high-pressure 100 W mercury lamp and a 100 W halogen lamp. For fluorescence microscopy two filter sets were used: filter set 1 (excitation filter 365 nm, chromatic beam splitter 395 nm, emission filter 397 nm) and filter set 2 (excitation filter 390–420 nm, chromatic beam splitter 425 nm, emission filter 450 nm). Digital images were captured with a Pursuit 4MP Slider camera and processed with SPOT version 4.6 software.

8. The sliver is located 16.5 cm from the bottom right corner.

9. The dimensions of *Lake Como* recorded in the Opus List suggest the height of the painting was not altered even though the tacking margin along the top edge is missing.

REFERENCES

Anderson 1997. Nancy K. Anderson. *Thomas Moran/ Nancy K. Anderson*. Exh. cat. Washington, D.C.: National Gallery of Art, 1997.

Morand 1996. Anne Morand. *Thomas Moran: The Field Sketches, 1856–1923*. Norman: University of Oklahoma Press, for the Thomas Gilcrease Institute of American History and Art, 1996.

PICTURE CREDITS

Unless otherwise indicated, photographs of works in the Metropolitan Museum's collection are by the Photograph Studio, The Metropolitan Museum of Art.

Department of Paintings Conservation, The Metropolitan Museum of Art: Figures 2–9

A Technical Examination of the Lion Helmet

◆

Edward A. Hunter

Acquired by The Metropolitan Museum of Art in 1923, the so-called Lion Helmet (23.141a–c; Figure 1) has long been recognized as one of the earliest extant examples of Renaissance armor.[1] Of Italian manufacture and dated to 1475–80,[2] the helmet was no doubt intended to recall the Nemean Lion of Herculean myth and confer the glory of the ancient hero on the wearer. Alexander the Great is depicted wearing such a helmet on the eponymous sarcophagus in the collections of the Istanbul Archaeological Museums (inv. no. 370),[3] as are King Alfonso I, his son, and their retainer in reliefs on the Aragonese Arch, completed 1447.[4] The Lion Helmet is a rare fifteenth-century example of the extravagant and fanciful armors that became popular in the sixteenth century and is clearly a masterpiece of the armorer's art. Its form, which is certainly unusual and possibly unique, earns the helmet not only a prominent place in the Museum's galleries but encourages a closer examination.[5]

Technical investigation of the Lion Helmet was carried out in conjunction with a loan request. To determine its suitability for travel, it was necessary to disassemble the helmet, allowing a rare opportunity to examine and photograph its three components—a gilded

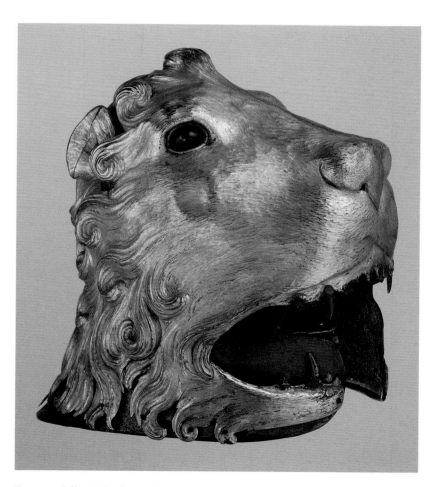

Figure 1 ◆ Sallet in the shape of a Lion's Head. Also known as the Lion Helmet. Italian, 1475–80. Steel, gilded copper, glass, paint, textile, H. 29.8 cm (11¾ in.), W. 21.0 cm (8¼ in.), D. 31.8 cm (12½ in.), Weight 3574 g (7 lb., 14 oz.). The Metropolitan Museum of Art, Harris Brisbane Dick Fund, 1923 (23.141a–c)

Figure 2 ◆ Sallet "in the
Venetian style." Italian,
ca. 1460. Steel, gilded
copper alloy, textile,
H. 27.3 cm (10¾ in.),
W. 20.3 cm (8 in.),
D. 25.4 cm (10 in.),
Weight 2144 g (4 lb., 12 oz.).
The Metropolitan
Museum of Art, Bashford
Dean Memorial Collec-
tion, Funds from various
donors, 1929 (29.158.17)

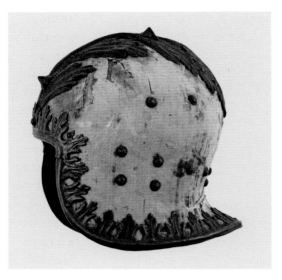

copper shell in the shape of the head of a lion,
a steel sallet, and a padded textile lining—in
their entirety.[6] Study of the helmet and compari-
son with contemporaneous examples support
the idea that the sallet was not newly fashioned
as a support for the shell but is older and
apparently was incomplete before it was chosen
for that purpose. Visual and radiographic
examination combined with instrumental
analysis revealed a clearer picture of the con-
struction details of the shell, the history of
repair and restoration, and new information
about pigments found on the sallet.

Nothing is known of the helmet prior to
1816, when it appeared on the London art
market, and neither the sallet nor the shell
bears a maker's mark. The ensemble is in good
condition, despite wear, tarnish, and physical
damages to the shell, some of which have been

repaired. The sallet is also well preserved, though
corroded, and exhibits several layers of paint
from various restorations. The lining is not
attached to the helmet but fits neatly inside.

This type of construction and decoration
was common for Italian Renaissance helmets.[7]
The Metropolitan Museum has on display, for
example, an Italian sallet "in the Venetian
style" of about 1460 (29.158.17; Figure 2) fitted
with gilded copper-alloy appliqués and a velvet
covering. A similar helmet in the Odescalchi
Collection, catalogued as a "barbuta alla
veneziana" (barbute in the Venetian style), also
displays the characteristic appliqués, including
a pair of gilded lion masks, one on either side.[8]
These examples are much less elaborate, but
their style and construction help to put the
Metropolitan Museum's Lion Helmet in context.

The shell is constructed from two sheets of
copper, raised and chased and then soldered
together down the center from front to back
(Figure 3). X-ray fluorescence spectroscopy
(XRF) was used to determine the composition
of the solder.[9] Several other smaller seams may
be repairs but are more likely related to cuts
made to facilitate shaping of the copper sheet.
Great attention has been paid to detail, from
the intricately chased hair over much of its
surface to the delicate ears. The mane has ele-
gant raised whorls and locks, sweeping down
the back and sides of the neck. A significant
feature of the shell is the way the lion's mouth,

Figure 3 ◆ Lion Helmet.
Computed radiograph of
the gilded copper shell,
overhead view. The
soldered central seam is
clearly visible.

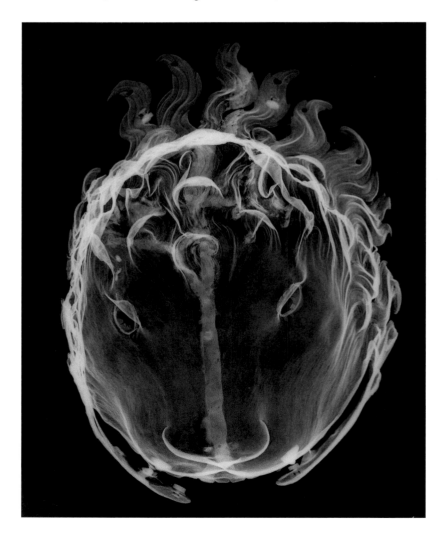

complete with individually formed teeth, wraps around the T-shaped opening in the sallet's faceplate, allowing the wearer to see through the gaping maw (Figure 4). The part of the sallet's exterior that is visible inside the opening has been painted black and red to simulate the lion's mouth and tongue.

Two glass eyes in copper bezels have been set into the shell using a black resinous bedding material[10] and secured around the edges by a series of small, bent metal tabs. The left eye is green glass, with small bubbles easily seen in transmitted light, while the right eye is reverse-painted colorless glass. The green glass eye is most likely a replacement. As the bezels are identical, it seems probable both eyes were remounted at some point, in which case the other eye may be a replacement as well.

The entire exterior of the shell is amalgam-gilded, as XRF analysis showed residual mercury. Bright and clean with minimal wear of the gilding, the surface shows silver tarnish only along the soldered seam. By contrast, the interior of the shell is extensively corroded. Although the thickness of the copper is relatively uniform over most of the shell, there are several places where the sheet is thin and has split or has small holes, apparently due to mechanical stresses incurred during the repoussé process.

Several repairs and alterations to the shell were found. Originally, the shell was riveted to the sallet through the tips of the locks of the mane (Figure 5). The rivets are now lost, but the matching pairs of holes are still clearly visible. The shell is currently secured with four small threaded bolts that reuse some of these original sets of holes. Although the copper sheet is fairly robust, both hard- and soft-solder repairs are visible, as are mechanical repairs, especially in the extremities that represent the mandible and the curls of the mane. The left side of the lower jaw has been repaired with a sheet-copper backing, riveted in place, which not only secures the break but also supports a significant second fracture. The canine tooth in this section is also backed, but

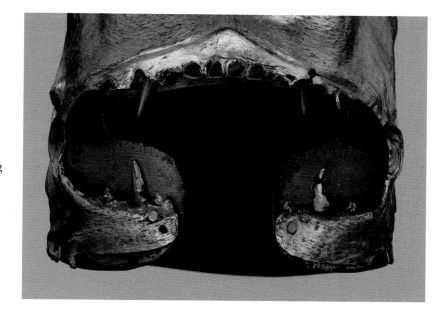

Figure 4 • Lion Helmet. Detail of T-shaped mouth opening, including teeth and polychromy

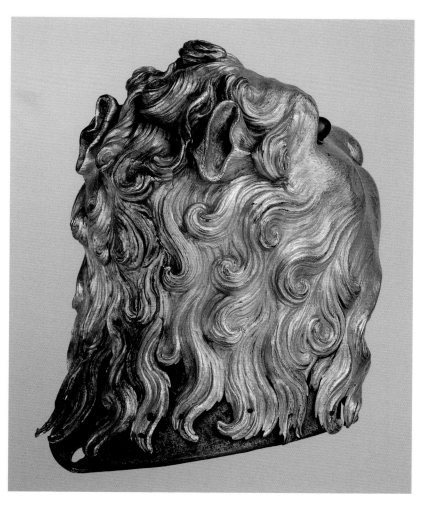

Figure 5 • Lion Helmet. Side view showing sallet on lower edges where not covered by the gilded copper shell

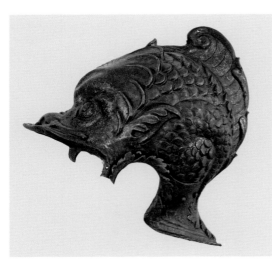

Figure 6 ◆ Burgonet. Italian, probably Milan, 1535–45. Steel, embossed, partly gilded and silvered, H. 27.5 cm (10¹³⁄₁₆ in.), W. 20.5 cm (8¹⁄₁₆ in.), D. 29.6 cm (11⅝ in.), Weight 1709 g (3 lb., 12 oz.). The Metropolitan Museum of Art, Gift of William H. Riggs, 1913 (14.25.597)

with a soldered copper strip, now thickened with corrosion.

One of the original large locks of the mane in the back is missing and has been replaced with a facsimile, also fashioned in copper and gilded yet noticeably different in surface appearance and less skilled in execution than its counterparts. This replacement is riveted to the shell, but its contours do not quite match the outline of the painted decoration directly underneath. This finding suggests that the repair postdates the final campaigns of gilding

Figure 7 ◆ Lion Helmet. Steel sallet without gilded copper shell

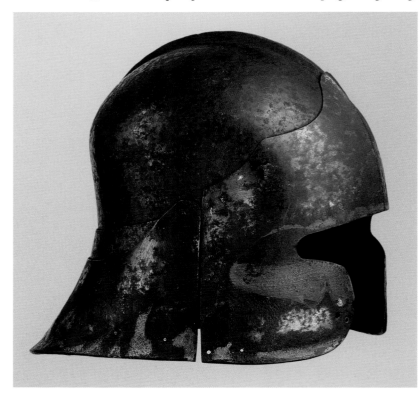

and painting the helmet and is therefore part of the most recent restoration efforts. The two replaced upper canines, one in steel and the other in brass, are also riveted in place. Several of the original teeth have been overpainted.

Despite the delicate form and relative fragility of the shell, there is no question that the steel sallet is battle-ready armor. Parade helmets, typically made entirely of steel, are often thin and have elaborate raised forms that lack the smooth and rounded weapon-deflecting shape or robust construction of a helmet intended for use in combat (e.g., 14.25.597; Figure 6). Placing a decorative shell over a steel support offers the style of a heroic helmet combined with the strength of an effective head defense, though it seems unlikely that the Lion Helmet was intended for anything other than ceremonial use.

The sallet is constructed of four separate plates (Figure 7). The main portion is a bowl fashioned from a single plate and includes two extensions that cover the ears. The bowl features a low-profile comb—a flat-topped medial ridge extending from the brow to the back of the head—with a keyhole opening for mounting a crest. The bowl exterior is dark and rough from the forge, with file and hammer marks still visible. The bottom rim of the bowl is ragged, having been cut rather than forged to shape (Figure 8). On the interior, heavily corroded rivets along the circumference of the bowl retain small fragments of the leather strap to which the lining would have been sewn, as was typical for European helmets.

The faceplate is secured to the bowl and earpieces using rivets. It has a wide, T-shaped opening with rounded corners and extends around either side to the halfway point of the bowl. The upper half of the faceplate has a pronounced medial ridge and tapers neatly to a rounded point over the comb of the bowl, providing additional protection for the forehead. The plate fits closely against the bowl, without any gaps.

On the back, two lames cover the neck and extend around the sides of the sallet to where they meet the faceplate, thus forming a robust

and rigid support for the shell as well as providing a contiguous defense (Figure 9). These plates, the first a narrow strip and the second a much larger piece that flares out and then tapers to a point, are also riveted in place. The faceplate and the main neck lame retain evidence of heat-bluing and a fine polish, although both are much reduced due to corrosion. Some file marks are visible on the narrow lame, in spite of its corroded surface; furthermore, it never received a high polish, and there is no evidence that it ever was blued.

Although a departure from earlier fifteenth-century Italian barbutes, with their high, one-piece construction, the Lion Helmet does retain the characteristic T-shaped face opening (e.g., 60.151; Figure 10).[11] In terms of overall shape, however, it is similar to contemporaneous sallets (e.g., 29.150.13; Figure 11) that feature the low profiles of the bowl and comb as well as an articulated tail, but have an articulated visor rather than a T-shaped opening.[12] On the Lion Helmet, the tail does not actually hinge but is riveted into a fixed position, presumably the better to support the delicate mane of the shell. The result is an unusual mixture of features from early barbutes with the overall lines of a later, sallet-style helmet.

When the shell is fitted over the sallet, edges of the faceplate and lower neck lame remain visible. As noted above, these surfaces appear to have been heat-blued, a common means of decorating armor that also provides a measure of protection against corrosion. When combined with gilding, the visual effect could be striking. Over the course of multiple restoration campaigns, the blued areas were at one point gilded and later painted white (see Figure 9).[13] Massive corrosion products are visible under the white paint, suggesting that it was applied to refresh the surface after the gilding was damaged by wear and corrosion of the steel support. The gold was probably applied over the blued surface after it, too, was worn or pitted. Examination and analysis of this paint revealed it to be mostly lead white.[14] All the mineral pigments identified on the basis of XRF

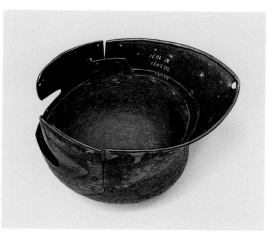

Figure 8 ◆ Lion Helmet. Interior of steel sallet, showing construction details, including cut edge of main bowl

analysis were common in the fifteenth century, but equally so in subsequent centuries. Given the stratification, however, it is most likely that the paint was applied during a later restoration, possibly just prior to the 1816 sale.

The peculiar construction and condition of the helmet have led to much speculation about its origins.[15] There is no question that the shell was fashioned to fit this specific sallet, but it has been suggested that the latter was reworked to better function as a support rather than

Figure 9 ◆ Lion Helmet. Reverse of steel sallet, showing paint on neck lames

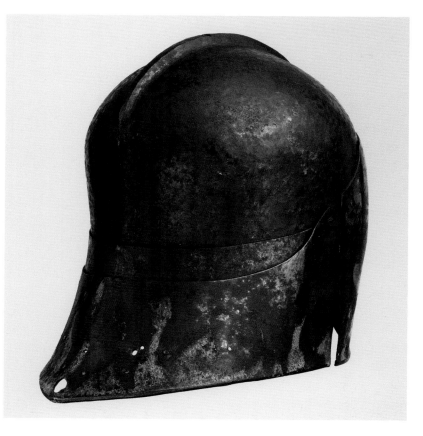

newly made for that purpose. Because the helmet is unmarked and lacking early documentation, it is difficult to say with certainty, but the hypothesis that the sallet was constructed from an older but unfinished bowl using newer additional parts seems plausible. The condition and rough exterior of the bowl suggest that its surface was never finished, whereas the smoothly polished and blued added plates indicate intentional surface

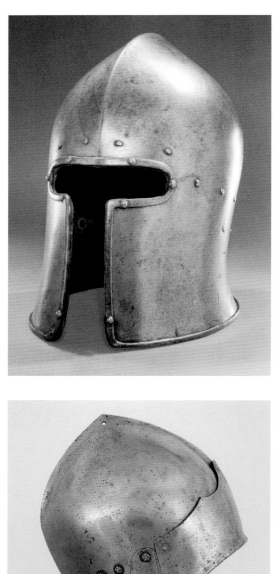

Figure 10 ◆ Jacobo da Cannobio, called Bichignola. Barbute. Italian, Brescia, ca. 1460. Steel, H. 28.9 cm (11⅜ in.), W. 20.0 cm (7⅞ in.), D. 27.0 cm (10⅝ in.), Weight 2381 g (5 lb., 4 oz.). The Metropolitan Museum of Art, Gift of Mrs. George A. Douglass, in memory of her husband, 1960 (60.151)

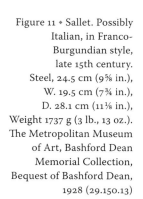

Figure 11 ◆ Sallet. Possibly Italian, in Franco-Burgundian style, late 15th century. Steel, 24.5 cm (9⅝ in.), W. 19.5 cm (7¾ in.), D. 28.1 cm (11⅛ in.), Weight 1737 g (3 lb., 13 oz.). The Metropolitan Museum of Art, Bashford Dean Memorial Collection, Bequest of Bashford Dean, 1928 (29.150.13)

decoration and protection. Had the sallet always been a completely realized helmet, the entire surface would show evidence of such preparations, not only some sections.

However, although the overall construction approximates that of a later sallet form, the rough cutting of the bowl edge suggests it originally had a different shape that was then adapted to support the shell. It is possible that the bowl as originally forged resembled another helmet in the Metropolitan Museum's collection, a contemporaneous Milanese sallet (04.3.230; Figure 12) with a low bowl, a low medial ridge, and a flared nape. The Lion Helmet presumably originally had a similar nape, which was cut away so that the faceplate would fit properly, permitting the shell to wrap around the head and to give the impression that the wearer was peering out of the lion's mouth. The addition of lames may have been intended to give the flowing mane greater length and a more dramatic appearance as well as to integrate the overall shape and profile. Also of significance is the presence of the keyhole opening on the medial ridge, a means of attaching a crest that is covered by the shell and is unused in the helmet's present configuration. Overall, the unfinished surface on a modified earlier helmet shape suggests a repurposed but unused bowl, which was then combined with new parts intended to create the outward appearance of a later sallet while accommodating restriction incurred by the shape of the shell.

It is rare for a helmet of this period to retain an intact lining (Figure 13), much less one of such high quality and in such good condition. The lining consists of three layers, each stitched together from four sections of fabric to form a bowl shape padded with horsehair. The outer layer, closest to the sallet's inner surface, is a plain-weave linen.[16] The middle layer is a higher-quality twill weave with a linen warp and cotton weft. This layer is covered with the third layer, a satin-weave silk that would have been in direct contact with the wearer. The entire lining is quilted in a V-shaped pattern. Linen tape, attached around the perimeter of

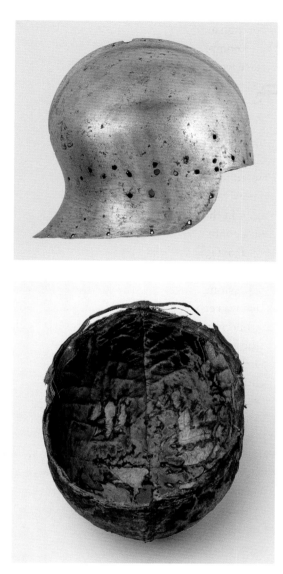

repairs it has sustained, as well as the fabrication and alteration of the unusual steel sallet, are now better understood, but to reconstruct the circumstances that led the armorer to repurpose an earlier, unfinished bowl is far more difficult. Nonetheless, this impressive work will continue to capture the imagination of viewers in the Arms and Armor Galleries.

EDWARD A. HUNTER

Conservator
Department of Arms and Armor
The Metropolitan Museum of Art

ACKNOWLEDGMENTS
Grateful thanks and appreciation are given to Stuart W. Pyhrr, Department of Arms and Armor, The Metropolitan Museum of Art, not only for his support and guidance but also for his inspiration and sage advice. Acknowledgment also must be given to Donald J. La Rocca, Department of Arms and Armor, and to Jonathan Tavares, Art Institute of Chicago, for useful and enlightening discussions that helped shape this note. Similarly, it would not have been possible to complete this text without the generosity of Tony Frantz, formerly of the Department of Scientific Research, and Florica Zaharia, Department of Textile Conservation, whose knowledge and analysis were crucial to the understanding of the Lion Helmet. Finally, grateful thanks to Juan Trujillo, the Photograph Studio, for his excellent photography.

Figure 12 ◆ Sallet. Italian, Milan, 1470–80. Steel, H. 22.9 cm (9 in.), W. 20.3 cm (8 in.), D. 27.3 cm (10¾ in.), Weight 1625 g (3 lb., 9 oz.). The Metropolitan Museum of Art, Rogers Fund, 1904 (04.3.230)

Figure 13 ◆ Lion Helmet. Interior view of textile lining

the third layer, serves to dress the edges; it was also used to sew the lining to the leather band on the inside of the steel bowl. The outer layer also retains evidence of an adhesive used to secure it to the interior of the sallet.[17] It has long been assumed that the lining is original because of its quality and excellent fit, but more research on this and on other helmet linings is necessary before this can be stated with certainty.

The disassembly of the Lion Helmet for the first time since it was acquired by the Museum and the ensuing technical examination have revealed much new information. Although some details of its puzzling history have been clarified, the picture is not yet complete. The fabrication of the copper lion's head and the damages and

NOTES
1 Dean 1923, p. 226; Pyhrr and Godoy 1998, p. 92.
2 Pyhrr and Godoy 1998, p. 92.
3 An image of the sarcophagus is available online at http://www.istanbularkeoloji.gov.tr/web/27-106-1-1/muze_-_en (accessed September 26, 2013). The figure in question, a mounted warrior on a rearing horse, is visible on the left-hand side of the long relief panel. For a detail, see http://upload.wikimedia.org/wikipedia/commons/6/60/Alexander_Sarcophagus_Battle_of_Ussus.jpg (accessed September 26, 2013).
4 Pyhrr and Godoy 1998, p. 92.
5 Dean 1923. Bashford Dean's article in the *Metropolitan Museum of Art Bulletin* reviews the acquisition history of the helmet, starting in the early nineteenth century, and notes misattributions and confusion regarding the helmet's origins.

6 Throughout this article the term "helmet" refers to the entire ensemble of the Lion Helmet, and the term "sallet," a particular style of head defense common for the period, refers to the inner defense of steel.

7 For a detailed study concerning this type of helmet style and construction, with reference to the Museum's Lion Helmet, see Dolcini et al. 1993, especially Mario Scalini's contribution "La celata di Borghese Borghesi ed altri copricapi onorifici del Quattrocento," pp. 137–41.

8 Barberini and Germoni 2002, p. 72.

9 James H. Frantz, examination report, August 2, 2010, Department of Scientific Research, The Metropolitan Museum of Art. Nondestructive XRF surface analysis results indicate that the shell is copper and the solder a silver-copper alloy. Quantitative data and operating conditions were not provided in the report.

10 Ibid.

11 Mann 1962, p. 97, pl. 55.

12 Blair 1958, pp. 200–201 (ill.); Mann 1962, p. 93, pl. 57.

13 James H. Frantz, personal communication, August 2010.

14 Frantz, examination report. The red paint used to represent the lion's mouth contains cinnabar (HgS), red lead (Pb_3O_4), and lead white, generally a mixture of cerussite ($PbCO_3$) and hydrocerussite $[(Pb_3(CO_3)_2(OH)_2]$. The black paint surrounding the mouth contains an iron-based pigment, possibly magnetite (Fe_3O_4). The white paint on the two lower canine teeth of the lion contains lead white. Lead white is probably also in the paint overlying the gilded decoration. This paint is now darkened to gray, probably due to its partial conversion to galena (PbS) by sulfidation.

15 For instance, see Dean 1923.

16 Florica Zaharia, examination report, November 29, 2011, Department of Textile Conservation, The Metropolitan Museum of Art.

17 Photographs of the helmet when it was acquired by the Metropolitan Museum seem to indicate that the lining was still attached at that time, although probably only with glue. This was not usual practice for helmet linings and is likely a restoration, intended to secure the lining in lieu of stitching.

REFERENCES

Barberini and Germoni 2002. Maria Giulia Barberini and Silvano Germoni. *Belle e terribili: La collezione Odescalchi—Armi bianche e da fuoco*. Exh. cat. Rome: Palombi, 2002.

Blair 1958. Claude Blair. *European Armour*. London: B. T. Batsford, 1958.

Dean 1923. Bashford Dean. "A Lion Headed Helmet." *Metropolitan Museum of Art Bulletin* 18, no. 10 (1923), pp. 224–27.

Dolcini et al. 1993. Loretta Dolcini, Michel Bourbon, Thierry Favre, Giorgio Pieri, and Thessy Schoenholzer Nichols, with a contribution by Mario Scalini. "Un restauro polimaterico: L'Elmo del Capitano del Popolo' di Siena." *OPD Restauro*, no. 5 (1993), pp. 126–41.

Mann 1962. Sir James Mann. *Wallace Collection Catalogues: European Arms and Armour*, vol. 1, *Armour*. London: Trustees of the Wallace Collection, 1962.

Pyhrr and Godoy 1998. Stuart W. Pyhrr and José-A. Godoy. *Heroic Armor of the Italian Renaissance: Filippo Negroli and His Contemporaries*. Exh. cat. New York: Metropolitan Museum of Art, 1998.

PICTURE CREDITS

Unless otherwise indicated, photographs of works in the Metropolitan Museum's collection are by the Photograph Studio, The Metropolitan Museum of Art.

Tony Frantz, courtesy of the Department of Objects Conservation, The Metropolitan Museum of Art: Figure 3

An Investigation of Tool Marks on Ancient Egyptian Hard Stone Sculpture: Preliminary Report

◆

Anna Serotta

By the fourth millennium B.C., ancient Egyptian craftsmen were fashioning objects from a variety of hard stones such as diorite, basalt, and granite.[1] Although secondary sources including tomb paintings and excavated tools provide insight into their methods, many questions remain about how these stones were carved. Unlike softer varieties such as limestone or sandstone, which often bear well-preserved tool marks, hard stones could not be cut with chisels[2] and were instead probably worked with a combination of percussion and abrasion.[3] These methods leave behind fewer distinct tool marks than cutting, thus making it difficult to distinguish by what means surface features and finishes were produced. However, because hard stones are relatively resistant to weathering agents, any tool marks extant on their surfaces after manufacture is completed are generally well preserved. If properly analyzed, they can serve as the primary record of a craftsman and his working methods.

This technical note is the introduction to an ongoing study focusing on the documentation and characterization of tool marks on ancient Egyptian hard stone sculpture in the collection of The Metropolitan Museum of Art. The need for systematic characterization of tool marks

on stone sculpture, particularly for the benefit of authenticity studies, has already been noted,[4] and it is hoped that the data resulting from this larger study will serve as a reference with which tool marks on unprovenienced objects can be compared.

Figure 1 ◆ Highlight-based reflectance transformation imaging (RTI) setup at The Metropolitan Museum of Art

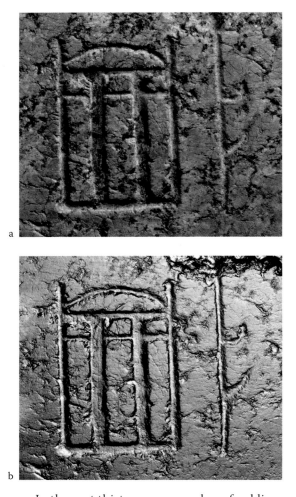

a

b

Figure 2 ◆ *Sarcophagus of Mindjedef*. Egypt, probably Memphite region, el-Giza, East Cemetery, Mastaba G7760, Pit B, Old Kingdom, Dynasty 4 (ca. 2520–2472 B.C.). Red granite, H. 104.1 cm (41 in.), W. 96.5 cm (38 in.), L. 236.9 cm (93¼ in.). The Metropolitan Museum of Art, Rogers Fund, by exchange, 1954 (54.80a, b). Details, two "snapshots" from an RTI capture of a hieroglyph carved in sunk relief: (a) in default mode; (b) in specular enhancement mode

In the past thirty years a number of publications have described studies of tool marks based on silicone rubber impressions taken from originals and analyzed using scanning electron microscopy (SEM).[5] This method has several advantages. The tool marks are seen in reverse, allowing the viewer to better observe the depth of individual marks and their internal details.[6] In addition, because SEM provides higher magnification and a greater depth of field than traditional microscopy, the resultant images contain both qualitative and quantitative data that can be compared with relative accuracy.

Nevertheless, when the extant tool marks are numerous and varied, high magnification may also be a weakness. In SEM studies, the focus is often on isolated marks, and the degree of magnification can make it difficult to see the relationship among marks extending over larger areas. For this reason, reflectance transformation imaging (RTI),[7] a noninvasive

documentation tool used to record three-dimensional surface features, was chosen as the primary method of investigation in this study. The technique combines digital photography with software analytics to obtain precise surface information over broad areas.[8] RTI files are derived from a series of digital images captured using a camera in a fixed position as the angle of incident light with respect to the object is systematically changed to produce different highlights and shadows in each image (Figure 1).[9] The RTI software mathematically synthesizes these data into a single file containing an accurate visual rendering of the subject's surface in three dimensions. The RTI Viewer software allows the user to vary the direction of lighting in the digital image and select the angles that best illustrate characteristic properties of an object's surface. By using various enhancement modes that apply mathematical transformations to the data, the user can also emphasize and clarify certain surface features (Figure 2).

Objects selected for the initial phase of this study come predominantly from Egyptian sites excavated by the Metropolitan Museum between 1906 and 1936. The RTI files generated from a hard stone statue excavated at Lisht, a funerary and residential center about 35 miles south of Cairo, can be used to illustrate this technique's potential for the analysis of tool marks on hard stone sculpture. The *Block Statue of Minhotep* (15.3.227; Figure 3) is carved from diorite[10] and has tool marks well preserved in much of its surface. "Snapshots" of the back of the wig (Figure 3b) and the inscription (Figure 3c) extracted from two RTI files[11] show differences and similarities in the depth, width, and trajectory of incised lines, the directionality of both coarse and fine tool marks, and the degree of overall surface polish. Within the incisions, the percussive removal of stone is indicated by slight depressions where a pointed tool struck the surface. These marks vary in depth, width, and spacing, likely due to the angle at which the tool was held, the shape of its tip, the strength of the blow, or a combination of these

factors. The relatively varied tool marks in the inscription, compared with the more regular marks in the wig, may suggest the hand of a second craftsman.

Visible in the inscription are fine, roughly parallel scratches that are generally 1–2 centimeters in length. The nature of the abrasive that produced such marks has been much debated,[12] but it is commonly suggested that hard stone surfaces were polished with naturally occurring forms of silicon dioxide, either as a loose abrasive such as sand or in the form of a grinding stone.[13] No abrasion marks are visible, however, in the RTI of the wig. In general, the similarities and differences between the tool marks on this particular sculpture and on others examined in this study may be attributable to numerous factors—degree of

finish, skill of the craftsman, workshop traditions, desired aesthetic effect, and so forth— and will require a larger dataset to determine their relative significance.

This method for the systematic documentation and characterization of tool marks provides a means to thoroughly study an individual sculpture or fragment. Moreover, the relative consistency of the data facilitates the recognition of general trends or patterns in carving techniques. As greater numbers of objects are investigated, it may be possible to assign tool marks to specific tools more accurately, particularly when comparing them with the

Figure 3 ◆ (a) *Block Statue of Minhotep*. Egypt, from Lisht North Cemetery, Middle Kingdom, Dynasty 12 (ca. 1850–1640 B.C.). Diorite, H. 17.5 cm (6⅞ in.). The Metropolitan Museum of Art, Rogers Fund, 1915 (15.3.227); (b) detail, "snapshot" of the back of the wig extracted from RTI file in specular enhancement mode; (c) detail, "snapshot" of the inscription extracted from RTI file in specular enhancement mode

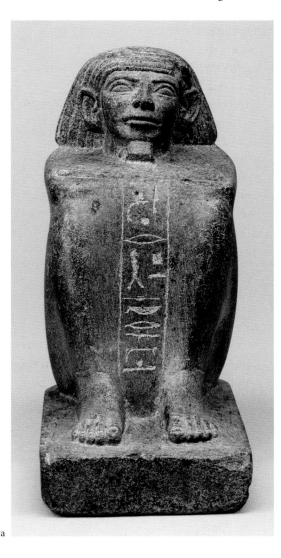

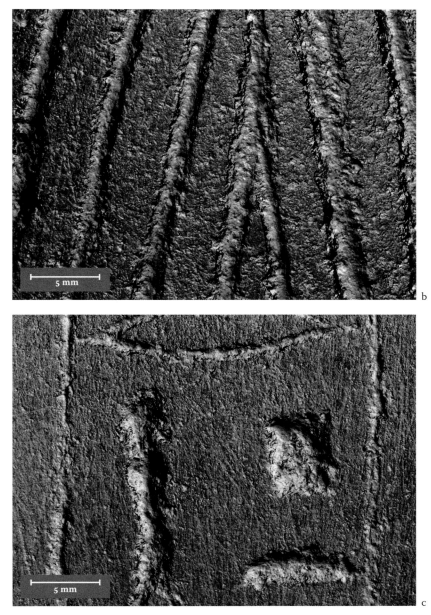

results of replication experiments, the utility of which studies by Denys A. Stocks[14] and Leonard Gorelick and A. John Gwinnett[15] have demonstrated. To augment the data generated by RTI capture, a selection of tool marks that were studied will also be examined with SEM of silicone rubber impressions, following the protocol described by Margaret Sax and Nigel D. Meeks.[16] Confocal microscopy and atomic force microscopy, techniques that have been previously used to study minute surface details and abrasions,[17] will be investigated as possible methods for the further characterization of extant polishing marks. The use of these methods in tandem has the potential to provide rich descriptions of preserved tool marks, providing a means by which to decode the practices of the craftsmen who made these fascinating objects.

ANNA SEROTTA

Assistant Conservator
Sherman Fairchild Center for
Objects Conservation
The Metropolitan Museum of Art

ACKNOWLEDGMENTS

The author would like to thank the following colleagues at The Metropolitan Museum of Art for their generous contributions to this ongoing project: in the Department of Egyptian Art, Diana Craig Patch, Lila Acheson Wallace Curator in Charge, and Dieter Arnold, Dorothea Arnold, Marsha Hill, Adela Oppenheim, and Catharine Roehrig; in the Sherman Fairchild Center for Objects Conservation, Lawrence Becker, Sherman Fairchild Conservator in Charge, as well as Ann Heywood and Ashira Loike; and in the Department of Scientific Research, Federico Carò, Adriana Rizzo, and George Wheeler, as well as Tony Frantz, formerly of the department. Thank you also to Carla Schroer, Mark Mudge, and Marlin Lum of Cultural Heritage Imaging, and to the Andrew W. Mellon Foundation for funding this research.

NOTES

1 This study generally follows Denys A. Stocks's (2003, p. 74) definition of Egyptian hard stones as those rated 7 or greater on the Mohs hardness scale, which would include granite, basalt, quartzite, diorite, and porphyry.
2 Arnold 1991, p. 48.
3 Rough shaping was probably done with dolerite balls, mauls, and axes, which bruised and crushed the stone surface (Stocks 2003, p. 76; Arnold 1991, p. 48). Finer details were likely fashioned using pointed chisels or punches held at a steep angle to the stone surface, removing stone by smashing or fracturing small areas with each hammer blow (Rockwell 1993, p. 23). The nature of these tools has been debated (Stocks 2003, p. 74; Arnold 1991, p. 48), and research in this area is ongoing.
4 Craddock 2009, p. 245.
5 Leonard Gorelick and A. John Gwinnett utilized this method to investigate drilling methods employed by ancient craftsmen (Gwinnett and Gorelick 1979; Gwinnett and Gorelick 1993; Gorelick and Gwinnett 1983) and to make a case for emery having been used as an abrasive in ancient Near Eastern lapidary work (Heimpel, Gorelick, and Gwinnett 1988). Benner Larsen applied a similar methodology to identify and document tool marks on the silver Gundestrup Cauldron (Larsen 1987; Larsen 2005), as did Margaret Sax and Nigel D. Meeks (1995) to examine lapidary methods used to engrave Mesopotamian quartz cylinder seals and Chinese jade. See also Sax et al. 2004.
6 Sax and Meeks 1995, p. 27.
7 RTI was developed by the San Francisco–based nonprofit organization Cultural Heritage Imaging (CHI) with a team of international collaborators. See http://culturalheritageimaging.org/ (accessed September 26, 2013).
8 Artal-Isbrand, Klausmeyer, and Murray 2011; Mudge et al. 2005; Earl, Martinez, and Malzbender 2010.
9 RTIs are generated in this study using the highlight method. Highlight-based RTI utilizes a handheld light source that is moved around the subject at a fixed distance. Information about the incident angle of the light is calculated from the specular highlights on black spheres included in the camera's field of view (Happa et al. 2009). The other available method for RTI image capture uses a fixed light array or "dome," which sequentially lights the subject at fixed angles for sequential images (Artal-Isbrand, Klausmeyer, and Murray 2011).
10 Identified visually by Federico Carò, Department of Scientific Research, The Metropolitan Museum of Art.
11 The RTI Viewer software allows the user to save "snapshots" of the viewing window, which can be saved in PNG or JPEG format.
12 Gorelick and Gwinnett 1983; Stocks 2003, p. 105.
13 Arnold 1991, pp. 263–64; Lucas 1962, p. 66; Aston, Harrell, and Shaw 2000, p. 66; Stocks 2003, p. 91.
14 Stocks 2001; Stocks 2003, pp. 83–95.
15 Gwinnett and Gorelick 1979; Gorelick and Gwinnett 1983.
16 Sax and Meeks 1995, p. 27.
17 Artal-Isbrand, Klausmeyer, and Murray 2011; Lu et al. 2005.

REFERENCES

Arnold 1991. Dieter Arnold. *Building in Egypt: Pharaonic Stone Masonry.* New York: Oxford University Press, 1991.

Artal-Isbrand, Klausmeyer, and Murray 2011. Paula Artal-Isbrand, Philip Klausmeyer, and Winifred Murray. "An Evaluation of Decorative Techniques on a Red-Figure Attic Vase from the Worcester Art Museum Using Reflectance Transformation Imaging (RTI) and Confocal Microscopy with a Special Focus on the 'Relief Line'." In *Materials Issues in Art and Archaeology IX: Symposium Held November 29–December 3, 2010, Boston, Massachusetts, U.S.A.*, edited by Pamela B. Vandiver, Weidong Li, and Jose Luis Ruvalcaba Sil, pp. 3–33. Materials Research Society Symposium Proceedings 1319. Warrendale, Pa.: Materials Research Society, 2011.

Aston, Harrell, and Shaw 2000. Barbara G. Aston, James A. Harrell, and Ian Shaw. "Stone." In *Ancient Egyptian Materials and Technology*, edited by Paul T. Nicholson and Ian Shaw, pp. 5–77. Cambridge: Cambridge University Press, 2000.

Craddock 2009. Paul T. Craddock. *Scientific Investigation of Copies, Fakes and Forgeries.* Oxford: Butterworth-Heinemann, 2009.

Earl, Martinez, and Malzbender 2010. Graeme Earl, Kirk Martinez, and Tom Malzbender. "Archaeological Applications of Polynomial Texture Mapping: Analysis, Conservation and Representation." *Journal of Archaeological Science* 37, no. 8 (2010), pp. 2040–50.

Gorelick and Gwinnett 1983. Leonard Gorelick and A. John Gwinnett. "Ancient Egyptian Stone-Drilling: An Experimental Perspective on a Scholarly Disagreement." *Expedition* 25, no. 3 (1983), pp. 40–47.

Gwinnett and Gorelick 1979. A. John Gwinnett and Leonard Gorelick. "Ancient Lapidary: A Study Using Scanning Electron Microscopy and Functional Analysis." *Expedition* 22, no. 1 (1979), pp. 17–32.

Gwinnett and Gorelick 1993. A. John Gwinnett and Leonard Gorelick. "Beads, Scarabs, and Amulets: Methods of Manufacture in Ancient Egypt." *Journal of the American Research Center in Egypt* 30 (1993), pp. 125–32.

Happa et al. 2009. Jassim Happa, Mark Mudge, Kurt Debattista, Alessandro Artusi, Alexandrino Gonçalves, and Alan Chalmers. "Illuminating the Past: State of the Art." *Virtual Reality* 14, no. 3 (2009), pp. 155–82.

Heimpel, Gorelick, and Gwinnett 1988. W. Heimpel, Leonard Gorelick, and A. John Gwinnett. "Philological and Archaeological Evidence for the Use of Emery in the Bronze Age Near East." *Journal of Cuneiform Studies* 40, no. 2 (1988), pp. 195–210.

Larsen 1987. Benner Larsen. "SEM-Identification and Documentation of Tool Marks and Surface Textures on the Gundestrup Cauldron." In *Recent Advances in the Conservation and Analysis of Artifacts: Jubilee Conservation Conference Papers*, edited by James Black, pp. 393–408. Papers of the conference held to celebrate the 50th anniversary of the Institute of Archaeology, July 6–10, 1987. London: University of London, 1987.

Larsen 2005. Benner Larsen. "The Gundestrup Cauldron: Technical Investigations—Work in Progress." *Acta Archaeologica* 76, no. 2 (2005), pp. 9–20.

Lu et al. 2005. P. J. Lu, N. Yao, J. F. So, G. E. Harlow, J. F. Lu, G. F. Wang, and P. M. Chaikin. "The Earliest Use of Corundum and Diamond, in Prehistoric China." *Archaeometry* 47, no. 1 (2005), pp. 1–12.

Lucas 1962. Alfred Lucas. *Ancient Egyptian Materials and Industries.* 4th ed., revised and enlarged by J. R. Harris. London: E. Arnold, 1962.

Mudge et al. 2005. Mark Mudge, Jean-Pierre Voutaz, Carla Schroer, and Marlin Lum. "Reflectance Transformation Imaging and Virtual Representations of Coins from the Hospice of the Grand St. Bernard." In *VAST 2005: The 6th International Symposium on Virtual Reality, Archaeology and Intelligent Cultural Heritage, Incorporating 3rd Eurographics Workshop on Graphics and Cultural Heritage: ISTI-CNR Pisa, Italy, November 8–11, 2005*, edited by Mark Mudge, Nick Ryan, and Roberto Scopigno, pp. 29–39. Aire-la-Ville, Switzerland: Eurographics Association, 2005.

Rockwell 1993. Peter Rockwell. *The Art of Stoneworking: A Reference Guide.* Cambridge: Cambridge University Press, 1993.

Sax and Meeks 1995. Margaret Sax and Nigel D. Meeks. "Methods of Engraving Mesopotamian Quartz Cylinder Seals." *Archaeometry* 37, no. 1 (1995), pp. 25–36.

Sax et al. 2004. Margaret Sax, Nigel D. Meeks, Carol Michaelson, and Andrew P. Middleton. "The Identification of Carving Techniques on Chinese Jade." *Journal of Archaeological Science* 31, no. 10 (2004), pp. 1413–28.

Stocks 2001. Denys A. Stocks. "Testing Ancient Egyptian Granite-Working Methods in Aswan, Upper Egypt." *Antiquity* 75, no. 287 (2001), pp. 89–94.

Stocks 2003. Denys A. Stocks. *Experiments in Egyptian Archaeology: Stoneworking Technology in Ancient Egypt.* London: Routledge, 2003.

PICTURE CREDITS

Unless otherwise indicated, photographs of works in the Metropolitan Museum's collection are by the Photograph Studio, The Metropolitan Museum of Art.

Department of Objects Conservation, The Metropolitan Museum of Art: Figures 1, 2, 3b, 3c